Jeff Seward

THE CITIES OF THE
ANCIENT ANDES

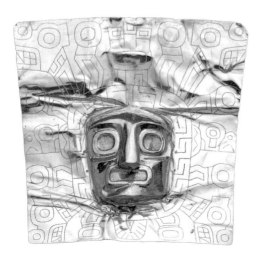

THAMES AND HUDSON

THE CITIES OF THE
ANCIENT ANDES

Adriana von Hagen and Craig Morris

WITH 147 ILLUSTRATIONS, 27 IN COLOR

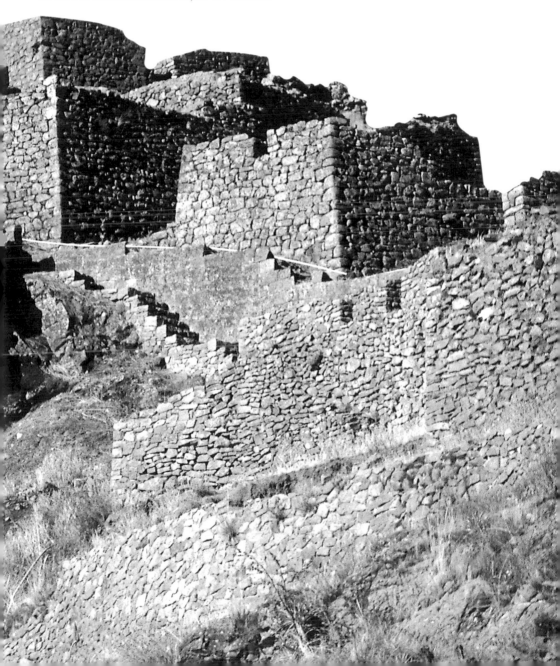

© 1998 Thames and Hudson Ltd, London

First published in the United States of America in 1998 by
Thames and Hudson Inc., 500 Fifth Avenue,
New York, New York 10110

Library of Congress Catalog Card Number 97-60276

ISBN 0-500-05086-4

Printed and bound in Hong Kong

To John Hyslop (1945–1993)
Andean scholar and generous friend

Contents

Introduction 9

1 The Andean People and their Land 13

2 Cities for the Andes 27

3 Early Monumental Architecture
 in the Andes 39

4 The Highland Center of
 Chavín de Huántar 59

5 The First Cities 83

6 Imperial Cities:
 Wari and Tiwanaku 113

7 Cities of the Desert 139

8 City and Countryside in
 the Inka Empire 161

9 Reconstructing Life
 in the Ancient Cities 199

Gazetteer 220

Further reading 228

Notes to the text 234

List of illustrations 235

Acknowledgments 237

Index 238

CHRONOLOGICAL CHART

	EARLY CERAMIC	CHAVÍN CULT	FIRST CITIES	IMPERIAL CITIES	DESERT CITIES	INKA EMPIRE

SOUTH HIGHLANDS			PUKARA					AYMARA KINGDOMS			
		CHIRIPA		TIWANAKU				KILLKE INKA			
CENTRAL HIGHLANDS				HUARPA WARI							
	KOTOSH RELIGIOUS TRADITION							WANKA			
SOUTH COAST		PARACAS		NAZCA							
							CHINCHA				
CENTRAL COAST				PACHACAMAC							
			LIMA				CHANCAY				
NORTH COAST	CUPISNIQUE			MOCHE			CHIMÚ				
					LAMBAYEQUE						

SPANISH INVASION

| 2000 | 1000 | 800 | 600 | 400 | 200 | 0 | 200 | 400 | 600 | 800 | 1000 | 1150 | 1250 | 1350 | 1450 | 1532 |

Introduction

Almost everyone has heard of the magical splendor of Machu Picchu, perched on its mountain overlooking the tropical forest from the edge of the Andes. Many also know of Cuzco, the legendary capital of the Inka empire, and even of Chan Chan, the enormous adobe city built by the rulers of Chimor. These are only the best-known of the dozens, even hundreds, of large archaeological sites to be found in the varied landscapes of the Andes. They testify to the achievements of the civilizations that developed in the region during the millennia before the European invasion and conquest in the first half of the sixteenth century.

Both of us have lived and worked in the Andes for decades and have visited the ruins of many magnificent Andean cities. Because the architectural remains are large and monumental, we initially tended to see them in the images of modern cities with large permanent populations and economies based on trade and manufacturing. Over years of observation and study, however, that image changed. The cities themselves, and the artifacts found among their fallen walls, forced new ideas about how life was lived in them.

As it became increasingly clear that the information yielded by Andean cities fits poorly with many of our general notions of cities and urbanism, the sites became increasingly enigmatic. Our research (and that of our colleagues) advanced, however, and we began to see how some of the unusual features of Andean cities can be understood in terms of the character of the civilizations that built them and the natural environments in which they developed.

This volume looks closely at that development. It traces not only the emergence of cities but also the dialogue between archaeologists and the sites they study, as they ask the questions that make it possible to reconstruct urban patterns. We hope we can give the reader an understanding of some of the special qualities of urbanism in the Andes and also convey some of the excitement that we have felt as we visited many of these sites and worked extensively in a few of them. The state of current research does not allow us entirely to dispel the mystery that surrounds the cities; all the same, it does now allow us to show how some of their unusual features came about.

From the beginning we stress how the diversity of the Andean landscape has stamped a special character on its cities. As we shall see, the relationship between cities and nature was expressed through two crucial sets of institutions: religious and economic. The cities lived a vibrant ceremonial and religious life aimed at mediating society's ties with nature. As a result, Andean artists created a brilliantly colored backdrop for urban life, portraying pumas, condors, serpents and other creatures from a hostile world. Painters made grand murals and friezes on buildings; smiths formed shimmering adornments of gold, silver, copper and bronze; potters produced an incredible variety of richly decorated vessels; spinners and weavers turned out beautiful fabrics, exhausting virtually all the conceivable forms of textile structure.

As part of religious ceremonies, oracles advised the people and their leaders of coming events and of the action they needed to take to ensure their well-being. The people obliged with ceremonies and offerings of beautiful objects, animals and, occasionally, a human life. People competed in ritual battles, sometimes with fatalities, to verify or establish the hierarchy of groups – and also perhaps to shed blood in a kind of offering to the earth and to the gods. The locations of cities often followed the dictates of sacred geography. Buildings frequently faced towards sacred mountains, and canals brought water from holy springs. The sky was as sacred as the earth, and city plans sometimes followed orientations based on astronomical observations.

The economies of these highly ceremonial cities were as notable for the characteristics they lacked as for those they demonstrated. There were no formal markets. People did not come in from the countryside to trade their goods. They came for the religious ceremonies, and some came to produce luxury goods and to serve the élite. Religious celebrants flooded the cities during certain seasons; at other times many of them had a small core of craftspeople and service personnel standing watch over hundreds of empty buildings. Populations were large and dense during times of festival, but the extensive urban ruins that we see in many places in the Andes are somewhat deceptive as measures of permanent populations.

The magnificent cities built of adobe on the desert coast and of stone in the Andes mountains had more subtle economic functions than providing market centers. The ruling élite bestowed gifts from the urban storehouses on the people who came as celebrants, even though they did not bring goods for trade. The sojourners enjoyed a rich festival life and were indulged with food and drink. Like cities throughout the world, those of the Andes treated the senses to more varied and luxurious experiences than were to be had in the countryside. People came away with gifts and hospitality; the cities had fulfilled some of the functions of exchange, even though they lacked

great markets. The image of cities as sources of gifts, hospitality and entertainment contributed to their power and influence. But, despite their unusual economic features, Andean cities – like cities all over the world – also played a role as centers of innovation and power. Cities are the well-springs of civilization, and in the Andes they played that part brilliantly for more than 1,500 years.

As urban centers spread through the mountains, plains and deserts of the Andean region, the religious and economic institutions they developed shaped both the cities themselves and the character of the countryside that supported them. We hope to lead the reader on a voyage of discovery and to reveal both the monumental beauty of these cities and the urban activities that forged the links between the cities and the spectacular land-scapes in which they were built.

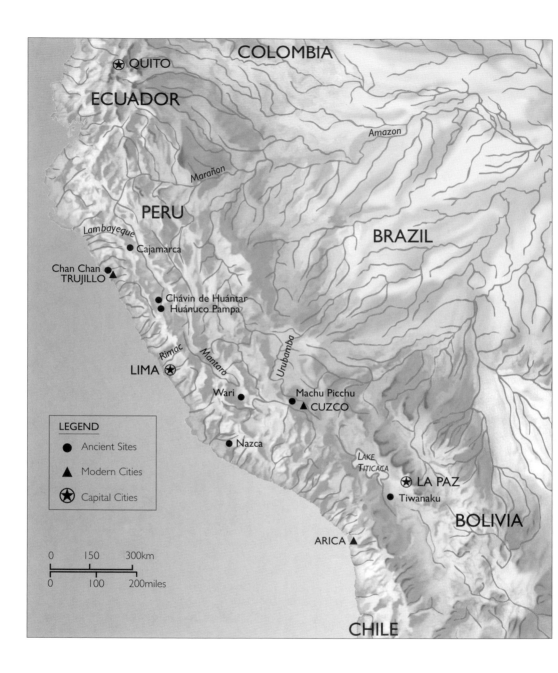

1 Map of the Andean region.

The Andean People and their Land

The Andean landscape is remarkable for its juxtaposition of contrasts – ranging from desert to jungle, and from sea-level to snowy peaks over 7,000 meters (23,000 feet) high. The people of this land developed complex and sophisticated ways to meet its challenges, building irrigation networks to make the desert fertile and terracing steep highland slopes to create more arable land.

Andean civilization appeared against a daunting backdrop of arid deserts, highland valleys, rolling grasslands and tropical forest. The prehistory of the Central Andes – or western South America, including the coast and highlands of Peru and the highlands of Bolivia – is as complex as its geography. No region in the ancient world embodied such a patchwork of peoples and places or straddled such imposing and rugged terrain. In the words of the native chronicler, Felipe Guaman Poma de Ayala, writing in the early 1600s, "this kingdom produced so many customs and languages because of the land, which is so twisted and broken up."[1] How did ancient peoples adapt to this geographical diversity and how did it influence the unfolding of civilization in the Andes?

A land of extremes

In essence, the Central Andes can be divided into three distinct geographical regions: the coast, the highlands and the tropical forest that begins on the eastern slopes of the Andes and descends to the Amazon lowlands. But these simple divisions, where changes in altitude give rise to new microclimates, belie the complexity and diversity of ecosystems that meet a traveler moving from west to east.

In the west, a narrow strip of desert runs along the coast of Peru, sliced by some fifty rivers that originate in the Andes to the east. Only about a third of these carry water all year round, and life in these parched valleys depends on rainfall in the highlands. Yet some of the greatest Andean civilizations developed in these coastal regions, their economies sustained by irrigation agriculture.

The lack of rainfall along the coast has also contributed to the preservation of archaeological remains, among them one of Peru's most enduring and enigmatic monuments, the Nazca lines. Some two thousand years ago people living in the river valleys that converge to form the Río Grande de Nazca etched huge animal figures and geometric shapes into the desert. As we shall see in Chapter 5, some of these lines and images may be linked to ancient rituals to summon up the region's scarcest resource: water.

Along the western edge of South America the cold Humboldt (or Peru) current sweeps up the coast from Antarctica. This causes both the extreme aridity of the coast and the fog that shrouds much of it in the southern hemisphere's winter, from June to September. The current chills the prevailing south-westerly winds that buffet the coast. As this cooled air blows over the coastal plain it heats up, increasing its ability to hold moisture, so that no rain falls. Only when the air rises up the western flanks of the Andes does it cool again; then the moisture condenses into clouds

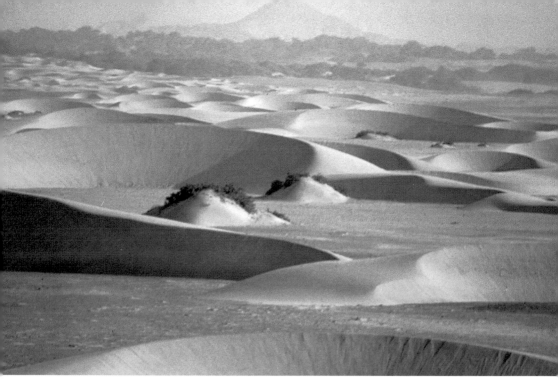

2, 3 **Peru – a land of contrasts** Sand dunes in the coastal desert near Lambayeque, in northern Peru (*above*). An oxbow lake off the Manu river in the Amazon rainforest of south-eastern Peru (*below*).

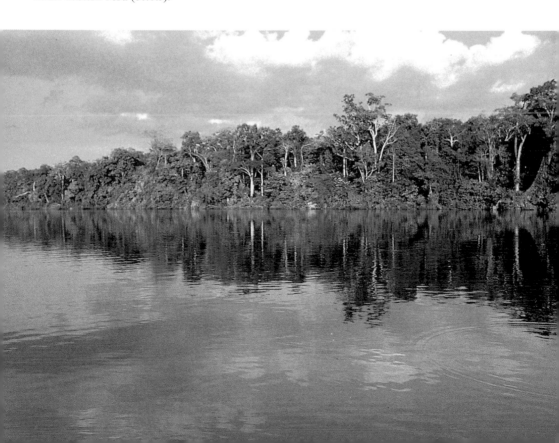

and, rising higher still, falls as rain. In the winter these clouds are trapped beneath a layer of warm air. This creates a temperature inversion that envelopes much of the coast in thick fog and mist, known as *garua*. This rarely falls as rain but it does nurture the *lomas* meadows in the coastal foothills.

Before they developed irrigation agriculture, coastal peoples settled mainly along the shoreline. There they lived off the ocean's riches, for the Humboldt current, coupled with an upwelling of water from a deep marine trench, has created some of the richest fishing grounds in the world. Nutrient-rich waters rise to the surface, teeming with phytoplankton, and this forms the basis of a food chain that includes shellfish, fish, seabirds and sea mammals. These were exploited by ancient Peruvians, who also cultivated the seasonally inundated flood-plains of the desert rivers, gathered wild fruits and rhizomes and hunted in the *lomas*.

When people began tapping the waters of the rivers and building irrigation canals, around 1800 BC, they moved their settlements inland – often near the necks of the valleys, where they could better control the flow of water – planting cotton, squash, gourds, beans and other crops. The combination of the sea's riches and produce from irrigated fields made coastal inhabitants relatively self-sufficient, and dwellers in the highlands – who relied on marine salt, dried fish, seaweed and coastal crops to supplement their diet – established links with coastal peoples early in prehistoric times.

Along the eastern edge of the desert strip lie the *chaupi yungas*, a term that describes the temperate western foothills of the Andes, ideally suited for growing maize, coca, *aji* (chili peppers) and tropical fruits. Farther inland, the valleys climb east, rising precipitously toward the snow-covered peaks of the Andes and the fertile intermontane valleys, running north–south, which flank them. At 2,300 to 3,200 meters (7,500 to 10,500 feet) above sea-level, these valleys lie within the so-called *quechua* cultivation zone. Often extensively terraced, they became the breadbaskets of the realm in Inka times, when they were planted with maize: an important ritual crop used to make *chicha*, maize beer, an indispensable ingredient of Andean ritual and feasting. On the slopes of the intermontane valleys lies the *suni* cultivation zone, ranging from 3,200 to 4,000 meters (10,500 to 13,000 feet) above sea-level. There, farmers grow potatoes and other tubers, such as *olluco*, *oca* and *mashwa*, as well as such nutritious Andean grains as *quinoa* and *quiwicha*.

Higher still, at 4,000 to 5,000 meters (13,000 to 16,500 feet) lies the *puna*, or rolling grasslands of the *altiplano*, the home of wild camelids – guanacos and vicuñas – and their domesticated cousins, llamas and alpacas. Llamas are a source of meat and serve as beasts of burden, while alpacas provide

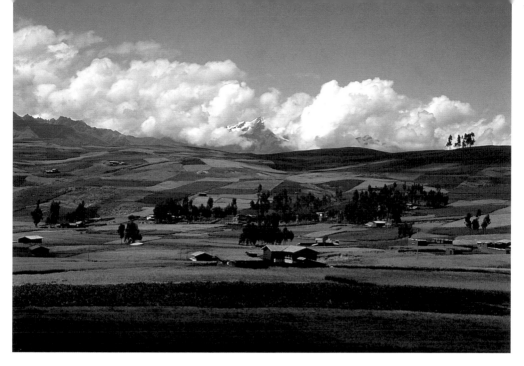

Highlands and coast
4 (*above*) Farmland near
Cuzco in the southern
highlands is planted with
native crops, such as potatoes,
as well as barley and wheat.
5 (*right*) At Pimentel on the
north coast fishermen ply
the waters of the Pacific in
traditional reed boats.

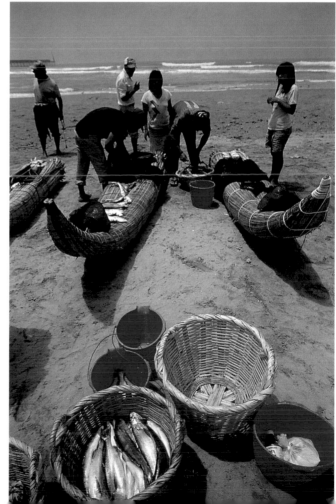

the luxurious fiber used to weave the fine cloth so esteemed by Andean peoples. As hostile and bleak as the *puna* may appear, people have roamed its rolling hills for millennia. They lived there in rock shelters and caves, whose walls they painted with hunting scenes; Andean pastoralists may have domesticated the llama in this area as early as 3500 BC. The shores of Lake Titicaca, surrounded by *puna*, became the setting for some of the highest urban settlements in the ancient world.

Lower down, on the eastern slopes of the Andes, lies the high tropical forest – poetically called the "eyebrow of the jungle" in Spanish – where the major tributaries of the Amazon rise. From there came tropical forest products such as coca leaves, honey, exotic woods, medicinal plants and the feathers of colorful birds. The region also provided important cultigens, such as manioc, peanuts and sweet potato. The tropical forest and adjacent lowland rainforest have been settled since prehistoric times, and many areas remained largely on the margins of developments in the coast and highlands. Other regions were less isolated, such as Chachapoyas, famed for its hilltop towns of stone and cliff tombs.

Earthquakes and *Niños*

Geologically, the Andes is a young and dynamic area. The western edge of South America, a part of the earth's crust known as the Nazca Plate, is slowly sinking beneath the continent, and occasionally these movements can be violent, unleashing earthquakes. In 1970 an earthquake in the Callejón de Huaylas in Peru's north-central highlands leveled dozens of cities and towns, killed 70,000 people and left thousands more homeless. One of the landslides it triggered raced down Huascarán, the country's highest peak, and buried a town of 18,000 people. In 1600 Guaman Poma documented the eruption of Huaynaputina, which blanketed much of the south coast in volcanic ash, destroying crops and livestock and contaminating water sources. Earthquakes also trigger tsunamis (tidal waves), most recently in February 1996, when a tsunami in northern Peru flooded coastal villages and swamped fishing boats.

In addition to all this, every thirty years or so the region's equilibrium is disrupted by a devastating climatic event known as *El Niño* (named after the Christ child, because its onset is usually noted around Christmas), which alters oceanographic conditions and weather patterns across the Pacific. Warm *El Niño* currents swirl south from the Gulf of Guayaquil, displacing the Humboldt current far offshore. (During the 1982–3 *Niño* event, sea temperatures rose 8 to 9° C above normal.) Thousands of seabirds died of starvation when the anchovy shoals they feed on moved offshore, following the cold current far out to sea. At the same time, *El Niño* brings drought

A land of extremes

6 (*right*) In 1600 during the eruption of
Huaynaputina, much of southern Peru was
blanketed in volcanic ash – including the city
of Arequipa, shown here in a drawing by the
native chronicler Felipe Guaman Poma de
Ayala.

7 (*below*) Every 100 years or so a devastating
climatic event known as *El Niño* unleashes
torrential rains on the otherwise arid coast.
This view shows flooding of the Piura river in
northern Peru in 1983, which inundated fields
and severed the Panamerican highway.

8 (*overleaf*) The Cordillera Blanca in
north-central Peru contains some of the
country's highest peaks.

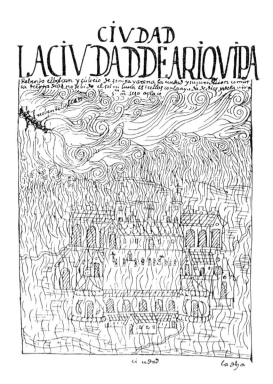

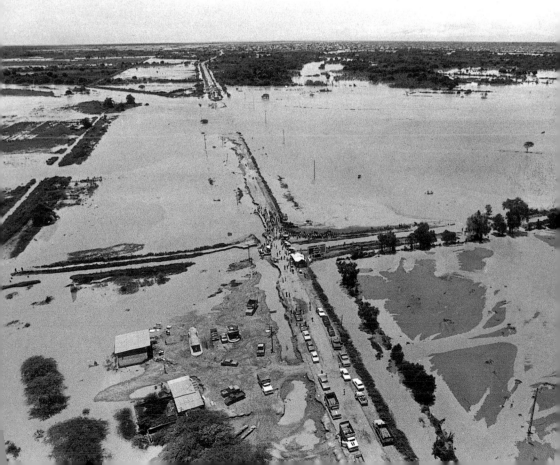

to the southern Andes and torrential rains to the north coast, flooding cities, washing out roads and bridges and destroying irrigation canals and field systems. Evidence for the destructive force of *Niños* is apparent at the Moche site of the Huaca del Sol and Huaca de la Luna in northern Peru, where a flash flood around AD 600 buried much of the urban area in alluvium washed down by the swollen river.

Judging by the devastation wrought by the 1982–3 *Niño*, the most severe in the past hundred years, such cataclysmic events in the past must have influenced the ebb and flow of Andean civilization. Some scholars have suggested that the rise and fall of Andean civilization is somehow related to these periodic natural disasters and to the generally high level of environmental stress in the Andes. Others have speculated that major floods and droughts contributed to the downfall of the Moche and Tiwanaku cultures. With the help of studies of cores from the Quelccaya ice-cap south of Cuzco, archaeologists have reconstructed ancient weather patterns of drought and unusually heavy rainfall dating as far back as AD 500. Faced with this land of extremes, Andean peoples developed a number of sophisticated and complex responses to the challenges of drought, floods, earthquakes and erratic harvests. These advances made cities and urban life in the Andes possible.

On the coast, irrigation canals transformed parts of the desert into fertile oases; by AD 1200 irrigation networks on the far north coast connected as many as five river valleys, bringing water from valleys with plenty of water to those that had little. In the highlands, on the other hand, agricultural terracing increased the amount of arable land and helped to drain soils, while other land-reclamation projects, such as the canalization of rivers, confined meandering rivers to a fixed course.

On the shores of Lake Titicaca farmers devised ingenious raised-field systems called *waru waru* that made wetlands productive and mitigated frost damage. Highland people also took advantage of freezing nights and warm days, developing *chuño* (freeze-dried potatoes) and *charki* (freeze-dried meat), long-lasting foodstuffs that could easily be stored. By the early 1500s the Inka had built vast complexes of storehouses throughout their empire to warehouse some of these products, partly to guarantee foodstuffs in times of crop failure.

Another response to the vagaries of the Andean environment was the southern highland tradition of maintaining access to far-flung resources without controlling the intervening land. We know from Spanish documents that peoples living near Lake Titicaca established enclaves of colonists in valleys on the western slopes of the Andes as well as in the tropical lowlands of modern Bolivia. This peculiarly Andean exploitation of distinct "islands" of resources may have been established by as early as 200 BC.

9, 10 **Animal husbandry** Alpacas (*above*), valued by ancient and modern Peruvians for their silky wool, are native to the highlands. Llamas (*below*) are used as pack animals and as a source of meat.

Andean crops

11 (*top left*) *Quinoa* is a staple in many areas of the highlands, replacing maize at higher altitudes. It is used to thicken soups and is ground into a flour.

12 (*left*) Coca has been cultivated since antiquity for its leaves, which yield a mild stimulant.

13 (*below*) Maize, drying in the Andean sun.

14 (*top right*) The seeds of the lupine are known as *tarwi*.

15 (*above*) *Mashwa*, a relative of the nasturtium, is grown for its edible, cone-shaped tubers.

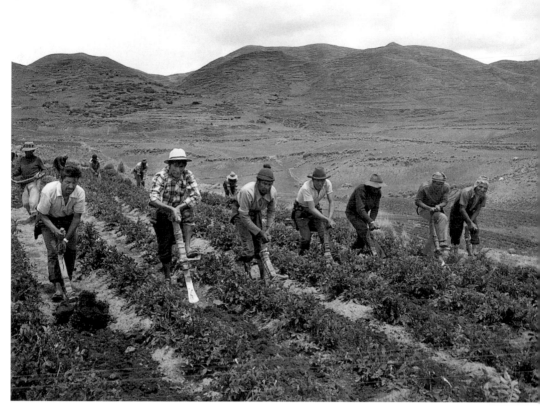

Traditional farming
16 (*above*) Farmers using the Andean foot-plow, or *chakitakylla*, prepare a field near Yanaoca in the southern highlands of Peru.
17 (*below*) A farmer in the Ocongate region, department of Cuzco, sorts potatoes for processing into *chuño*, naturally freeze-dried potatoes.

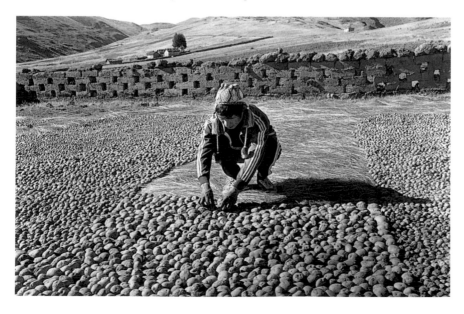

Unity and conflict

The Andes abound in natural resources, but these are often unevenly distributed. The fragmented landscape encouraged peoples to seek more productive combinations of goods and resources and to establish working relations with neighboring peoples. Some scholars have noted that large states are better able to co-ordinate production in a number of distinct ecological zones, and this favored the growth of empires such as those of Wari and the Inka.

Throughout Andean prehistory societies came together to form collaborating groups, only to break up again or realign with others. From very early times this pattern can be detected: periods of relatively close contact among far-flung regions, followed by periods of conflict and division. And yet, although states and empires existed, there was still no sense of a regional identity that encompassed the Andes as a whole.

Related art styles swept over much of the Central Andes at three points in prehistory, although the nature of each stylistic expansion was somewhat different, as we shall see in later chapters. In Chapter 4 we will explore the ceremonial network based at Chavín de Huántar in the north-central highlands that linked much of Peru from 400 to 200 BC through the awe-inspiring religious imagery of its cult: fanged supernatural beings, jaguars, birds of prey and caymans decorating works in stone, metal and cloth. Centuries later, beginning around AD 650, the people of Wari connected the Central Andes with a different kind of network, discussed in Chapter 6. Religion and its imagery, painted on ceramics and woven into textiles, still played a part in Wari's quest to control territories beyond its homeland, but what spurred it to build its administrative centers along the spine of the Andes was the control of resources. Later still, but on an even larger scale, the Inka spread rapidly far beyond their base in the Cuzco basin, stamping their distinctive art and architecture across the Andes, as we shall see in Chapter 8.

Cities for
the Andes

*The evolution of Andean settlements – from the
early monumental ceremonial centers of coastal Peru
to the Inka empire's network of cities linked by a vast
and efficient road system some four thousand years
later – is one of Andean archaeology's most
complex and intriguing stories.*

Urban life developed independently in several regions of the world. The ancient cities of the Near East, the Indus valley, China, Mesoamerica and the Andes of Peru and Bolivia have some characteristics in common. But they are also different in many respects – shaped by the specific cultural and environmental circumstances of the areas in which they developed. Urban centers in the Andes evolved from the monumental religious centers of the mid-third millennium BC to culminate, almost four thousand years later, in the network of cities, roads and state installations built and managed by the Inka empire. The specifics of this process will be traced in later chapters. Here we explore the more general aspects of urbanism as it emerged and developed in the Central Andes.

Monumental ceremonial buildings appeared by 2500 BC, overshadowing the village settlements whose communal labor built them. One of the earliest ceremonial sites archaeologists have documented is Aspero, a Preceramic-period coastal center whose small stone platforms are topped by buildings. These are contemporary with the Old Kingdom pyramids of Egypt and the ziggurats of Sumer in Mesopotamia, and they predate by a thousand years or so the monumental constructions of the Olmec in Mexico – once considered the earliest builders of public monuments in the Americas.

But can these early Andean ceremonial centers be called cities? We have included them in this book because of the monumentality of their architecture and because, in many cases, they were quite extensive. All the same, impressive as many of these sites are, they had neither dense, permanent populations nor the variety and scope of architecture characteristic of a city. Their buildings lack the diversity that suggests both a hierarchical social structure and the corresponding variety of occupations among their inhabitants that give cities their specifically urban character.

There is considerable debate over what constitutes the pre-industrial city. Nonetheless, scholars agree that ancient cities can be characterized as large, dense and diverse. Inhabitants not only differed in their social status but in their occupational specialization as well, and the range of architecture – from the humble houses of craft workers to the monumental adobe or stone structures of the ruling élite – reflects this. The question of population is especially problematic in the Andes, where many people lived in cities only part-time and the number of inhabitants of any given city rose and fell with the seasons and the ceremonial calendar. How large is a large population? Researchers vary in their definition of "large." Some suggest a population of 5,000 as a minimum limit for a "city," and this seems appropriate for pre-industrial times.

Our perception of what a city is often reflects our impressions of the cities we have visited or where we have lived. Modern cities are large and have

18 (*above*) The façade of a group of finely built Inka structures at Huánuco Pampa that may have been reserved for the ruler on his rare visits to this provincial administrative capital.

19 (*below*) The circular plaza in front of Chavín de Huántar's Old Temple is decorated with a stone frieze depicting mythical figures and jaguars. (See also ill. 45.)

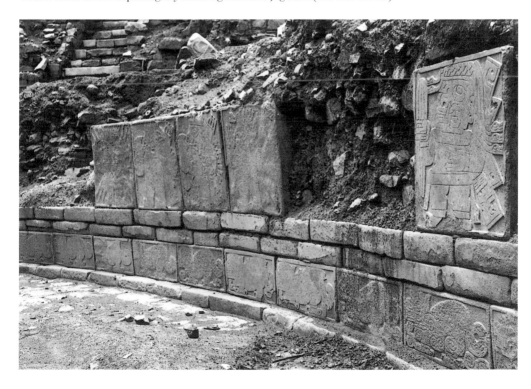

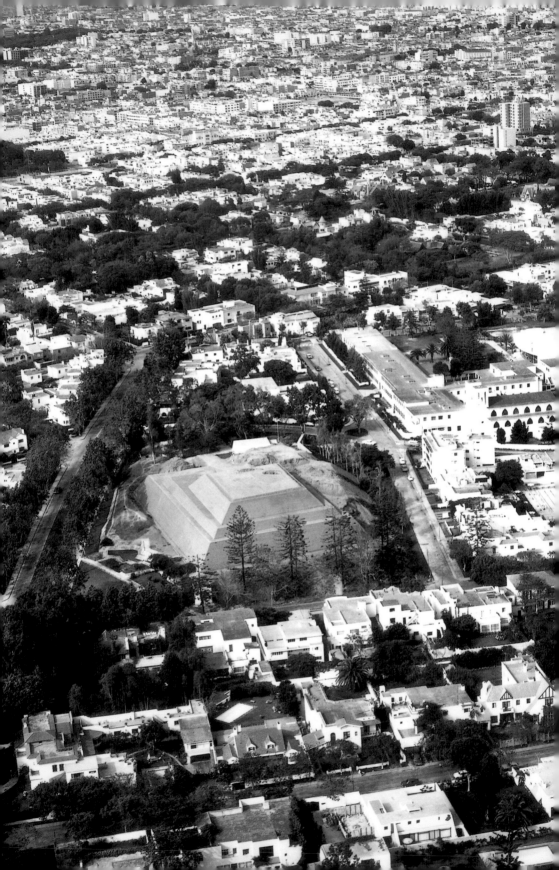

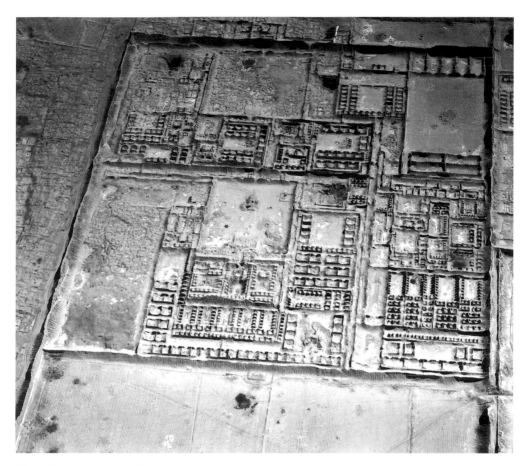

The urban environment
20 (*left*) The modern encroaches on the ancient. A partly restored *huaca*, or terraced temple mound, center, surrounded by modern houses in Lima's San Isidro suburb.
21 (*above*) Chan Chan, the Chimú capital, flourished on the north coast from around AD 900 to 1470. This aerial view of Ciudadela Laberinto shows the central sector of the compound with its storerooms. The remains of perishable structures are visible inside the compound on the left, as well as outside its walls.

densely spaced buildings in a variety of sizes and architectural styles. Some structures, monumental in scale and often luxurious in their decoration and detail, are civic buildings – for example, palaces and houses of parliament, which are associated with government or the authorities who exercise power in society. There are also religious or ceremonial buildings, such as temples and churches. Many cities have monumental structures or spaces devoted to cultural and recreational activities that are neither

specifically political nor religious; these include museums, theaters and sports complexes.

At the other end of the scale, there are small structures. Residential buildings are the most typical of these, but such structures are also often used for small-scale craft production and as small shops or markets – activities that are often attached to residential spaces. In among the vast, monumental structures and the small, primarily residential buildings, the modern city has a multiplicity of architecture varying in size and form. This fulfills a range of functions, meeting the needs of people who occupy many different positions in a society and its economy. Typically, such buildings are related to administration and bureaucracy, to commerce and storage, and to the police and military. They are not residential *per se*, though they may include temporary housing, such as hotels and barracks. In an ancient settlement these buildings are among the most difficult to identify and study, yet they are perhaps the most important for defining the character of a city.

How do our impressions of modern cities influence our reading of ancient settlements? We tend to look at the remains of ancient sites and imagine that they accommodated the same kinds of activities that similar structures and groups of structures house in the cities we know. Architecture provides the primary evidence for urbanism, but it is only through excavation, and the painstaking comparison of the excavated material with architectural features, that the nature and function of a settlement can be revealed. Only then can we go beyond a sketch of life in the past to the more compelling details that distinguish individual cities.

Archaeologists can begin answering some of our questions by determining the extent of a site and the density of its buildings. Are there large open spaces, such as plazas? Is most of the area covered by the remains of buildings set relatively close together? Then researchers can turn to the more difficult problem of architectural diversity. Is there a range of buildings, discussed above, that housed the diversity of activities that distinguish a city from a village or some other kind of settlement?

These intermediate buildings, the hallmark of urbanism, are usually identified by a process of elimination. Monumental ceremonial or official structures and small, primarily residential buildings are usually obvious, both from their size and form and from the kinds of artifacts excavated in them. Structures that do not fall into either category must then be studied carefully by looking at architectural details (such as doors, windows, floors and roofs) and built-in features (such as sleeping platforms, benches, fireplaces, work surfaces) that may have been related to specific activities. The contents of the buildings are then checked through excavation to identify their ancient use.

Location and resources

Modern cities have been shaped by market forces, by transportation tech-
nology and by the requirements and tastes of the people who controlled the
resources needed to build them. Many cities grew up as trade centers,
linked to transportation systems. For centuries great waterways moved the
goods that sustained them; later, with the Industrial Revolution, trains came
and spawned such cities as Chicago. Growing demand for industrial goods
saw many cities in northern Europe and North America expand rapidly.
Governments, trade and industry groups, and even important individuals
founded or transformed cities ranging from Venice and Hamburg in Europe
to Brasilia and Washington in the Americas. What, then, were the factors
that determined the locations of ancient settlements in the Andes?

As elsewhere in the ancient world, the siting of settlements, as well as
the alignments of certain buildings within them, often reflected concepts of
sacred geography. We shall see in Chapter 3 that the early, U-shaped mon-
umental centers on the Peruvian coast invariably faced the Andean foothills
and rivers: the sources of the water so vital to farming and irrigation
systems. Such alignments underscore an age-old Andean preoccupation
with water and fertility, and with the supernatural powers believed to con-
trol these forces.

In some centers, the builders aligned ceremonial architecture with the
cardinal directions. In such cases the ceremonial constructions became
stages for rites linked to the supernatural world, reinforcing the bonds
between society and the cosmos. In the highlands, for instance, the summit
of the Akapana temple at Tiwanaku became a viewing platform for this
society's two most sacred natural landmarks: Lake Titicaca, the great body
of water that lies to the west of the city, and snow-clad Illimani, which
crowns the Cordillera Real to the east.

This link between ceremonial architecture and sacred geography turned
natural features, such as lakes and mountains, into symbolic landmarks;
artificial features, like the Akapana and the moat that surrounded it, echoed
these. On the coast, the Moche often placed their terraced adobe mounds
at the foot of, or within sight of, the region's dominant mountains. These
massive, tiered mounds towered many meters above the valley floors, sym-
bolizing the mountains by mimicking their forms.

Other, more prosaic factors also shaped the siting of Andean settlements.
At times, societies founded their centers in politically and economically
strategic locations, so that peoples and products could be organized and co-
ordinated. Highland peoples often established their centers along natural
trade corridors; Chavín de Huántar, for instance, lay halfway between the
desert coast and the tropical forest, where it acted as a gateway community

and, in its heyday, as the center of an influential religious cult. Access and proximity to natural resources also determined the locations of settlements. At the north-coast site of Batán Grande, its prolific metal-workers depended on nearby copper mines and gold from the highlands to the east, while the surrounding vast forests of *algarrobo* provided charcoal to fuel their smelters.

Religion and ceremony

The role of supernatural forces in the droughts, floods and earthquakes that periodically afflict the Central Andes was, and is, thought to be crucial. These forces had to be placated and propitiated: all over the world people draw a sense of stability from the belief that the natural world they depend on is controlled by beings that they can influence through their own actions and ceremonies. From the outset, ceremony dominated ancient Andean settlements. They served as the settings for colorful feasts and celebrations, but beneath the pageantry and ritual lay the more serious issue of a society's prosperity and survival.

Religion and politics were the motors of Andean cities. Although economics proved vital, and became increasingly so as Andean urbanism developed, it remained closely linked to politics and religion. Economic and personal insecurity is a common denominator of most human existence, and this underlay religion and its associated beliefs and rites. People built temples and they came to them in order to try and control nature by means of appeals and gifts to the supernatural forces to which the temples were dedicated. Such rites cemented the ties not only between these temple centers and the supernatural world but also between the centers and the people who worshipped there. That is why, early in the development of Andean urbanism, the settlements that would become cities functioned primarily as religious centers.

By 400 BC this picture became more complex, and the economic dimension more elaborate. At Chavín de Huántar, explored in Chapter 4, the objects that conveyed the trappings of Chavín religion were produced on a scale greater than would have been possible for ordinary people working from their homes and leading otherwise secular lives. Artisans began to devote more and more time to making the objects and costumes related to the religion, many of them richly decorated with the cult's symbols. Religious functionaries increasingly became officials who not only organized the ceremonies but also managed the political organization and the economy that supported the religion.

In a sense, all Andean cities were ceremonial centers, some almost exclusively so – meccas for pilgrims who came from afar with tribute in

llamas, guinea-pigs, gold, fine cloth, pottery and other offerings, to gather at the centers and consult oracles. In many cases, these pilgrimage centers retained their religious allure long after their influence had ebbed, and people continued to bury their dead there and leave offerings. From its founding around the time of the birth of Christ, the powerful oracle at Pachacamac on Peru's central coast spawned a thriving community that catered to the needs of the pilgrims and managed the storage of tribute – but its population never reached the size or density of cities such as Chan Chan, Tiwanaku or Wari. Other centers had even fewer permanent residents. The size of their population depended on the ritual calendar; at times they could be almost empty, inhabited only by a small group of resident priests or administrators; at other times, they assumed a city-like appearance and filled with people, color and life.

Those Andean cities that were not primarily pilgrimage centers served mainly as centers of power and residence for the political and religious élite. In later times, as cities took on a more secular guise, it became the rulers (rather than the priests) who administered the people and their labor, and cities became major instruments for the management of society. Retainers served the ruling élite, who wore the finery made exclusively for them by the artisans at their service.

Centers of redistribution

A market economy, in the strict sense, did not prevail in the Andes, and marketplaces were very rare. While barter and some form of long-distance trade certainly existed from very early times, special political ties among and between communities and societies spurred the exchange of most commodities. The fragmented geography of the Central Andes placed a variety of ecological zones within relatively short distances of each other, so both subsistence and luxury goods could be procured without the need for long-distance trade relationships with unallied groups. Only in the case of extremely rare and valued products, such as the sacred *Spondylus* shell native to the warm waters off Ecuador, did trade with distant peoples become important.

The nature of the Andean economy produced a form of urbanism quite different from that of modern cities with their market-based economies and trade-stimulated production. Andean urbanism looked beyond the city as we usually think of it to far larger units of exchange and production. Craftworkers produced goods from dispersed materials, populations were linked to provide the materials, and the state distributed goods to suit its political and economic aims. The Inka, for instance, built more than a dozen cities similar to the great administrative center of Huánuco Pampa (discussed in

Chapter 8). Most have not been excavated, but we suspect that what they had in common was relatively small populations of permanent residents. Many lay at critical junctions between the north–south highland road that ran along the spine of the Andes and the lateral roads leading to the coast. Examples of such cities are Vilcas Waman, 80 kilometers (50 miles) south of Ayacucho, or Hatun Xauxa in the central highlands, which is now largely covered by modern Jauja. Both of these centers contained hundreds of storehouses.

Cities like these became centers of redistribution, where the ruling élite, not market forces, controlled the production and exchange of sumptuary goods, such as objects made of *Spondylus* shell or precious metals and fine cloth. Specialized artisans produced many of these goods, either at the capital or at distant centers managed indirectly from the capital. The ruling élite dispersed such goods as gifts and hospitality (usually in the context of religious and political ceremonies), and it was the storage facilities where they were warehoused that became the foci of exchange, rather than markets as we know them. Cities served vital roles in both production and exchange, but the rulers, their relatives and other state officials controlled the output and redistribution.

Satellite cities and urban networks

We shall see in Chapter 5 that the Andean cityscape underwent a second metamorphosis as settlements attracted ever-larger numbers of inhabitants with increasingly varied functions. This new phase, which seems to have been in place by AD 500, is characterized by the appearance of settlements planned by a ruling élite but often built some distance from the élite's center of residence. Certain edifices, especially monumental ones, imitated buildings at the center, but each site retained its individuality. To varying degrees, planners designed each settlement to further the political, economic and religious aims of the ruling élite residing at the center.

In parts of the Andes this basic pattern was transformed around AD 650 into a system defined not by the individual settlements but by an urban network, which became virtually synonymous with the state itself. Urban centers containing certain features modeled on those at the capital are the hallmarks of settlements founded by the Chimú, Wari and Inka. In earlier times religious institutions had focused the development of centers, such as those built by the Moche; however, as Andean civilization evolved, its leadership became increasingly secular. Religion remained central, and its rites played a prominent part in urban life throughout Andean prehistory, but in most cities the palaces and other élite residences increasingly eclipsed temples, giving the cities a more secular semblance. The tombs of

the kings of Chimor, for example, became prominent landmarks in the sacred cores of Chan Chan's royal compounds, blurring the distinctions between the rulers and the supernatural forces.

We know more about the satellite settlements built by the Inka because the vivid testimonies of Spanish eyewitnesses supplement archaeological information. But the Inka did not invent satellite cities. Centuries earlier, the kings of Chimor had established such settlements to control strategic coastal valleys rich in farmland and natural resources. The rulers of Wari, too, had founded such cities in the highlands, linking them to the capital with roads that the Inka later assimilated into their own road system. The nature of the cities and satellite settlements, however, changed over the centuries, although all mimicked the general patterns of their respective capitals. Whereas the Inka built provincial centers with great open plazas, the Chimú preferred walled compounds, and the people of Wari favored compounds with tightly clustered, cell-like buildings.

The road systems that frequently linked these satellite cities and more specialized centers into formal networks of cities created a new level of urbanism in the Andes, one that transcended the individual city. Similar systems also developed in other parts of the world, but they were rarely as centrally planned and co-ordinated as those in the Andes appear to have been. The Roman road network that linked garrison towns is probably the most notable parallel, but the Roman towns seem to have been more specialized than their Andean counterparts.

Andean states may have used satellite settlements primarily as tools of political and military strategy, as no doubt the Romans did, but the Andean satellites may have a more peculiarly native origin. Andean peoples, especially in the southern highlands, maintained access to far-flung resources without controlling the intervening land. This allowed dispersed resources to be co-ordinated and distributed, providing highland dwellers with warm-valley produce – such as maize, cotton, *aji* and coca leaves – from both flanks of the Andes.

Roads and cities built in a hinterland not fully dominated by a major state like those ruled from Wari and Cuzco (the Inka capital) are in some sense analogous to the villages built by one people in an area controlled by others, although on a much larger scale. Urban networks created in this way not only gave Andean states access to scattered resources, they provided empires with the most important resource of all: human labor. At the same time, they helped to create and to sustain the structure of the state itself, and in a sense formed a critical part of the state's very identity.

By AD 1500 the Andean city had become a place where ceremony symbolized and co-ordinated the nature, expansion and perpetuation of the state. The purpose of the state was to maintain a growing élite and to direct

people toward new levels of control over the social and natural world. Over time, the cities and the states that built them adapted to the character of the Andean landscape. This evolution and transformation – from the early monumental centers of coastal Peru to the satellite cities and the road network of the Inka – is one of Andean archaeology's most complex and intriguing stories.

Early Monumental Architecture in the Andes

Centers built to appease the gods and celebrate ceremonial life were, from very early times, focused on monumental architecture. By 1500 BC many consisted of multi-tiered mounds of stone and adobe, often with vividly colored friezes and murals of supernatural beings with feline fangs and claws.

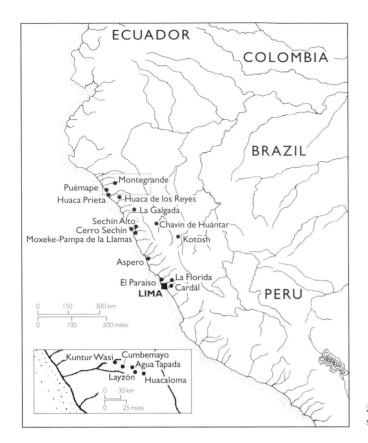

22 Map showing the principal
sites discussed in Chapter 3.

To understand how settlements turned into cities and how urbanism evolved in the Andes, we must begin at a point before cities as we know them had developed. The onset of the Early Ceramic period, around 2000 BC, heralds the beginning of one of the most remarkable epochs in the Peruvian Andes. The oldest public constructions in the Americas date from this time, and many are the largest monuments ever built in the Andes. Technological innovations accompanied the building boom of Early Ceramic times: pottery first appeared in the Central Andes, and cloth woven on the heddle loom began to replace the twined and looped textiles of the Preceramic period. Settlements began shifting inland to areas closer to the valley necks, ideally suited for tapping rivers and building intakes for irrigation canals: an innovation that allowed farmers to harvest more than one crop per year.

This chapter explores the Early Ceramic public monuments of the coast and highlands and their Preceramic antecedents. As explained earlier, centers built during these times are included because of the monumentality of their architecture and because many of them covered impressively large areas. They are not, properly speaking, cities either in general terms or in the special Andean sense discussed in the preceding chapter. On current

40

evidence, the sites lack the variety and range of architecture that typify cities. The architecture seems to fall into two main categories: monumental buildings devoted to religious cults, and small, rather simple domestic dwellings in which people carried out craft production at the household level. What is lacking is the middle range of buildings that suggests both marked social stratification among the residents and the scope of activities, neither primarily domestic nor primarily religious, that give a city its character. Nevertheless, it is from these two poles – domestic buildings on the one hand and religious monuments on the other – that Andean cities, and perhaps cities in general, seem to have developed. It is important, therefore, to investigate these origins in order to understand the fuller manifestations of urbanism in the Andes that emerged gradually over the succeeding centuries. Significantly, these early centers of religion and residence were created by societies that lacked pottery and did not practice irrigation agriculture.

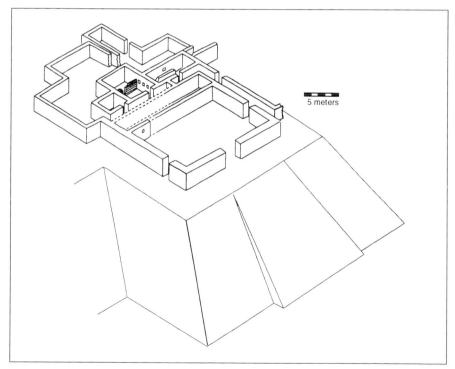

5 meters

23 Isometric reconstruction of the Huaca de los Idolos, one of two larger ceremonial mounds excavated at Aspero on the north-central coast. This Preceramic settlement, of *c.* 2700 BC, consisted of plazas, terraces and extensive refuse deposits spread out over 12 ha (30 acres) on the south side of the Supe valley.

Preceramic monumental architecture on the coast

The transition from life in settled fishing villages such as Huaca Prieta to centers with monumental architecture is quite short. Huaca Prieta, a small fishing village overlooking the Pacific Ocean near the mouth of the Chicama river in northern Peru, was occupied by about 3000 BC. Its inhabitants lived in subterranean houses built of beach cobbles set in mud mortar, and none of the structures in the sectors so far excavated appear to have had a ceremonial function.

The architectural remains may be unexciting, but thousands of fragments of cloth have been found at Huaca Prieta. Many were made of naturally pigmented Peruvian cotton (*Gossypium barbadense*, one of the first industrial crops in the Andes) in shades of white, brown and tan, and more than 70% were twined (the weft yarns turning around the warp, rather than interlacing with the warps, as in true weaving), others were fashioned by looping and knotting. To the naked eye they seem undecorated, but painstaking tracing of the paths of the warps under a microscope has revealed a variety of natural and geometric designs. These hint at some sort of belief system (besides illustrating the antiquity of the textile arts in the ancient Andes). They include a frontally depicted, human-like figure with flowing hair, a condor with a snake in its stomach, double-headed snakes, felines and crabs; some of the motifs, like the double-headed snake and interlocking figures, continued to be used by Andean weavers for the next four thousand years.

South of Huaca Prieta at Aspero, however, archaeologists did unearth monumental mounds as well as plazas, terraces and extensive middens (refuse deposits) spread out over 12 hectares (30 acres) along a bluff on the north side of the Supe river. Dating to around 2700 BC, and perhaps to even earlier, the outer walls of Aspero's larger ceremonial mounds (archaeologists have excavated two and identified at least seven large mounds, as well as six smaller ones) were made of locally quarried rock set in mud mortar. The builders also used loose mesh bags made of looped sedge fibers and filled with rubble, river cobbles or quarried stone. These mesh bags, called *shicra*, are a trademark of late Preceramic and Early Ceramic coastal architecture and, significantly, have not been found in the context of domestic architecture. The use of these bags and other features such as restricted access (established by a series of ever-narrower doorways), along with dedicatory caches, niches, friezes, and paint on mound walls point to these buildings' ceremonial function.

The largest late Preceramic coastal site is El Paraíso, located 2 kilometers inland on the south bank of the Chillón river near Lima, where it sprawls over 50 hectares (125 acres) across a gently sloping plain. This site marks

the onset of two new trends: settlements began to be established inland, although people still depended mainly on marine resources for their protein; and ceremonial structures on the coast adopted a U-shaped layout (the significance of this is explored below). By 2000 BC construction had begun at El Paraíso, and its builders used more than 100,000 tons of quarried stone to make its platform mounds and buildings. Large midden deposits identify the site as a major late Preceramic population center in the Rímac–Chillón valleys. Residents ate mostly fish, but they cultivated crops and collected sedges and cattails along the river's edge. On the flood-plain they grew cotton, their major crop, which they used to make fishnets and fishing lines and to fashion simple clothing.

El Paraíso's two largest mounds each measure more than 50 meters (55 yards) in width and run parallel for almost 400 meters (a quarter of a mile), embracing a 7-hectare (42-acre) plaza. At the base of the U-shaped plan lies a small, stone structure measuring about 50 square meters (540 square feet) and standing 8 meters (26 feet) high. Two stairways provided access to it, and one led to a chamber that was once painted red and had four circular pits, each about 1 meter (39 inches) in diameter, in the floor. These pits and the traces of charcoal found in them may indicate contact with the highlands, where fire-pits in ceremonial structures often contain the charred remains of offerings.

Highland ceremonial architecture

Ceremonial architecture appeared in the highlands at much the same time as it did on the coast. Ritual activities at highland sites, however, focused on small chambers with central fire-pits. These chambers could hold only a few worshippers, in contrast to the late Preceramic coastal centers, where flat-topped mounds surmounted by multi-chambered structures were associated with large plazas and courtyards that could accommodate large numbers of people for public gatherings.

At the north-central highland site of Kotosh, near the headwaters of the Huallaga river, archaeologists unearthed a structure they named the Temple of the Crossed Hands for the pair of sculpted clay panels, each with a plastered mud frieze of human arms crossed at the wrists, set below two niches in one of the temple's walls. This temple, built around 2000 BC, is roughly square with rounded corners. In the center is a shallow, stone-lined fire-pit connected to the outside of the temple by an air vent.

The Temple of the Crossed Hands is one of two mounds with superimposed ritual fire-pit chambers built at Kotosh during this time. Archaeologists believe that it served as the setting for a highland rite that involved the burning of offerings, a key ritual in the so-called Kotosh

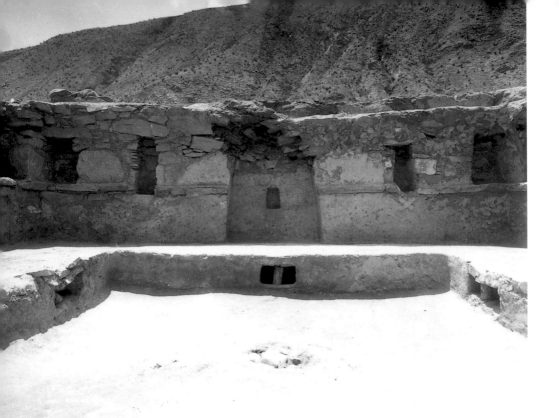

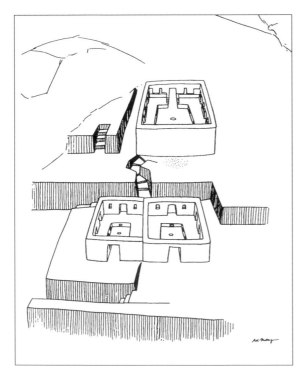

24–6 **Kotosh** Dated to *c.* 2000 BC, the temple's ritual fire-pit (*above*) – linked to the outside of the temple by a vent – was used to burn offerings. (*Left*) One of two mounds at Kotosh with superimposed ritual fire-pit chambers. The temple is named after two sculpted clay panels, one (*below*) depicting human arms crossed at the wrists.

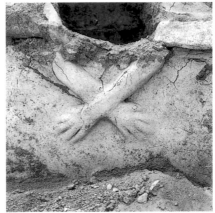

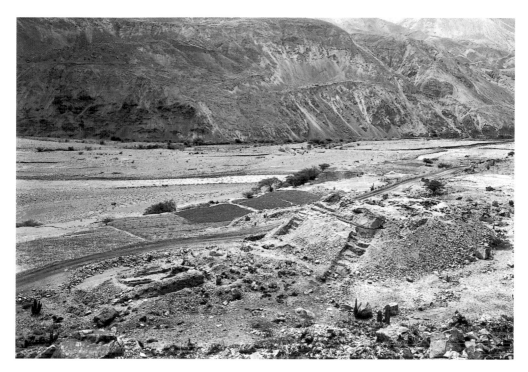

27 La Galgada in north-central Peru perches above the arid, dusty Tablachaca canyon. This view looking toward the south-east corner of the northern mound – one of two ceremonial structures at the site – shows the revetment wall.

religious tradition. The trend did not necessarily originate at Kotosh, but its sphere of influence has been traced over a distance of 250 kilometers (155 miles) to the north and south, and evidence for the rite has been found at highland sites on both the eastern and western slopes of the Andes. The fire-pits often contain the charred remains of burnt offerings, such as *aji* peppers, marine shells, bones, and precious, often exotic items: feathers, deer antlers and rock crystal.

Only at one highland Preceramic site have archaeologists excavated domestic structures. This is La Galgada, which perches 1,100 meters (3,600 feet) above sea-level in a narrow, dusty canyon overlooking the Tablachaca river, a tributary of the Santa. The people who lived and worshipped there from around 2400 to 1900 BC resided in round or oval houses with about 14 square meters (150 square feet) of floor area. Archaeologists recorded the remains of some fifty houses scattered around La Galgada's two ceremonial mounds. Their walls were of fieldstone laid in mud mortar

and they stood about a meter high. Excavators also noted the remains of two canals at the northern end of the site and traces of field and cultivation patterns below the mounds.

La Galgada's two mounds are oriented east–west, flanked by a circular courtyard and topped by ritual fire-pit chambers and tombs. People were buried in temple chambers or gallery tombs, accompanied by elaborately decorated textiles, bone pins with stone inlay and stone beads.

Ceremonial centers of the Early Ceramic period

The ceremonial centers built from around 1500 BC, during the centuries leading up to the Chavín florescence (see Chapter 4), are some of the largest ever constructed in ancient Peru, and in number they greatly surpass those built during the Preceramic period. As coastal sites began shifting inland and irrigation agriculture became more widespread, shoreline settlements grew smaller. The people's diet clearly emphasized domesticated plants, and the gradual switch from a primarily maritime economy to a farming one is reflected in the contents of middens from newly established lower- to mid-valley centers, where remains of agricultural products outnumber marine ones. A diet based on both crops and marine resources could sustain population numbers and density, but the spread of irrigation agriculture, which allowed farmers to harvest more than one crop per year, contributed to population increases. This, in turn, helped supply the labor for building monumental complexes.

These coastal centers were not empty ceremonial sites; rather, some one thousand people are estimated to have lived in and around each center. A small resident population was probably in charge of maintaining the center, and others dwelt in scattered hamlets set among fields and canals. While we know something of the domestic structures that clustered around these centers, the majority have been obliterated by modern cultivation, and excavations have generally focused on the monumental sectors of the settlements.

People from the surrounding countryside came together for community projects, perhaps under the aegis of a leader or religious authority who resided at the center. As in Preceramic times, the unifying force that inspired the building of these monumental ceremonial centers was probably religion (related to rites to ensure rainfall and fertility), and Andean conventions of communal labor (*mit'a*) may already have been in place to provide the necessary manpower. Perhaps the surrounding communities provided produce for communal feasts at these centers as part of their labor obligation, in the same way that highland communities do today. These Preceramic and Early Ceramic settlements may lack the architectural and

social differentiation that allows us to call them cities, but in them evolved many of the underlying concepts upon which Andean cities would later be formed.

Clues such as lavish funerary offerings, which indicate wealth, power and status, help archaeologists establish whether social differentiation existed among ancient peoples. There is little evidence that such diversity permeated Early Ceramic-period societies – although the occasional special offerings in tombs, or the presence of residential structures on top of cere-monial mounds, do suggest that *some* individuals may have attained special status. Nor do we see occupational specialization such as craft production; people were either farmers or fisherfolk and they made pots, textiles or fishing tools at the household level for their own use. Some trade items have been found, but such exotics were usually reserved for dedicatory offerings. They include obsidian (a volcanic glass used to fashion spear points), anthracite coal for mirrors, and *Spondylus*, the coral-rimmed shell native to the warm waters off Ecuador. The last was valued throughout Andean prehistory because it was considered the favorite food of the gods and used in rituals to summon rain.

Each valley was economically self-sufficient and linked by exchange networks to shoreline settlements exploiting marine resources, to mid-valley villages that cultivated cotton, beans and squash (probably watered by small gravity canals) and to upper-valley hamlets that supplied chili peppers, fruits such as *chirimoya*, and coca leaves (source of a mild stim-ulant that, by Inka times, had become an important ritual commodity). Irrigation was still controlled at the local level, but there must have been some sort of relationship between communities located at canal intakes and those at the ends of canals to ensure that they received water. Links with highland communities provided produce such as potatoes and other tubers and grains.

For the first time in Andean prehistory, people began to produce pottery and weave cloth on a large scale. The shift from flood-plain agriculture to irrigation farming yielded abundant cotton harvests, and this, together with the widespread adoption of the heddle loom (a much more efficient weav-ing technology, in which the heddle lifted some of the warp threads so that the wefts could be passed through them more easily), led to more intensive production of cotton cloth. The plentiful food supply may have contributed to the widespread adoption of ceramics. Ceramic containers were not only employed as receptacles for storing food and brewing fermented beverages such as *chicha*, they were also used in serving and cooking the new array of plant foods that irrigation agriculture had made available all year round.

Curiously, societies in Ecuador, Colombia and the Amazon lowlands had already been producing ceramics for several centuries. Although some

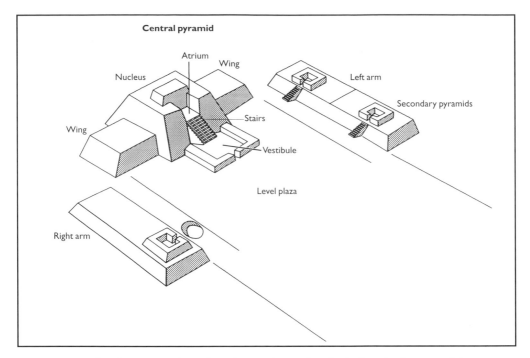

28 Idealized view of a U-shaped mound complex, the hallmark of ceremonial architecture on Peru's central coast in Early Ceramic times. Two lateral wings enclose a large courtyard or plaza, with a flat-topped mound at its base. The great majority of such mounds face north-east toward the Andes, where all the coastal rivers originate.

central Andean pottery styles were no doubt influenced by those of Ecuador and the tropical lowlands, the adoption of ceramics in the Peruvian Andes appears to have occurred independently, as seen by the considerable experimentation and variety among early Peruvian pottery styles.

Regional variations in ceremonial architecture

Archaeologist Richard Burger views the Early Ceramic centers as part of a regional social system made up of "culturally related but ostensibly autonomous"[2] centers, each with its own hinterland. Three regional patterns emerged on the coast during this time, characterized by different styles of public architecture: the U-shaped mounds of the Lurín, Rímac, Chillón, Chancay and Huaura valleys; the rectangular mounds and circular forecourt complexes of the Supe, Casma and Nepeña valleys; and the low-lying, civic-ceremonial centers found from Virú to Lambayeque, known as Cupisnique, after the associated ceramic style.

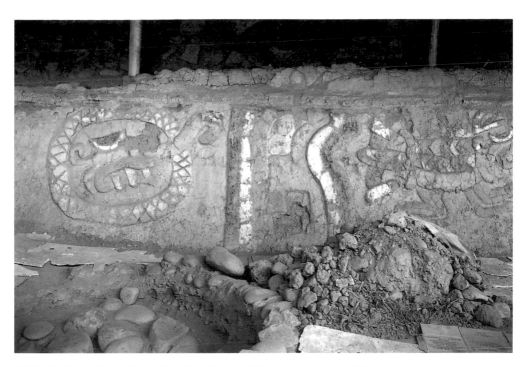

29 Detail of mud-brick frieze from the atrium of the central mound at Garagay, a U-shaped temple complex in the Rímac valley on the central coast. The supernatural being on the left, painted in shades of blue, red, yellow and white, may be a spider, the cross-hatching around the face representing its web.

Some archaeologists regard Preceramic El Paraíso as the prototype for the U-shaped centers that become the hallmark of central-coast ceremonial architecture in Early Ceramic times. The archetypal U-shaped center consists of a flat-topped mound at the base of the U, flanked by two lateral wings or arms that enclose a large courtyard or plaza. Centers with this layout vary from valley to valley, but they do have a number of features in common. The majority of the mounds face north-east toward the Andes, where the coastal rivers originate. The architectural focus is on a massive central mound, often towering several meters above the valley floor. The central mound is flanked by two lateral wings or arms that are usually of different sizes, with one wing often separated from the central mound. All three mounds embrace a large, rectangular plaza.

Aside from the obvious symbolic significance of the mounds' orientation towards mountains and water sources, we can speculate that this layout may reflect other basic religious beliefs of the peoples who worshipped there. In the view of archaeologist William Isbell, the parallel arms or wings

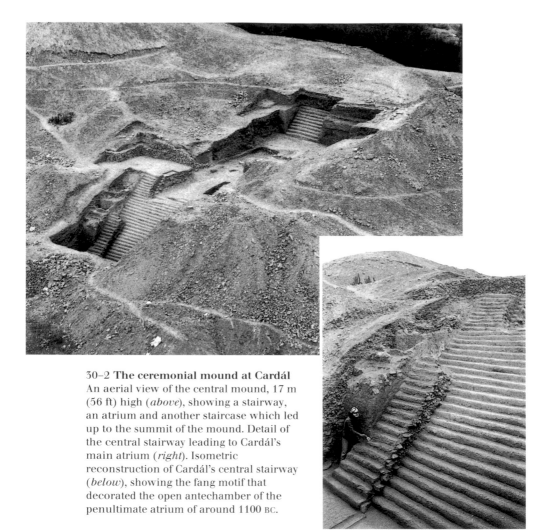

30-2 The ceremonial mound at Cardál
An aerial view of the central mound, 17 m (56 ft) high (*above*), showing a stairway, an atrium and another staircase which led up to the summit of the mound. Detail of the central stairway leading to Cardál's main atrium (*right*). Isometric reconstruction of Cardál's central stairway (*below*), showing the fang motif that decorated the open antechamber of the penultimate atrium of around 1100 BC.

of the U represent the opposing and yet complementary forces of the cosmos and society; the plaza between these arms mediates between the opposing powers and the building at the apex of the U represents the synthesis of the forces.

Archaeologists have discovered elaborate clay friezes on many of the central mounds. The walls of the summit structures and the stairways that led to them are carefully plastered. Building materials included uncut fieldstones, small, hand-shaped adobes and mesh-bag fill. As the mounds grew, the builders covered over the earlier constructions and capped them with new layers of clay; in cross-section these mounds resemble the layers of an onion.

The central coast in the Early Ceramic

The earliest U-shaped ceremonial center of this period to be explored by archaeologists is La Florída in the Rímac valley, which lies at the foot of low coastal hills once covered in *lomas* vegetation. Located 11 kilometers (7 miles) inland, construction was under way by 1750 BC and continued until its abandonment several centuries later. Ceramics found at La Florída are the earliest recorded on the central coast, and domestic refuse discovered at the foot of the central mound as well as the presence of smaller mounds, visible in aerial photographs from the 1940s, suggest that a small resident population lived in and around the center. The central mound rises over 17 meters (56 feet) above the valley floor, flanked by two arms or wings 3–4 meters (10–13 feet) high and some 500 meters (550 yards) long. They frame a massive plaza that today serves as a playing field for a Lima soccer club. As with other U-shaped centers, the open end of the U faces north-east toward the Andean foothills and the Rímac river.

Cardál is the most southerly of the U-shaped centers recorded by archaeologists. Located in the Lurín valley just south of Lima, excavations at this 20-hectare (50-acre) site revealed an extensive domestic occupation south of the central mound, an area that contained remains of structures 2.5 meters (8 feet) on a side, with stone foundations, in which excavators uncovered cooking pots, bowls, agricultural tools, cotton seed and pottery spindle whorls. Construction began around 1300 BC, and builders added to its ceremonial constructions over a span of 300–400 years. Like that at La Florída, Cardál's central platform is 17 meters (56 feet) high, and its two wings or arms enclose a 3-hectare (7½-acre) terraced forecourt. The site appears to have been one of five monumental centers that flourished in the Lurín valley during Early Ceramic times.

33 View from the summit of Sechín Alto, looking north-east to the Andean foothills. The massive, truncated central mound, faced with large granite blocks, towers 44 m (144 ft) above the valley floor.

Monuments of Early Ceramic Casma

Some of the most spectacular monumental architecture of the period appeared in Casma, the best-studied valley of the north-central coast. In Casma the second coastal ceremonial tradition is typified by centers that are dominated by rectangular, tiered platform mounds with sunken circular forecourts and plazas. Sculpted mud friezes often embellished the mound terraces. Five ceremonial centers existed simultaneously in Casma at the start of the Early Ceramic period, and just before the rise of Chavín de Huántar six centers flourished in the valley. The layout of these complexes is usually U-shaped, like that of their central-coast counterparts, with the open end of the U directed toward a water source. The plan is linear, and the axes coincide with the center-line of the main mound.

Sechín Alto and Pampa de las Llamas–Moxeke, Casma's largest centers, each cover some 200 hectares (495 acres). The massive, truncated central mound at Sechín Alto is probably the largest construction in the New World in the second millennium BC. A massive structure faced with large granite blocks, it measures 300 by 250 meters (985 by 820 feet) and towers 44 meters (144 feet) above the valley floor. Extending for over a kilometer

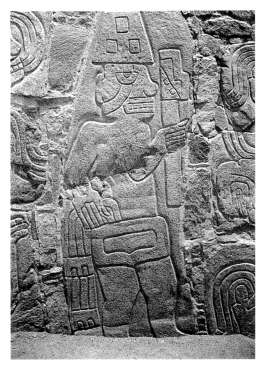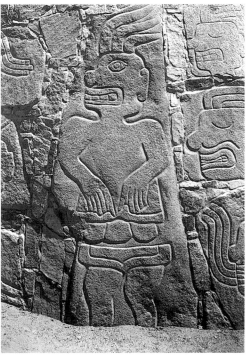

34–5 Part of Cerro Sechín's stone façade of some 400 sculpted slabs enclosing a three-tiered platform mound nestled at the foot of a hill in the Casma valley. These are some of the earliest stone sculptures in the Andes, dating to *c.* 1500 BC.

north-east of the central mound are at least four plazas, three of which contain sunken circular courtyards aligned with the axis of the central mound. Smaller constructions flank the plaza area. Remains of domestic occupation have been largely obliterated by modern cultivation.

Construction at Pampa de las Llamas–Moxeke began around 1800 BC, and the site was occupied for some four hundred years. Low mounds and domestic constructions border its plazas, where Thomas and Shelia Pozorski excavated small, stone-walled structures and discovered ceramics, clay figurines and spindle whorls, which point to textile manufacture. Two monumental mounds, Moxeke and Huaca A, face each other across a kilometer-long series of plazas, the largest of which is 350 meters (1,150 feet) long. The Moxeke mound, which was designed with a symmetrical plan, is almost square and stands about 30 meters (98 feet) high. Julio C. Tello, who excavated it in 1937, uncovered elaborately carved, free-standing, clay figures as well as colossal heads, 2.4 meters (8 feet) wide, that once stood 3 meters (10 feet) high. Painted red, blue, white, green and black, these must have awed worshippers gathered in the plaza below them. Huaca A is smaller. On its summit archaeologists found a complex of rooms with high thresholds and doorways that once had wooden bars to prevent

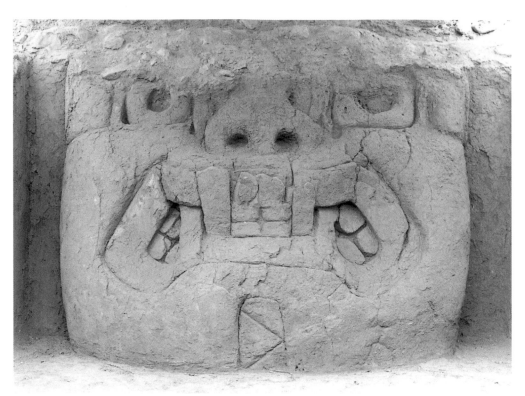

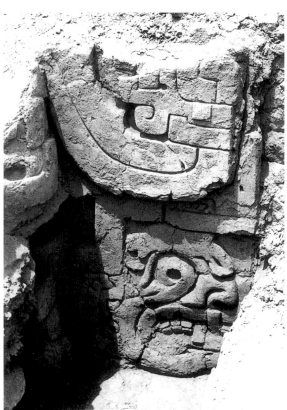

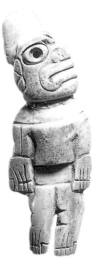

36–9 Cupisnique imagery One of four adobe heads (*above*) found at Cabello Muerto portraying a snarling, fanged creature. (*left*) A superimposed frieze set within a niche at Cabello Muerto. A human-like figure of carved shell (*below*). A spotted feline and cacti are modeled on this Cupisnique-style ceramic vessel (*opposite*).

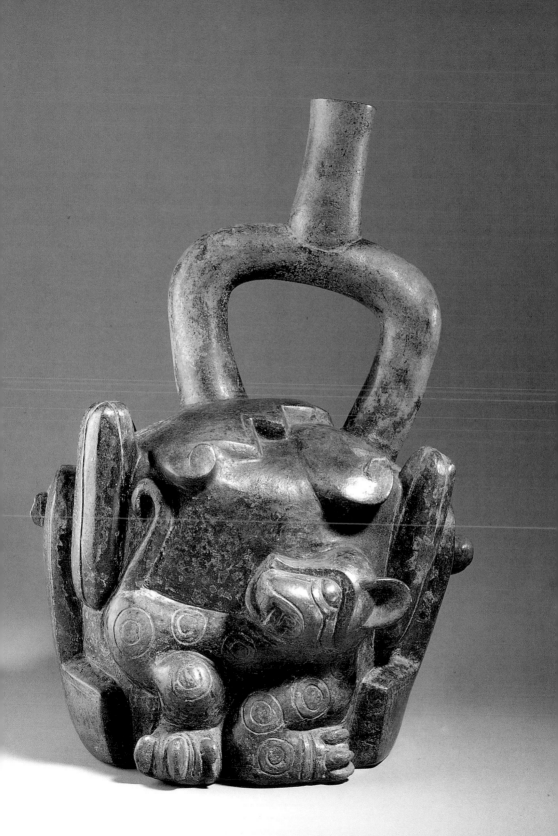

entry, suggesting that goods, perhaps ritual paraphernalia, may have been stored there.

Cerro Sechín, a smaller center, covers 5 hectares (12 acres) and consists of a three-tiered platform mound flanked by buildings on either side. It is unusual because of a rare stone frieze, one of the earliest examples of stone sculpture in the Andes. A wooden post associated with the frieze is dated 1519 BC. The stone façade, which may commemorate a mythical battle or historical event, includes over four hundred granite slabs. Carved in low relief, these portray a macabre procession of victorious warriors sporting pillbox hats. Their victims are depicted as a jumbled array of disarticulated human heads, arms, legs and entrails.

These north-central-coast centers functioned independently from those on the central coast, although they did share several common traits, which points to widespread contact. Burger sees each valley as a "patchwork of tiny, independent pre-state polities"[3] linked by kinship, shared ideology and ceremony, technology and exchange networks. Some scholars suggest that Casma may have been a center of regional authority during the Early Ceramic period, indeed even the seat of an emerging state. Others, however, argue that the emblems of statehood, such as bureaucracy and standardized architecture and artifacts, only emerged in the Central Andes several centuries later.

The north-coast Cupisnique style

The third regional architectural tradition is Cupisnique. Although Cupisnique was first used to describe a ceramic style, the term has now come to embrace the art and architecture found from Virú to Lambayeque in the Early Ceramic period. The tradition is distinguished by its low-lying monumental platform mounds with rectangular forecourts and inset stairways, their summits topped by colonnades and painted adobe sculpture. Low, lateral wings flanking the central mound confer a U-shaped plan on the centers. For many years Cupisnique was mistakenly thought to be contemporary with the florescence of the Chavín de Huántar cult (see Chapter 4), but recent excavations have shown that Cupisnique predates Chavín's apogee by several centuries, although the style continued to flourish alongside the Chavín cult. Cupisnique ceramics are much more elaborate than those of its southern neighbors and feature modeled and incised stirrup-spouted vessels in black or gray.

In the Moche valley, Huaca de los Reyes, the best-preserved of the eight mounds at the 200-hectare (495-acre) Caballo Muerto complex, underwent several remodelings. No domestic architecture was found nearby, although people probably lived on the hillsides flanking the site to the west. The plan

of Huaca de los Reyes is U-shaped, with a central platform 6 meters (20 feet) high and lateral wings framing a spacious central courtyard. The open side of the U faces up the valley.

On the summit of the principal mound, colonnades of rectangular pillars, semi-sunken rectangular courtyards, towers and rectangular rooms with multiple entryways were made of stone set in mud mortar. Near the main façade of this platform archaeologists discovered four adobe heads over 2 meters (6 feet) high and 1.8 meters wide, modeled in relief. Shown in frontal view, they portray snarling, fanged creatures with feline features and interlocked canine teeth.

At the shoreline settlement of Puémape, north of the Moche valley, arch-aeologists uncovered some 20 hectares (50 acres) of domestic architecture, cemeteries and a stone-lined temple. Puémape's earliest ceramics resemble those found at Montegrande, a ceremonial and residential complex in the Jequetepeque valley, where excavators unearthed the remains of residences built of cane and mud surrounding ceremonial mounds. Dense mid-valley occupation in Jequetepeque includes over fifty Early Ceramic and Chavín sites, of which more than half feature public architecture.

Archaeologist Carlos Elera, who excavated Puémape, believes that the entire Cupisnique region was linked by a powerful religious ideology whose iconography featured human trophy heads, the hallucinogenic San Pedro cactus, a feline/bird/reptile triad, fish and *Strombus* and *Spondylus* shells imported from Ecuador, all associated with a fertility and water cult. Cupisnique's priests probably drank a brew made of San Pedro, whose active ingredient is mescaline, and in their hallucinogenic visions trans-formed themselves into supernatural alter egos, such as jaguars. Images like these are reflected in Cupisnique pottery vessels, which portray scenes of jaguars amid San Pedro cactus, or half-human, half-jaguar beings that herald the religious imagery of Chavín de Huántar, discussed in the next chapter.

Ceremonial centers of the northern highlands

The Jequetepeque valley was, and is, a major corridor linking the coast with Cajamarca in the northern highlands. The monumental centers of the northern highlands were also non-urban sites that served as hubs of cere-monial and civic life. Located halfway between the coast and tropical forest, the Cajamarca basin developed strong ties with Cupisnique and with societies in the tropical lowlands to the east. Rainfall agriculture and hunting sustained its scattered villages, whose people came together periodically to worship at centers such as Huacaloma, Kuntur Wasi and Layzón.

Huacaloma is the earliest site with ceremonial architecture recorded in the northern highlands. Archaeologists discovered a residential area surrounding the mound, the smallest of ten late Early Ceramic sites in the Cajamarca basin. The largest is Layzón, which, together with the nearby site of Agua Tapada, was associated with Cumbemayo: an ingenious canal system partly carved into the living rock which took water from the Pacific watershed and diverted it to the Atlantic side. The late Early Ceramic occupation at Layzón featured a six-tiered platform mound carved into the volcanic tuff bedrock, with stone-lined subterranean canals draining its summit and terraces. Kuntur Wasi, located at the headwaters of the Jequetepeque river, was occupied from late Early Ceramic to Chavín times. It features a quadrangular, tiered platform mound, built about 1000–700 BC, with a level summit that covered 13 hectares (32 acres).

To the south of Cajamarca, Kotosh and La Galgada remained important centers after their Preceramic florescence, and the summit of La Galgada's largest platform was remodelled in U-shaped form. Burials became more elaborate; those found at La Galgada are the richest in the Andes dating to this time. Ceramics found at Kotosh and at other sites in the Huallaga basin show strong influence from the tropical forest.

Burger describes these highland centers as cosmopolitan, in contrast to the more parochial centers of the coast. Perhaps this is because many highland ceremonial centers were located along trade corridors and because the highlands were less self-sufficient than the coast, forcing highland people to travel farther to obtain everyday produce and exotics.

The decline of the major coastal centers, such as Huaca de los Reyes and Cardál, coincided with the founding around 900 BC of Chavín de Huántar as a local ceremonial center in the north-central highland valley of the Callejón de Conchucos. Scholars once believed that the spread of the Chavín cult and its associated art style had occurred much earlier, but research over the past twenty years has shown that much of what was once labelled Chavín art and architecture had in fact developed on the coast and in the highlands during the Early Ceramic period – several centuries before Chavín's florescence. Chavín de Huántar's architects skillfully blended coastal traits – the U-shaped, truncated platform mound and sunken circular and square forecourts – with local traditions, such as the masterful carving of stone. The result was an imposing ceremonial center that, as we shall see in the next chapter, provided the basis for a widespread and powerful cult that from around 400 to 200 BC united previously isolated regions with a shared religion and technology.

CHAPTER FOUR

The Highland Center
of Chavín de Huántar

*As the prestige of the Chavín cult grew,
it attracted large numbers of pilgrims and
vast amounts of tribute from devotees. By 400 BC it
sustained specialist artisans, who fashioned textiles
and gold objects bearing the icons of the Chavín
religion, introducing innovations in weaving and
metallurgy across a wide swath of the Central Andes.*

PLACE: Chavín de Huántar, Callejón de Conchucos, north-central highlands of Peru

CIVILIZATION: Chavín

The lead llama – a bell hanging from his neck, his ears festooned with red tassels – guided the slow-moving caravan up the narrow valley toward hilltops bathed in the first rays of the early-morning sun. The animals picked their way past stands of column-like cactus that fringed the track, their brown-and-white-striped saddle-bags bulging with dried fish from the coast and coca leaves and bright orange *aji* peppers collected from the villages strung out along the valley bottom. In a few hours the caravan would reach the forested slopes of the upper valley. Only a short distance beyond that the barren peaks of the western range and the rolling hills of the adjacent *puna* would come into view, and they would reach the half-way point of the six-day journey to Chavín de Huántar.

The drover knew the route well. He had been this way only a few months before, carrying goods bound for the temple at Chavín. Now he was bringing more offerings to the oracle, in time for the harvest festival. He could hear voices echoing through the canyon, and he made out a group of people climbing the track ahead – probably other pilgrims heading for the festival. His own people had left the day before, and he would rejoin them at Chavín.

This time, the drover had prepared for his pilgrimage: eating his food bland, without salt or *aji*, and sleeping apart from his wife. Only after this could he approach the lower plaza at Chavín's temple. But he would never be able to enter the dark galleries inside the temple that his father had told him about. One gallery, his father said, contained a stone idol so holy only priests could approach it; they conferred with the idol, who foretold what would happen during the year, and then conveyed the idol's words to the pilgrims.

On the third day the caravan reached the *puna*. A small group of wild vicuñas watched warily from the distance as the caravan plodded along the stone paved road. Ahead rose the jagged, snowy peaks of the eastern range, crowned to the north by the ice-clad massif of Huascarán. The drover recited the names of the peaks as his father had taught him to do, stopping to make a quick offering of coca leaves before hurrying his reluctant llamas on again. Now they were over the watershed, and below them sparkled the waters of Lake Conococha, the source of the great river that ran northward along the broad valley that lay between the great ranges. The road now followed the river, and by nightfall they would reach the side-valley that would lead them up and over the pass and down into Chavín de Huántar.

Agaves lined the road leading to the narrow trail that led up the valley to the pass – a two-day climb. When the caravan finally reached the snow-covered saddle the drover added a small stone to the tall pile of rocks beside the track; like all those who had done this before him, he felt he was leaving his spiritual burdens behind. After that the trail led down another valley, along the rushing stream that would take them to Chavín. Mt Huantsán, to his left, looked so close he could almost touch it. As darkness fell over the valley he could see the first

houses of Chavín, where he would spend the night, his llamas secure in a corral.

Waking early, the drover loaded his llamas and began walking toward the temple. A stone bridge crossed the river, but he kept to its right, following the straggling groups of pilgrims, and caught up with his people, who had arrived the day before; without the llamas, they had been able to walk more quickly. As he joined them, they came upon an enormous stone wall. They had never seen anything like it. Grimacing monster-heads loomed gargoyle-like and appeared to be floating above them. The heads had big, bulging eyes and some had sharp fangs, while others had snakes writhing from their eyes or over their heads; some looked like cats, monkeys or eagles, others like men.

Now they stood on the bank of the river that flowed past the east side of the temple. They heard murmuring voices and, looking up, they saw hundreds of people congregated in the plazas in front of them; llamas, still laden with their saddle-bags, milled around the edges of the plazas. Beyond rose the temple, glowing in the early morning sun, framed by the valley and the distant peak of Huantsán.

The drover approached a man dressed in a short tunic who seemed to be in charge of unloading the llamas, laden with tribute of dried fish, coca leaves, maize and *aji* peppers. But these were familiar things; more intriguing were the coral-rimmed shells (they came from distant shores, he was told), fine cloth in all sorts of colors and patterns, strange pottery painted with designs he had never seen, and emerald-green feathers, plants and roots from the warm valleys to the east.

Suddenly, a roar reverberated through the plazas; the noise rose and fell, and finally trailed off, like distant thunder. The buzzing crowd was silenced. Frightened, everyone looked toward the temple, and the haunting sound of a shell trumpet echoed through the plazas.

Magically, a brightly dressed man appeared on the summit of the temple, blowing the trumpet. Where had he come from? The temple had no doors or windows or stairways. He held a golden tumbler aloft and drank from it. Then, as suddenly as he had appeared, he disappeared again. Another figure appeared, resplendent in a shirt covered with small golden spangles that glinted in the sun. A large golden disk covered his chest; a jaguar mask, canines bared, covered his face; a jaguar pelt covered his back, and a plumed headdress crowned his head. Then this figure, too, disappeared.

Again the roaring sound filled the plazas, and the trumpet's call drifted among the pilgrims. The jaguar figure emerged once more – this time from one of the balconies halfway up the temple's façade. Now the jaguar-man spoke. The oracle was pleased with the gifts the people had brought, he proclaimed, and the gods would not cause the ground to shake. The many gifts of shells ensured that there would be plenty of rain, so that the fields in the mountains would not lie parched, as they had in the time of the grandfathers. Nor would the gods send floods to the coast and chase away the fish and kill the birds. This year the llamas and alpacas would produce many young. It would be a good year.

Long after it had fallen into ruin, Chavín de Huántar's renown lingered on in the minds of Andean peoples. The place was still tinged with mystery when the first Spaniards passed through the region in the sixteenth century. "In many parts of it there are human figures and faces, all wonderfully represented," noted Pedro de Cieza de León, who saw Chavín de Huántar in the 1540s. He suggested that "long before the Incas reigned, there lived in these regions men like giants, as large as the figures sculpted in stone reveal."[4]

Chavín de Huántar intrigued nineteenth-century travelers as well. Charles Wiener paused at Chavín de Huántar in the 1870s and wondered "what could have been the purpose of this dark labyrinth, of this house without windows, of these floors without light." He pondered whether it had served as a prison or a fort, but concluded, "It was obviously a temple, and the hieroglyphs inscribed on the two sculpted pillars contain information on the divinity they believed in and invoked."[5]

In the twentieth century, the pioneering work of archaeologist Julio C. Tello revealed that Chavín de Huántar had been the center of a powerful cult. It inspired works of art in metal, cloth, stone and ceramics bearing the emblems of Chavín and disseminated throughout much of the Central Andes. But Tello believed that Chavín de Huántar had flourished much earlier than recent research has shown, and he claimed that it served as the inspiration for many of the monumental constructions he had explored along the coast. Recent studies indicate that in fact Chavín de Huántar represented the synthesis and culmination of these earlier developments. Its temple and oracle were established around 900 BC, centuries after the Early Ceramic ceremonial centers of the coast and highlands, and the widespread art style inspired by the stone sculpture of Chavín de Huántar has been shown to date to 400–200 BC.

The founding of Chavín de Huántar

Chavín de Huántar's founding around 900 BC coincides with the decline of the major coastal centers. Like its coastal and highland counterparts, it began as a local ceremonial center. The site lies about 3,000 meters (9,800 feet) above sea-level near a pass through the Cordillera Blanca, roughly halfway between the coast to the west and the tropical lowlands to the east. This location, in a narrow valley along a trade route, was ideally suited to control the movement of goods, people and ideas.

Like many Andean ceremonial centers, Chavín de Huántar's siting expresses concepts of sacred geography. It lies at the confluence of two rivers (the Wacheqsa and the Mosna), a location Andean people consider propitious. The Wacheqsa originates to the west on one of the Cordillera

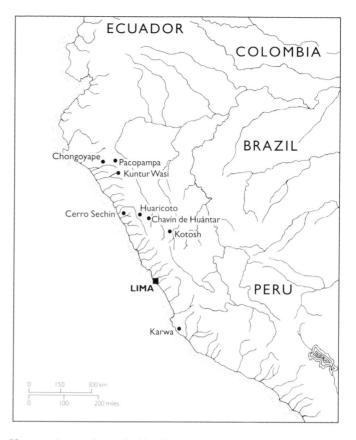

40 Map showing the principal sites discussed in Chapter 4.

Blanca's highest mountains, Huantsán, and symbolically connects Chavín de Huántar to this snow-covered peak. Anthropologist Johan Reinhard, who has linked several Andean ceremonial centers to mountain-worship, has shown that Huantsán was revered in antiquity as well as today. The open end of Chavín's u-shaped temple precinct faces east toward the Mosna river and the rising sun. Against this backdrop of sacred mountain, confluence of rivers and alignment with the heavens, construction began on the massive, flat-topped mound known as the Old Temple sometime around 900 BC. This earliest occupation, called Urabarriu, is typified by its ceramic style dated from 1000 to 500 BC.

Richard Burger suggests that when Chavín de Huántar was founded some 500 people lived near the temple in rectangular houses. The settlement covered around 6 hectares (15 acres) on both sides of the Wacheqsa river, and a stone bridge of Chavín date, some 7 meters (23 feet) long and 3 meters (10 feet) wide, spanned the river until swept away by a landslide in 1945. People from nearby villages and hamlets worshipped at Chavín de Huántar, farmed the valley floor and mountain slopes, and herded and hunted on the *puna*. In the Urabarriu phase a huge wall was built north of the temple, effectively blocking traffic through the valley.

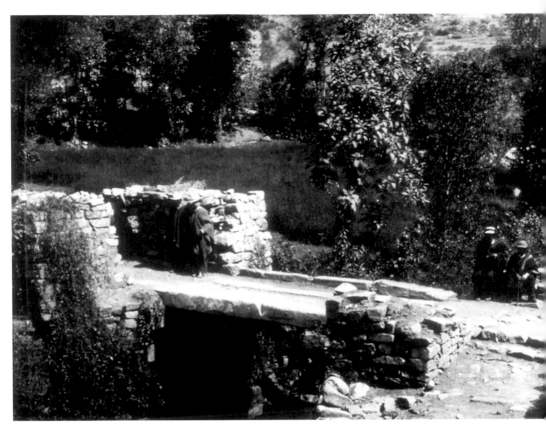

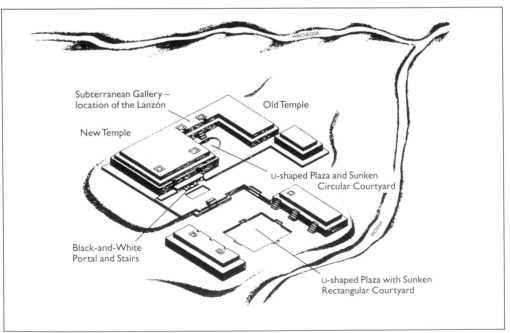

WACHEQSA

Subterranean Gallery –
location of the Lanzón

Old Temple

New Temple

U-shaped Plaza and Sunken
Circular Courtyard

Black-and-White
Portal and Stairs

MOSNA

U-shaped Plaza with Sunken
Rectangular Courtyard

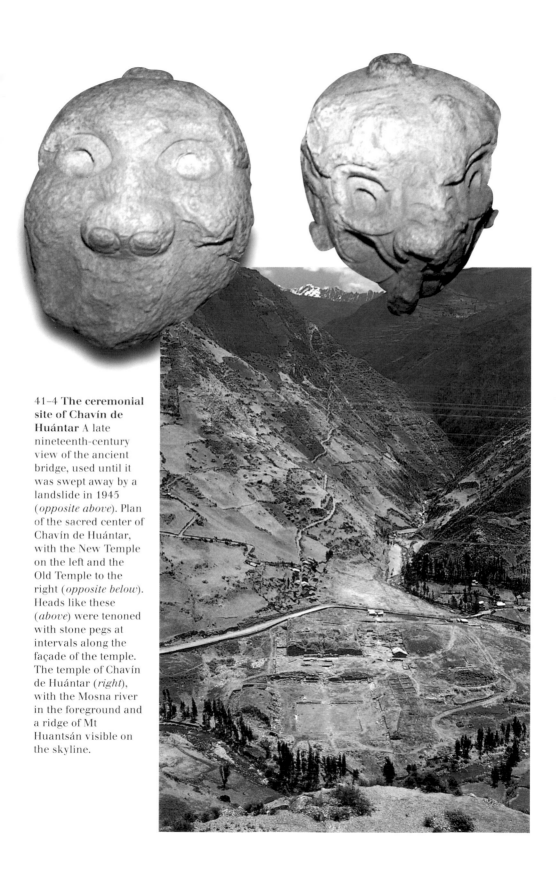

41–4 The ceremonial site of Chavín de Huántar A late nineteenth-century view of the ancient bridge, used until it was swept away by a landslide in 1945 (*opposite above*). Plan of the sacred center of Chavín de Huántar, with the New Temple on the left and the Old Temple to the right (*opposite below*). Heads like these (*above*) were tenoned with stone pegs at intervals along the façade of the temple. The temple of Chavín de Huántar (*right*), with the Mosna river in the foreground and a ridge of Mt Huantsán visible on the skyline.

The Old Temple

The Old Temple occupies terraced and leveled land overlooking the Mosna river. It consisted of an earthen and rock core sheathed by polished slabs of granite, sandstone and limestone. Its layout recalls the sacred U-shape of the coastal centers, complete with smaller and larger wings and a sunken circular courtyard. The central platform is 11 meters (36 feet) high, while the southern one is 16 meters (52 feet) high, and the larger, northern one rises 14 meters (46 feet). Some 10 meters (33 feet) above the temple floor on the central platform, large, projecting stone heads were tenoned to the façade at intervals. They depict fearsome, fanged, half-human creatures – sadly only one remains *in situ*. Cornice stones, carved on the undersides, ringed the summit about a meter above the heads.

Despite its seemingly solid construction and lack of doorways and windows, the Old Temple's interior is honeycombed with chambers and passageways called galleries. These were connected by stairways, vents and drains, forming a labyrinth that bore the stress of the temple's rubble core. Conduits provided air to the dank passageways, and stone-lined canals drained rainwater from the flat-topped summit. Some galleries led to the top of the temple, allowing priests to appear mysteriously on the summit and awe the worshippers gathered in the plazas below.

Archaeologists have noted that the network of drainage canals and air ducts, around 500 meters (1,650 feet) in the Old Temple alone, far exceeded the demands of simple engineering. Some have suggested that worshippers gathered in front of the temple associated the sound of water rushing through the canals, amplified by the opening and shutting of vents and drains, with the thunder-like roar of Chavín de Huántar's oracle (see Chapter 9).

The Old Temple's flanking platforms embrace a sunken circular court-yard 21 meters (69 feet) in diameter and 2.5 meters (8 feet) deep, where some five hundred people could have gathered. Two wedge-shaped stairways led into the courtyard, which is faced with stone slabs, some carved with jaguars and others with anthropomorphic figures, marching toward one of the stairways. Burger believes that this procession may have marked a mythical event that served as a model for the rituals carried out at Chavín de Huántar. The jaguars shown below the human-like figures may represent the metamorphosis of the humans into jaguars, recalling the coastal Cupisnique tradition that often depicted man/jaguar transformations. Burger also suggests that the tenoned heads studding the façade of the central platform may illustrate successive altered states, as priests, aided by hallucinogenic brews and snuffs, transformed themselves into their jaguar or bird-of-prey alter egos.

The courtyard's western stairway faced another flight of steps located in the central platform at the apex of the U. These led to a gallery entrance and the Old Temple's main object of worship, perhaps its earliest oracle: the 4.53-meter- (15-feet-) high granite monolith known as the *Lanzón* or the Great Image.

The *Lanzón*, unlike the majority of Chavín de Huántar's stone sculptures, still occupies its original position. Facing east, it commands the end of a dank, cross-shaped gallery. It portrays a human-like form, its right hand raised and its left lowered, whose feet and hands end in claws. The deity's almost human earlobes hang heavy with pendants, and its thick-lipped mouth is drawn back in a snarl to display fearsome upper canines. Its eyebrows and hair end in snakes' heads, and it wears a headdress of feline heads and a tunic-like garment also adorned with feline heads. The notched top of the monolith reaches through the ceiling into an unexplored gallery above, from which Chavín de Huántar's priests, acting as the voice of the oracle, may have spoken to supplicants.

Next to the circular plaza Luis Lumbreras and his colleagues discovered another gallery. They named it the Gallery of the Offerings for the remains of about eight hundred broken ceramic vessels scattered about its chambers. The vessels are decorated in a variety of styles ranging from coastal Cupisnique to imports from the northern highlands. Camelid, deer, guinea-pig and fish bones found with the vessels indicate that some once held foodstuffs, while bottle-like containers probably held liquids, perhaps *chicha*. Some archaeologists believe that the Gallery of the Offerings served to store ritual paraphernalia; others suggest it warehoused offerings to the temple or housed priests or initiates into the Chavín religion.

Eclectic iconography

The iconography of Chavín de Huántar's sculpture reflects its cosmopolitan style. Scholars have pointed out that none of the animals and plants carved on the sculptures is native to the highlands. The Tello Obelisk, for instance, a granite monolith 2.52 meters (8¼ feet) long found buried near the surface of the New Temple's rectangular sunken plaza, portrays a supernatural cayman carved in low relief. The top is notched, and the obelisk probably stood upright; like the *Lanzón*, it may have graced a gallery. It is festooned with carvings, among them images of crops foreign to Chavín de Huántar, such as manioc and peanuts, both native to the tropical forest, as well as *Strombus* and *Spondylus* shells from the coast of Ecuador. Other carvings show jaguars, snakes and birds of prey identified as harpy or crested eagles.

This imagery inspired Tello and others to posit a tropical-forest origin

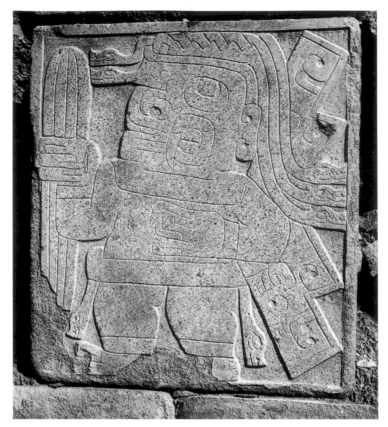

45–7 Stone carvings at Chavín de Huántar A human-like figure (*above*) carrying a San Pedro cactus at Chavín de Huántar's sunken circular courtyard. The jaguar (*below*) is part of a procession leading toward the stairway of the circular courtyard. The *Lanzón* (*opposite*), perhaps the major cult image of Chavín's Old Temple.

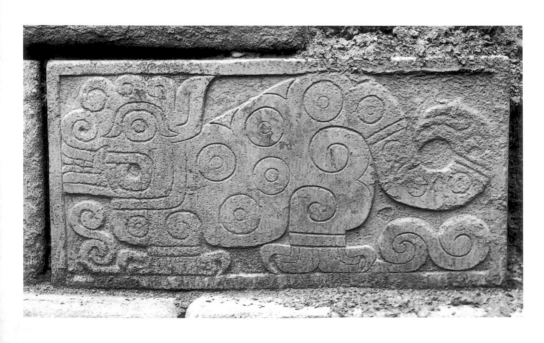

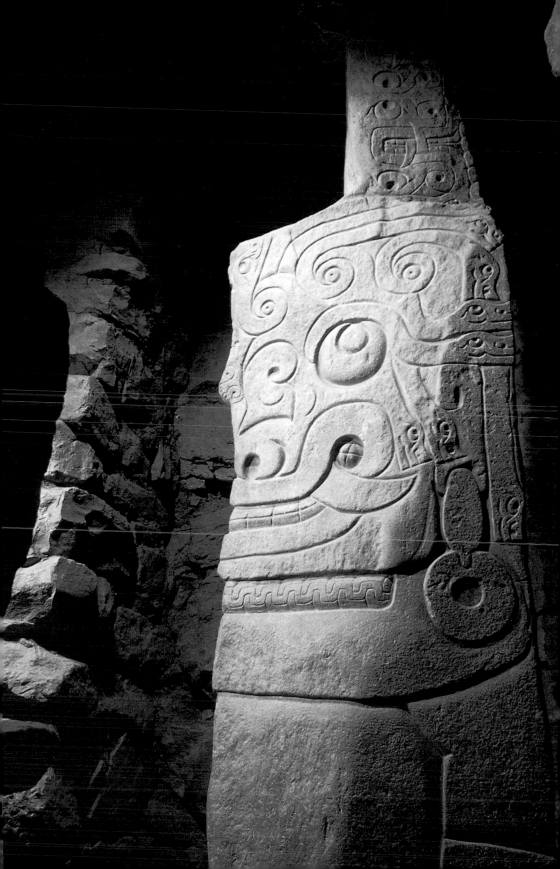

for Chavín de Huántar. But subsequent research has shown that, although its religion may have borrowed animal imagery and cosmology from tropical-forest societies, Chavín's architecture has more in common with coastal styles, while its subsistence economy is typically highland. Some of the animals – the jaguar, the cayman, the snake – are also found on the north coast, and some of the emblems – *Spondylus* and *Strombus* shells and the hallucinogenic San Pedro cactus – were held sacred by coastal peoples. Just as Chavín de Huántar's architects drew on coastal traditions for the design of their temple, so its sculptors fused sacred imagery from the coast, and perhaps Amazonian cosmology from the tropical lowlands, into their stone-carvings. These borrowings, combined with original sculptural designs, forged a style unique in the Andes.

By 500 BC Chavín de Huántar had become a flourishing ceremonial center to which worshippers came from afar, bearing gifts and tribute to the temple. At the onset of the Chakinini occupation (500–400 BC) the settlement at Chavín surrounded the temple precinct on both sides of the Wacheqsa river and covered some 15 hectares (37 acres): almost double the size of the earlier Urabarriu settlement. Unlike Urabarriu-period inhabitants, the thousand or so Chakinini-period residents dined off ceramics decorated with the symbols of Chavín religion, something which Burger interprets as evidence for closer ties between the settlement and the temple. At the same time, Chakinini people consumed more llama meat, suggesting that they devoted less time to hunting and had established closer links to herders in the *puna*, who provided them with llama meat. Fish and shellfish from the Pacific coast are also more abundant in the midden. The wealth of exotic foods and imported raw materials such as obsidian in Chakinini-phase Chavín de Huántar suggests that the temple's position as an increasingly important ceremonial center allowed its priests to procure more and more exotic goods, which they then distributed to the local community.

A new pottery style typifies the Janabarriu occupation (400–200 BC), which coincides with the remodeling of Chavín de Huántar's temple precinct and the creation of the so-called New Temple. The settlement covered 42 hectares (104 acres), much bigger than any of the surrounding communities, and its population may have trebled to as many as three thousand residents: one of the largest settlements in the Andes for its time. The temple and its plazas made up only twelve percent of the total settlement area, which lay on the west bank of the Mosna.

In this period households may for the first time have specialized in craft production for exchange – making, for example, beads from *Spondylus*, which was imported to Chavín de Huántar as unworked shells. Bone weaving tools and needles indicate that some households engaged in

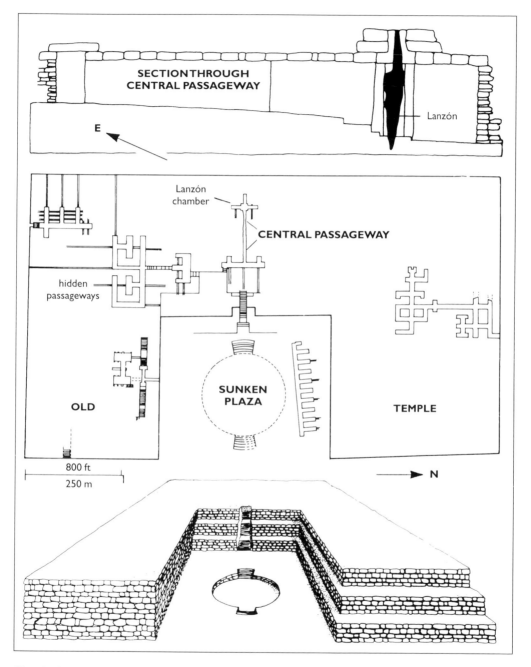

SECTION THROUGH
CENTRAL PASSAGEWAY

Lanzón

E

Lanzón
chamber

CENTRAL PASSAGEWAY

hidden
passageways

SUNKEN
PLAZA

OLD

TEMPLE

800 ft
250 m

N

Chavín de Huántar
48 (*top*) Cross-section, showing the location of the *Lanzón* at the end of a gallery;
(*center*) plan, showing some of the galleries hidden within the temple; (*below*) the Old
Temple and its sunken circular courtyard.

71

weaving. We have no idea what these textiles looked like, but on the basis of analogies with Karwa, discussed below, and Tiwanaku, explored in Chapter 6, we can speculate that the carvings adorning Chavín's temple may have mimicked the canons of Chavín's weaving style.

Although Burger admits that evidence for social stratification at Chavín de Huántar is slim, he feels that the Janabarriu settlement provides the first evidence for the initial stages of urbanism and the social changes that often accompany it. Apparently not everyone had the same access to resources: some houses had more imported pottery and foodstuffs, and analyses of llama bones indicate that some of the residents consumed younger, more tender llama meat. Since the modern town of Chavín covers a considerable portion of the site, archaeologists have not been able to explore much of the domestic and common areas of the ancient settlement to gain a clear picture of its architectural variation. A more marked differentiation of wealth, however, seems to be echoed in buildings of intermediate scale that emerged in Janabarriu times.

As the cult and its priests grew in importance, religion motivated art and supported artisans. A group of specialized emblem-makers emerged to fashion the signs and symbols of the religion, which were distributed on artifacts through a system in which the exchange of objects and the spread of the religion contributed to each other. This combination of permanent religious personnel, artisans and others who supported the cult began to create the kind of varied, dynamic and innovative setting that we think of as urban.

Most of the people at Chavín de Huántar at any given time may have been pilgrims, but the religion was supported by a whole apparatus of people who administered it and produced and exchanged the goods associated with it. In this setting the conditions that would lead to marked social stratification and to the centralization of power began to emerge.

Burger has referred to this setting as "proto urban."[6] Chavín de Huántar marks the threshold of urbanism in the Andes: a place with architecture that was both monumental and varied and a center that brought together people of different social positions, occupations and probably, to some extent, ethnic origins. Officials, artisans, servants of the religion and pilgrims all interacted to form a vibrant center of the Chavín cult.

The New Temple

Chavín's growing prosperity is reflected in the remodeling and enlargement of the temple precinct into the structure known as the New Temple. Scholars once believed that at this time the ritual focus at Chavín de Huántar had shifted to the New Temple, but it now appears that both tem-

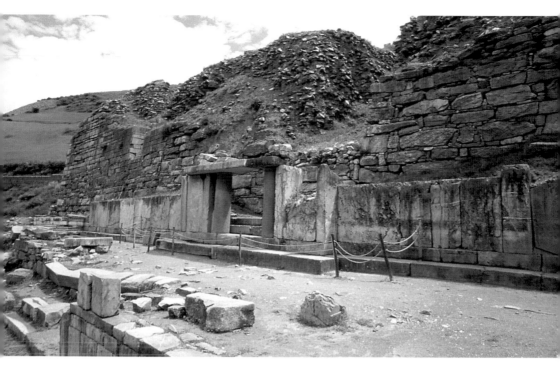

49 The eastern façade of the New Temple at Chavín de Huántar, showing the polished slabs of granite, sandstone and limestone that sheathed its earth-and-rock core. The Black and White Portal (*center*) includes two elaborately carved columns depicting crested eagles and is topped by a carved lintel.

ples were used simultaneously. Chavín's designers created the New Temple by enlarging the south wing of the Old Temple, doubling its size; they did not modify the Old Temple's north wing, however, and the New Temple's plan was not as symmetrical as the old one, although it retained its basic U-shape. They also built new galleries, connected to those in the Old Temple. On the summit of the central platform, builders fashioned a platform 2 meters (7 feet) high on which they built a matching set of two-roomed structures. No central stairway led to the summit, as in the Old Temple, and priests probably emerged into public view on the summit from galleries and stairways. Two inset rectangular openings with short stairways formed "reverse balconies" about 6 meters (20 feet) above ground level that would also have enabled temple attendants to appear mysteriously from the façade.

At the base of the New Temple's central platform its builders added a portal with two elaborately carved columns depicting crested eagles, topped by a carved lintel (mentioned by Wiener in the quotation at the beginning

of this chapter). This led into a square patio or court 20 meters (66 feet) wide, decorated with sculpted panels. From there, a monumental stairway of black limestone and white granite led into the New Temple's main plaza that sweeps eastward toward the river. Measuring 105 meters (345 feet) by 85 meters (279 feet), this rectangular plaza enclosed a smaller, sunken court 50 meters (164 feet) on a side. Together the courts and plazas could have held some fifteen hundred worshippers.

Chavín's iconography became even more elaborate as its sculptors created new works in stone to decorate the larger temple precinct. These included the image of a new supreme deity found on a relief in the patio of the New Temple. Like the figure on the Lanzón, it sports fangs and wears bracelets, anklets and ear pendants; it carries a *Strombus* shell in its right hand and a *Spondylus* shell in its left. Another stone carving in the late style, found at Chavín in the 1840s, is the Raimondi Stela. This 1.98-meter- (6½-feet-) high polished granite slab portrays a staff-bearing deity, similar to others found at Chavín but more stylized, with an intricate headdress that covers more than half the carving.

As with the layout of other Andean ceremonial centers, Chavín's sacred architecture dictated how people moved through the precinct. Some later centers, such as Tiwanaku, emphasized gateways that marked boundaries between one sacred space and another (see Chapter 6), but worshippers at Chavín de Huántar approached the temple through a series of carefully planned plazas that became progressively smaller, higher and probably more sacred and restricted. Those gathered in the plazas saw rituals performed on the temple summit, while only priests witnessed rites conducted in the galleries. This juxtaposition of private and public ritual is an Andean tradition that dates back to the ceremonial centers of the Late Preceramic.

The spread of the Chavín cult

Richard Burger believes that the expansion of long-distance trade, the pan-Andean popularity and acceptance of the Chavín cult and the integration of specialized llama-herding into the local agricultural system fueled Chavín de Huántar's success. Its wealth was based on temple tribute and control over the production and distribution of portable art embellished with the emblems of the Chavín cult. Moreover, construction had ceased at many of the once-thriving coastal centers, several of which were abandoned, and their collapse allowed the Chavín cult and its related art style to spread freely.

The symbols of the Chavín cult – images derived from the stone sculpture at Chavín de Huántar decorating ceramics, textiles, goldwork and

stone – have been found on the coast from Ica in the south to Lambayeque in the north. In the northern highlands, Chavín-inspired art has been discovered at Pacopampa north of Cajamarca, and it spread south to the Mantaro valley and to Huancavelica and Ayacucho. For the first time, a shared religion and technology linked much of the Central Andes. Like Tiwanaku, Wari and Inka – the other great unifying Andean civilizations that followed centuries later – the Chavín cult brought together previously unrelated regions.

How did this cult spread so rapidly across such a broad area? Some scholars have seen a model for its expansion in the spread of the later cult of Pachacamac, an important ceremonial center that flourished for many centuries in the Lurín valley on the central coast. Ethnohistorical documents and archaeological evidence have pinpointed Pachacamac as the center of a highly revered oracle and vast ceremonial network that, on the eve of the Spanish invasion, had expanded throughout much of Peru. Its much-feared deity was thought to punish offenders by sending earthquakes. Spanish documents reveal that far-flung communities sought the permission of Pachacamac's priests to set up branch oracles that were viewed as the wives, siblings or children of Pachacamac. Once permission was granted, the communities set aside farmland and herds to support the regional cult center, with part of the produce paid to Pachacamac as tribute. Tribute included cotton, maize, coca leaves, dried fish, llamas and guinea-pigs, as well as such precious goods as finely woven textiles, ceramic drinking vessels and raw materials such as gold, all kept in storehouses.

The concept of "feeding" temples and oracles (or *huacas*, a Quechua word meaning sacred places, people or objects) is an ancient Andean tradition. People regarded *huacas* as potent sources of prosperity that had to be worshipped and cared for in return for the benefits they bestowed. Offering tribute to the *huacas* was a way of "feeding" the supernaturals, who spoke through oracular shrines. Tribute and labor offered to the *huacas* strengthened reciprocal ties between communities and the supernatural world, ensuring rainfall, bountiful crops and fertile herds and preventing such natural disasters as earthquakes, drought, hail and frost.

What did these oracular shrines look like, and what kind of images did the priests consult? Cieza, who saw a ruined temple at Pachacamac, said it "had many gates, which, like the walls, were adorned with figures of wild animals. Inside, where the idol stood, were the priests who feigned great sanctimoniousness."[7] Describing Pachacamac's oracle, Miguel de Estete, one of the first Spaniards to see it in 1533, said its wooden idol resided in a "dark and fetid" chamber. "At the foot of the Idol there were some offerings of gold, and it was held in such veneration that only the attendants and servants ... were allowed to officiate before it. No other person might enter."[8]

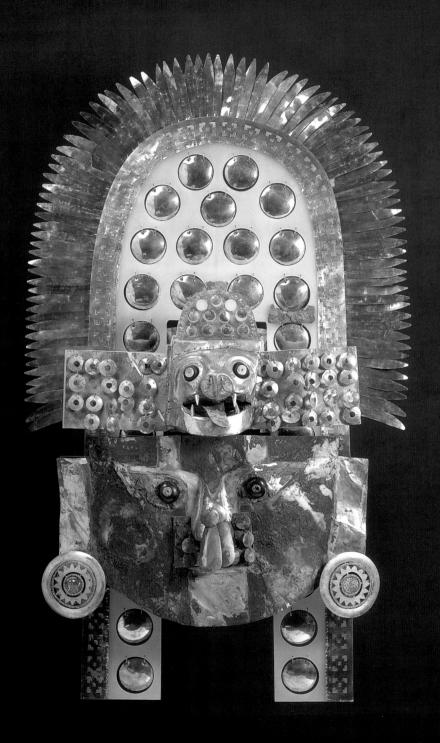

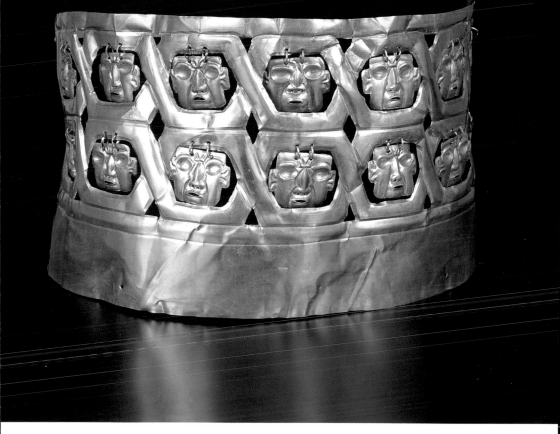

50-2 Ancient Peruvian metalwork
Lambayeque (Sicán) gold mummy
mask and head-dress of around AD
900-1100 (*opposite*), unearthed in
a tomb at the foot of Huaca del Loro
at Batán Grande on the north coast.
Fourteen human heads dangle from
a crown of hammered sheet gold
(*above*). Found in the tomb of an
elderly man on the summit of
Kuntur Wasi in the northern
highlands of Peru, it dates from the
apogee of the Chavín cult. The gold
pectoral (*right*) comes from another
tomb unearthed on the summit of
Kuntur Wasi. It represents a feline
whose left eye is surrounded by a
serpent.

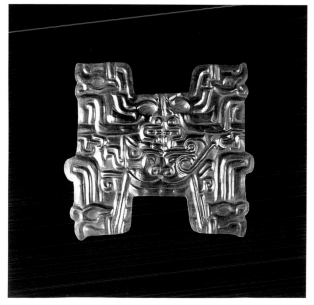

53 Reconstruction of the summit of the temple at Kuntur Wasi, as rearranged in Chavín times to accommodate three platforms embracing a sunken rectangular plaza. The stairway from the plaza was embellished with carvings recalling Chavín de Huántar's late sculptural style.

Regional cult centers

Applying the Pachacamac model to the Chavín cult, scholars suggest that it may have had a regional center at the south-coast site of Karwa, where Chavín-style motifs appear on early Paracas ceramics, pyro-engraved gourds and textiles. These date to 400–200 BC, and so are contemporary with Chavín de Huántar's Janabarriu phase.

Karwa, located 8 kilometers (5 miles) south of Paracas, was discovered in the 1970s by looters, who dug up a cache of ceramics and some two hundred fragments of painted textiles whose iconography is unquestionably Chavín. The most common image found on the painted cloth is that of the staff-bearing deity. But, unlike the staff god portrayed on Chavín's Raimondi Stela (its contemporary), Karwa's staff deity is invariably female. Moreover, many of Karwa's textiles were painted in a resist technique similar to batik and tie-dye: an innovation linked to the spread of the Chavín cult.

Textile specialist William Conklin believes that a number of innovations in weaving technology and textile decoration were first used to display Chavín designs and may be directly connected to the spread of portable objects linked to Chavín rituals. At the apogee of the Chavín cult (400–200 BC) camelid fiber, which absorbs dye more readily than cotton, began to appear in cotton-warped textiles, and coastal weavers began to use new techniques such as tapestry.

In metallurgy the Chavín cult was accompanied by such innovations as soldering, sweat-welding, repoussé decoration and the alloying of gold and silver. Burger argues that the existence of full-time craft specialists such as those at Chavín de Huántar, who produced Chavín-style objects for export,

54 Snuff spoon, 11.1 cm (4.4 inches) long, reportedly found at Chavín de Huántar. Fashioned of hammered gold and silver sheet soldered together, it portrays a man blowing a conch-shell trumpet.

55 (*overleaf*) This gilded copper feline of around AD 200, discovered in a tomb at Sipán, highlights the remarkable quality of north-coast metalwork, a tradition dating back to the florescence of the Chavín cult. Its fangs, nose, eyes and ears are inlaid with *Spondylus* shell and stone, as is the double-headed serpent design on its forehead. A double-headed serpent head-dress, inlaid with shell and decorated with dangling, gilded copper disks, arches above the figure.

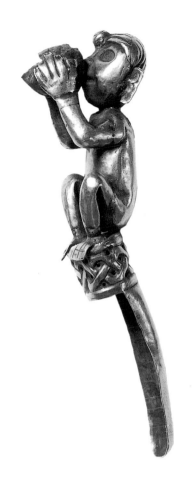

contributed to the success of the cult, while the exchange network allowed ideas and objects to spread rapidly.

Chavín de Huántar was not the only thriving ceremonial center at this time. Those that have been best documented lie in the northern and north-central highlands. In the heartland of the Kotosh religious tradition, centers such as Kotosh in Huánuco and Huaricoto in the Callejón de Huaylas continued to flourish, and worshippers built a sunken circular plaza similar to the one at Chavín de Huántar alongside Huaricoto's traditional fire-pit chambers.

In the northern highland centers of Pacopampa and Kuntur Wasi, too, Chavín-style stone sculptures point to links with the Chavín cult: a stone sculpture from Pacopampa depicts a fanged female supernatural holding a *Strombus* shell, and on the summit of Pacopampa's mound was a sunken rectangular plaza of cut and polished stone. Kuntur Wasi's architects re-arranged the summit of their tiered platform mound to accommodate three platforms embracing a sunken rectangular plaza, and they embellished a

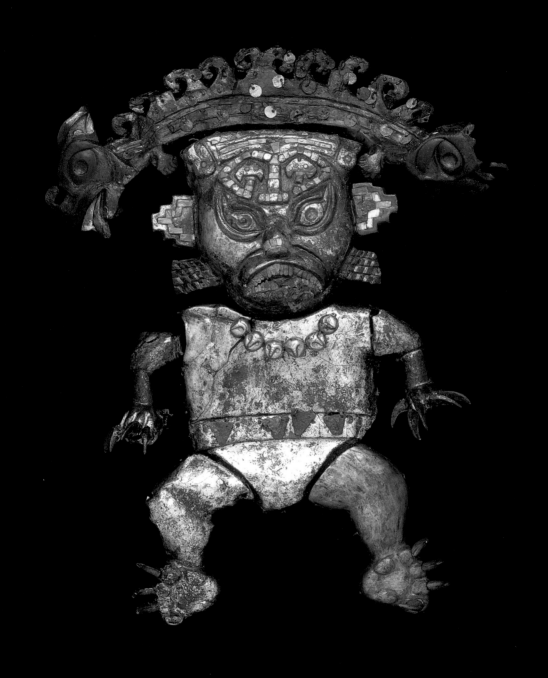

stairway leading from the central plaza with sculpture reminiscent of Chavín de Huántar's late sculptural style.

Works have been found in metal, shell and other materials that are elegant examples of north-coast art portraying the emblems of the Chavín cult. At Kuntur Wasi ceramics from recently excavated tombs show strong affinities with Cupisnique, while decorative elements in the goldwork found there relate it to objects from Chongoyape, a site in the Lambayeque valley contemporary with the florescence of the Chavín cult. On Kuntur Wasi's platform summit archaeologists uncovered four shaft tombs, each about 2 meters (6½ feet) deep. The rich grave goods include a braided crown 18 centimeters (7 inches) high hammered from a single sheet of gold, with fourteen human heads dangling in its diamond-shaped openings. An adjacent tomb yielded another gold crown, carved *Strombus*-shell trumpets and an H-shaped gold chest-ornament depicting a fanged supernatural.

The Chongoyape cache, reportedly from three tombs, includes pottery, stone bowls and various objects made of sheet gold, including a spoon (probably used for inhaling snuff) on which perches a man made of hollow gold blowing a silver *Strombus*-shell trumpet. A crown from Chongoyape depicts a staff-bearing supernatural that recalls the Raimondi Stela figure. The earliest evidence for the Chavín style on the north-central coast comes from the shrine of Cerro Blanco in the Nepeña valley just north of Casma. This small adobe mound was built in the shape of a Chavín supernatural, with richly decorated friezes painted red, white, yellow, orange, pink and black.

The tombs from Kuntur Wasi and Chongoyape are rich but rare glimpses of the opulent offerings that accompanied certain individuals to the afterlife; the majority of burials dating to this period consisted of shallow pits with only a few offerings, recalling the tombs of Early Ceramic times. The portable items with Chavín-style decoration found in the dozen or so élite burials that have been discovered show that a few people, perhaps local leaders or priests, had gained social prominence. The lavish burials from northern Peru also provide evidence for the early association of gold with élite burials. Throughout Andean prehistory gold, imbued with religious and political symbolism, was reserved exclusively for the élite and conveyed social status and power.

The fall of Chavín de Huántar

Around 200 BC, a mere two centuries or so after its rise, the Chavín cult began to languish. The reasons are not clear, but archaeologists have noted that in central and northern Peru construction of monumental architecture came to an abrupt halt during the third century BC, and some centers were abandoned altogether.

Several factors probably contributed to Chavín's demise, but Burger believes that Chavín civilization was doomed because it lacked a strong and coercive centralized state apparatus that could maintain long-term stability. If so, instability probably disrupted the long-distance networks of exchange and tribute so vital to it. At Chavín de Huántar squatters occupied the circular sunken plaza, using some of the sculpted stone slabs to build their houses, and archaeologists have documented similar patterns at Pacopampa and Kuntur Wasi. On pottery, designs related to the Chavín cult were replaced by local styles, and hill-top fortresses became widespread on the coast and in the highlands.

Chavín de Huántar brought Andean civilization to the threshold of urbanism. It never became more than a ceremonial center, but it apparently sat at the top of a hierarchy of centers, clearly the leader and a place of major innovation. Although drastically different from modern market-based cities, it had an active economic life that included exchange and craft production. The exchange system was tied to religion and ceremony, and production was geared to providing the goods the religion and the élites required. Artistic innovation created the designs and symbols for communicating religious ideas and marking the identities of the religious élite, and technological innovations introduced new ways of producing the goods that the religion required. This fusion of the ceremonial and the economic would become a fixture of Andean cities. Later it became more elaborate and took on a more secular guise, but the main features were present in Chavín times.

Throughout the Andes, the void left by the collapse of Chavín's unifying cult was filled by independent, regional societies. Yet, as we shall see in the next chapter, in many areas (even in those lying far beyond Chavín's sphere of influence) the art and architecture of these newly emerging societies recalled the legacy of Chavín de Huántar.

CHAPTER FIVE

The First Cities

By AD 500 the ceremonial centers of the Central Andes began to emerge as incipient cities. Appearing in the archaeological record as settlements planned by a ruling élite, who had them built some distance from their centers of residence, they attracted ever-larger numbers of inhabitants with increasingly varied functions.

TIME: AD 550

PLACE: Pyramids of the Sun and Moon, Moche Valley, Peru

CIVILIZATION: Moche

That year the priests had forecast that it wouldn't rain in the valley, only in the mountains to the east. The river would fill with water, and there would be good harvests.

It was reassuring. In bad years the ocean warmed up, the fish disappeared, the seabirds and the sea-lions left the beaches and the islands. Worse still, it rained on the coast for days and days, so that the rivers burst their banks and washed away the canal intakes, flooding the fields. Then insects would come and eat any crops that survived. Even the great temple, with its bricks of sun-dried earth, had melted in those rains.

As she followed her father to the cotton fields, the little girl could see dark clouds gathering to the east, where the mountains grew steeper and the valley narrowed. The river began high in the mountains up there, and far up the valley canals tapped its waters.

Smaller canals, lined with *pacae* and *lucuma* trees, branched off the main canals and criss-crossed the entire valley. In a good year its irrigated fields could grow plenty of maize and squashes and beans, as well as the cotton, with its white and tan and brown bolls, that the weavers could spin and weave into cloth.

Near the cotton-fields the girl stopped to watch workers making bricks at the river's edge. They dug shallow pits in the rich silt and mixed the soil with gravel and water to make gooey, wet mud. Then they pressed the mud into molds and left them to bake in the sun. Before the mud was too hard, though, they pressed marks into the clay, so everyone would know who made the bricks. Some people made footprints with their feet, others used fingertips to make dots and lines in the tops of the bricks.

They were needed for the town's two great temples. Work never stopped there, and they grew ever higher and wider as new sections were added. Platforms and ramps led to the work site, where the dry bricks were tossed from hand to hand until they reached the builders, who laid them in tall, column-like segments and mortared them in with mud.

Other workers perched on scaffolding, plastering the surface of the new brickwork with a thick layer of more mud. When it had dried painters applied layers of dark red and muted yellow to the new terraces, so that the temple stood out against the desert hills like a painted mountain.

The girl's home was near the great temple – her father had built it, and neighbors had helped him dig the trenches for the foundation of stones he had gathered from the river bed. But he hadn't used any bricks; he had made the walls of split cane and then plastered them with mud.

There were some much fancier houses across the town, though, near the temple at the foot of the mountain streaked with black stone. They had well-made walls of stone and mud brick finished off with plaster. That was where the potters' and the metal-workers' workshops were, too.

She remembered watching the smiths pounding ingots of copper into thin sheets with their stone hammers, and then shaping the sheets around wooden or stone molds. How the noise had rung in her ears! It was much more peaceful in the potters' workshops, with their large earthen pots on the floor full of stored clay, and other vessels filled with water collected from the canal that snaked through the town. She had watched the potters quietly pressing the clay into the two halves of their molds, fitting the halves together and putting them into their furnaces to fire. They made small statues of strange beings with plumed headdresses and ear-ornaments, feline-like faces and fangs; some of them were shown playing drums or a flute – and some of the little statues had pebbles inside that rattled when you shook them.

Next door a potter had been using a smooth stone to burnish the base of a black pot shaped like a duck. It had glared at her menacingly from eyes inlaid with white shell, and under its wings it carried a shield and a club.

She watched the river flowing serenely past the brick-makers. Downstream it would reach the ocean, where big waves tumbled onto the beach. That was where you could find the fishermen and their little boats made of reeds bundled and tied together (they cut the reeds from the marshes along the coast and laid them out to dry in the sun on the beach).

Early in the mornings they bounced through the breakers and out to sea, sitting astride their craft, legs trailing in the water, and paddling furiously with oars made of split stalks of cane. Then, in the late afternoon, when the sun was burning like a fireball on the horizon, they returned with their catch, riding their boats up the beach on the waves and then propping them up to dry.

Sometimes flotillas of boats went to the islands that lay far, far offshore to hunt sea-lions with clubs, or to collect guano, the droppings of the millions of birds that nested there. They would bring the guano back to spread on the fields as fertilizer. The fishermen said the spirits of the ancestors lived on the islands, and they took them offerings of beautiful pots and weavings.

The centuries that followed the decline of Chavín influence were marked by regional developments culminating around the turn of the millennium in the rise of two of Peru's most famed pre-Inka societies: Moche on the north coast and Nazca in the south. The renown of these two societies rests, in part, on the technical skill of Moche metal-workers, rarely rivaled by the peoples who came after them, and of the potters and weavers in both cultures. Substantial settlements flourished in valleys such as the Rímac on the central coast and Cañete and Chincha on the south-central coast, but less is known of them. In the southern highlands, Pukara and Tiwanaku – which we shall explore in the next chapter – also began to emerge as urban centers.

But did these societies build cities? Lack of archaeological information makes it impossible to pinpoint when or where settlements and activities began to take on the more strictly economic, political and bureaucratic aspects that lie between the pillars of religious and domestic life and make settlements urban. The evidence, however, increasingly suggests that these features were present in Moche settlements by at least AD 500. Some of these sites, especially the settlement dominated by the Huaca del Sol and the Huaca de la Luna in the Moche valley, embodied a wide range of architecture harboring a variety of activities and housed residents whose wealth and status differed greatly. Religion was still the cornerstone of urban life, but the social – and architectural – structures that served it were now more complex and embraced a range of specialist occupations and their practitioners. It is this complexity of parts working together in close proximity that is the essence of urban society. Such interaction may have occurred elsewhere in the Andes at an earlier date, but it is first clearly documented at the Huaca del Sol and Huaca de la Luna in the lower Moche valley.

Moche and its precursors

The Moche culture prospered from around AD 1 to 700. It was in many ways a continuation of the Cupisnique, Salinar and Gallinazo cultures that successively lived on the north coast from around 1500 BC. In some valleys, irrigation networks reached their greatest pre-Hispanic extent before the rise of Moche, and Gallinazo centers foreshadow those built by the Moche people a few centuries later.

Salinar settlements dating from 450 to 200 BC have been documented in the valleys from Lambayeque to Nepeña. In general, Salinar peoples in the Moche and Virú valleys located their villages and fortified hill-top settlements in the upper valley, often near the valley neck, whereas the earlier Cupisnique sites, described in Chapter 3, lay in undefended locations in the lower valley. The largest known Salinar settlement is Cerro Arena, which

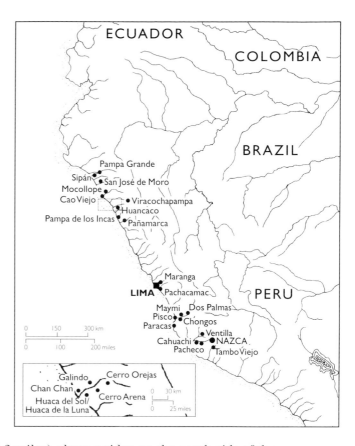

56 Map showing the principal sites discussed in Chapter 5.

sprawls for 2 kilometers (1.2 miles) along a ridge on the south side of the Moche valley, overlooking an ancient route leading to the Virú valley. Its two thousand structures, made of quarried granite, range from crude one-room residences to elaborate twenty-room structures and show considerable architectural variation. There are no ceremonial structures, however. The upper-valley focus of Salinar settlements and their defensible locations point to a growing concern with control of irrigation canal intakes and suggest the likelihood of tension and conflict with rival groups in neighboring valleys.

The Gallinazo people, unlike the Salinar, founded their settlements in middle-valley areas. Gallinazo was eventually eclipsed by Moche in the valleys immediately north and south of Trujillo, but in the Lambayeque region it lingered on well into the final phases of Moche. Gallinazo is best known from the Virú valley, where it replaced Salinar sometime in the first century after Christ. Adobe bricks became the primary building material for its platform mounds, such as the sprawling Gallinazo Group, where large adobe mounds surrounded by an estimated thirty thousand rooms presage the civic-ceremonial centers of the Moche. The majority of the population, however, lived in villages of irregular adobe buildings.

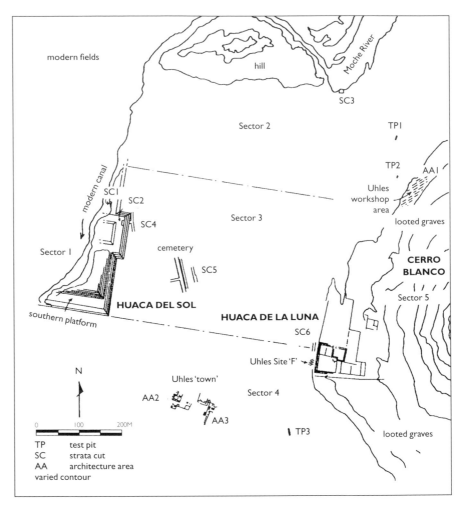

57 The Moche pyramids The Huaca del Sol and the Huaca de la Luna, the paramount center in the Moche valley on the north coast from around AD 100 to 700. Between the *huacas* lay houses, as well as workshops for potters and metal-smiths.

The largest Gallinazo settlement in the Moche valley is Cerro Orejas, which extended for 3 kilometers (1.9 miles) on the south side of the valley. Its inhabitants used stone to build their residences, but the ceremonial mounds are of adobe. Archaeologists believe that it was the Gallinazo people who extended the irrigation canal on the south side of the Moche valley to its pre-Hispanic maximum, to reach Cerro Blanco. There they began building what was to become the Huaca de la Luna, one of two monumental adobe platforms that later dominated the principal Moche settlement in this valley.

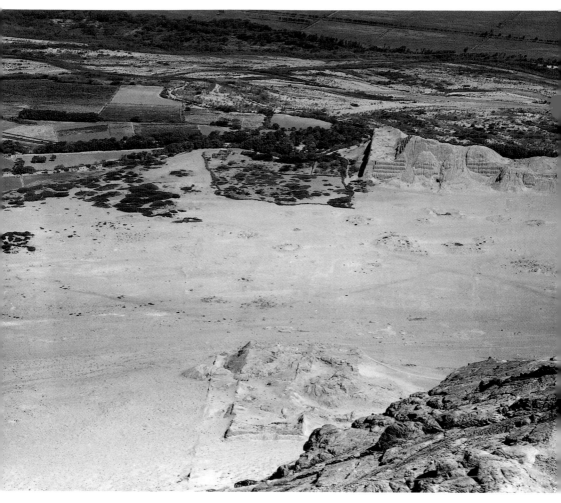

58 Aerial view of the Huaca del Sol and Huaca de la Luna, taken in the 1930s. Cerro Blanco and the Huaca de la Luna are in the foreground, the Huaca del Sol (two-thirds of it washed away by seventeenth-century treasure hunters) in the background.

For many years, scholars envisaged a centralized Moche state governed by a ruling élite of warrior-priests who controlled the north coast from their capital in the Moche valley. In the past ten years, however, this view has been challenged by the wealth of new information emerging from excavations in Lambayeque and Jequetepeque. Archaeologists agree that there may have been two Moche spheres of influence that emerged simultaneously. One of these was centered in the Chicama and Moche valleys and those to the south, and the other, separated by 50 kilometers (30 miles) of the inhospitable Pampa de Paiján, lay in the valleys farther north. These

59 Residential remains unearthed in 1996 at the foot of the Huaca de la Luna. The Huaca del Sol looms in the distance.

widely scattered valleys shared an art style, religion, culture and perhaps language, but it appears that the northern area was never consolidated into the dominant Moche state in the southern heartland.

The revision of the traditional picture has introduced some uncertainty in the dating of these widely scattered Moche settlements. The dating is based in part on a scheme devised by Rafael Larco that divided the Moche period into five sequential phases keyed to changes in the forms and decoration of ceramic vessels. He derived this relative chronology from ceramics found from Trujillo to Nepeña, the southern Moche heartland. But Larco's five-phase sequence, which spans more than seven hundred years, inadequately reflects the regional variations of the Moche style, especially the art uncovered by the recent flurry of discoveries in the valleys north of Chicama. Until Larco's sequence is refined, however, the scheme continues to be widely used.

The Huaca del Sol and the Huaca de la Luna

By the end of Larco's phase IV, around AD 550, the southern Moche held sway over the valleys from Chicama to Huarmey. A series of Moche civic-ceremonial centers dating from about AD 300 to 550 administered these valleys: Huancaco in Virú, Pampa de los Incas in Santa, Pañamarca in Nepeña and Mocollope in Chicama.

Construction at the political and ceremonial center of the Moche valley,

the Huaca del Sol (Pyramid of the Sun) and the Huaca de la Luna (Pyramid of the Moon), began around AD 100. ("Sol" and "Luna" are modern names. We are not sure of the ancient name, although ethnohistorian Jorge Zevallos has found an early Spanish colonial document that refers to the site as "Capuxaida.") Destruction wrought by centuries of looting, flooding, invading sand dunes and intense but sporadic rainfall makes it hard today to envision the thriving community that resided there. Some ten thousand people may have lived and produced a wide array of crafts in the 500-meter- (550-yard-) plain separating the two Huacas, the settlement's most imposing structures. Indeed, the settlement may have been as large as 300 hectares (740 acres), but alluvium, at times 2 meters (6½ feet) deep, has covered much of the city, burying residential areas, cemeteries and workshops.

Residences have been excavated south-west of the Huaca de la Luna and at the base of the Huaca del Sol. These range from houses with foundations of river cobbles that once supported perishable superstructures to well-made houses of stone and finely plastered adobe walls. Residents in the latter area had access to finer pottery, and the rooms and storage areas of their homes were generally larger.

60 These distinctive "maker's marks" were impressed on adobe bricks found in the Huaca del Sol. The mold-made bricks were laid in tall, column-like segments, and archaeologists estimate that some 143 million of them were used to create the mound – the largest structure in the Americas for its time.

On the plain near the Huaca de la Luna recent excavations unearthed a pottery workshop dating to the Moche IV phase (*c.* AD 450–550). In their workshop patios, potters stored water in large ceramic vessels, ground clay and fired pottery. They produced fancy wares for ritual purposes – portrait heads and vessels painted with scenes of combat, the taking of prisoners and deer-hunting – as well as figurines and rattles, spindle whorls for weavers and crucibles for metal-workers. The quantity of ceramic forms, including several dozen molds, as well as tools and kilns that have been uncovered, suggests that production was intense. Two potters were buried in the floor of their workshop in simple, shallow pits, accompanied by richly decorated ceramic vessels.

Tuyères (ceramic tips of blow-tubes used in metal-working) and lumps of slag scattered on the surface near the pottery workshop hint at metal-working activities yet to be confirmed by excavation. Recent excavations have also discovered a canal winding through the site that brought water to the workshops and perhaps to the residential area.

The Huacas, or terraced adobe mounds, that dominate the settlement may have complemented each other: the Huaca del Sol serving an administrative function and the Huaca de la Luna a religious one. In its time, the Huaca del Sol was the largest structure in the Americas, measuring some 345 meters (1,130 feet) in length, 160 meters (525 feet) in width and looming some 40 meters (130 feet) above the valley floor. Little remains of its original massive grandeur, however, because in 1602 enterprising Spanish treasure hunters diverted the waters of the Moche river, washing away roughly two-thirds of the Huaca. The approach to the summit of the cross-shaped Huaca may have been via a ramp on its largely destroyed northern side. Much of this massive monument was once painted red, and perhaps other colors.

Archaeologists have identified eight stages in the construction of the Huaca del Sol, with most of them completed before the end of Moche phase III, around AD 450. Its builders used some 143 million mold-made adobe bricks, with some bricks arranged in tall, column-like segments. Adobes in some of the segments share so-called maker's marks, curious markings ranging from hand- and footprints to circles and squiggles, impressed on each brick. According to Michael Moseley and Charles Hastings, who recorded more than a hundred of these marks, they probably served to distinguish bricks made by different groups and may have identified these groups' tribute or labor obligation to the Moche leadership. This, they argue, implies the existence of a highly organized, well-established central authority with access to a vast labor force.

The Huaca de la Luna, built at the foot of Cerro Blanco, is a terraced adobe structure measuring 290 meters (950 feet) from north to south and

210 meters (690 feet) from east to west, and rising some 32 meters (105 feet) above the plain. Excavations have recorded at least six construction stages spanning almost six hundred years. Courts and ramps connected the structure's three platforms and four plazas, and some of the enclosures were roofed. Murals and friezes decorated many courtyards, while some of the exterior walls were painted in shades of white and red and yellow ochre. Builders employed an estimated fifty million adobes in the construction of the Huaca de la Luna, and used many bricks to bury earlier structures and create platforms for new ones. A huge looters' pit dating to colonial times destroyed more than two-thirds of the uppermost platform.

Human sacrifice

Archaeologist Santiago Uceda believes that the Huaca de la Luna served as the region's paramount shrine and the setting for ceremonies of human sacrifice. Priests presided over the rituals, acting as the alter egos of a Moche deity called the Decapitator. This awesome half-human, fanged deity – often shown holding a ceremonial *tumi* (a knife with a crescent-shaped blade) in one hand and a severed human head in the other – appears in a variety of guises on Moche pottery and in works in metal, and features in murals and friezes embellishing the Huaca de la Luna.

In an enclosure at the back of Huaca de la Luna, Steve Bourget, a member of the excavating team, found the remains of more than forty men ranging in age from fifteen to thirty. Their scattered bones lie buried in thick layers of sediment, indicating that they were sacrificed during the heavy rains that accompanied a *Niño* event. The men were apparently pushed from a stone outcrop in the enclosure that echoes Cerro Blanco: the mountain of granite banded with diorite that rises imposingly behind the Huaca de la Luna.

Some of the skeletons are splayed as if they had been tied to stakes. Many men had their femurs forcibly torn from pelvis joints, and finger-, arm- and leg-bones as well as ribs and crania show cut marks. Several of the victims were decapitated and had their lower mandibles removed, which lie scattered among the skeletons. Bourget suggests that the occasion of their deaths was not an ordinary *Niño*, but a "mega-*Niño*" event that only occurs once every century. He believes that some of the victims were sacrificed to the gods in a bid to stop the rains, while others were sacrificed after the rains had ended.

The place of human sacrifice in Moche religion is shown not only by the finds at the Huaca de la Luna and others at Sipán in the Lambayeque valley, but also by its depiction in Moche art. Human sacrifice is portrayed in an elaborate blood-letting ritual known as the Sacrifice Ceremony illustrated

on ceramics, and emblems related to the rite have been found in murals embellishing the walls of Moche temples and in a handful of tombs (see Chapter 9 for a more detailed description of the Sacrifice Ceremony). Archaeologists once believed that the Sacrifice Ceremony was an imaginary ritual or commemorated a mythical event, but evidence from Sipán and subsequent discoveries at other Moche sites provided the first solid and chilling clues that it was a real event.

The first hint came in 1987 from Sipán in the Lambayeque valley, when looters led Walter Alva to Sipán's burial platform, where he subsequently uncovered three royal tombs. The platform, which is 10 meters (33 feet) high, lies in the shadow of two larger, heavily eroded adobe platform mounds and served as a mausoleum for a succession of local lords. We know little of those who served these lords, and nothing of the workshops and skilled artisans who produced the lavish grave goods buried with them, but cemeteries and remains of residences about 1 kilometer east of the site hint that people connected to Sipán may have lived there.

Archaeologists have long known that opulent offerings in gold, silver and gilded copper, often studded with inlays of seashell and semi-precious stones, accompanied high-ranking Moche lords to the afterlife. Yet the vast majority of élite Moche tombs have been looted, and their contents scattered among private collections and museums around the world without any of the contextual information derived from scientific excavation. Before the discoveries at Sipán, researchers had rarely been able to plot the sequence and association of offerings as they emerged from the ground nor yet to see all the grave goods from one tomb as an ensemble of offerings.

As Alva and his colleagues began to excavate the first tomb at Sipán, the rich finds suggested that the person buried there was a Moche noble. But he was not an ordinary Moche noble – the offerings bore an uncanny resemblance to parts of the costume worn by the mythical Warrior Priest, whom Christopher Donnan had identified as the leading protagonist in the Sacrifice Ceremony. Like him, Sipán's Warrior Priest wore a back-flap (a crescent-shaped metal object worn by Moche warriors to protect their backs) and rattles suspended from a belt. His tomb also contained three pairs of gold and turquoise ear-spools (one depicting a warrior in full combat gear, perhaps a portrait of the Warrior Priest himself), a crescent-shaped gold headdress-ornament, a similarly shaped nose-ornament, and two *tumi* knives, one of gold and one of silver. Next to the body lay a gold, box-like scepter embossed with scenes of combat, tipped by a spatula-like handle of cast silver studded with military paraphernalia. Decorating the rattles and the back-flaps is the deity known as the Decapitator. Sipán's Decapitator is an anthropomorphized spider distinguished by his fanged mouth and double ear-ornaments.

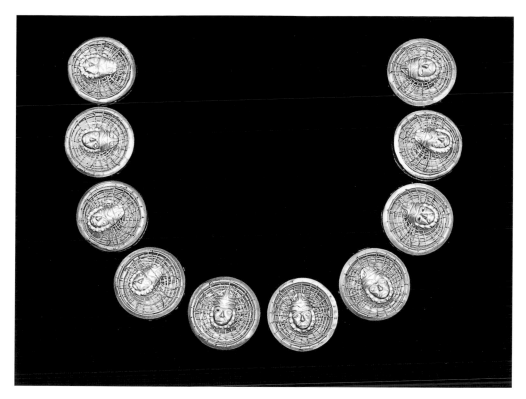

61 A necklace of golden spiders, perched on webs of gold, found in one of the royal tombs unearthed at Sipán. Spider imagery has been linked to the Moche Sacrifice Ceremony. (See also ills. 140–2.)

Metallurgy

The spectacular finds in the Sipán tombs illustrate that Andean metal-working reached its pinnacle of creativity and technical mastery in the coastal valleys dominated by the Moche. It had evolved from the rich and long-standing metallurgical tradition of the Lambayeque region, which was based on ready access to gold, copper and other ores, abundant labor to work the mines and, most importantly, skilled craft specialists.

For the Moche, as for other Andean societies, metal in general – and gold in particular – had a special status. Gold, the first metal to be worked in the Andes, was imbued with religious significance and seen as a symbol of power. Copper–gold alloys, such as *tumbaga* (gold-rich *tumbaga*s with high silver concentrations are equivalent to 16-carat gold), were also produced by the Moche, and later used extensively by Lambayeque and Chimú smiths.

With the exception of tin bronze (developed in the southern highlands), Moche smiths were familiar with almost every metal, alloy and metal-

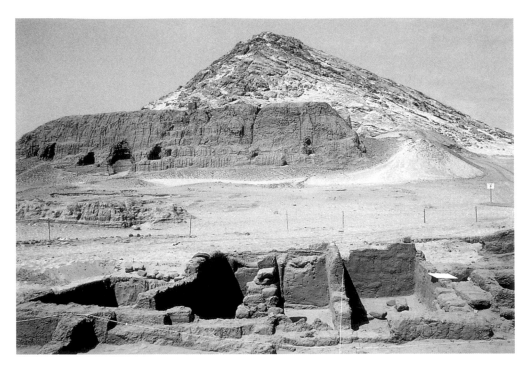

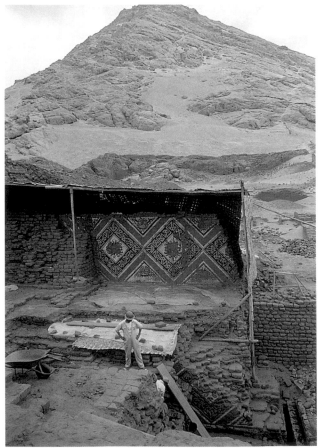

The Huaca de la Luna
62 (*top left*) Cerro Blanco, a mountain of granite banded with diorite, towers above the Huaca de la Luna. Excavations in the foreground have exposed part of the settlement's residential sector.
63 (*left*) One of the courtyard walls, with a frieze portraying the Moche decapitator deity. The huge seventeenth-century looters' pit in the foreground destroyed more than two-thirds of the mound's uppermost platform.

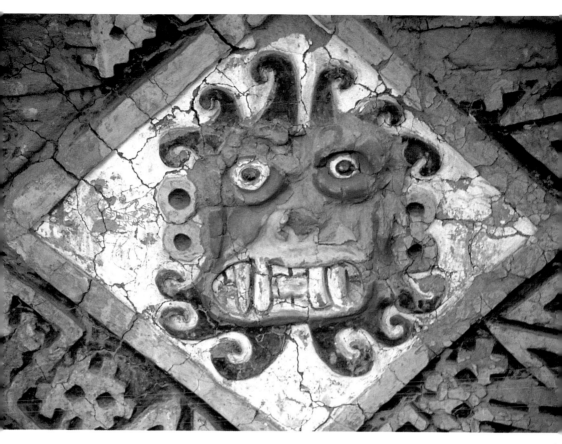

64–6 Three details of the frieze, painted in shades of red and yellow ochre as well as in black and white, discovered in the summit courtyard. The double ear-spools and fangs identify this deity as the Moche decapitator god, associated with human sacrifice ceremonies. (See also ills 140–2.)

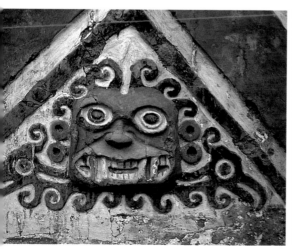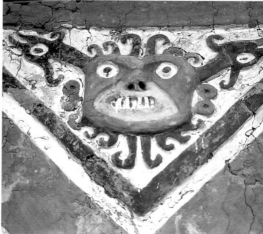

working technology known in the Andes. They smelted copper carbonates and oxides, made copper–gold and copper–silver alloys, experimented with arsenic–copper alloys, and they mastered casting. As in both preceding and succeeding cultures, most metalwork was made from hammered sheet-metal, but casting was used for some objects: mold-casting was used for large pieces (such as agricultural tools and weapons) and, less commonly, lost-wax casting for smaller and more detailed decorative items. The assembly of hammered or cast components into complete objects involved a broad array of techniques – soldering, welding, crimping, stapling and interlocking tabs.

Moche smiths also developed several techniques for giving a golden or silvered finish to objects made of gold/silver/copper alloy or even pure copper. One was depletion-gilding, or silvering. To produce a golden surface, they repeatedly hammered and annealed an alloy ingot into a thin sheet. As they did so, a brown scale of oxidized copper formed on the surface. This they then dissolved by pickling the sheet in a weak corrosive solution, such as plant juice or stale urine. As repeated hammering, annealing and pickling reduced the metal to the desired thickness and color, more surface copper was oxidized and removed, so that a thin layer of enriched silver formed on the surface. If a gilded surface was wanted, the smiths then dissolved the silver in the enriched surface layer by means of corrosive mineral mixtures, such as ferric sulphate and common salt. This produced a dazzling golden surface on objects with gold contents as low as about 12 percent by weight.

To gild or silver objects made of copper, Moche metal-workers used electrochemical replacement plating. They apparently dissolved gold or silver in a highly acidic solution of water and such corrosive minerals as common salt, potassium nitrate and potassium aluminum sulphate, and dipped the copper object into the mixture. The gold or silver ions in the solution had a positive electrical charge and so were attracted to the negatively-charged surface of the copper, clinging to it as a metallic coating, or plate. Remarkably, Moche craftsmen were able to create these shimmering surfaces without the use of electricity or chemicals like aqua regia or cyanide that are used for this process today.

Late Moche society

The upheavals wrought by *Niño* events and other natural disasters, recorded at the Huacas del Sol and Luna and elsewhere in the Moche heartland, not only undermined the prestige and credibility of Moche's rulers and priests, but also inflicted serious damage to its economy, which was largely based on irrigation agriculture. Rain-swollen rivers washed out canal

intakes, flooded fields, eroded soils and deposited sand at the mouths of the rivers. Sand blown inland by the prevailing winds blankets much of the Huacas at Moche today.

The evidence for flooding at the Huacas of Moche is borne out by studies of cores from the Quelccaya ice-cap north of Lake Titicaca. They reveal that a thirty-two-year drought was followed by a rainy period that began in about AD 602 and lasted until 635. Around this time a flash flood destroyed part of the Huacas at Moche, depositing the alluvium on the plain. Some rebuilding took place in the wake of the *Niño*, but people began abandoning their once-thriving capital. Construction at the Huacas stopped, and Moche control over many of the southern valleys ceased. Some people did continue to occupy the plain between the two Huacas well into late Moche times, and occasional offerings and burials into historical times point to the site's lasting religious prestige.

Galindo and Pampa Grande

Around AD 550–600 Galindo, which covers around 5 square kilometers (2 square miles) and lies some 20 kilometers (12½ miles) inland, became the largest settlement in the Moche valley. Its location near the neck of the valley afforded farmers improved control over irrigation waters and access to lusher, upper-valley farmland. The settlement includes four platform mounds, rectangular adobe compounds flanked by elaborate residences, four zones of residential architecture, storage areas, llama corrals and a pottery workshop.

Galindo's platform mounds recall the Huacas at Moche, but they are much smaller and no longer dominate the landscape – perhaps a reflection of Moche's waning power and diminished territorial dominion. Storage areas, such as stone-lined bins on terraced hillsides flanking the enclosures, cover about one-fifth of Galindo: a much greater area than had been devoted to storage at earlier Moche settlements. Had storage and control of food-stuffs become a paramount concern in the face of environmental stress?

One of Galindo's platform mounds, which lies within a large enclosure, heralds the compounds or *ciudadelas* that were to dominate the Chimú capital at Chan Chan in the same valley several centuries later. This may hint at the emergence of secular administration, for the enclosure may have served as the residence of Galindo's ruling élite. Galindo's wealthier residents lived in large, well-built areas with storage facilities, benched rooms and kitchens, while poorer ones lived on a crowded hillside overlooking the site, segregated by a large wall and a ditch.

The late Moche peoples of the Lambayeque valley, 170 kilometers (105 miles) to the north, also founded a new settlement near the valley neck at

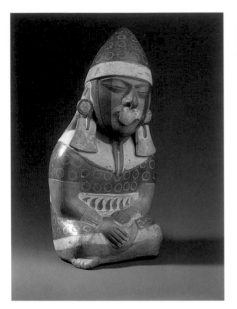

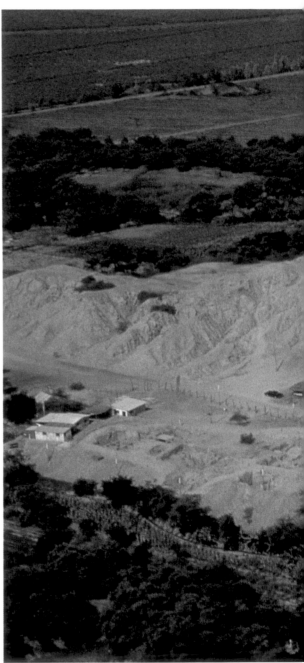

67 (*above*) This Moche ceramic vessel, painted in buff and red ochre, displays the artistry of Moche potters. It depicts a seated warrior with his eyes closed. He wears a conical hat tied under his chin as well as ear-spools and ornaments and rests his hands on a bowl in his lap

68 (*right*) Aerial view of Sipán in the Lambayeque valley on Peru's north coast. Archaeologists discovered rich Moche tombs dating to around AD 300 in the low burial platform in the foreground. The platform may have been connected to the adobe mound that rises in the center; the flat-topped mound in the background was probably built several centuries later.

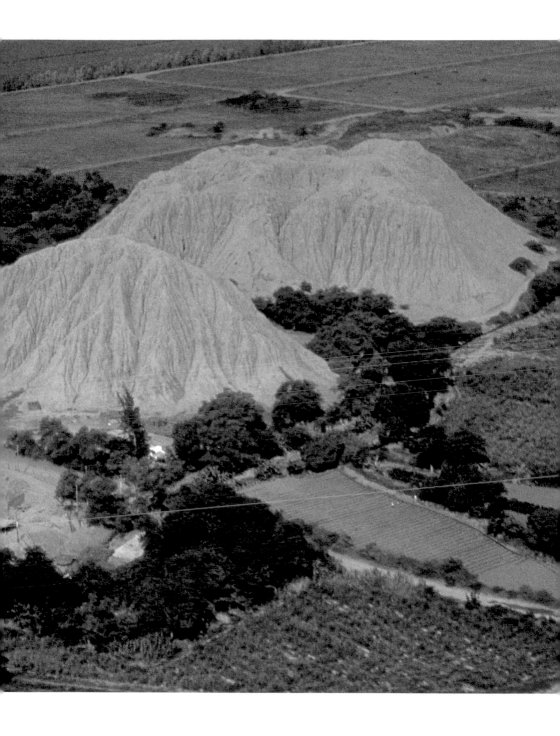

69 The huge adobe mound of Huaca Fortaleza, rising 38 m (125 ft) above the floor of the Lambayeque valley, dominated the late Moche settlement of Pampa Grande. The remains of the ramp that led to its summit are visible in the foreground.

Pampa Grande. Like Galindo, Pampa Grande was established around AD 550–600. Today, it sprawls over 450 hectares (1,110 acres), but Izumi Shimada estimates that in antiquity it may have covered over 600 hectares (1,485 acres), and he views Pampa Grande as the urban capital of late Moche peoples in Lambayeque. Its monumental Huaca Fortaleza dominates Pampa Grande in the tradition of the Huacas del Sol and Luna, pointing to a strong, centralized administration. Shimada suggests that the ruling religious and political élite lived on Huaca Fortaleza or at the northern end of the compound surrounding the Huaca, while high-level administrators resided in complexes where they supervised the production of sumptuary goods, such as beads made from *Spondylus* shell.

Low-level administrators lived in smaller compounds, and farmers and craft specialists resided in the small, irregular rooms. Judging by the num-

ber of these rooms, Shimada estimates that there were some 2,500 house-holds at Pampa Grande, giving a population of 10,000–12,500. The diversity of Pampa Grande's architectural forms – unrivaled at other contemporary settlements – includes adobe and stone enclosures, rooms, platforms, ter-races, three kinds of storage facilities, craft workshops and small, irregular, attached rooms, all linked by a network of streets, pathways and corridors. Storage facilities include large-scale storage of raw materials and finished craft goods, communal and household storage.

The settlement's most imposing structure, Huaca Fortaleza, measures 270 by 180 meters (885 by 590 feet) and rises 38 meters (125 feet) above the valley floor. A compound measuring 600 by 400 meters (1,970 by 1,310 feet) enclosed the Huaca, and a ramp 290 meters (950 feet) long led to its summit. Unlike the Huaca del Sol, the Huaca Fortaleza was built in two stages, much of it using the chamber-and-fill technique of adobe-walled chambers filled with rubble or refuse, a hallmark of monumental mound construction in the Lambayeque region. On the summit of the mound arch-aeologists uncovered a complex of rooms with floors of adobe tiles, columns that supported the roof and a mural depicting felines. Entry was indirect, restricting access to the area and pointing to an exclusive function, perhaps as the residence of Pampa Grande's élite or the setting for ceremonial feasting.

Some time around AD 700 people abandoned both Pampa Grande and Galindo. According to Shimada, Pampa Grande came to a sudden and violent end. Much of the central sector was burned, and the fire was so intense that the adobes on Huaca Fortaleza's summit turned into fired bricks. Shimada attributes its abandonment to internal unrest which was exacerbated in the late seventh century by a severe *Niño*, in turn followed by a drought. Others blame the fall of both these late Moche centers on a Wari invasion. Although Wari had established an administrative center at Viracochapampa in the highlands to the east (as described in Chapter 6), and Wari influence has been noted on late Moche ceramics, there is as yet no compelling evidence for either Wari conquest or settlement of the north coast.

There is no doubt, however, that during the period when Wari prospered in the south-central Peruvian highlands, major changes took place on the north coast. Innovations in architecture, iconography and burial patterns point to profound shifts in religion, the economy and the organization of north-coast society. The burning of Pampa Grande and the abandonment of Galindo marked the end of Moche culture on the north coast, although it lingered on in some valleys for another century or so. Several centuries later, the Lambayeque and Chimú emerged in the valleys that had once housed these late Moche settlements.

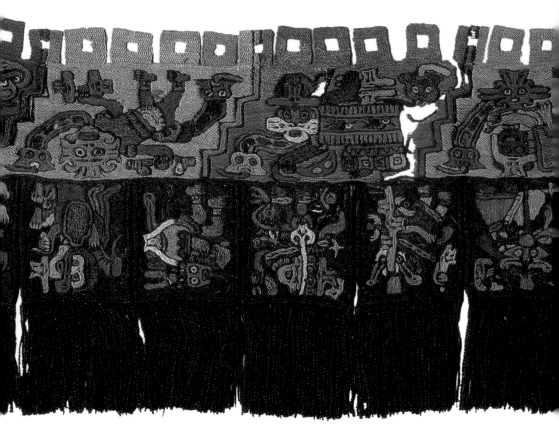

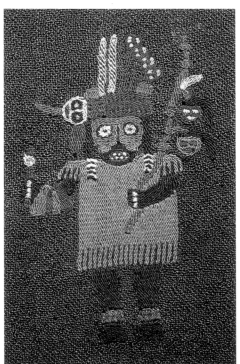

Textiles of the Paracas culture

70 (*above*) This multi-colored, double-faced embroidered textile was found at Paracas on the south coast. The warp and weft are of cotton, while the embroidery yarn is of wool: probably alpaca. The lower half of the embroidered border consists of nine fringed tabs depicting mythological figures in stepped compartments. The top border is edged with square tabs.

71 (*left*) Detail from an embroidered mantle. The figure depicted wears a tunic and an elaborate head-dress. In one hand it carries a staff from which hang trophy heads, and in the other a weapon or digging stick.

The central and south coast

While Moche flourished on the north coast, Maranga in the Rímac valley – dominated by tiered platform mounds made of thousands of small adobes – had become the pre-eminent center of the central coast. In the adjacent Lurín valley, Pachacamac gained prestige, becoming one of the most long-lived and influential pilgrimage centers in the Andes (see Chapters 4, 6 and 8).

Farther south, people produced Paracas-style textiles and ceramics and lived in settlements such as Chongos on the edge of the Pisco valley, where residential structures were made of river cobbles and adobe, with rooms measuring about 5.5 meters (18 feet) on a side. They also built small fishing settlements strung along the bay of Paracas near the town of Pisco. Today, as in the past, the windswept bay is a rich source of fish and shellfish, and flocks of flamingos pause in the shallow waters below the ancient settlement.

The most renowned settlement on the Paracas peninsula is an area of cemeteries and habitation sites on and around a hill called Cerro Colorado, occupied from about 300 BC to AD 200. In the residential area, contemporary with the Paracas Cavernas-phase cemetery, archaeologists recorded some 4,000 square meters (1 acre) of habitation remains. The north face of Cerro Colorado served as a cemetery for later Paracas Necropolis or Topará-phase peoples. Here Tello discovered hundreds of mummies tightly arranged in an almost fetal position and wrapped with multiple layers of stunning, lavishly-decorated textiles including large mantles or shrouds – sometimes more than sixty layers of textiles covered a single mummy. (Andean textiles were used principally for clothing, but much of what has survived consists of garments and wrappings from mummy bundles – mostly discovered in the coastal desert, where the arid climate has contributed to their excellent preservation.)

The textiles of the Paracas and Nazca cultures show the great inventiveness of early weavers, who had already developed most of the techniques used in later textile production. By about 300 BC, Paracas weavers were using camelid fiber (probably alpaca from the highlands) to create tiny figures decorating the borders of enormous cloaks. Made by crossed looping, these figures were fashioned with needle and thread to produce tiny, but very detailed, three-dimensional figures.

Near the cemetery, domestic structures and refuse sprawl for over 54 hectares (133 acres). A small spring provided the ancient residents with water, but they relied on the nearby Pisco valley for most of their produce. The limited residential remains at Paracas do not reflect the large population buried there, and some archaeologists suggest that people living in

72, 73 **Paracas** An aerial view of the bay of Paracas (*above*), taken in the 1930s. Ancient fishing communities lay along the shore (foreground). The peninsula's most famous settlement included cemeteries and habitation sites and was occupied from about 300 BC to AD 200. The foundations of domestic structures sprawl below Cerro Colorado on the Paracas peninsula (*below*).

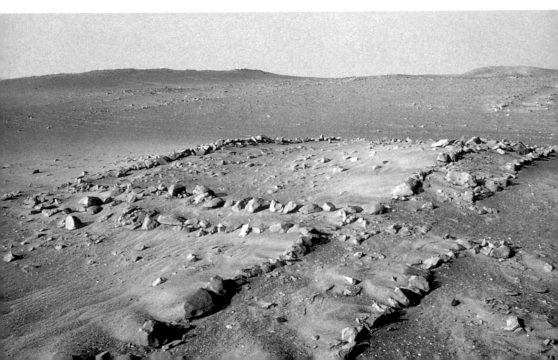

nearby valleys may have regarded the Paracas peninsula as the area's holiest shrine and taken their dead there for burial.

Monuments of the Nazca people

Paracas has been pinpointed as one of the sources of inspiration for the distinctive art style of Nazca society, which held sway on the south coast from about 100 BC to AD 700. The Nazca sphere of influence extended from its heartland in the Ica and Río Grande de Nazca watersheds south along the coast to Acarí and into the Ayacucho highlands to the east.

Unlike the broad coastal valleys of the north, the southern valleys are much narrower, and their rivers rarely reach the Pacific. The unpredictable water supply and limited agricultural potential of these parched valleys prevented south-coast peoples from developing irrigation networks on the scale of those created by north coast societies. Helaine Silverman argues that the Nazca drainage's 13,000 hectares (32,120 acres) of cultivable land could only have sustained 15,000–22,000 people. (In contrast, as we have seen, Pampa Grande alone housed an estimated 10,000–12,500 residents.) She believes that the people of these southern valleys were united as a confederacy of independent societies who shared an art style, culture and religion. Among their most enigmatic creations, described in more detail below, are the so-called Nazca lines: animal figures and geometric shapes etched into the flat *pampa*, or desert plain, north of the modern town of Nazca and along valley edges and on hill-tops throughout the region.

By AD 100 Cahuachi in the Nazca valley had become the most important site in the region. It probably started as a small village, later serving as the region's leading pilgrimage center until construction ceased around AD 550. Thereafter, although it no longer drew worshippers from afar, people continued to leave offerings there and bury their dead. In the twentieth century Cahuachi became a favorite haunt of grave-robbers, whose relentless looting has transformed its mounds and plazas into a lunar landscape.

The choice of Cahuachi as the site of a pilgrimage shrine is no coincidence. For geological reasons, water in the Nazca river only flows above the surface up-valley from the modern town of Nazca; in mid-valley, near the town, it disappears underground and resurfaces just below Cahuachi. Ancient settlement patterns in the Nazca region reflect this scarcity of water and the strange behavior of some of the basin's rivers. No doubt the Nazca people, so dependant on rainfall in the highlands and constantly threatened by drought, noted this phenomenon when they established their paramount pilgrimage shrine.

Increasing aridity on the coast, brought on by drought in the highlands (the source of all coastal rivers) compelled Nazca people to search for more

permanent sources of water. Around AD 500–600, perhaps in response to a prolonged drought, they developed an ingenious system for tapping the water table, much of which is still in use today. They constructed underground aqueducts or filtration galleries, reminiscent of the *qanats* of Iran, that minimized evaporation and terminate in reservoirs and irrigation canals. Water levels in these galleries – also known as *puquios* – vary according to the season, dropping before the onset of the rains in the mountains to the east, but they are of obvious benefit in a region whose rivers only see water for part of the year (in some years not even a trickle reaches Nazca). Most researchers agree that the *puquios* are of Nazca vintage, but others have suggested that Spanish settlers introduced *puquio* technology to the region in the sixteenth century.

In contrast to the monumental adobe platform mounds that overshadow north-coast settlements, the south coast ones are much more modest. Nor have archaeologists discovered, at Cahuachi or elsewhere, rich tombs to rival such royal burials as those discovered at Sipán. Cahuachi's adobe structures cap some forty low-lying hills overlooking the Nazca river and,

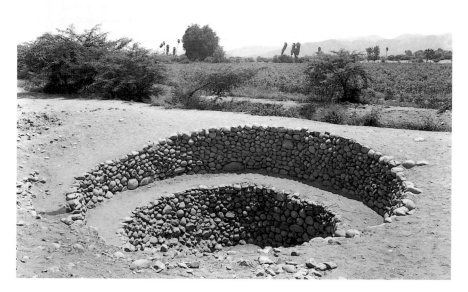

74, 75 The Nazca culture Aerial view of Cahuachi (*opposite*), the leading Nazca ceremonial center from around AD 100 to 500. Its adobe structures cap some forty low-lying hills overlooking the Nazca river. Its most massive construction is the Great Temple (*center*), some 30 m (98 ft) high with several broad terraces. At Cantalloq (*above*) is a restored entrance to a *puquio*: one of several underground filtration gallery networks in the Nazca area.

in the distance, the *pampa* of Nazca, site of the famed markings. The settlement covers some 150 hectares (370 acres), but only about a sixth of the site includes mound architecture and its associated plazas. The most massive structure is the so-called Great Temple, a modified hill some 30 meters (98 feet) high composed of six or seven broad terraces and outlined with adobe walls. Excavations at its base in the 1950s uncovered small rooms that contained caches of clay panpipes, musical instruments associated with Nazca ritual. Silverman views Cahuachi's mounds as ceremonial constructions, not residential architecture, and the plazas as places where pilgrims congregated. Cahuachi assumed a city-like appearance only when it filled with pilgrims coming from the surrounding area to worship.

The lack of domestic refuse, workshops and storage facilities confirms that Cahuachi never housed a large resident population or developed into an urban center. Indeed, only thirty percent of the ceramics found at Cahuachi are domestic wares, underscoring the site's ceremonial function. Silverman found few storage vessels, and there are no formal storage facilities except those used to store ritual paraphernalia. Nor, with the exception

of one possible area of textile manufacture excavated in the 1950s, have any areas of craft production been discovered.

Markings in the desert

Silverman suggests that as the south coast grew more arid, and people abandoned Cahuachi, the focus of Nazca religious ritual shifted north to the adjacent *pampa*, where archaeologists have noted an increase in the elaboration of ground markings. Over the millennia, manganese and iron oxides naturally deposited on the *pampa*'s desert surface have covered its stony surface with a thin patina, known as desert varnish. South-coast peoples created their markings by removing this darker surface layer to reveal the lighter-colored soil beneath, enhancing the outlines by laying the cleared stones along the edges. This labyrinth of geoglyphs or markings – large-scale ground drawings of animals such as birds, a spider and a monkey, and straight lines and geometric shapes – is perhaps the best known Nazca monument and the object of endless (and occasionally outlandish) speculation. The markings criss-cross the *pampa* of Nazca itself as well as the desert and hills flanking the Nazca drainage.

The ancient preoccupation with water may be connected to the creation of certain *pampa* markings; indeed, the region's scant rainfall has contributed to the preservation of the markings, many of which are over two thousand years old. Among the more plausible theories are those that link them to agricultural fertility, mountain-worship and rituals to summon up water. Silverman believes Cahuachi was connected ritually to the geoglyphs on the *pampa*; in fact, one line appears to lead from Cahuachi across the *pampa* to the site of Ventilla on the south side of the Ingenio valley.

At Ventilla, Silverman argues, the Nazca people established the "great urban center that Cahuachi was not."[9] She suggests that Cahuachi and Ventilla may have been early Nazca dual capitals, with Cahuachi serving as the region's ceremonial center and Ventilla as its urban capital. Much of Ventilla has been destroyed by modern cultivation, but aerial photographs taken in the 1940s show that it once covered at least 200 hectares (495 acres) of habitation terraces, walled compounds and mounds – by far the largest Nazca site recorded.

Only excavation will reveal whether Ventilla was an urban center. Nonetheless, the majority of habitation sites in the region contemporary with the flowering of Cahuachi are under 4 hectares (10 acres) in size. Examples include the settlement of Dos Palmas in the Pisco valley, a dense concentration of rectangular rooms surrounding five small plazas, or Tambo Viejo in the Acarí valley, whose eight thousand closely packed rooms fill two walled areas.

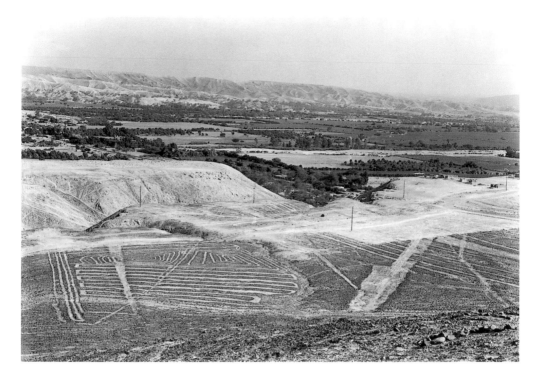

76 At Sacramento, overlooking the Palpa valley on the south coast, spirals and cleared areas are etched into the desert surface. In the middle ground is the irrigated valley floor, and beyond is the pampa of Nazca, site of the largest concentration of geoglyphs (large-scale ground drawings of animals such as birds, a spider and a monkey, as well as straight lines and geometric shapes).

By AD 600 the Nazca region came under the influence of peoples from the Ayacucho highlands to the east, the cradle of the Wari empire discussed in the next chapter. Links between the south coast and the Ayacucho highlands are well-documented and much less tenuous than Wari's relationship to the north coast. Nevertheless, the nature of the connection between Wari and Nazca is still unclear, and archaeologists have not encountered any architectural remains that unambiguously suggest Wari settlement in the area. Evidence for the Wari presence on the south coast comes from caches of ceremonial pottery, such as the urns excavated by Tello at Pacheco near Cahuachi, Wari-style ceramics and textiles found in tombs or the surface scatters of Wari pottery sherds in valleys such as Ingenio. At Maymi in the Pisco valley Martha Anders discovered richly decorated Wari-style pottery, some buried in caches, as well as evidence for ceramic manufacture.

As Wari peoples began to extend their influence on the south coast, and as Moche languished on the north coast, the cultural initiative shifted to the

highlands. In the Ayacucho basin to the east of Nazca, the city of Wari thrived for some three hundred years as the area's leading residential and ceremonial center. Farther south in the Titicaca basin, Tiwanaku, founded several centuries before Wari, reached its florescence. In the next chapter we will discuss how these highland empires, which dominated the Andes for several centuries, united previously independent culture areas and set the stage for the emergence of the Inka empire.

Imperial Cities:
Wari and Tiwanaku

Around AD 650 an urban pattern emerged in the Central Andes that was based not on individual settlements but on a system of linked centers that became virtually synonymous with the state itself. The rulers of Wari and Tiwanaku established networks of cities and other settlements, joined by roads and trade connections, that marked a new level of Andean urbanism transcending the city.

PLACE: Tiwanaku, Bolivia, and the southern part of Lake Titicaca

CIVILIZATION: Tiwanaku

Dawn came suddenly, the sun rising over the jagged, snow-covered mountains framing the great expanse of water, setting the lake ablaze in an orange glow. As a group of quarry workers strode past low, adobe houses up toward the quarries on the hill they saw smoke wafting up through the thatch of the roofs and heard people talking softly, while llamas and alpacas stirred in their stone-lined corrals. Climbing the path to the quarry they heard men shouting to each other in the distance and the sound of their hammers of rounded river cobbles pounding on rock as masons shaped the enormous blocks of stone they had pried from the quarry with wooden crowbars.

From the highest quarry Lake Titicaca glinted in the early-morning light. Farther in the distance Tiwanaku's tallest temple rose above the plain like a small mountain, and, as the sun bathed the city, it struck the gold sheet decorating its walls and dazzled them with its reflection. The stones from the quarry were destined for new buildings at Tiwanaku.

The men rigged ropes as thick as a man's thigh around a block, preparing it for its journey down the mountain to the lake's edge. Soon the stone, almost the height of a man, was covered in a net which was attached to long ropes thrown over the top and sides of the block. Two hundred men formed four lines in front, while others stood behind with braking ropes and with wooden levers.

With many shouts and a great heave the rock finally budged and began to inch down the slope. It took several hours of straining to haul it to the lake, where others had lashed together several boats made of *totora*, the reeds that grew along the lake. Some time later the workers finally succeeded in hauling the block onto the raft, which then settled into the thick mud.

Once more the sweating men heaved and pulled and strained at their levers to free the raft; finally it floated reluctantly out into the shallow water. Using poles to clear the shore, the boatmen began to propel the raft, now lying low in the water. If the wind picked up they would rig a sail and speed across the lake to Iwawe.

At Iwawe another work crew took over and attached new ropes to the block for its journey across the flat *pampa* to Tiwanaku. As the long line of men dragged it across the *pampa*, farmers paused from their work to rest and watch. As far as the eye could see, fields like broad platforms formed an enormous, sinuous checkerboard of purple-flowered potatoes and deep red *quinoa*, and the canals between the fields teemed with ducks and other water fowl. It took the men several days of hauling to reach Tiwanaku and drag the block to a staging area just beyond the city.

As they rested, rubbing aching muscles and inspecting their blistered hands, they could see dozens of masons pecking away with hammer-stones, shaping irregular lumps of rock into smaller building blocks. The hammer-stones left cup-like depressions on the surface, so the masons then had to smooth and polish the blocks using a flat stone and a slurry of clay and sand.

Nearby another group of men worked on reddish blocks of sandstone from the Quimsachata mountains which they would use to repair the city's drainage system. They pecked T- or I-shaped cavities in the sides of the stones, so that when they were fitted snugly together, metal-workers could pour molten bronze into the depressions. When the metal hardened it would form clamps that locked the blocks so firmly together that not even an earthquake could shift them.

The masons spent many weeks shaping the block that had been brought from the quarries on the other side of the lake. They intended to fashion it into a portal with a small doorway in the center for the new shrine that lay beyond the moat encircling Tiwanaku's most sacred buildings.

The city's rulers and priests lived on this artificial island, an area of large plazas and gateways, carved entryways and lintels, and terraced temples and sunken courts. In the middle of one sunken court rose an enormous block of stone portraying a man as large as a giant, and arrayed next to it were smaller statues said to have been taken by the rulers from other cities far across the lake, beyond the quarries.

Rising above them all was the terraced structure whose silhouette the quarrymen had seen, its seven terraces sheathed in stone. Some of the temple's stones were richly carved and painted, and heads of pumas and men jutted out from the upper tiers. Guarding access to one of the temple's stairways were two pumas of black stone, with carved human heads in their laps.

At the new temple site, beyond the sacred core, skilled masons would be spending many months using ever-smaller stone chisels to carve an intricate design on the front of the portal. In the center would be a figure standing on a stepped temple (like the one whose entry the portal would adorn) with sun-like rays projecting from his head and two staffs in his hands: one a spear-thrower and the other a container filled with spears. He was the weather god and when he threw his spear he caused thunder and lightning.

Around this relief figure, winged attendants would be carved, and below them an array of sun-like images. Painters would come, with their pigments made from metallic ores, and color the carved images blue-green, and the lapidary workers would inlay turquoise-colored stones into the eye-sockets. Metal-workers would then pour molten gold into the recessed areas and pre-drilled holes in the stone surrounding the images. When it hardened the images would be surrounded by more gold, and the metal that had flowed into the holes would act as anchor pins, securing the whole golden sheet. Finally, ropes would be tied to the portal and used to raise it onto its stone base in the temple's eastern entry-court. There, painted and sheathed in gold, it would catch the first rays of the rising sun.

The large, ethnically and ecologically diverse regions controlled by both Wari and Tiwanaku foreshadow the scale of the Inka empire some five hundred years later. Indeed, the Inka borrowed strategies of statecraft from both, creating a spiritual link with Tiwanaku and its haunting stone monuments, and adapting Wari's novel scheme of far-flung urban settlements linked by an imperial road system.

The city of Tiwanaku, founded by AD 200, was older than Wari and prospered for almost a millennium. Wari, on the other hand, grew rapidly and flourished for some three hundred years, but by around AD 650, when Wari began to expand outside Ayacucho in the south-central highlands, Tiwanaku's influence was already extending far beyond its more southerly cradle in the Titicaca basin. With the exception of one fleeting Wari foray into Tiwanaku territory, the La Raya pass south of Cuzco apparently served as a buffer zone between the two empires.

Scholars have long noted intriguing similarities between the two cultures. Resemblances between the iconography of Tiwanaku's stone monuments and motifs on Wari textiles and ceramics are the most convincing evidence that a relationship did exist. There are, however, also notable differences. Tiwanaku's ceremonial core was designed with a preconceived plan, while Wari appears to have developed haphazardly, incorporating new architectural elements as the city grew. Tiwanaku's religious architecture was one of public ceremony, while Wari's was aimed at smaller and more private groups. Tiwanaku artists depicted the emblems of their religion primarily on stone sculpture at the capital, whereas Wari artists portrayed theirs on ceramics and textiles.

Did Tiwanaku missionaries take the symbols of their religion to Wari? Did Wari pilgrims visit Tiwanaku? Or did both cities draw their inspiration from the earlier Titicaca basin site of Pukara? Do these cultures represent two empires or one? Did Wari become the leading city in the first millennium, or was Tiwanaku the paramount center and Wari its subsidiary? Were they dual capitals? Continuing research at the presumed capitals of the two empires may one day answer these questions, but until then the nature of the relationship between Wari and Tiwanaku remains one of the most hotly debated issues in Andean archaeology.

Tiwanaku and its forerunners

Unlike Wari, Tiwanaku has clear-cut local antecedents founded on a religion that apparently united the Titicaca basin as early as 1000 BC. Ceremonial structures dating to around 600 BC at Chiripa on the Bolivian side of Lake Titicaca, for instance, herald civic architecture at Tiwanaku centuries later. The most notable culture to follow Chiripa was Pukara, which

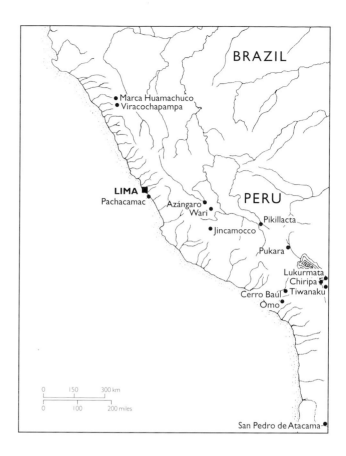

77 Map showing the principal sites discussed in Chapter 6.

flourished from the end of the first millennium BC until around AD 200. Located north of Lake Titicaca, the type site of Pukara covered an area of about 600 hectares (1,480 acres), the largest *altiplano* settlement for its time. There, high on steep terraces overlooking the Pukara river and the ancient residential area on the plain below, lies a set of U-shaped courts flanked by fine masonry rooms. Modern Pukara covers much of the old residential sector, which sprawled over 400 hectares (990 acres) in antiquity. Extensive surface remains, mainly middens and traces of house foundations, suggest that the site had a dense and permanent population.

Tiwanaku lies at a breathtaking 3,850 meters (12,600 feet) above sea-level on the Bolivian side of Lake Titicaca. For more than a century arch-aeologists have been trying to make sense of the jumble of its monuments, looted and stripped of their gold long before the Spanish invasion. Spanish settlers then removed stones from the city, some of which grace the nearby village of Tiwanaku, and as late as the nineteenth century the site provided a source of stone for building the railway that passes close by. The nineteenth-century traveler, E. George Squier, noted that "The first thing that strikes the visitor in the village of Tiahuanuco [Tiwanaku] is the great

number of beautifully cut stones, built into the rudest edifices, and paving the squalidest courts. They are used as lintels, jambs, seats, tables, and as receptacles for water. The church is mainly built of them; the cross in front of it stands on a stone pedestal which shames the symbol it supports in excellence of workmanship."[10]

To many, Tiwanaku is an enigma. How could a city have arisen on the bleak and windswept *altiplano* to become the center of one of the most influential and long-lived empires in the southern Andes? How did the rugged and seemingly infertile *altiplano* sustain such a dynamic city? Recent excavations and research are sketching a new picture of Tiwanaku, however. They show that the land around it was once much more fertile and could have supported a large population, thanks to an elaborate network of *waru waru*, or raised fields (discussed below), as well as dikes, canals, causeways and aqueducts.

The city of Tiwanaku

Major building was under way at Tiwanaku by AD 200, when the site had already been occupied for almost five hundred years. By AD 300 building had begun on the city's carefully planned ceremonial core, an area of stone temples, sunken courts, gateways and architraves embellished with such emblems of the Tiwanaku religion as the so-called Gateway God, described below. By AD 500 Tiwanaku had become a prosperous urban center and the hub of an expanding empire whose religion and art style influenced a wide swath of the southern Andes. Inhabited from 250 BC to AD 1000, few settlements in the Andes can boast such a long occupation.

Tiwanaku's location reflects concepts of sacred geography. Its founders placed their city amid the natural features they worshipped: the sacred, snow-covered peaks of the Cordillera Real to the east and Lake Titicaca to the west. Its ceremonial architecture followed a grid pattern, and structures were aligned with the cardinal directions. A moat segregated the ceremonial core from the rest of the city, creating an artificial island that mirrored the sacred islands of the Sun and Moon in Lake Titicaca: both of them sites of Tiwanaku shrines. Stone-lined underground canals criss-crossed much of this sector to drain rainwater into the moat.

It is difficult to assign specific functions to the various buildings in the ceremonial core. Some served as palatial residences, but the gateways and monuments show that the area was clearly public in nature and provided large spaces for religious and civic rites. Traces of gold anchor pins (to hold a metallic inlay, probably molten during installation) as well as paint on some of the carvings indicate that many stones were decorated or perhaps even covered in finely woven textiles.

Tiwanaku's residential areas

Most excavations have focused on the ceremonial core, but new research in the surrounding areas suggests that the majority of Tiwanaku's inhabitants lived in dense concentrations of adobe-walled houses with foundations of river cobbles, much smaller and less elaborate than the lavish palaces found in the ceremonial core. Curiously, neither in the core nor in outlying areas have archaeologists encountered storehouses or anything that resembles administrative architecture, the hallmarks of imperial infrastructure. Admittedly, storage structures may have been built of adobe without the stone foundations that the residences had, and so may have melted in the torrential *altiplano* rains.

In Tiwanaku IV times (AD 400–750) élite residential areas formed distinct *barrios*, or neighborhoods, distinguished by high adobe walls set on foundations of river cobble. During Tiwanaku V (AD 750–1000) these were razed to make way for elegant palaces such as the Putuni, an elevated platform measuring some 50 meters (165 feet) on a side with a sunken courtyard on its summit. Next to this lies the Palace of the Multicolored Rooms, named for the remains of green, blue and orange stucco that once covered its walls. In the Palace kitchen excavators uncovered hearths, ceramics for storing food and drink, wells and a network of subterranean stone-lined canals that drained the Palace; surface canals may have brought in fresh water to its residents.

Residential areas beyond the ceremonial core also expanded during Tiwanaku V times. In the Akapana East Sector, archaeologists uncovered smaller houses with foundations of river cobbles, remains of adobe walls and traces of thatching. Some houses had wells and drainage systems, hearths and storage pits, and small patios inside and outside the houses have been found. Many households, even high-status ones, engaged in weaving, bone-carving and stone-working, and some areas may have housed specialized artisans serving Tiwanaku's élite. At Chijijawira on the eastern edge of the city, for instance, archaeologists found mortars (probably for grinding pigments), polishing tools, molds for figurines and misshapen pots in a workshop that produced both fancy and plain wares.

Alan Kolata describes Tiwanaku as a "patrician city"[11] whose residents included the native aristocracy, bureaucrats and retainers. At its peak the ceremonial core covered 400 hectares (990 acres). The total urban area may have been as large as 600 hectares (1,485 acres), housing anywhere from 20,000 to 40,000 residents, although the city's population grew when it accommodated pilgrims or the masons and stone-carvers occupied in constructing its monuments. Like the Inka capital at Cuzco centuries later, right of residence at Tiwanaku was probably restricted.

The ceremonial core

Tiwanaku's most sacred shrine was the Akapana. For years it was believed that the Akapana was a modified natural hill, but Cieza got it right almost five hundred years ago when he described it as "a man-made hill, built on great stone foundations."[12] Recent excavations have shown that the Akapana's builders used fill and clay excavated from the moat to create an artificial hill some 17 meters (56 feet) high.

Roughly cross-shaped in plan, the Akapana measures about 200 meters (650 feet) on a side. Its seven terraces are sheathed in sandstone slabs, and the upper levels may have been painted and carved or adorned with sheets of metal and textiles. Lake Titicaca and Mt Illimani are both visible from the summit, which was reached by stairways on the western and eastern sides. The summit contained a 50-square-meter (540-square-foot) rectangular sunken court of andesite paved with sandstone flagstones. Two stairways led into the court, which was flanked by rooms that may have served as living quarters for priests. (Treasure-hunters ransacked the top of the Akapana, and today a massive looters' pit fills with water at the end of the rainy season.) Stone-lined surface and subterranean canals drained rainwater from the summit court via the terraces into the Tiwanaku river. Kolata believes that the sound of the water cascading from one terrace to the next mimicked that of torrential rain falling on nearby mountains, recalling the roaring sound made by the water rushing through the temple at Chavín de Huántar.

South-east of the Akapana, and isolated from it, lies the Pumapunku, which probably served as a second area for religious ceremony. Its sandstone slabs are some of the city's largest, and scholars rank its stonework among the finest examples of the Tiwanaku masonry style. This shrine, much lower than the Akapana, is a T-shaped mound 5 meters (16 feet) high, and covering 150 square meters (1,615 square feet), made up of three terraces with a sunken court on the summit. Carved doorways and lintels embellished its eastern entry court, probably the original location of the Gateway of the Sun, described below.

Closer to the Akapana lie several other monuments, including the Semi-Subterranean Temple. Reached by a stairway on its southern side, this rectangular sunken court of sandstone measures 28.5 by 26 meters (94 by 85 feet), and stylized human heads fashioned in stone stud its walls. The carved sandstone Bennett Stela, which was uncovered there, is the largest sculpture ever uncovered in the Andes: 7.3 meters (24 feet) high. Named after its discoverer, Wendell Bennett, and today in a plaza in Bolivia's capital La Paz, the stela portrays a richly attired human figure, perhaps one of Tiwanaku's rulers or a deity. He wears a headdress and holds a decorated

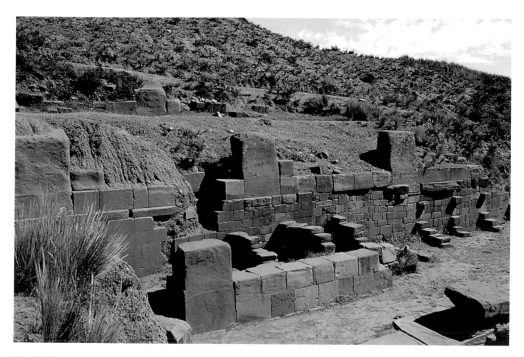

78, 79 The Akapana temple at Tiwanaku A detail of the construction of this man-made hill (*above*), some 17 m (56 ft) high. The idealized reconstruction of the Akapana (*below*), seen from the north-east, shows its seven terraces, sheathed in sandstone, and its summit courtyard.

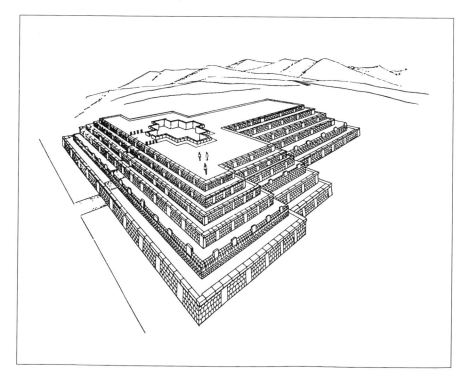

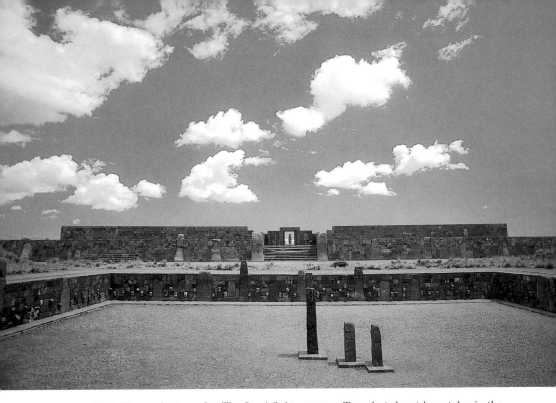

80–2 **Tiwanaku temples** The Semi-Subterranean Temple (*above*) has stelae in the center and stone human heads in the walls; the Kalasasaya gateway frames the Ponce monolith (*opposite*). Only scattered blocks remain of the Puma Punku temple (*below*).

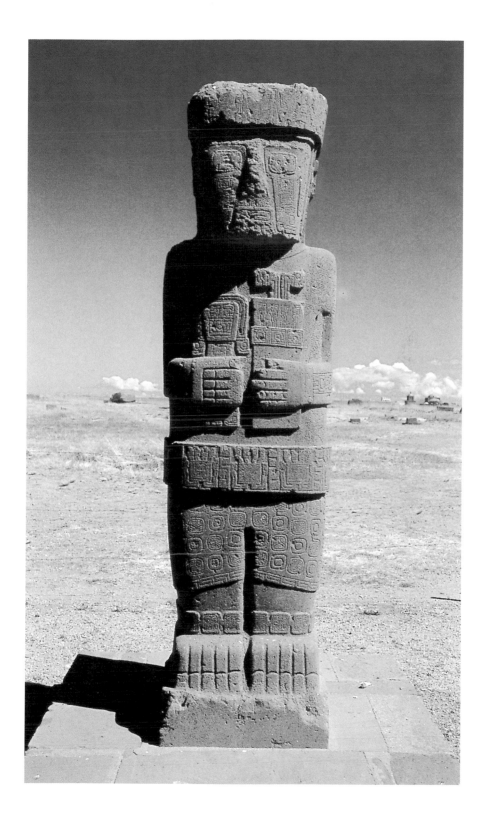

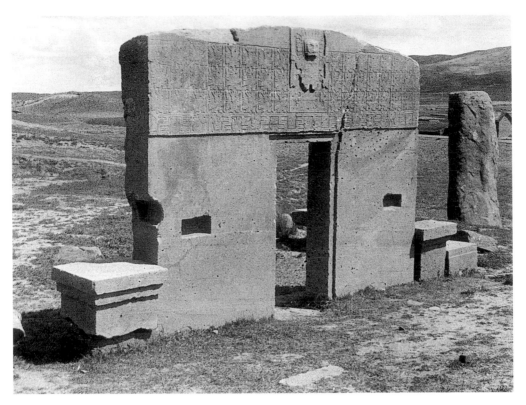

83 The Gateway of the Sun now stands in the north-west corner of the Kalasasaya, but in antiquity may have been in the Puma Punku temple (see ill. 82). Its central figure, the Gateway God, may represent Thunupa, an ancient weather and sky deity.

kero beaker in one hand and a staff or snuff tablet in the other. Cieza remarked, "Beyond this hill [the Akapana] there are two stone idols of human size and shape, with the features beautifully carved, so much so that they seem the work of great artists or masters. They are so large that they seem small giants."[15] It is not clear whether these "idols" could be the ones recovered by Bennett in the sunken temple and by archaeologist Carlos Ponce in the Kalasasaya, or if they are other sculptures that have long since disappeared.

The Kalasasaya – a low-lying rectangular platform, 130 by 120 meters (427 by 394 feet), reached by a stairway hewn out of stones set between two huge, vertical pillars – lies west of the Semi-subterranean Temple. There stands one of Tiwanaku's more striking monuments, the Gateway of the Sun, carved out of a single block of andesite. As noted, it may once have adorned the Pumapunku. The portal's central figure, the Gateway God, probably portrays Thunupa, a weather deity and sky god worshipped in the Titicaca region, who was believed to bring rain, thunder and lightning. Rays, perhaps representing the sun, project from his head, and he stands on

a stepped platform, holding a spear-thrower "staff" in one hand and what appears to be a container holding spears in the other.

We can only speculate about how the people of Tiwanaku perceived this god, but we do know that Inka religion embodied aspects of Titicaca cosmology, and that Illapa, the Inka thunder god, was modeled after Thunupa. The Inka saw Illapa as "a man who lived in the sky ... he was made up of stars, with a war club in his left hand and a sling in his right hand. He dressed in shining garments which gave off flashes of lightning when he whirled his sling, when he wanted it to rain."[14]

Quarrying and transporting Tiwanaku's building stones, including andesite slabs such as that used to fashion the Gateway of the Sun, must have involved an enormous investment in labor on a scale that presages the ambitious Inka engineering projects centuries later. According to Jean-Pierre Protzen, Tiwanaku's builders extracted the andesite from a quarry between Yunguyo and Zepita on the Peruvian side of Lake Titicaca, shipped the blocks across the lake to the port of Iwawe, and then hauled them overland to Tiwanaku. Some of the city's sandstone came from quarries in the Quimsachata range 10 kilometers (6 miles) south of the city, but the provenance of larger sandstone blocks, such as those found in the Pumapunku, is still a mystery.

Tiwanaku's economy

The key to Tiwanaku's prosperity was its rural hinterland, devoted to growing crops in raised-field systems, herding llamas and alpacas on the *puna* and exploiting fish, birds and aquatic plants along the shores of Lake Titicaca. *Waru waru*, or raised fields, in the Titicaca basin date to Pukara and perhaps to as early as Chiripa times, and they continued to be used for centuries after the collapse of Tiwanaku (the technology was lost after the Spanish invasion, however, and has only recently been revived). The fields formed an enormous network covering wetlands along the southern, eastern and south-western shores of Lake Titicaca, where they extended some 15 kilometers (9 miles) inland.

These curvilinear field systems consist of earthen platforms 5–15 meters (15–50 feet) wide and up to 200 meters (655 feet) long. Some have cobblestone foundations topped with one layer of clay and three layers of gravel and then covered by topsoil. Water in the canals between the cultivated ridges acts like a series of miniature lakes, absorbing solar radiation during the day and releasing the conserved heat at night, thus mitigating frost damage. These field systems increased harvests and ensured a dependable food source in a region beset by droughts, hail, frost, torrential rains and strong winds. Modern experiments, comparing potato harvests from raised

84 In the Pampa Koani, near Tiwanaku, farmers tend potatoes on raised fields
(*waru waru*). The technology of these field systems, lost in the turmoil of the Spanish
invasion, has only recently been revived. In antiquity such fields formed an enormous
network covering wetlands along the shores of Lake Titicaca; along with herding and
fishing, they were the basis of Tiwanaku's economy.

fields to those grown by dry-farming methods without fertilizers and pesti-
cides, have shown up to sevenfold increases in the yields from raised fields.

Among these field networks the people of Tiwanaku established agri-
cultural estates such as Lukurmata, as well as smaller settlements scattered
among and on the edges of fields. By AD 500 Tiwanaku's hinterland was
"a constructed landscape of state production,"[15] whose three valleys sus-
tained an estimated rural population of 250,000 and an urban population of
115,000.

Tiwanaku's productive base may no longer be a mystery, but many
details of how its economy functioned remain unclear. Much of its wealth
was based on its vast herds of llamas and alpacas. In an area where people
needed warm clothing and where textiles and weaving had long been
assigned a high value, people amassed great wealth in their alpaca herds,
while llamas provided meat and served as pack animals. (In the highlands
the domestication of camelids – especially the alpaca, which was valued
for its luxurious, soft wool – may have gone hand-in-hand with the
emergence of the textile arts). We do not know, however, what kind of
exchange relationships linked the inhabitants and rulers at the capital to

the farmers and herders in the hinterland who supplied the resources. Some scholars believe that Tiwanaku established colonies to exploit a variety of ecosystems. What do Tiwanaku's far-flung settlements tell us about the nature of its economy?

Tiwanaku expansion and decline

Tiwanaku remains have been found throughout much of the southern Andes, although the nature of Tiwanaku administration appears to have varied from one area to another. Close to the heartland on the northern and western shores of Lake Titicaca, rule was apparently direct. Farther afield in northern Chile, long-distance trade networks linked the region of San Pedro de Atacama to the capital, some 700 kilometers (430 miles) away. The people of Tiwanaku often founded sites in sparsely occupied areas, probably settled by *altiplano* colonists from the vicinity of Tiwanaku itself. As noted earlier, establishing enclaves in a variety of ecosystems was the key to the way Andean peoples, especially highlanders, dealt with the uneven distribution of resources. It also underlies the kind of direct exchange relationships discussed in Chapter 2 that were the Andean equivalent of trade and markets.

Tiwanaku founded the largest colony recorded so far outside the Titicaca basin in the Moquegua valley of southern Peru. There, sprawling for some 40 hectares (100 acres) across three bluffs overlooking the river, settlers built a ceremonial and administrative complex called Omo. First occupied in Tiwanaku IV times (AD 400–750), by Tiwanaku V (AD 750–1000) Omo boasted a temple composed of three adobe-walled enclosures with a sunken court on its uppermost level, recalling similar structures in the *altiplano*. A sizeable residential area surrounded the temple, where some inhabitants feasted using ceramic vessels imported from Tiwanaku. The temperate Moquegua region provided Tiwanaku with access to warm-valley produce like chili peppers and ritually important commodities such as coca leaves and, especially, maize. Tiwanaku settlements in the Cochabamba valley in the tropical Bolivian lowlands east of Tiwanaku may have served a similar purpose.

Researchers have noted a decrease in rainfall in the southern Andes, beginning around AD 950 and culminating in a prolonged dry spell that lingered for several centuries. Data from Quelccaya ice-cap cores and studies of sediments from Lake Titicaca indicate that as rainfall decreased the level of Lake Titicaca dropped several meters. By AD 1000 Tiwanaku and Lukurmata were abandoned. We will probably never know for certain all the reasons for Tiwanaku's decline and fall, but drought certainly contributed to it.

The Rise of Wari

The ancient city of Wari lies in the south-central highlands of Peru, some 700 kilometers (430 miles) north-west of Tiwanaku as the condor flies. It perches on a plateau averaging 2,800 meters (9,180 feet) in elevation in an arid intermontane valley, roughly halfway between the Huamanga and Huanta basins, around 25 kilometers (16 miles) north of Ayacucho.

Unfortunately, the site has been so ravaged over the centuries that it is hard to make sense of its walls, some still 12 meters (40 feet) high, others razed by farmers clearing areas for fields or using the material to build new walls to delimit them. The site is so poorly preserved and in such disarray that only excavated sectors can be reliably mapped. Extensive rebuilding was under way on the eve of Wari's abandonment, and vast areas had been cleared and earmarked for new constructions. The city's tombs were probably looted in antiquity, and archaeologists found the sculptures that once embellished the city at nearby farmhouses. The site lay in ruins when Cieza traveled through the area in the 1540s: "there are some large and very old buildings," he wrote, "which judging by the state of ruin and decay into which they have fallen, must have been there for many ages."[16]

Huarpa, the Ayacucho culture that thrived in the region from around AD 500, immediately before the emergence of Wari, is distinguished by its scattered residential communities (three of which were later occupied by the city of Wari) and by its ceramics, which show a mix of local styles and Nazca influence. Wari, which is built on undulating terrain with little regard for topography, shows architectural forms that have no local forerunners, however. Its high-walled enclosures became the hallmark of the Wari culture (along with the well-documented ceramics, whose iconography and distribution form the basis of a relative chronology for the culture's style) and of its far-flung satellites, scattered across the Andes from Huamachuco in northern Peru to Cuzco in the south.

The core of Wari, much of which is sculpted into broad terraces, covers some 200 hectares (495 acres), but its nucleus may have been as large as 300 hectares (740 acres), while its periphery included an additional 250 hectares (620 acres). Population estimates range from a low of 10,000–12,000 to a high of 35,000–70,000 residents. By AD 600 the settlement had become a ceremonial and a residential center, featuring several enclosures surrounding ceremonial structures built of dressed stone. Examples are the slab chambers of the Cheqo Wasi enclosure and the temple complexes of Vegachayoq Moqo and Moraduchayoq, a semi-subterranean temple made of dressed slabs of volcanic tuff whose stonework recalls that of Tiwanaku. Apart from these few examples of dressed-stone architecture, however, most of Wari was built of quarried stone set in mud mortar.

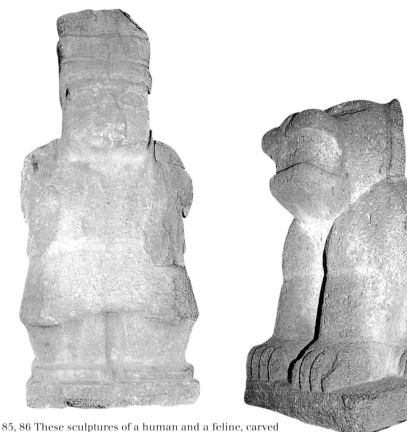

85, 86 These sculptures of a human and a feline, carved
from volcanic tuff, once embellished the sprawling settlement
of Wari. The city has been so ravaged over the centuries that their
exact original location remains a mystery.

Around AD 650 the Moraduchayoq temple was dismantled, and residential architecture began filling areas beyond Wari's ceremonial enclosures. These distinctive residential groups are characterized by large rectangular compounds flanked by the narrow streets that formed Wari's urban grid. This pattern is especially evident in the northern sector of the city, where the rectangular or trapezoidal compounds measured from 150 to 300 meters (490 to 985 feet) on a side. These compounds are subdivided into patio groups: open square, rectangular or trapezoidal enclosures with patios in their centers surrounded on all four sides by long narrow rooms, or galleries, some of which were multi-storeyed.

Rows of projecting corbels supported the upper floors, and the roofs were probably thatched. The patios had low benches and wall niches, and many featured stone-lined canals under their floors that apparently served as drains. Narrow doorways led from galleries to patios and between patio groups. In the Ushpa Qoto sector in the northern part of the city excavations

87, 88 **The city of Wari** These walls in the Capillapata sector (*above*) date to late in Wari's construction history, *c.* AD 700–800, when the city's architects earmarked certain areas for rebuilding. The slab chambers of Cheqo Wasi (*below*), some of the few examples of dressed stone masonry at Wari, may once have contained tombs.

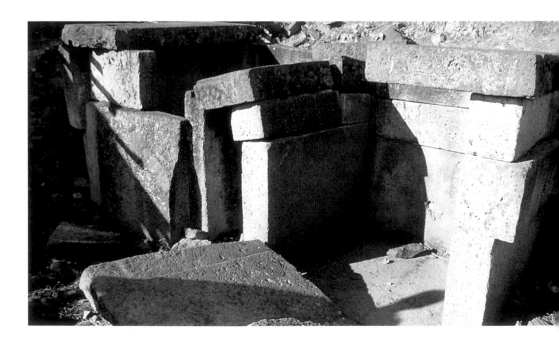

by Luis Lumbreras revealed buildings up to three storeys high surrounding rectangular patios. In one large compound a pottery workshop was unearthed, as well as a storage area containing pottery molds and other supplies and equipment for making ceramics.

William Isbell and his colleagues suggest that the long, massive walls that characterize the site date to the final years of the city's history, around AD 700 to 800, or perhaps even later. These walls, some several meters wide, may reflect the last stages of an ambitious urban renewal scheme, intended to enclose buildings that were never constructed. Shortly after they were built construction ceased, and Wari was abandoned.

Wari expands

As the city of Wari grew, agriculture in the Ayacucho basin intensified with the introduction of extensive terracing and irrigation to the arid hillsides surrounding the Wari heartland. The main crop appears to have been maize, used for brewing *chicha*, an indispensable ingredient of Andean reciprocity and ritual. Close to the capital in the nearby Huanta valley lies the planned center of Azángaro, where occupation began around AD 650 and continued until its abandonment some one hundred and fifty years later. The area served as Ayacucho's breadbasket as well as a source of plants used to produce textile dyes and of mineral pigments for decorating ceramics. The settlement may have housed administrators who oversaw maize production. Like other Wari provincial centers, Azángaro is distinguished by its large rectangular enclosure divided into three sectors measuring 175 by 447 meters (574 by 1,467 feet) and covering 7.8 hectares (19 acres). The northern sector features patio groups, while the southern sector is scattered with buildings of irregular construction.

The founding of Jincamocco in the Carhuarazo valley south-west of Ayacucho also seems to be connected with agriculture, notably maize production. When this center was established, around AD 650, the local inhabitants who lived in higher areas moved closer to the valley floor, and agricultural terracing increased. Jincamocco has a typical Wari rectangular enclosure measuring 130 by 260 meters (427 by 853 feet), while surface remains indicate that the total area of occupation covered around 17.5 hectares (43 acres). Jincamocco, which lies halfway between Wari and Nazca, also served as Wari's gateway to the south coast.

Ceramics found at Wari provincial centers show that most were established around AD 650. Some archaeologists have attributed Wari expansion to military conquest, while others have suggested that environmental stress, perhaps drought, was the spur. The fundamental factor, however, appears to have been the economic impulsion of strategies to secure resources,

backed by new and more sophisticated religious and political tactics. These provincial centers also provide clues to the origins of Wari's architectural style, such as patio groups and their multi-storeyed galleries, features which had no forerunners in the Ayacucho area.

Interestingly, one of the earliest Wari provincial centers lies not near the capital but 700 kilometers (435 miles) to the north at Viracochapampa in Huamachuco, close to the northern frontier of Wari dominion. Viracochapampa's compound measures 540 by 570 meters (1,772 by 1,870 feet) and contains a central plaza and multi-storeyed patio groups; it is the earliest Wari center where archaeologists have identified this trademark architectural style. The site also featured niched halls, large buildings with wall niches at either end, probably inspired by constructions at the nearby site of Marca Huamachuco. Wari apparently established trade links with the people of Huamachuco early in its history in order to gain a foothold in northern Peru, perhaps to ensure access to resources such as highly valued *Spondylus* shell from the Gulf of Guayaquil. For reasons that are still unclear, however, Wari's plans were stymied, and its intense but fleeting presence in the region came to an end. Viracochapampa was never finished or even occupied.

At Pikillacta in the Cuzco region, some 250 kilometers (155 miles) southeast of Ayacucho, Wari peoples built an enormous rectangular enclosure measuring 630 by 745 meters (2,067 by 2,444 feet) and covering 47 hectares (116 acres). The largest Wari provincial installation, Pikillacta formed part of a network of settlements, roads, shrines, walls and garrisons in the Cuzco valley's Lucre basin that guarded Wari's southern frontier. According to Gordon McEwan, Pikillacta served as the "nerve center"[17] of Wari occupation in the Lucre basin, a hub of political administration and the home of religious and political élites.

Wari peoples established Pikillacta around AD 650 and occupied it for around two to three hundred years. Midden up to 3 meters (10 feet) deep in some areas indicates that the occupation was quite intense. The builders first constructed the outer walls, or shell, suggesting a preconceived plan; some walls within the enclosure still stand 12 meters (40 feet) high. McEwan discovered gypsum-plastered floors and staircases, and the remains of collapsed floors indicate that some structures were multi-storeyed. Some of the four sectors into which Pikillacta is divided are filled with peripheral galleries and niched halls, and others with cell-like rooms.

For many years, archaeologists thought that these cells served as storerooms, but recent excavations revealed domestic occupation. When Pikillacta was abandoned around AD 850–900 its occupants sealed some of the doorways; there is also evidence of a fire in the central sector at this time or shortly after the city's abandonment.

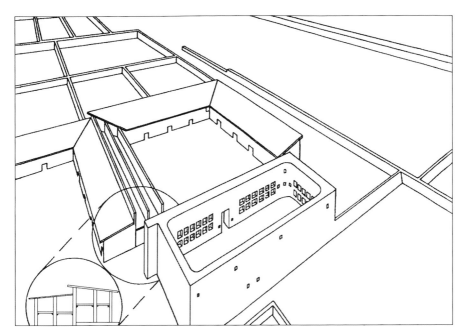

89 Reconstruction of a niched hall and patio complex at Viracochapampa, a Wari
provincial installation east of Trujillo in the north-central highlands. The arrangement
of niched halls and patio groups recalls architecture at Pikillacta (see overleaf).

Wari's brief encounter with Tiwanaku took place in the Moquegua valley,
in the heart of Tiwanaku-controlled territory and well beyond Wari's sphere
of influence. There, on Cerro Baúl, Wari built its only defensive site
recorded so far atop a sheer-sided mesa towering 600 meters (1,970 feet)
above the valley floor. The 10 hectares (25 acres) of summit structures inc-
lude remains of circular and D-shaped masonry buildings, mainly adjoining
rectilinear, single and multi-storey rooms surrounding patios, in typical
Wari fashion. The architecture recalls the capital itself rather than the great
rectangular enclosures of Pikillacta, Azángaro or Jincamocco. Ceramics
found on Cerro Baúl date from AD 600 to 700. Did Wari try to establish a
foothold in a Tiwanaku-controlled area to exploit warm-valley produce or
mine semiprecious stones and metallic ores? Archaeological research in
Moquegua reveals a break in the Tiwanaku occupation of the area. What-
ever the final scenario, though, Wari apparently retreated, and Tiwanaku
regained control over Moquegua.

Wari on the coast

As noted in Chapter 5, Wari had a long-standing relationship with the Nazca
region, but on the coast, in contrast to the highlands, no clear-cut Wari
architectural remains have been found. Wari-inspired ceramics have been

Pikillacta, a Wari center near Cuzco

90 (*above*) Excavations of multi-storeyed gallery rooms: this view shows a narrow rectangular room, with the person standing on the ground floor of a two-story building. The white material on the walls and on the floor is plaster of Paris (gypsum), and the floor is of solid plaster, 5–10 cm (2–4 inches) thick.

91 (*right*) Pikillacta was built on undulating terrain with little regard for topography. It was the largest provincial Wari installation, and its enormous compound, divided into four sectors, covers 47 hectares (116 acres).

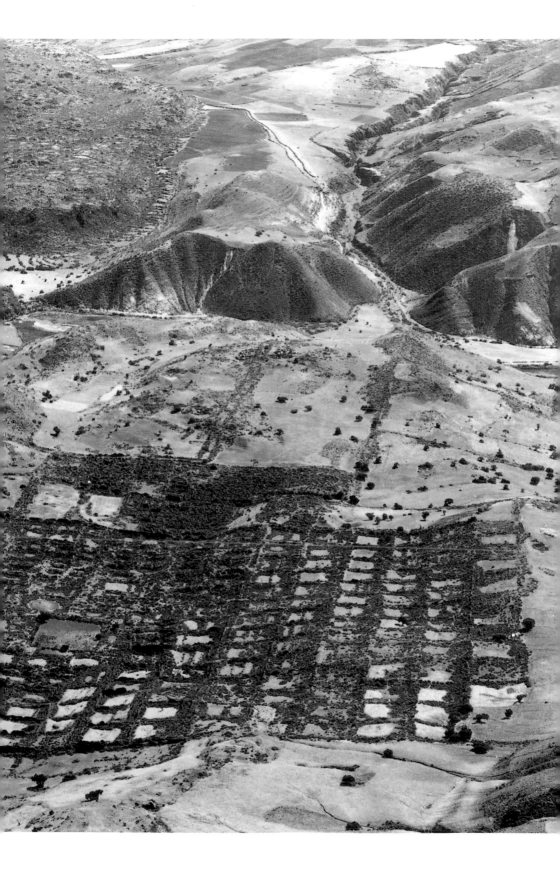

92 Cerro Baúl, a Wari outpost in the upper Moquegua valley, southern Peru, perched on top of a sheer-sided mesa rising 600 m (1,970 ft) above the valley floor.

encountered along much of the Peruvian coast, but, apart from finds in a ceramic workshop at Maymi in the Pisco valley that produced distinctive Wari pottery, these come from burials or offering caches.

Wari did, however, establish special links with the central coast, probably because of the prestige of the pilgrimage center of Pachacamac, a monumental site of temples, storehouses and plazas overlooking the Pacific. Throughout its long history Pachacamac played a part in local and regional religion and became the seat of one of the most feared and revered pan-Andean oracles; from around AD 800 to 1000 it was probably the most influential religious center on the coast. Elucidating Wari's relationship to Pachacamac is fraught with difficulties. Clearly, a widely distributed, Wari-

inspired ceramic style originated there. The layout of the so-called Pachacamac temple – the ceremonial focus of Wari Pachacamac and the only Wari structure recorded there – is difficult to discern, however, because of extensive rebuilding, remodeling and looting.

The legacies of Wari and Tiwanaku

It is no coincidence that the Inka targeted the former Tiwanaku heartland as the first region far beyond Cuzco to conquer, nor that the Titicaca basin's herds of alpacas and llamas became one of the great sources of Inka wealth. The Inka established a mythical association with Tiwanaku and assimilated the Titicaca region into one version of their origin myth. They also borrowed such strategies as the relocation of people to exploit resources, and they engaged in ambitious public works. In many ways too, the nature of

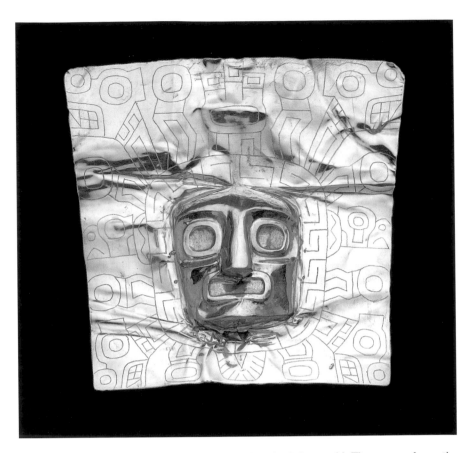

93 A Tiwanaku plaque made of hammered and incised sheet gold. The eyes and mouth may have had inlays of semi-precious stones.

Inka control over its provinces recalls that of Wari. A road system connected Wari's dispersed satellite outposts, a network the Inka later incorporated into their own. The Inka also borrowed the use of the Wari *quipu*, a string recording device, for their administration. Inka state installations, many built on virgin ground, follow the pattern established by Wari. The system of integrated settlements and roads foreshadows a new dimension of urbanism that extends beyond individual settlements into planned and co-ordinated networks of sites. Both Wari and Tiwanaku played on the religious prestige of local ceremonial centers. Before exploring Tawantinsuyu, the empire of the Inka, we will turn again to the coast and the kingdoms of Lambayeque, Chimú and Chincha.

Cities of the Desert

The kingdom of Chimor, the largest state yet to control the coast of Peru, built its capital, Chan Chan, near the Pacific at the mouth of the Moche valley. By AD 1400 it had become the largest city ever built in the Central Andes, with imposing royal compounds and sprawling barrios of artisans. Its rulers established satellite settlements to control coastal valleys rich in natural resources.

TIME: AD 1370

PLACE: Chan Chan, north coast of Peru

CIVILIZATION: Chimú

The boy made his way through the narrow, winding streets in the center of the city, struggling with the heavy sack on his back. It was a load of alpaca wool he had collected from the administrator at the llama caravanserai. He dropped the sack and rested for a minute, eyeing the dyed skeins of blue, pink and gold; one day those would be part of rich tapestries and brocades. Then he shouldered it again and lumbered on.

As he neared the weavers' compound he could hear women's voices. Inside there was a small patio with ducks waddling about in the middle and a low bench running round it. Again he paused, leaning against the wall, and watched as some of the women used sticks to beat unspun cotton that they had laid out in neat piles on the ground.

In the shade of the wattle-and-daub roof that half-covered the patio sat another woman, twirling her spindle absent-mindedly as she deftly spun a long thread of cotton; she kicked furtively at a guinea-pig that scampered across the patio. He saw a weaver tie one end of her loom to a wooden post and sit on the ground with the backstrap at the other end around her waist, the half-completed, brilliant white textile with its pelican designs stretching taut in front of her.

The boy crossed the patio and dropped his heavy sack in front of one of the women. She picked out the skeins, separated them by color and dropped them in bunches into small clay-lined bins, chatting as she did so.

Unlike the cotton in the other bins, she used the wool sparingly, she told him. It came from alpacas that lived in the mountains far away to the south-east; they looked rather like the llamas in the caravanserai, but they had shorter necks and dense, soft coats – much too thick for the *yungas*, the warm coastal valleys like the one surrounding Chan Chan. She saved the alpaca wool for the tassels that decorated the shirts she wove for the lords who lived in the royal compound just beyond the artisans' *barrio*.

Once, the young boy and his family had been allowed inside the royal compound. He remembered how its tall adobe walls dwarfed him, and he recalled the wooden figures guarding its entrance. Inside there was a huge patio – much, much bigger than this one where the weavers worked. Its walls were covered with adobe friezes depicting fish and birds and curly, wave-like designs that reminded him of the surf on the beach.

He remembered the chanting, the music of drums, trumpets and rattles and the people serving the *chicha* beer that he was still too young to drink. He had even caught a glimpse of the king as he passed through the palace, carried high in a brightly-painted wooden litter.

But there was no time for day-dreaming; the caravanserai administrator was an impatient man, he must hurry back to pick up his last delivery of the day: heavy copper ingots to be delivered to the metal-workers.

It was hard work, but he enjoyed working at the caravanserai, seeing the llamas laden with all sorts of exotic goods and marveling at the strange people

from far away who milled about and exchanged gossip and news. One trader had told him about the warm valleys that lay on the other side of the mountains, where everything was green and the rivers carried water all year round. That was the man who kept the blue-and-yellow macaw that entertained them all with its mimicry and strident call; he said that where he traveled the sky was full of birds like those.

Another trader had told him that the bronze and copper ingots came from the east, far up the valley near the source of the river that watered Chan Chan; there were mines and smelting-ovens up there, he said. Other ingots came from the north: from hills surrounding the wide Lambayeque valley, with its winding irrigation canals and fields of maize and beans and cotton. Llamas carried the ore from the mines to the smelting site, where workers mixed the ores and added charcoal made from the dense forests.

He heard how they put the ores in clay crucibles and heated them in shallow ovens, blowing through cane tubes until the chips of rock melted into liquid and glowed dark red. Then, when the metal had cooled, the workers crushed the slag on big, flat rocks and picked out little pellets of pure metal. These they melted a second time and poured the liquid into molds to cool and turn into the ingots that they shipped to Chan Chan.

He reached the caravanserai, picked up a sack of these ingots and staggered back the way he had just come – for the metal-smiths lived quite near the weavers. Like the weavers, they worked in a patio shaded by a roof. Many of them came from Lambayeque.

They sat on benches, hammering the ingots of copper and bronze into flat sheets, occasionally heating the metal so that they could hammer it into ever thinner sheets. Panting under his sack (not as big as the last one, but heavier), he neared their workshop and heard the steady sound of stone hammers pounding the metal on stone anvils.

Inside the compound, he delivered his load and lingered to get his breath back. One of the workers was shaping copper into tweezers, like the ones his father used to pluck the stray hairs on his chin. Others were making sewing-needles, or fashioning simple bangles and rings, or beads for necklaces. Scraps of copper littered the workshop floor, and one of the smiths swept these into a pile, dumping them in one of the bins that lined the work-space.

His day's work was over now. He wondered whether to walk down to the beach, past the sunken gardens planted with maize and lined with fruit-trees that lay along the shoreline. He decided to go straight home, though. There was work to do there to help the family: fetching water from the deep walk-in well that lay at the end of his *barrio*'s winding alleyway, or giving a hand with the kitchen chores. He was always tired when he lay down at night, but as soon as he went to sleep he drifted off into dreams of distant places and llama caravans.

Around AD 1000, following the fall of Wari in the south-central highlands and the abandonment of Tiwanaku in the southern *altiplano*, the cultural initiative again shifted to the coast. On the north coast the Moche legacy spawned two notable successors: Lambayeque, or Sicán, centered in the La Leche and Reque valleys of the Lambayeque region, and Chimú, or Chimor, based in the Moche valley. On the central and south-central coast the Chancay and Chincha cultures came to prominence, while the pilgrimage center of Pachacamac continued to flourish, its oracle attracting worshippers from near and far.

Events in the highlands between about 1200 and 1400 are, however, less well documented. This is partly because the peoples living there on the eve of the Inka conquests never developed the monumental architecture or the art to rival their coastal counterparts or their Wari and Tiwanaku predecessors.

The north coast

At Batán Grande in the La Leche valley the descendants of the Moche established a new center of the Lambayeque or Sicán culture (not to be confused with the nearby Moche site of Sipán described in Chapter 5). Izumi Shimada, who heads a team of researchers working at Batán Grande, labels the onset of the Lambayeque period Early Sicán. This period, spanning the two centuries from AD 700 to 900, was a time of political reorganization marked by outside influences and stylistic syntheses as well as strictly local growth and development.

By Middle Sicán (AD 900–1100) there were several monumental adobe mounds at Batán Grande, and the site was the region's political and religious center. Shimada notes, however, that it was in essence a religious precinct and a ceremonial city, and that, in contrast to its late Moche predecessors, it lacked a large resident population.

The people of Batán Grande were probably the most prolific metalworkers of all the north-coast societies. The site was so famed for the sheer volume and wealth of the metal goods it yielded that its temple mounds and cemeteries have been ransacked since colonial times. One of the major tombs plundered in the twentieth century reportedly contained more than a hundred and fifty gold and silver *keros* (beakers), a thousand gold beads, twenty necklaces, a *tumi* or ceremonial knife, as well as emeralds, pearls and ceramics. The mummy bundles of Batán Grande's lords were topped with gold or *tumbaga* funerary masks hammered from sheet-metal and encrusted with semiprecious stones, shell, metal spangles and colorful feathers. The masks were often painted bright crimson with cinnabar, an ore of mercury.

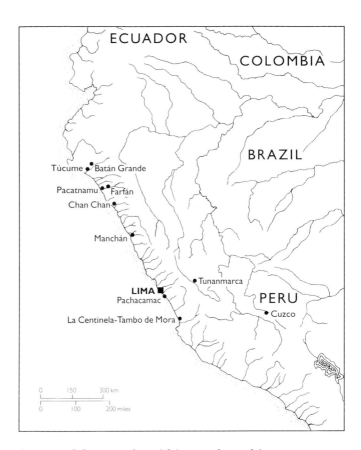

94 Map showing the principal sites discussed in Chapter 7.

By excavating workshop sites used for metal-smithing and smelting, Izumi Shimada and his colleagues have been able to trace the evolution of metal-working in the Batán Grande area from AD 900 to 1500. Smiths used bowl furnaces to smelt copper ore, heating them with charcoal from the wood of the *algarrobo* tree that abounds in the area. They then added crushed ores of copper, arsenic and iron (the iron acting as a flux, fusing with non-metallic substances in the charge and separating them from the resultant copper-arsenic alloy). The heat of the furnace was then increased by blowing through wooden tubes that ended in ceramic tips, called *tuyères*, and the smelting charge became a thick slag containing prills (droplets) of nearly pure arsenical copper. When the slag cooled it was crushed on large, flat stones called *batánes* (hence the name of the site) and the prills removed. These were then remelted to form the ingots that the smiths cast or hammered to fashion a wide range of objects.

Batán Grande's monumental mounds and rich, gold-filled tombs are striking reminders of the golden hoards found at the Moche tombs of Sipán; there too, in the tradition of Lambayeque, wealthy lords went to their tombs accompanied by retainers and great treasures made possible by the rich mines of the region. Batán Grande's glory was cut short around 1100,

however, when its inhabitants abandoned the precinct, igniting wood piled up against the temple walls and setting fire to its monuments. There is evidence that a *Niño* event devastated the region around the same time.

After the abandonment of Batán Grande, the Lambayeque people established a new center at Túcume, to the west. It flourished as the leading center in the region from about 1050 until its conquest by the Chimú around 1350. Its fields were watered by the Taymi canal, which was probably extended when Túcume was founded. Geographer Paul Kosok believed that during this time inter-valley canals linked the Lambayeque valley complex of Motupe, La Leche, Reque, Zaña and Jequetepeque.

The Chimú and the Inka covered over many of Túcume's early buildings, but archaeologists believe that the majority of its monumental constructions – some twenty-six enormous, truncated adobe mounds – were originally the work of Lambayeque peoples. They lived in and around their fields, in small communities along the valley edges or in fishing villages strung along the coast, rather than at Túcume itself.

The rise of the Chimú kingdom

As Batán Grande and, later, Túcume flowered in the Lambayeque region, a new state emerged in the Moche valley that would become the largest pre-Inka kingdom ever to dominate the coast of Peru. Thanks to the wealth of information from excavations and the rich cultural traditions of the north coast that survived the Inka conquest and even the early years of Spanish colonial dominion, Chimú is one of the best-understood civilizations of ancient Peru. At its apogee around 1400, the kingdom of Chimor, or Chimú, dominated some 1,300 kilometers (800 miles) of coastal valleys, from Tumbes in the north to perhaps as far south as Chancay, near Lima.

The history of the Moche valley between the abandonment of Galindo and the founding of Chan Chan, the Chimú capital, is especially obscure. Sometime around 900 the Chimú founded Chan Chan not far from the Pacific Ocean on marginal land unsuitable for irrigation agriculture. Ultimately, the central part of Chan Chan – an area of monumental, rectangular adobe compounds called *ciudadelas* – covered 6 square kilometers (2.3 square miles). The city as a whole sprawled over an area of 20 square kilometers (7.7 square miles) and included élite compounds scattered among the *ciudadelas*, monumental adobe *huacas*, or mounds, *barrios* of small-roomed, cane-walled residences made of *quincha* (wattle and daub), cemeteries, and sunken fields. Not all of Chan Chan was occupied simultaneously, however, and the city's architects probably initially earmarked much of the open land for future expansion. Nonetheless, at its apogee Chan Chan became by far the largest city ever built in the ancient Andes.

A myth recorded in the seventeenth century has helped archaeologists to reconstruct the history and expansion of Chimor, albeit only partially. The *Anonymous History of Trujillo* (1604) traces Chimú origins to a legendary founder, Tacaynamu, who came from the north on a balsa raft and founded his kingdom at Chan Chan. Tacaynamu's son Guacri-caur subdued the lower part of the Moche valley, and Guacri-caur's son Ñanen-pinco overpowered the valleys of Zaña, Jequetepeque and Chicama to the north and Virú, Chao and Santa to the south. Seven kings followed until the reign of Minchançaman, who ruled when the Inka conquered Chimor around 1470.

Correspondences between the *Anonymous History* and archaeology are intriguing, and the patterns of Chimú expansion and conquest it outlines are often borne out by archaeology. Some scholars have associated the number of kings recorded in the legend with the number of *ciudadelas*. Such correlations are fraught with problems, however: the early kings were probably mythical, while the reigns of several of the later kings are probably subsumed under the names of just a few of them. We know that Minchançaman existed, though, because native informants told the Spaniards that he had been captured by the Inka and taken to Cuzco as a hostage.

The ciudadelas of Chan Chan

Depending on how they are counted, there were between nine and twelve *ciudadelas* or palace compounds. Most scholars believe that these were built sequentially (so the sequence charts the city's growth) and served as the residences of successive Chimú kings, their families and retainers. Most also functioned as seats of government and centers for redistributing the wealth of Chimor. In the early years Chimú kings apparently did not build new palace compounds when they assumed leadership, but by late Chimú times this pattern changed, and new kings established their own palaces. The families of previous kings continued to live in the earlier *ciudadelas*, which also served as mausolea for the deceased monarchs and their descendants.

There is considerable dispute over the building sequence of the *ciudadelas*, but most scholars agree that Chayhuac, to the south, is one of the earliest. (We don't know what the *ciudadelas* were called in antiquity. The names used today are modern ones; some – such as Bandelier, Squier or Velarde – honor scholars or explorers; others – such as Laberinto ("labyrinth") – are descriptive.) Archaeologists believe that the city first expanded northward, then grew westward (*ciudadelas* Tello and Laberinto), with *ciudadela* Gran Chimú and a great wall marking the city's northern limits. The city then grew back on itself (*ciudadelas* Squier, Velarde,

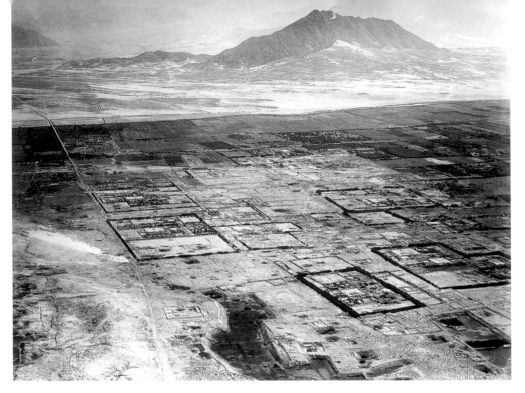

Chan Chan, the Chimú capital

95 (*above*) Aerial view, looking north-west, showing the city's rectangular *ciudadelas* – enormous adobe-walled compounds that served as the residences of the Chimú rulers. The city also contained cemeteries (foreground) and sunken gardens (bottom center).

96 (*left*) Plan of Ciudadela Rivero. A single entrance on the north side provided access. Visitors then entered an enormous entry court; beyond this were administrative structures and storerooms, a burial platform in the central sector and a walk-in-well in the southern sector.

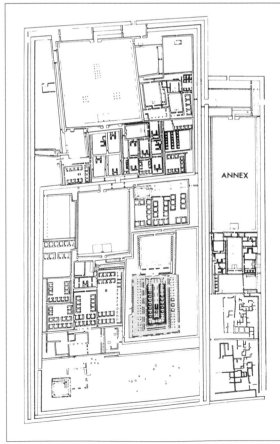

ANNEX

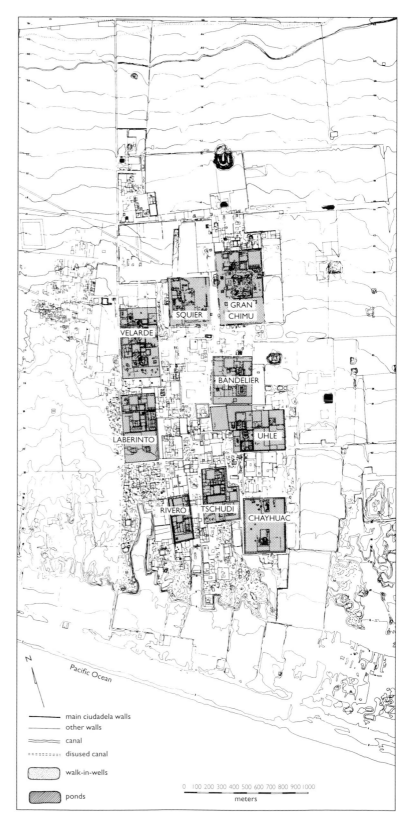

97 (*right*) Plan of Chan Chan. Construction began around AD 900 and the city thrived for several centuries until conquered by the Inka *c.* 1470. Central Chan Chan and its compounds covered 6 sq km (2.3 sq miles); the whole city sprawled over 20 sq km (7.7 sq miles).

SQUIER

GRAN CHIMU

VELARDE

BANDELIER

LABERINTO

UHLE

RIVERO TSCHUDI

CHAYHUAC

N

Pacific Ocean

main ciudadela walls
other walls
canal
disused canal
walk-in-wells
ponds

0 100 200 300 400 500 600 700 800 900 1000
meters

Bandelier, Tschudi and Rivero) with earlier constructions in the city's old southern core razed to build *ciudadelas* Tschudi and Rivero.

Some researchers argue that the rectangular layout and tripartite division of Chan Chan's *ciudadelas* were inspired by the walled compounds of the Wari provincial centers described earlier. Others believe that they reflect a local trend that saw the emergence of secular government at Galindo in late Moche times. Perhaps they embody a mixture of highland patterns and local traditions, part of a developing tradition in Andean administrative organization and its related architecture.

Most of the compounds are aligned north–south and surrounded by imposing adobe walls on foundations of stone, some of them towering 9 meters (30 feet) high. The internal organization of the *ciudadelas* varies, especially in the early ones, but a standard late *ciudadela* such as Rivero was divided into three sectors: north, central and south. Variations in the size of the *ciudadelas* or the number of storerooms may reflect the rise and fall of the Chimú kings' fortunes.

A single entryway on the north side provided access to the palace compound. Pairs of painted and carved wooden human figures set in niches flanked these entryways. They led into the northern sector, where there was an enormous court flanked by benches, with a raised area approached by a ramp on the southern side. Mud-brick friezes with geometric designs and patterns of birds, fish and mythical figures embellished the entry courts' walls. From this court, which appears to have been the most public, corridors led to an area of u-shaped structures, called *audiencias*, that probably served as administrative offices and residences for the nobility. Some *audiencias* apparently controlled access to courts containing storerooms, while others served some other type of administrative function.

The central area also included courtyards, *audiencias* and storerooms, but its primary feature was the burial platform, the final resting place of the Chimú king. Such platforms were the last structures built in the palace compounds, and most scholars agree that they served as the tombs of the rulers. The southern sector contained a walk-in well, dug deep to tap the water-table. Judging by the cane architecture and domestic debris excavated there, this sector housed a resident population of low-status retainers.

Chan Chan's minor nobility and state administrators may have lived in so-called élite compounds located at the core of the city among the palaces. They, too, contained walk-in wells, but lacked burial platforms. Whereas some *ciudadelas* boasted as many as two hundred storerooms, the élite compounds usually had no more than ten.

Not surprisingly, the tombs in the palace compounds are the most heavily looted structures at Chan Chan. Excavations only hint at the wealth

they contained: fine pottery, textiles, weaving tools, carved wood, metal artifacts and whole and ground *Spondylus* shells. One such tomb is the Las Avispas burial platform adjacent to Ciudadela Laberinto. A ramp led to its summit, and it was honeycombed with cells; an I-shaped chamber in the center served as the principal tomb.

Archaeologists estimate that some two to three hundred bodies were buried in Las Avispas; skeletons for which the sex and age could be discerned included those of young females, who may have been ritually sacrificed to accompany the Chimú king into the afterlife. Every so often these cells would apparently be opened and replenished with new offerings. Colonial documents tell us that the Inka ransacked the burial platforms when they conquered Chimor, and, to judge from the intensive looting organized by the Spaniards, they must have contained very rich burials indeed.

What kinds of ceremonies took place in the *ciudadelas*? A Chimú architectural model found in a tomb at the Huaca de la Luna in 1995 provides some clues. The wooden model, 41 centimeters (16 inches) wide by 48 centimeters (19 inches) long, portrays a rectangular compound decorated with a frieze of fish painted in shades of yellow ochre, brown, black and white. It has a single, narrow entryway. Human figures inside the enclosure, carved of wood and inlaid with mother-of-pearl and *Spondylus* shell, represent musicians and officiants. Some stand on benches running along the sides of the enclosure, others serve *chicha* beer, and they face a platform reached by a ramp. At the back of the platform, partly covered by a columned structure with a gabled roof, is a narrow, sunken chamber. In the chamber archaeologists found three miniature mummy bundles of carved wood, representing two females and one male. According to Santiago Uceda, this tableau may illustrate a public ceremony marking the periodic opening of tombs and replenishing of offerings to the ancestors buried at one of Chan Chan's *ciudadelas*.

Chan Chan also features five monumental adobe mounds that may have served as temples. They have been so destroyed by looters, however, that it is hard to discern their layout. One, Huaca Obispo, rises some 20 meters (66 feet) above the valley floor. On the southern side of the city sprawl extensive cemeteries and sunken gardens – garden plots flanking the shoreline and dug below the valley floor to tap the water-table – many of which are still cultivated today.

Barrios and artisans

Most of Chan Chan's urban population lived in areas of small, irregular rooms with common walls that were set among the smaller élite compounds and along the city's south, west and south-west sides. The rooms

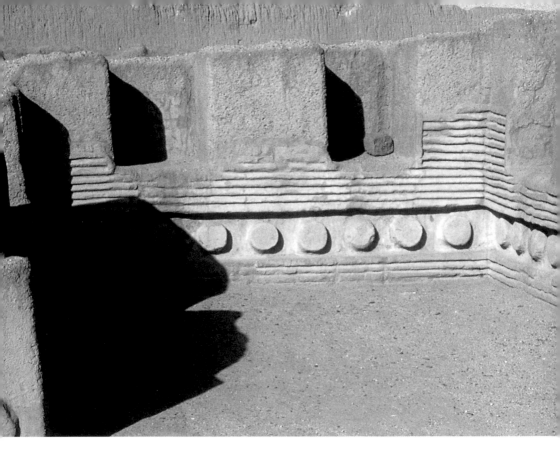

The decorated walls of Chan Chan
98 (*above*) Elegant mud-brick friezes, such as this in Ciudadela Tschudi, adorned the walls of Chan Chan's compounds.
99 (*below*) A mud-brick frieze of stylized birds on a wall in Ciudadela Tschudi.
100 (*opposite, above*) Wooden figures graced entryways at Chan Chan. This figure once guarded the entry to Ciudadela Rivero and held a staff or spear.

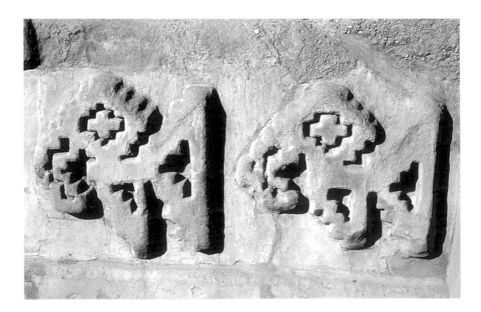

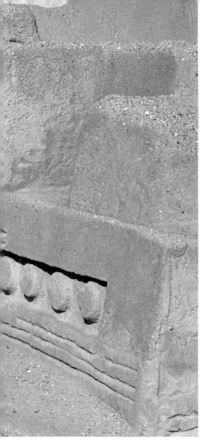

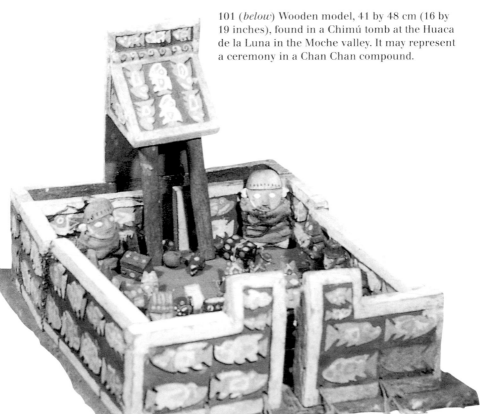

101 (*below*) Wooden model, 41 by 48 cm (16 by 19 inches), found in a Chimú tomb at the Huaca de la Luna in the Moche valley. It may represent a ceremony in a Chan Chan compound.

were constructed of cane covered in mud: wattle-and-daub, or *quincha*. Housing included single-family residential complexes with kitchens, guinea-pig pens, hearths and storage and work areas surrounded by low benches.

These areas formed self-contained *barrios*, or neighborhoods, of winding streets, with their own wells and cemeteries. They were the focus of the city's productive economy, and late in the city's history the *barrios* housed some 20,000 people, about half of whom were laborers, traders and personal retainers of the city's élite, the others skilled artisans. Some of the artisans carved objects from wood and shell, but most of them produced fine textiles and objects made of gold, silver and bronze. Two caravanserais near the city center served as redistribution points for raw materials brought to the capital by llama caravans: skeins of pre-dyed alpaca fiber from the highlands for the weavers, for example, or ingots from smelting sites for the metal-workers.

The evidence for intensive craft production at Chan Chan dates mainly to the city's final phases, beginning around 1300 or 1350. Pots left on hearths indicate that residents hastily abandoned their workshops when the Inka conquered the region around 1470, taking many of Chan Chan's most skilled artisans, especially its metal-smiths, to Cuzco. We know from early colonial sources that occupational specialization still existed on the north coast on the eve of the Spanish invasion; the documents speak of artisans grouped together according to their speciality – craft production, fishing and farming. In addition, the range of architecture at Chan Chan indicates that artisans' status varied considerably, with the more skilled ones attached to the *ciudadelas* and the less-skilled workers organized into four *barrios*. Objects made by the skilled artisans were warehoused in the storage complexes within the *ciudadelas*, to be redistributed by or for the kings of Chimor.

The peak of irrigation agriculture in the Chimú heartland occurred well before Chimor reached its apogee. The Chimú tried to revamp the valley's canal system, embarking on the construction of an ambitious inter-valley canal. Rather than maintaining canals that only brought very limited increases in agricultural productivity, however, the lords of Chimor sought economic gain by expanding their realm to incorporate other areas. By 1400 Chan Chan relied more and more for its sustenance on produce from the provinces, especially the fertile valleys to the north.

102 Carved wooden doorway figure of a large feline crouched behind a human figure – one of six from a compound at Farfán, a provincial Chimú outpost in the Jequetepeque valley on the north coast.

Chimor expands

What do the provinces tell us about the economy of Chimor and its strategies of statecraft? Military force may have been involved in Chimú expansion, but its overwhelming strategy probably involved diplomacy. Chimor's goal was economic power: the management of irrigation networks for agriculture and the control over the production of sumptuary goods.

Around 1150–1200, when the Chimú kings embarked on their first episode of expansion, the Jequetepeque valley formed Chimor's northern frontier. It was during this first wave of conquests that the Chimú founded Farfán in Jequetepeque. There, six monumental compounds, probably once

0 3 5 CM

flanked by perishable structures made of *quincha*, stretch for 3.5 kilometers (2 miles) along what is now the Panamerican highway. The rectangular compounds and *audiencias* – the hallmarks of Chimú administrative architecture – recall Chan Chan. There are very few Chimú provincial centers that mimic exactly these compounds, suggesting that elsewhere Chan Chan's rulers played only an indirect role in provincial administration, leaving control in the hands of the lower-level nobility and local authorities.

Some have argued that Pacatnamú – a ceremonial city of thirty-seven truncated adobe mounds occupied since early Moche times – served as the seat of Chimú administration in Jequetepeque. Others believe that it was probably the region's paramount pilgrimage center. Its dramatic situation on cliffs overlooking the Pacific may give color to this view, for Pacatnamú lies in the desert facing away from the lush farmland of the Jequetepeque valley. Farfán, on the other hand, is strategically located along the north–south coastal road, not far from irrigation canal intakes and the main road to the highlands.

Beginning around 1300, the kings of Chimor launched a second wave of conquests. This time they overpowered Reque, La Leche and Motupe, the three valleys that made up the Lambayeque heartland, and continued their conquest as far north as Tumbes. South of Chan Chan they took over valleys as far as Casma – their dominion south of this valley was rather more tenuous, however. They occupied the mines in the La Leche valley that had provided the lords of Batán Grande with their mineral wealth and took the region's most skilled smiths to Chan Chan, where they produced works decorated with the symbols of their new masters.

There is an intriguing correspondence between the incorporation of Lambayeque into the Chimú state and the expansion of sumptuary goods production, especially metalwork. Capturing the skilled labor of the Lambayeque smiths for the Chimú redistributive network gave the state a substantial boost, politically as well as economically. At its height, Chimor commanded enormous quantities of high-status goods through its state-managed production, which the rulers redistributed to enhance their power. Although they – like the Inka who followed them – claimed to have divine powers, the role of religion in Chimor had probably become secondary to economic, political and military considerations.

Under the Chimú, and later during the Inka domination of the Lambayeque region, Túcume emerged as a leading political center, with both the Chimú and the Inka ruling through local lords. As we have seen, most of Túcume's monumental sector dates to Lambayeque times, but it underwent considerable remodeling under the kings of Chimor. They converted Huaca Larga, its largest monumental platform, from a free-standing truncated mound into the long platform that now rises onto Cerro La Raya,

the mountain that dominates the site. Huaca Larga may have served as the seat of Chimú administration in the area.

As Túcume's population expanded, smaller, élite structures, including workshops and residential areas, were built outside the monumental sector, and the settlement began to take on an urban aspect. Its rulers continued to live on the monumental mounds, but the small mounds in the western and south-western sectors housed people from the hinterland who were drawn to Túcume by the prospect of collaborating with the Chimú.

Closer to the southern fringes of their domain, the Chimú established a provincial center at Manchán on the south side of the Casma valley. The site covers 63 hectares (156 acres) and includes nine adobe compounds composed of patios with benches and ramps and U-shaped, *audiencia*-like structures. Extensive remains of perishable, *quincha* domestic structures flank the site, and as many as four hundred artisans lived there, working metal, weaving and brewing *chicha*.

In contrast to Chan Chan, the residents of Manchán devoted little space in their compounds to storage. What does this tell us about the nature of Chimor's redistributive economy in its later years? Apparently, by the time the Chimú embarked on their second wave of conquests, they had extended their management of craft production beyond the workshops of Chan Chan. Excavations at Manchán by Carol Mackey and Ulana Klymyshyn uncovered evidence of Chimú goods being produced for local consumption. Such a shift to state-managed craft production in the provinces seems to reflect a major change in the economy of Chimor in its later phases.

The central coast

While Chimor prospered in the north, two important cultural (and probably political) entities emerged on the central coast just north and south of Lima. One was Chancay, based in the Chancay valley, the other Pachacamac in the Lurín valley, which we described earlier. The Chancay culture, which may correspond to the small kingdom of Collique documented in ethno-historical sources by Maria Rostworowski, is known primarily for its elegant black-on-white ceramics and well-preserved textiles. The proximity of its cemeteries to Lima has made them favorite sites for grave-robbing. Few excavations, however, have illuminated the architecture, economy or political structure that fostered Chancay's prolific potters and weavers.

Pachacamac, on the other hand, has been explored ever since the land-mark excavations of Max Uhle in 1896–97. Excavations have, though, focused on the site's temples and cemeteries, especially those dating to Wari and Inka times, and little is known therefore of its residential community. Pachacamac's importance in the overall sweep of Andean prehistory is its

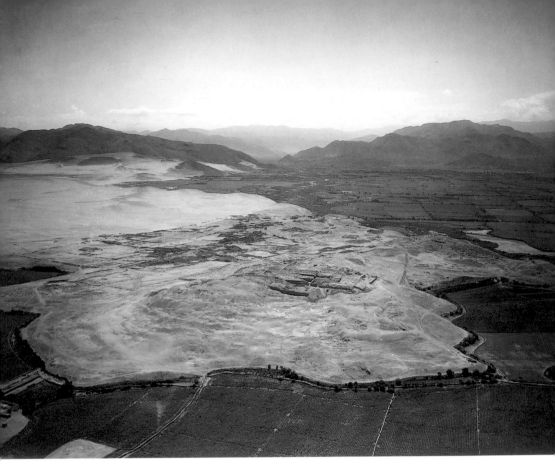

103, 104 The religious center of Pachacamac Aerial view (*above*), taken in the 1930s before Pachacamac was partly restored. The Inka sun temple is the large structure on the promontory. A so-called Pyramid with Ramp (*below*) has an entry court and ramp.

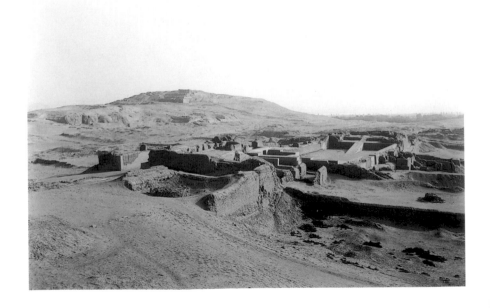

continuity. Probably no other major center played such a significant role for such a long period and in such a variety of political and economic circumstances.

Most of its monumental construction probably dates to the period between the Wari and Inka empires, when Pachacamac grew unfettered. Rostworowski has suggested that during this time it became the center of a loosely organized kingdom called Ichma (or Ychma or Ichimay), that brought together the Lurín and Rímac valleys, basing its authority on religion; as we saw in Chapter 4, controlling earthquakes was one of the attributes of the deity and oracle associated with Pachacamac.

Monuments dating to the Ichma period are the so-called Pyramids with Ramps, which are not really pyramids but terraced adobe platform mounds with central ramps and forecourts surrounded by walls and cell-like rooms. Archaeologists have recorded fifteen such structures strung along Pachacamac's two major north–south and east–west streets. Some have interpreted them as the centers of the various political units that venerated the Pachacamac cult; others argue that they predate the Ichma period (1200–1470) and suggest a connection around 900–1100 with Batán Grande, when the central coast came under strong north-coast influence. In any case, archaeologists concur that their function was ritual. The forecourts provided settings for public feasting and the exchange of ritual offerings, while smaller structures flanking or behind the platform mounds served as storerooms. Craft objects may also have been produced there.

The kingdom of Chincha

South of Pachacamac, several medium- and small-sized kingdoms prospered during the centuries separating the fall of Wari and the rise of the Inka. One of these thrived in Chincha, a broad valley rich in irrigated farmland. An anonymous sixteenth-century document describes Chincha as a land whose people were organized on the basis of occupational specialization, much like Chimor: farmers formed the largest group (12,000), followed by fishermen (10,000) and 6,000 *mercaderes,* or merchants engaged in long-distance trade.

The people of Chincha founded their capital at a large site now known as La Centinela. The nearby settlement of Tambo de Mora probably functioned as part of the capital, with much of the permanent population housed between the two sites in a large sector of structures made of perishable material. Three great roads radiated from the capital. One extended southward along the coast, passing several major Chincha settlements; a second ran east through the valley's agricultural heart; and the third angled southeast to a pass leading into the middle Pisco valley. We can speculate that

these roads somehow involved the specialist groups referred to in the sixteenth-century colonial document: the fishermen used the coastal road, the farmers the inland road and the merchants the road that connected to their clients in the highlands. The document relates that the fisherfolk lived in a settlement along "a beautiful and long street ... when they were not entering the sea [to fish] all their care was to drink and dance and so on."[18]

Regardless of any association between the roads and the specialist groups, the valley can be seen as an organized and co-ordinated whole. Its system of roads and settlements united a population of specialists and a variety of resources in a network that looks beyond urbanism as we usually think of it. The Andean penchant for co-ordinating diversity brought together the produce of the land and the sea, and trade routes extended Chincha's reach well beyond the valley it controlled. Roads linked numerous large sites which were composed of *tapia* (poured adobe) mounds, with spacious forecourts and ramps leading to multiple levels.

Most of the land surrounding the Chincha capital is now cultivated, but early aerial photographs and recent excavations show that Tambo de Mora–La Centinela was the largest of the Chincha sites. Its builders painted its walls almost entirely in brilliant white and embellished them with high-relief friezes of geometric designs, birds and fish. The forecourts of the largest mounds served, like related structures elsewhere on the coast, as settings for public ceremonies.

The people who built and maintained the compounds made offerings consisting of food and headless ceramic figurines on the tops of the mounds. Around the compounds archaeologists have uncovered a variety of residential structures, and the artifacts they found include dozens of enigmatic pottery discs and a bone balance beam, perhaps used by merchants to weigh trade goods.

Highland societies

Between 1200 and 1400 many societies, large and small, also emerged in the highlands. None, however, attained the political complexity or territorial extent of the coastal kingdoms, or created monumental architecture on the same scale. Excavations at Wanka sites in the Mantaro basin of the central highlands have sketched a picture of loosely linked groups without marked differences in wealth or class. Although they lived in large settlements such as Tunanmarca, they built few public and ceremonial structures; defensive walls surrounded many of their towns, suggesting considerable local conflict.

In the Titicaca basin, the Lupaca and the Qolla emerged as Tiwanaku's most distinguished successors. They drew their wealth from vast herds of

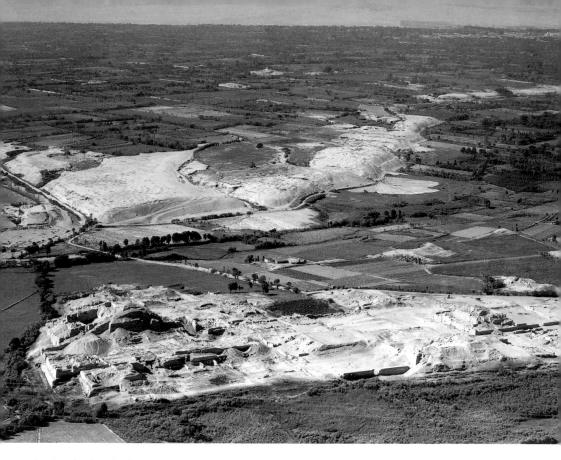

La Centinela: the Chincha capital

105 (*above*) Aerial view of La Centinela. The city's builders painted its walls almost entirely in brilliant white and embellished them with friezes.

106 (*below*) A mud-brick frieze of stylized birds on one of the walls on the summit of La Centinela's highest mound.

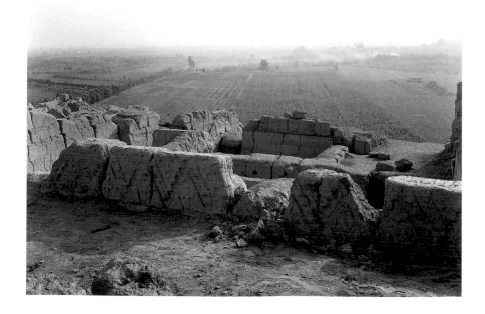

alpacas and llamas, and it was this wealth that made their region the target of the first Inka conquests beyond Cuzco. The Lupaca lived in hill-top habitation sites surrounded by walls, some of which appear to have been occupied only temporarily for refuge. They buried their dead in towers called *chulpas*, a practice continued by the Inka when they conquered the region, although the Inka *chulpas* were more elaborate.

In the south-central highlands a people who produced a pottery style known as Killke slowly began consolidating their hold over the Cuzco area around this time. Traditional models for the emergence of the Inka state suggest that relations among Cuzco's various ethnic groups were hostile. This scenario, however, derives in part from the biases of native informants who regaled the Spanish scribes with tales of heroic Inka leaders who tamed barbarians and vanquished their enemies in key battles. New research on Killke by Brian Bauer suggests instead that the Cuzco valley began to emerge as a regional power center during the Killke period (1000–1400), uniting Cuzco's many ethnic groups. It was these people who set the stage for the enormous empire discussed in the next chapter.

City and Countryside in the Inka Empire

By AD 1500 the Andean city had become a place where ceremony symbolized the nature and existence of the state. In under a century the Inka stamped their distinctive architectural style across the Andes. At state ceremonies in provincial capitals like Huánuco Pampa, singers, dancers and tellers of legends and the exploits of Inka kings dazzled their audience with Inka glory, frightened them with Inka might and impressed them with Inka riches.

TIME: AD 1500

PLACE: Cuzco, southern highlands of Peru

CIVILIZATION: Inka

It had been a long journey from the south, and as the procession neared Cuzco its pace was slow, almost majestic. It was a small party: a young girl with her mother and father (he was the *kuraka* of their village), along with porters and llamas laden with offerings. They followed the royal road into the valley, and the girl could see the fabled city nestled at the far end. As they came closer they saw terraces alongside the road, planted with maize, and storehouses dotting the hillsides. People came out of their houses to greet them as they passed, bowing their heads in respect.

It was only a week since the *chaski* messenger had reached their village with news of the Qhapaq Hucha, the most solemn feast in all the land. This particular Qhapaq Hucha, the messenger had said, was in honor of Wayna Qhapaq, who would don the royal fringe and become emperor, and the *kuraka* was to take his people's *huaca*, their principal idol, to Cuzco, where it would join all the *huacas* of the empire to celebrate the peace and prosperity of the empire and forecast the future of the new king.

Her father was very proud, because on such an occasion even he, a lowly provincial chief, could approach the emperor. Beside the *huaca*, he – and all the *kurakas* of the empire – had to bring offerings of maize, coca leaves, gold, silver, llamas, guinea-pigs and the finest *cumbi* cloth. And they were also required to bring the most precious offering of all: children between the ages of four and ten, without a blemish or a mole. Some of them would be sacrificed to the shrines of Cuzco; others would be dispatched to the provincial sanctuaries, where they, too, would be sacrificed. Because it was considered a great honor, this *kuraka* had decided to offer his daughter.

As the girl and her party reached Cuzco, they saw many delegations like theirs from all the four quarters, the *suyu*, of the realm. *Kurakas* in their distinctive headdresses, llamas and bearers laden with offerings, and children walked through narrow, cobbled streets lined with buildings of finely fitted stone to their lodgings: an immense hall with a thatched roof beside the great plaza at the center of the city.

The next day they joined the others in the main square. In the middle of the plaza Wayna Qhapaq sat resplendent on a low stool of gold; the red imperial fringe hung over his forehead, gold ornaments adorned his ears, and his exquisitely-woven shirt was laced with thin threads of gold that shimmered in the sun. Next to him were the idols from the Qorikancha, the sun temple: the image of Inti, the sun god, which was made of gold and set with many precious stones, and those of the gods of thunder and lightning. Alongside the idols sat the mummies of the dead Inka kings, who never missed a fiesta, dressed in their finery and seated on litters as if alive.

The girl watched as officials encircled the plaza with a great cable of gold and placed all the offerings inside it. Then the ceremony began. Wayna Qhapaq asked each *huaca*, one by one, "What will happen this year? Will there be abundance or

scarcity? Will Wayna Qhapaq have a long life? Or might he perhaps die this year? Will enemies invade the empire? Will the Chachapoyas or the Qollas rebel?" As the Inka questioned each *huaca* he drank *chicha* from a golden tumbler, and the *huacas* responded through their priests, who toasted the Inka. Soon, all the priests were quite drunk, and they stumbled through their answers; nevertheless, they sought to please and impress the Inka with their forecasts, for, if they did not, their shrines would be disgraced and receive no offerings the following year.

The feasting and drinking lasted several days while the shrines of Cuzco received their share of the offerings; the most important sanctuaries were given children, who were sacrificed and buried alongside the shrines. When all the Cuzco shrines had been honored, Wayna Qhapaq called the provincial priests. He divided the remaining offerings and children into four groups, one for each of the four *suyu* of the realm.

The Qhapaq Hucha maiden was to be offered to Ampato, the extinct volcano crowned with snow that was the highest mountain in her land, the provider of rain and fertility. But the processions, each accompanied by a representative of the Inka, could not return to their provinces by the roads they had used to come to Cuzco; they had to follow straight lines that extended to the very ends of their *suyu*.

After many days, the girl's procession reached her village. She was tired after so much hard walking, but the ceremonial went on, as she was fêted and prepared for her journey to the world of the *mallqui*, the ancestors. "You will serve our Inka king and our gods," the priest told her. "You will wear the fine clothes of *cumbi* woven for you in Cuzco, a headdress of feathers made from the *parihuanas*, the flamingos we saw by the great lake we passed, and your shawl will be fastened with a pin of silver. And you will take with you miniature bowls and plates, wooden *keros* and small statues of gold, silver and bronze, and llamas of silver and coral-colored *mullu* shell from the ocean, the mother of all waters. The statues, too, will wear rich clothing like yours, and headdresses of brilliant feathers."

So attired, the maiden began her ascent to the summit of Ampato, with the llamas, bearers, priests and the Inka official following. As they labored up the steep, ice-covered slope, nearby Sabancaya belched plumes of menacing ash and vapor, and the air was thick with the stench of sulphur. At night they slept in tents set up by the bearers, who covered the ground beneath them with thick clumps of *ichu* grass for insulation against the piercing cold. They climbed higher and higher – higher than she had ever been – until the girl could see the distant ocean and the surrounding snow-covered peaks.

Near the summit of Ampato she was given *chicha* to drink from a goblet of gold, and the priest solemnized the sacrifice with songs. Exhausted, gasping for breath in the thin air, she fell into a drunken stupor and was lowered into her stone-lined tomb. But she would not die; she would join the *mallqui* and become an oracle. She would watch over her people and Wayna Qhapaq's empire from her lofty tomb near the edge of the realm.

At the time of the Spanish invasion in the sixteenth century the Inka ruled the largest empire in the New World. They had begun to expand beyond Cuzco, their capital, sometime around the mid-fifteenth century. Then, according to their legends recorded by the Spaniards, they vanquished a rival people in a key battle that transformed them into a people with an imperial destiny. In less than a century they had assumed control of an empire that stretched for over 4,000 kilometers (2,500 miles) from end to end, embracing much of modern Peru, Ecuador and Bolivia and extending into northern Chile and north-western Argentina. It was an empire of striking ethnic diversity, rich with a great variety of natural resources.

107 The Inka settlement and agricultural terraces of Pisac are visible in the foreground. Inka retaining walls still confine the Urubamba river, below, to its banks.

Centuries before, earlier Andean peoples had developed the sophisticated mechanisms to manage and redistribute this wealth effectively. Yet, even if much of the Inka achievement was based on pre-existing technologies and institutions, the sheer scale of the enterprise made it unique, not just in the Andes but in the Americas. In urban organization and city-building – as in agriculture, metallurgy, weaving, road-building and even administration – the Inka excelled mainly because they took what already existed and incorporated it into a vast new vision of political and economic expansion.

No single Inka city covered as large an area as Chan Chan, Wari or Tiwanaku. Even Cuzco's ceremonial core was no larger than Pikillacta, the nearby Wari provincial center discussed in Chapter 6. Instead, co-ordinated networks of cities and other settlements and installations throughout the hinterland became the Inka urban trademark. The Inka literally defined their empire by building centers, way-stations and roads on the lands of others. Pachakuti, Thupa Yupanki, Wayna Qhapaq – the great kings who ruled before Atawalpa – usually won the right to build their roads and cities by means of negotiation, often involving threats veiled in rich gifts. If threats and friendship failed, however, the Inka maintained a well-organized supply system and could raise large armies.

Inka cities, especially those beyond Cuzco, can best be understood as satellites: instruments vital to Inka strategies of expansion. They did not all follow the same model, though. Like most Andean settlements, large and small, the Inka divided them into *hanan* (upper) and *hurin* (lower), and the majority of Inka cities, especially those along the main coastal and highland roads, boasted one or more plazas, *ushnu* (the great platforms for viewing public performances), temples to the sun, and *aqllawasi* (compounds for the resident women weavers and *chicha*-brewers). They also tended to have dozens of *qollqa*, or storehouses, and *kallanka*, the large halls used as temporary housing or for feasting in inclement weather.

We have discussed the striking diversity of the land that became Tawantinsuyu. Not only was this land remarkable for its geographical contrasts, but its people differed too – in language, customs and, most important, the degree to which they were accustomed to accepting the directives of a centralized government. Like previous Andean empires, that of the Inka combined its newly subjected peoples into an economically coherent whole. However, this coherence was based not on uniformity but on co-ordinated diversity. The Inka encouraged diversity, maintaining, for instance, local textile patterns, costumes and head-dresses as ethnic badges:

> *If they were Yungas, they went muffled like gypsies; if Collas, they wore*
> *caps shaped like mortars, of wool; if Canas, they wore larger caps ...*
> *The Cañari wore a kind of narrow wooden crown like the rim of a*

sieve; the Huancas, strands that fell below their chin, and their hair braided; the Canchis, broad black or red bands over their forehead.[19]

Moreover, although the Inka spread Quechua as the language of prestige and administration, they made no systematic attempt to displace local languages. The Inka legacy, nevertheless, is evident in the millions of people who still speak Quechua today, largely in Peru. Aymara, the other surviving Andean language, is mainly spoken in Bolivia.

The Inka name for their empire, "Tawantinsuyu," hints at both its vulnerability and its conceptual subtlety. Tawantinsuyu, which means "four parts," was made up of a loose confederation of ethnic groups linked to Cuzco by varying degrees of loyalty through conquests, alliances and kinship ties, both imagined and real. Like cultures that had managed to integrate far-flung territories and peoples in earlier times, the Inka spread across the Andes on more than just military skill. They were adept at negotiation and made use of age-old Andean social institutions that fostered reciprocity, carefully balancing rights and obligations. Foremost among the obligations of new citizens was to provide labor, on which the empire's wealth and productivity depended. The Inka based their institution of state labor on the traditional Andean view of communal work. The primary labor institution, known as *mit'a*, provided rotational labor for cyclical enterprises at predetermined times. The vast labor pool of the conquered included farmers to till the state fields, soldiers to fight the empire's battles and quarrymen and masons to build and maintain cities, roads, bridges, temples, irrigation canals, and agricultural terraces.

Another critical resource was colonists, or *mitmaqkuna*: people relocated into newly conquered or hostile areas to provide a labor force and consolidate the Inka hold. In addition, state officials enforced Inka policies and spread the solar cult of the Inka religion, bureaucrats kept track of the human and natural wealth on *quipu*, and artisans produced precious goods, such as the fine textiles that Inka officials used as gifts to cement alliances with conquered peoples. Effective control of this vast and ever-growing labor force lay at the heart of the Inka administrative genius.

A structured land

Inka cities arose in response to the diversity of landscapes and cultures. In areas of constant conflict and socio-political fragmentation (which characterized much of the highlands on the eve of Inka expansion), some cities were established to lay the groundwork for a structure of rule. At Huánuco Pampa, discussed below, the Inka created a setting for pageant and spectacle designed to win the hearts, minds and stomachs of peoples

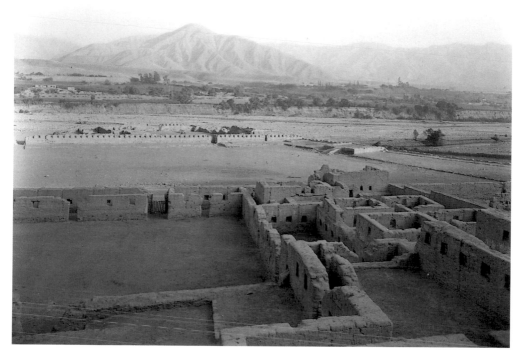

108 Tambo Colorado in the Pisco valley is one of the best preserved Inka coastal installations. This view, looking south, includes part of the compound, whose adobe walls still have traces of red and yellow ochre and white paint. The low platform with a ramp on the right is an *ushnu*.

not yet accustomed to the yoke of rule, but whose labor and loyalty were crucial to achieving Cuzco's aims.

In other cases, the Inka adapted existing, pre-Inka cities to their own purpose. At both La Centinela–Tambo de Mora and Pachacamac they constructed monumental buildings in the highly visible and distinctive Inka style, with striking new architectural emblems, such as the trademark trapezoidal windows, niches and doorways. As symbols of the "architecture of power,"[20] the buildings represented the state, its rulers and its activities.

The Inka are particularly famous for dressed-stone constructions, but they reserved this masonry style for the most important buildings in and around Cuzco and the nearby Urubamba valley – the Inka heartland – and for selected buildings and shrines in provincial capitals. They did most of their building with fieldstones set in mud mortar – though on the coast they used adobe, and stone only rarely. Nevertheless, in the course of a century, the Inka had stamped their distinctive building style across the Andes to

such an extent that "one should think that a single architect has built this large number of monuments."[21]

Following the tradition of ecological complementarity discussed in Chapter 1, the Inka often established settlements on virgin land within the territory of other societies. In other cases they annexed alien groups for their special talents or resources. For instance, when they conquered the Chimú capital of Chan Chan in the 1470s, they plundered its royal tombs and, along with the booty, carried off the Chimú metal-workers. Thereafter these smiths worked in Cuzco, producing works in the style of their new masters on an unprecedented scale that turned Cuzco into a dazzling showcase of Inka might. The coastal kingdom of Chincha, too, was needed for economic purposes; its merchants, with their fleets of rafts and experience of long-distance trade in valuable goods, could satisfy the hunger of the gods for shells from foreign shores and that of the people for objects of prestige. The Inka also needed Pachacamac and its oracle, perhaps because they valued its advice, but certainly because many of the people essential to their aims believed in its predictions.

Despite their differences, all Inka cities shared an emphasis on ceremony. We can trace much of their urban character to the cities of Tiwanaku and Wari times in particular. Inka stone-working technology does not seem to have been derived from Tiwanaku, as various chroniclers claimed, but great open plazas designed for ceremonies involving a massive public do recall that city and its mastery of glittering spectacle. Moreover, some Inka origin myths indicate a spiritual connection with Lake Titicaca and its principal city. At the same time, the Inka tempered the ceremonial extravagances of their cities' great plazas with the restricted, limited and more private spaces so characteristic of Wari and Chimú cities, where ceremony took place within a framework of careful administration.

Inka officials controlled access to, and movement through, the great public monuments of their settlements, while the cities' layout dictated where people should go and controlled with whom they could interact. Even Cuzco's architects and planners designed not just a city for pageantry but one suited to regulating both its permanent residents and its many official visitors according to the political scheme of the empire. It was not a city of markets, where the populace could choose to come and go as it pleased or as economic needs dictated. The Inka structured the landscape and erected buildings that reflected political and religious ideology and objectives.

109 Figurine, a few inches high, in a miniature woven textile fastened with a silver *tupu* (pin) and an elaborate feather head-dress. Such figurines accompanied the child sacrifices that were part of the Qhapaq Hucha: the empire-wide sacrificial cycle. This one was found on the summit of Cerro El Plomo in Chile.

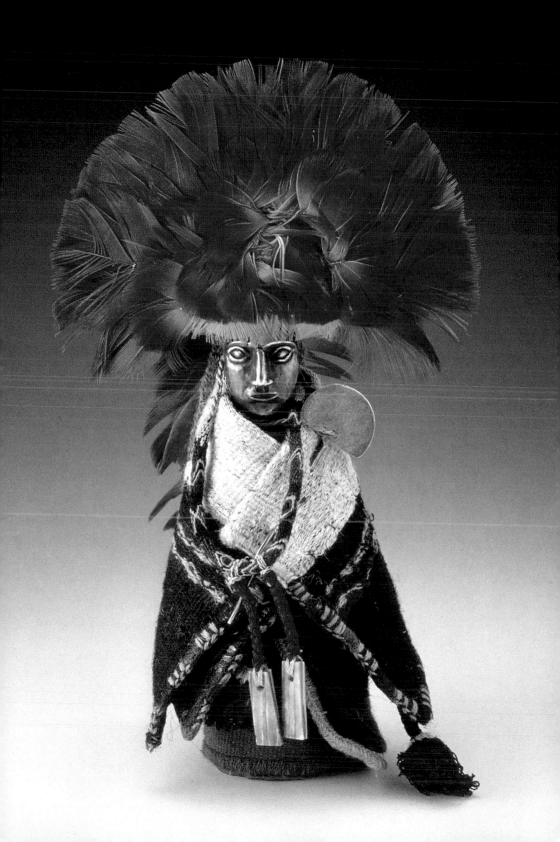

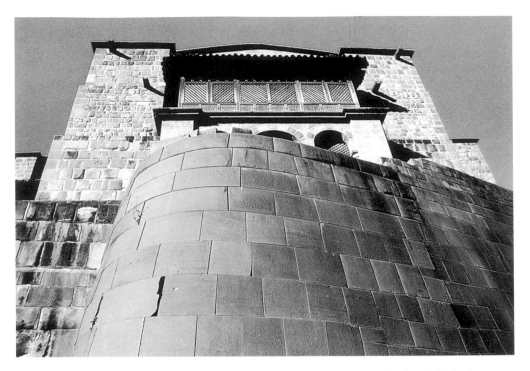

110 The Qorikancha, or sun temple, at Cuzco. The curving wall of andesite in the foreground is part of the original structure. The church of Santo Domingo, above it, was built soon after the Spaniards occupied the city in the sixteenth century.

Cuzco: center of the realm

Cuzco is the most famous of all Inka cities. Its rulers designed it as the ceremonial, political and administrative center, as well as the architectural showcase of a rapidly expanding empire: a city to dazzle and impress visitors with the virtuosity of its stonework, the pomp of its ceremonies and the holiness and wealth of its shrines.

Pedro Sancho, Francisco Pizarro's secretary and one of the first Spaniards to see Cuzco, remarked on the city's size and beauty, noting it "would be worthy to appear even in Spain."[22] Cieza, who saw it partly in ruins after the Inka had rebelled and besieged the Spanish invaders there in 1536, wrote, "Nowhere in this kingdom of Peru is there a city with the air of nobility that Cuzco possessed ... Compared with it, the other provinces of the Indies are mere settlements."[23] Nonetheless, such was the fame of Cuzco's wealth that even the usually level-headed Cieza could only babble, "it amazed me that the whole city of Cuzco and its temples were not of solid gold."[24]

It is difficult to assess Cuzco's population in Inka times; little archaeological research has been done, much of the city was destroyed and remodeled in colonial times, Spanish descriptions are unreliable and/or

exaggerated, and many of its residents probably lived in houses made of perishable adobe. Subject to these caveats, population estimates for greater Cuzco range from a low of 40,000 to a high of 100,000. Eyewitnesses reported seeing many houses on the hillsides surrounding the city, and others described it as "very large and very populous."[25] Even so, the city's population would have waxed and waned with the movements of pilgrims attending its many religious feasts or the workers engaged in Cuzco's monumental building projects.

Who lived in Cuzco? At the apex of its social structure sat the Sapa Inka. (The term "Inka," used today for the empire, its rulers, its subjects and associated art style alike, originally applied only to the nobles. The reigning monarch was known as the Sapa Inka, or "unique king." Inka noblemen wore distinctive ear-ornaments that stretched their earlobes, which is why the Spaniards referred to them as *orejones*, or "big ears.") The Sapa Inka's subjects believed that he was a direct descendant of the sun god, and sometimes they even called him the "son of the sun."

The rulers, along with their large entourages of wives, children and retainers lived in lavish palaces in Cuzco and maintained residences, or royal estates, in the vicinity of the city and in the nearby Urubamba valley. The nobility also comprised the descendants of dead kings, grouped into corporations called *panakas* that included all of the dead king's descendants except his successor. Other nobles, known as Inka-by-privilege, were assembled into non-royal corporations whose members were accorded the hereditary status of provincial nobility.

Provincial lords also resided at the capital, for the Inka required them to set up lodgings in the city and live there for part of the year. Their sons were exiled to Cuzco and educated in Quechua, the lingua franca of prestige and administration. In addition, the Inka took the idols of newly conquered peoples to Cuzco, where they were regarded as honored hostages. If a region rebelled, the Inka ordered its idols displayed in public and "whipped ignominiously every day until such province was made to serve the Incas again."[26]

Cuzco's layout and population mirrored the ethnic makeup of the empire. Some twelve districts of "foreign tribesmen,"[27] many of them laborers and artisans, lived in districts surrounding the ceremonial core. "This city," noted Cieza, "was full of strange and foreign peoples, for there were Indians from Chile, Pasto and Cañari, Chachapoyas, Huancas, Colla, and all the other tribes to be found in the provinces ... each of them established in the place and district set aside for them by the governors of the city."[28]

Despite Cuzco's importance, however, relatively few archaeological excavations have been carried out in the city itself. Much of what we know about Inka Cuzco comes from the often contradictory descriptions of the

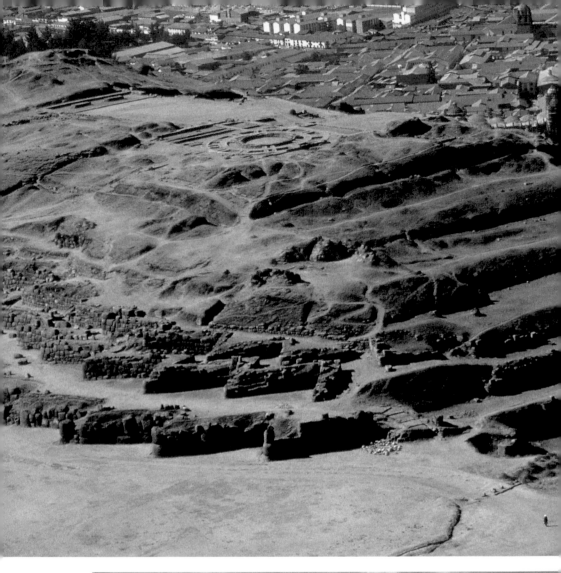

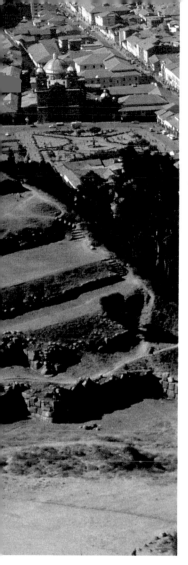

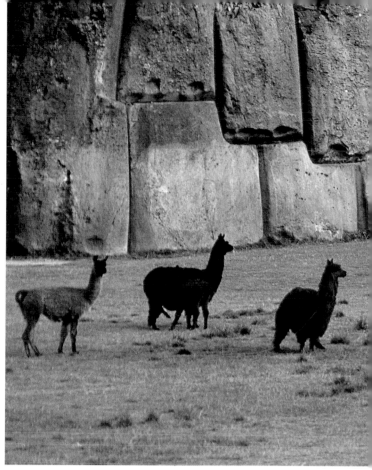

111–13 **Sacsawaman** (*top left*) is poised above Cuzco. Its massive limestone blocks (*above*) are bonded without mortar. Often called a fortress because of its rampart-like walls, its role may have been religious, with an esplanade (*below*) for ritual battles.

173

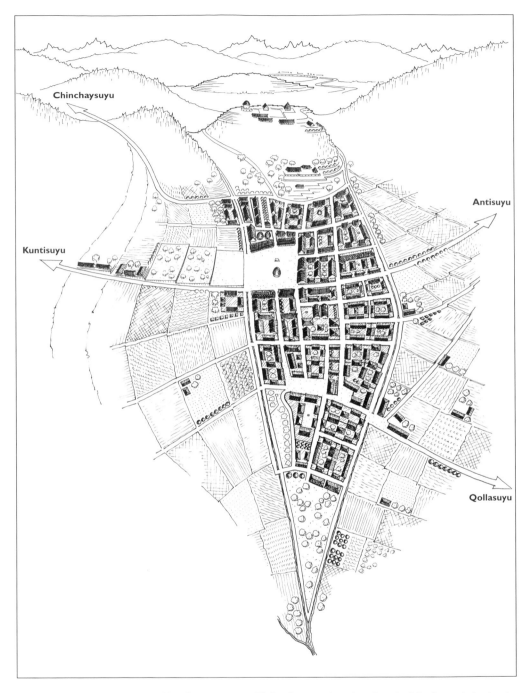

114 Hypothetical bird's-eye view of Inka Cuzco, showing the city blocks and the basic *kancha* plan (see ill. 121) of the houses within them. The dual plazas of the Aucaypata and the Cusipata are in the center, and Sacsawaman sits on the hill above the city. Arrows show the main roads connecting Cuzco to the four quarters of the Inka realm.

chroniclers, none of whom, curiously, has left us with a plan of the city as they first saw it. This, coupled with Spanish remodeling, has stimulated considerable debate about Cuzco's original layout and the identification and functions of certain buildings.

According to one chronicler, Pachakuti, often called the architect of imperial Cuzco, "named the whole city 'lion's body,' saying that the residents of it were limbs of that lion."[29] On the basis of this, some researchers have suggested that the city's founders laid out the ceremonial core of their capital in the form of a puma (Spaniards often used "lion" to refer to the puma), with Sacsawaman, the temple-fortress perched above the city, as its head, and the sector where the city's two rechanneled rivers came together forming the tail (an area still called *puma chupan*, "puma's tail"). Others, however, suggest that the puma shape should be read metaphorically rather than literally. The same account also noted that Pachakuti used models to design his city, ordering "clay figures made just as he planned to have it built."[30] Stone, rather than clay, models of structures do in fact exist, but their function is not clear, and they have not been identified with any particular buildings in the city.

Whoever designed Cuzco, careful planning is evident. The scheme embraced not only the city core but also scattered hamlets and agricultural estates set among cultivated fields, storehouses, terraces and irrigation canals extending many kilometers beyond Cuzco. Moreover, patterns reflecting dual and also quadripartite divisions of society and space can be detected. The city's ceremonial core consisted of upper (*hanan*) and lower (*hurin*) divisions, and like the empire itself, the Inka divided Cuzco into four *suyu*, or quarters. *Hanan* Cuzco included Chinchaysuyu and Antisuyu, while Kuntisuyu and Qollasuyu lay in *hurin* Cuzco.

These divisions were further intersected by a complex network of forty-one or forty-two conceptual lines or sight-lines, called *ceques*, which radiated from the Qorikancha, the city's sun temple.

> *From the temple of the Sun as from the center there went out certain lines which the Indians call* ceques; *they formed four parts corresponding to the four royal roads which went out from Cuzco. On each one of those* ceques *were arranged in order the guacas* [huacas] *and shrines which there were in Cuzco and its district, like stations of holy places, the veneration of which was common to all.*[31]

The orientations of the *ceques* were determined by some 328 *huacas*: shrines, natural features of the landscape (such as outcrops, springs, caves or mountain passes) or artificial features (such as houses, fountains or canals). The Inka associated some of the shrines with events in their mythology, while others marked boundaries among Cuzco's social groups, and

115–17 **Ollantaytambo** The rock-falls of Kachiqata (*above*) were the source of much of the stone used to build Ollantaytambo. An abandoned block (*below left*) still bears the marks made by ancient masons. The beautifully fitted Inka masonry at Ollantaytambo often includes stones with knobs (*below right*) whose function is not certain.

still others pinpointed locations such as mountain passes or summits. Water sources or the origins of principal irrigation canals made up about a third of the *huacas*. The *ceque* system thus not only organized political and ritual space, it also appears to have been linked to Cuzco's economic base: its water and productive farmland.

The ceremonial core of the central sector was formed by a large plaza open to the south-west. The modern Plaza de Armas (ancient Aucaypata), the neighboring Plaza Regocijo (ancient Cusipata) and perhaps the Plaza San Francisco are all that remain today of this space. Smaller plazas also graced the ceremonial core, but in antiquity the Aucaypata, along with the adjoining Cusipata, formed an enormous dual plaza divided by the Saphy, one of the city's two rivers. The river was "covered with broad beams, and great flags ... laid over them to make a floor."[32]

The Aucaypata served as the setting for the ceremonies that punctuated the Inka ritual calendar. As Cieza wrote, "in neither Jerusalem, Rome, nor Persia, nor anywhere else in the world, did any republic or king ever bring together in one place such wealth of gold and silver and precious stones as in this plaza of Cuzco when these feasts ... were celebrated."[33] The plaza also functioned as a hub for the four principal roads that led to the empire's territorial divisions, or *suyu*. More than twenty other roads linked Cuzco to its hinterland, but the four main ones overshadowed the others in importance because they connected the four *suyu* to the capital.

Around the plaza lay the finely built palace-compounds, or "splendid buildings" of the ruling monarch and the lineages of deceased rulers, as well as public buildings, temples and shrines "all made of stone, so skillfully joined that it was evident how old the edifices were, for the huge stones were very well set."[34] Sancho, one of the few early eyewitnesses to record his impressions, noted that,

> *most of the buildings are built of stone and the rest have half their façade of stone. There are also many adobe houses, very efficiently made, which are arranged along straight streets on a cruciform plan. The streets are all paved, and a stone-lined water channel runs down the middle of each street. Their only fault is to be narrow; only one mounted man can ride on either side of the channel.*[35]

Compounds surrounding the Aucaypata included the Hatunkancha, many of whose walls are still visible, and the *aqllawasi* that housed the "chosen women" who served the emperor and the religion, brewing *chicha* and producing fine cloth. (Appropriately, the convent of Santa Catalina apparently covers the remains of the *aqllawasi*.) The Qasana compound on the north-west side of the plaza may have served as Wayna Qhapaq's palace (it is not clear from the Spanish accounts whether these compounds served

as the palaces of the reigning monarch or of the lineages of deceased rulers).

The parts of the compounds that faced the plaza often contained *kallanka*, the great halls designed to house visitors or stage official and religious functions in rainy weather; one was so large "that sixty mounted men could easily joust with canes in it."[36] Among the shrines surrounding the plaza was one on the south-east side dedicated to Wirakocha, the creator deity, today the site of Cuzco's cathedral.

From the main square, one of the narrow roads described above by Sancho led to the Qorikancha (the "golden enclosure," Cuzco's sun temple and holiest shrine), which lay near the confluence of the city's two rivers. Soon after they occupied Cuzco, the Spaniards founded the monastery of Santo Domingo on this site, destroying many of the original building's walls. The wealth of Cuzco's temples, especially the Qorikancha, was the source of part of the ransom that the Inka emperor Atawalpa assembled to try to secure his freedom after Francisco Pizarro's men had captured him at Cajamarca in the northern highlands in November 1532.

Noting the Spaniards' lust for precious metals – baffling to him, because the Inka regarded these as inferior to cloth as symbols of wealth and power – Atawalpa ordered large quantities of gold and silver objects to be brought to Cajamarca. At today's values this ransom is estimated to have consisted of gold worth $30–50 million and silver worth another $1.5–2 million. Atawalpa's effort was in vain, however. It only exacerbated Spanish gold fever, and his captors killed him in July 1533, shortly after the ransom had been delivered.

By the time Cieza reached Cuzco in the 1540s the Qorikancha had been stripped of its treasures, but those who had seen the temple before its ransacking told him that it "was one of the richest temples in the whole world." All the loot plundered from it went into the Spanish melting pot, but eyewitnesses described an "image of the sun, of great size, made of gold, beautifully wrought and set with many precious stones." Below the temple "was a garden in which the earth was lumps of fine gold, and it was cunningly planted with stalks of corn that were made of gold ... there were many tubs of gold and silver and emeralds, and goblets, pots, and every kind of vessel all of fine gold."[37] The temple's finest surviving construction is a curved wall built of blocks of shimmering dark grey andesite. "In all Spain I have seen nothing that can compare with these walls and the laying of these stones."[38]

One of Cuzco's most imposing monuments is the temple-fortress of Sacsawaman, poised on a hill overlooking the city. Cyclopean limestone blocks, many weighing almost a hundred tons and fitted together without mortar, form the foundations of three zigzagging, rampart-like walls, above

which lie the foundations of two towers, one rectangular and one round. "These walls are the most beautiful thing that can be seen of all the constructions ... because they are of such big stones that no one who sees them would say that they have been placed there by the hand of man," marveled Sancho.[39]

To the Spaniards the walls resembled those of a fortress, which is what Sacsawaman is often called by modern writers. Cieza, however, called it a "house of the sun,"[40] which suggests that it had a religious role; as with so many imperial Inka structures, it is hard to separate the sacred from the secular.

If Sacsawaman had a military purpose, it was probably symbolic, and the wide esplanade that lies between its ramparts and a large, carved stone outcrop opposite may have served as a setting for ritual battles like the ones that the chroniclers say took place in the city square below. Sacsawaman also functioned as a huge depository for stockpiled goods, "arms, clubs, lances, bows, arrows, axes, shields, heavy jackets of quilted cotton, and other weapons of different types. And there was clothing for soldiers ... there was cloth and much tin and lead with other metals, and much silver and some gold."[41]

Some chroniclers noted that the building of Sacsawaman was such an undertaking that it took fifty years, or that it was still under construction on the eve of the Spanish invasion. Cieza wrote that four thousand laborers "quarried and cut the stones, six thousand dug the ditch and laid the foundations, while still others cut poles and beams for the timbers."[42] The great boulders that form the zigzag ramparts came from the limestone outcrops that dot the hills around the site.

Other stones, such as the smaller andesite blocks that the Spaniards removed from Sacsawaman to build their churches and mansions in the city below, came from Rumiqolqa, a quarry 35 kilometers (22 miles) southeast of Cuzco. Still worked today, Rumiqolqa is littered with Inka stones in varying stages of production. From Rumiqolqa, quarrymen shipped finished stones to construction sites in Cuzco, where they are found in the finely fitted walls of the *aqllawasi* on Loreto street and at the Qorikancha.

The Urubamba valley

In the Urubamba valley north of Cuzco the Inka built some of their most striking towns and embarked on elaborate land-reclamation and land-management projects, traces of which still sculpt the valley. In some parts, remains of retaining walls confine the meandering Urubamba river to its banks; in others, finely built agricultural terraces sustain the crops of modern farmers. The fertile valley, whose river flows into the Ucayali, a major

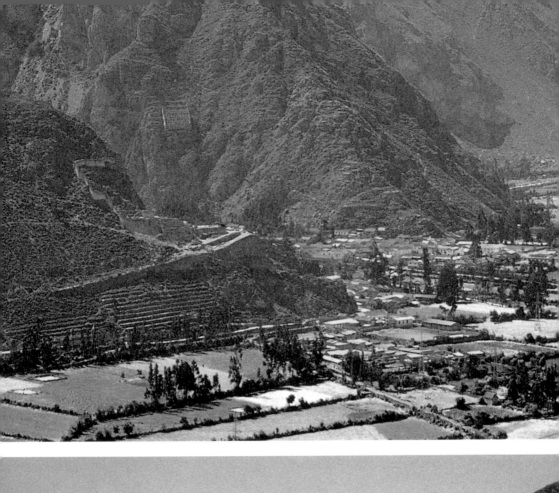

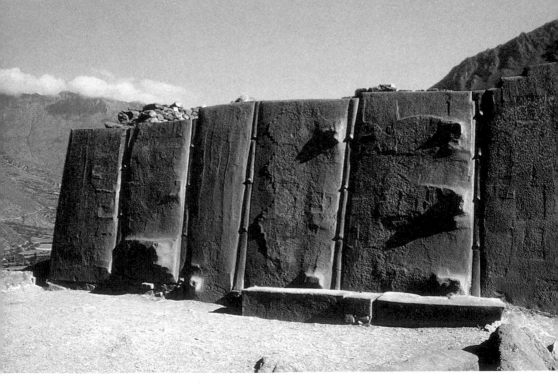

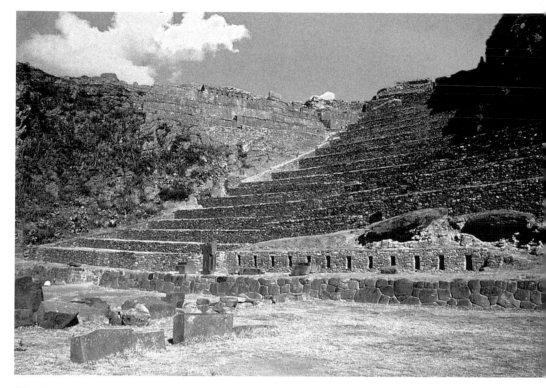

Ollantaytambo
118 (*top left*) The temple hill, from the opposite bank of the river. The ramp at the left,
350 m (1,150 ft) long, was used to drag stone up to the building site. The Spanish
invasion apparently cut short an ambitious remodeling plan: abandoned stones lie
scattered along the ramps, at the rock-falls and in maize fields on either side of the
river.
119 (*above*) Terraces below the temple hill, approached by a long flight of steps.
120 (*bottom left*) The Wall of the Six Monoliths – probably the foundations of an Inka
sun temple – built of rose-colored rhyolite from the quarries of Kachiqata across the
Urubamba (visible below the clouds on the left).

tributary of the Amazon, served as Cuzco's breadbasket. The Urubamba
valley's temperate climate is well suited to growing maize, used for making
chicha, the beer consumed in vast quantities on ceremonial occasions, and
the Inka settled the area with experienced maize-growers from other parts
of the realm. The chroniclers also tell us that the Inka kings founded their
royal estates there. "This valley excels all others in Peru," wrote the mestizo
chronicler Inca Garcilaso de la Vega, "so that all the Inka kings ... made it
their garden and haunt of pleasure and recreation."[45]

One such haunt may have been Ollantaytambo, one of several estates in
the valley managed by Pachakuti's *panaka*. The Patakancha river, a trib-

121 Reconstruction of an Inka-style *kancha*. At Ollantaytambo each city block contained two *kanchas*, each of four buildings surrounding a central courtyard. The house in the center had a common wall but the *kanchas* were not connected. A double-jambed doorway (see ill. 144) led into each compound.

utary of the Urubamba, divides Ollantaytambo into two sectors: a residential area to the east and the ceremonial temple hill to the west.

The residential sector is the only Inka settlement whose dwellings are still occupied today. The town's original grid is trapezoidal and includes four long streets crossed by seven shorter ones. Each of the resulting blocks contains two *kanchas*, or walled compounds, composed of four buildings surrounding a central courtyard. Impressive double-jambed doorways led into the compounds. Such doorways, reserved for only the most elaborate Inka structures, suggest that Ollantaytambo's Inka residents were members of the nobility.

On the temple hill is a religious precinct surrounded by a wall. A steep stairway, flanked by finely built terraces, leads to the precinct. The area around the so-called Wall of the Six Monoliths (probably the foundations of a sun temple), is strewn with massive blocks of andesite and rhyolite that range from partially worked to finished stones removed from earlier constructions – the Spanish invasion apparently cut short an ambitious remod-

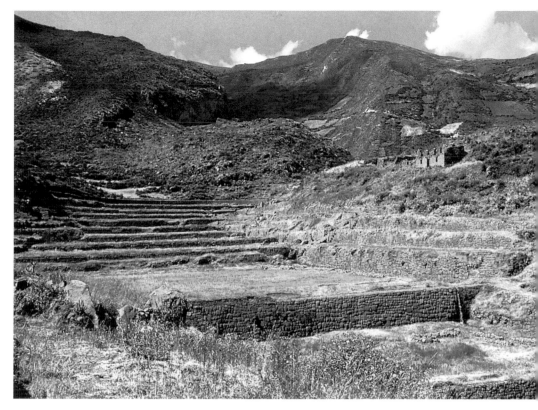

122 The Inka settlement of Tipón, just south of Cuzco, with elaborate terracing in the foreground and remains of a two-storey house at the right. Inka planning in the Cuzco valley embraced not only the city core but also scattered hamlets and agricultural estates, such as Tipón, set among fields, storehouses, terraces and irrigation canals.

eling plan. Behind the temple lies the staging area for a ramp, 350 meters (1150 feet) long, used to drag stones up to the construction site from the valley. The stones come from the rock-falls of Kachiqata.

Near the lower end of the Urubamba valley lies its most famous site, Machu Picchu. A daring road linked Machu Picchu to a series of settlements strung along the forested slopes of the high jungle. In this spectacular setting, amid distant views of the sanctified, snow-clad peaks of the Urubamba and Vilcabamba ranges, Machu Picchu's buildings and terraces spill over a ridge hundreds of meters above the rushing Urubamba river. Its architects harmonized architecture and sacred geography, framing views of nearby mountains in doorways and windows and even carving some stones to echo the mountains' shapes.

When the American explorer Hiram Bingham stumbled upon Machu Picchu in 1911, its remote setting led him to believe that he had found the lost, and last, Inka capital. Since Bingham's landmark discovery, however, exploration in the region has shown that the Inka founded their last capital

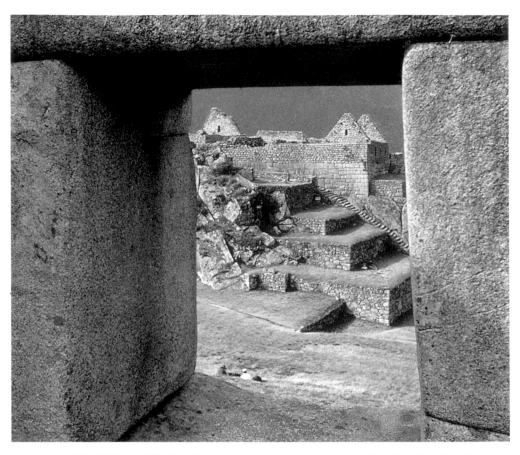

123–5 **Machu Picchu** View through one of the windows of the Temple of the Three Windows (*above*) and an aerial view (*below*) of Machu Picchu's central sector. Huayna Picchu (*opposite*), reached by a steep flight of steps and crowned by terraces, rises behind Machu Picchu.

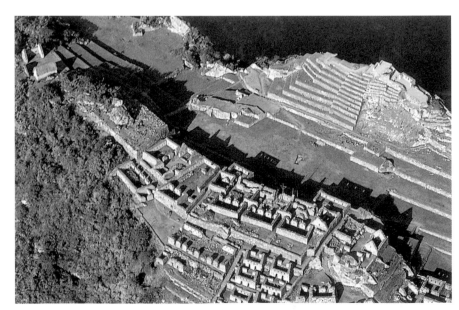

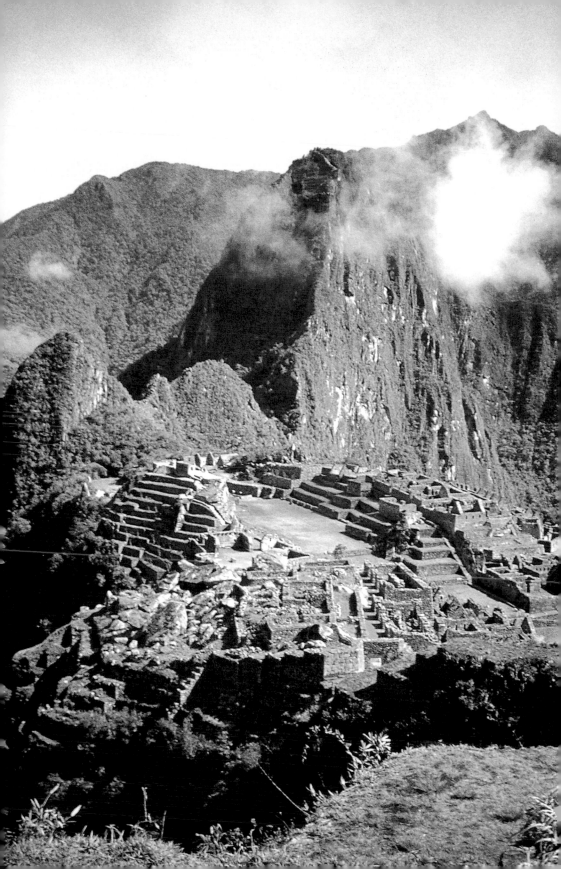

at Vilcabamba, a considerable distance down-river on a tributary of the Urubamba. We shall never be certain of Machu Picchu's function, but we know that the Inka often built monuments to commemorate their conquests, and both Machu Picchu and the smaller, neighboring sites connected to it by a narrow, paved road (the Inka "trail," walked by thousands of hikers every year) may have been built to honor the emperor Pachakuti's dominion over the region. In fact, sixteenth-century colonial land-tenure documents suggest that Machu Picchu may have served as a royal estate managed by Pachakuti's lineage.

Residential remains at Machu Picchu indicate that it could have housed some one thousand people. Yet the overall quality of its stonework, exemplified by finely wrought religious structures and a chain of sixteen spring-fed fountains, shows that it was more than a simple Inka outpost on the fringes of the empire's eastern provinces. The site's inaccessible location above the river, its surrounding walls, single entry and dry moat probably served to restrict access to what was a highly religious site, not to deter would-be invaders. In fact, the reason why the Spaniards never reached Machu Picchu was because it and its sister sites had been abandoned shortly before or after the Spanish invasion. Engaged in routing out a rebel Inka force ensconced at Vilcabamba, the Viceroy's men followed a route that led north-east of Ollantaytambo through the Amaybamba valley, bypassing Machu Picchu.

The Inka road system

Some of the most remarkable stretches of Inka road ever constructed connected Machu Picchu to Cuzco. But this was only a small part of the more than 25,000-kilometer (15,500-mile) network that formed the nervous system of the empire. The roads and the state installations built along them were probably conceived as a whole, and together display Inka state planning on a grand scale. The keys to the system were two roads: the *Qhapaq Ñan*, the main highland road that extended along the spine of the Andes between Cuzco and Quito and south into Chile and Argentina; and a parallel road that ran along the coast. Dozens of lateral roads connected these two. The sophistication of this communication network, rivaled in the ancient world only by that of Rome, was noted by the Spaniards, many of whom traveled along Inka roads. Cieza marveled at their audacity, describing how the roads he encountered ran:

126 The Inka road system. Parallel roads along the spine of the Andes and along the coast were the keys to the network. Dozens of lateral roads connected these two.

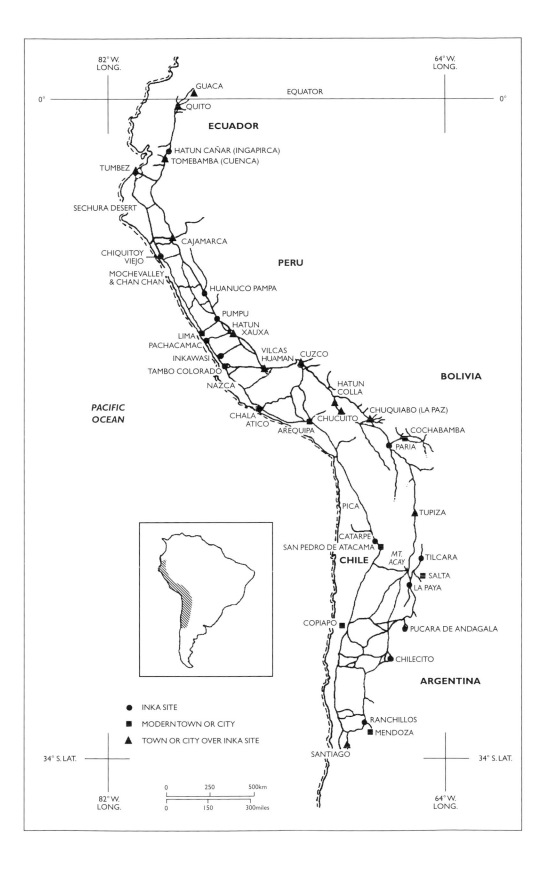

82° W.
LONG.

64° W.
LONG.

0° EQUATOR 0°

▲ GUACA

▲ QUITO

ECUADOR

● HATUN CAÑAR (INGAPIRCA)
▲ TOMEBAMBA (CUENCA)

TUMBEZ ▲

SECHURA DESERT

PERU

▲ CAJAMARCA

CHIQUITOY
VIEJO ●
MOCHE VALLEY
& CHAN CHAN ●

● HUANUCO PAMPA

PUMPU ●
▲ HATUN
XAUXA

LIMA ●
PACHACAMAC ●
INKAWASI ● VILCAS CUZCO
TAMBO COLORADO ● HUAMAN ▲ ●

BOLIVIA

NAZCA ●

HATUN
COLLA ▲

**PACIFIC
OCEAN**

CHALA ● ▲ CHUQUIABO (LA PAZ)
ATICO ● CHUCUITO ●
AREQUIPA ● COCHABAMBA ●
 PARIA ●

PICA ●

▲ TUPIZA

CATARPE ●
SAN PEDRO DE ATACAMA ■
 CHILE MT.
 ACAY ■ TILCARA

 ■ SALTA
 ● LA PAYA

COPIAPO ■ ● PUCARA DE ANDAGALA

 ● CHILECITO

 ARGENTINA

● INKA SITE

■ MODERN TOWN OR CITY

▲ TOWN OR CITY OVER INKA SITE

 ● RANCHILLOS
 ■ MENDOZA

34° S. LAT. 34° S. LAT.

SANTIAGO ●

82° W.
LONG.

0 250 500km
|————|————|————|
0 150 300miles

64° W.
LONG.

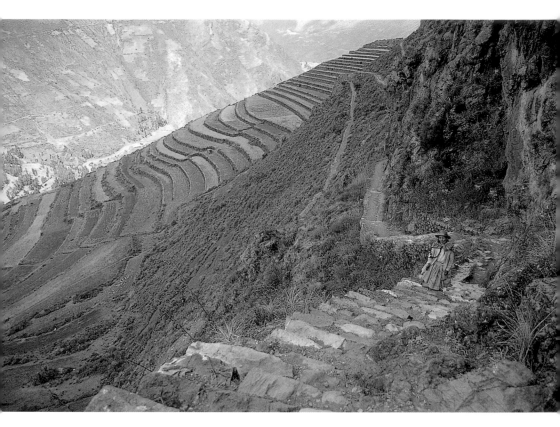

127 A narrow, paved road clings to the side of the mountain at Pisac in the Urubamba valley. Such building techniques characterize many Inka roads in the Cuzco region.

through deep valleys and over mountains, through piles of snow, quagmires, living rock, along turbulent rivers; in some places ... smooth and paved, carefully laid out; in others over sierras, cut through the rock, with walls skirting the rivers, and steps and rests through the snow; everywhere ... clean swept and kept free of rubbish, with lodgings, storehouses, temples to the sun, and posts along the way.[44]

These roads did more than facilitate travel. They moved goods, people and information and served as physical and conceptual links between the hinterland and Cuzco. Sometimes they appear almost over-engineered – even in remote regions Inka engineers paved and embellished some stretches with stairs, drains and culverts – and in this sense the road system was probably as much symbolic as it was practical. The road network served as a visible reminder to subject peoples of Inka might and sovereignty.

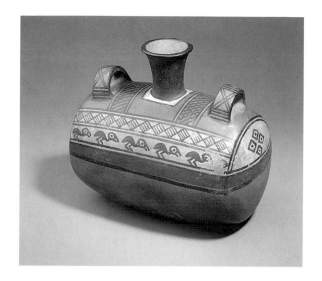

128 A barrel-shaped ceramic vessel in the Chincha style, with Inka-period designs. The Inka often imposed their pottery styles on conquered peoples.

Travel along the roads was apparently restricted to those engaged in state business: the Inka emperor, accompanied by his court, inspecting his far-flung domains; armies engaged in wars of conquest or in quashing the frequent rebellions that plagued Tawantinsuyu; great caravans of llamas carrying produce and goods to stockpile the storehouses scattered throughout the realm; bureaucrats on state missions; or *chaski*, the fleet-footed runners who carried messages from one end of the realm to the other. The chroniclers tell us that these *chaski*, running in relay, could cover 250 kilometers (155 miles) a day. They could deliver messages from Quito to Cuzco in a week, less time than it takes a letter to travel between these two cities today, and rush fresh fish from the coast to the emperor's table in Cuzco in two days. As Cieza remarked, "neither swift horses nor mules could carry the news with more speed than these messengers on foot." [45]

Provincial capitals

What strategies did the Inka use to conquer and administer such a vast realm? When possible, they sent emissaries to try and negotiate peaceful submission, a tactic that often succeeded, especially with societies that did not have the resources to resist. Among the incentives to join the expanding empire rather than fight it was the policy of ruling through the existing local leadership, instead of imposing Inka appointees on their new subjects.

If the Inka viewed a region as critical, but its people were recalcitrant, this could lead to conflict. On the other hand, if a wealthy and important region decided to collaborate, the Inka adopted a policy of closely integrated

Huánuco Pampa
129 View of the site from the storehouse hill. A plaza more than half a kilometer long dominates the plan of this Inka provincial capital in the north-central highlands.

alliance, as occurred in Chincha and the alpaca-rich kingdoms along the shores of Lake Titicaca. Finally, in regions fragmented into numerous small polities, the Inka organized the various groups into larger, more manageable entities that were ruled by local lords supervised by Inka administrators. Though the Inka exerted their control indirectly, they were obviously not content to leave control entirely in local hands. In such regions, many dispersed along the *Qhapaq Ñan*, they often established settlements on virgin territory from which they governed the people and stockpiled the region's resources in storehouse complexes. One of the most spectacular of these was Huánuco Pampa, on the main road between Cuzco and Quito.

Huánuco Pampa

Huánuco Pampa lies on a gently rolling *pampa* or plain, more than 3,800 meters (12,470 feet) above sea-level and 700 kilometers (435 miles) north-

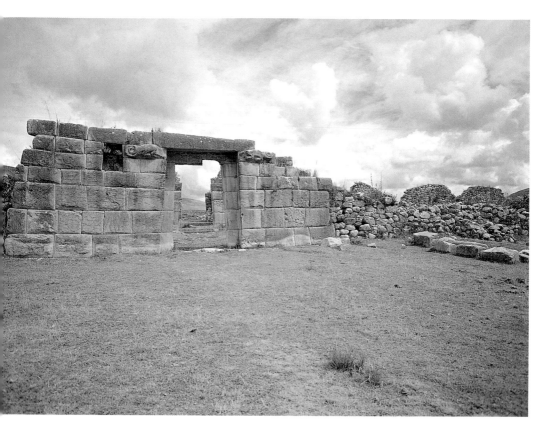

130 Sculpted pumas flank gateways to the plazas where great feasts were held at Huánuco Pampa.

west of Cuzco. Founded sometime in the second half of the fifteenth century, its ruins cover about 200 hectares (495 acres). The settlement served as a provincial capital from which Inka administrators controlled several groups of conquered peoples.

Huánuco Pampa probably had only a small permanent population, but its nearly four thousand buildings could have housed the many thousands who gathered there to celebrate festivities hosted by the state, filling the city at intervals with color and life. Cieza apparently never saw Huánuco Pampa, but he did leave us this vivid description, drawn from an unknown informant:

In what is known as Huánuco [Huánuco Pampa] *there was an admirably built royal palace, made of very large stones artfully joined. This palace or lodging was the capital of the provinces bordering on the Andes, and beside it there was a temple to the sun with many vestals*

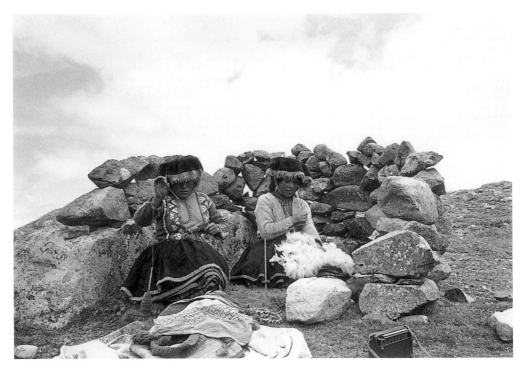

Weaving
131 (*above*) Women in the Ocongate area near Cuzco spin and prepare wool for spinning in much the same fashion as their ancestors.
132 (*below*) Women near Yanaoca in the Cuzco region weaving with traditional backstrap looms.

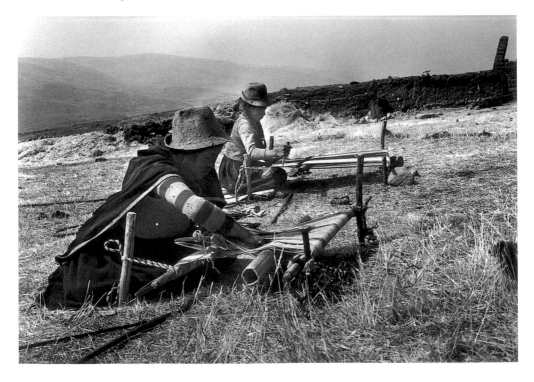

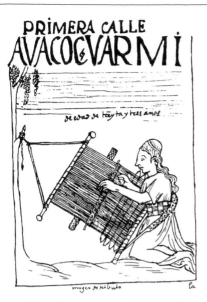

133 (*left*) A drawing by the native chronicler
Felipe Guaman Poma de Ayala shows a
woman using a backstrap loom.
134 (*below*) Coca bag with Inka star motifs.
The tapestry pouch, with its looped opening,
is attached to a decorative panel adorned
with a heavy fringe and tassels.

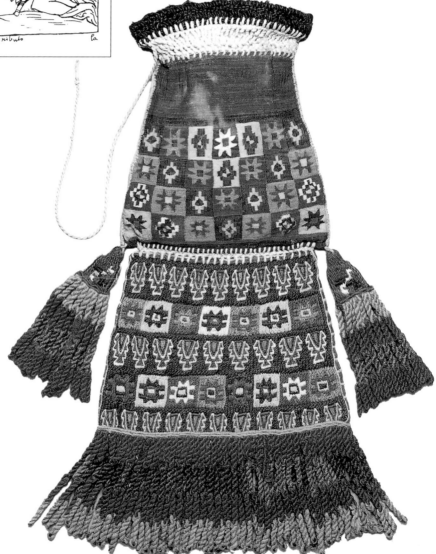

and priests. It was so important in the times of the Incas that there were always over thirty thousand Indians to serve it. The stewards of the Incas were in charge of collecting the regular tributes, and the region served this palace. When the Lord-Incas ordered the headmen of these provinces to appear at the court of Cuzco, they did so. They tell us that many of these tribes were brave and strong, and that before the Incas brought them under their rule many and cruel battles were fought between them, and that in most places the villages were scattered and so remote that there were no relations between them except when they met for their gatherings and feasts.[46]

On a hill to the south of the city the Inka built some five hundred store-houses, organized in orderly rows. Excavations there in the 1960s uncovered the remains of tubers, maize and other foods in storage chambers made of stone roofed with heavy thatch (see Chapter 9). This insulated the contents against the warm daytime sun, and the hill-side location, open to the prevailing winds, enabled the windows to be opened at night to cool the storehouses during the cold highland nights. The combination of ventilation and insulation allowed cool, fresh storage conditions to be maintained that enabled even hard-to-keep potatoes and other tubers to be stockpiled.

The storehouse hill affords a view of the full sweep of Huánuco Pampa. The city's main feature is a gigantic central plaza, more than half a kilometer long. In the center sits a perfectly rectangular platform of dressed stone, called an *ushnu*, measuring 32 by 48 meters (105 by 157 feet) at its base. On such platforms, the chroniclers say, "the Inca and his lords ascended ... to speak to the people and see the army when they made their reviews and assemblages."[47] Pairs of animal figures, probably pumas, flanked the entrances that led to the top of the *ushnu*.

The plaza so dominates the city plan that the rest of the settlement seems to cling to its edges. Most of the buildings that open onto the plaza are long, rectangular structures, each with several doorways. There archaeologists found plates, bowls and large jars for holding *chicha* or water, as well as evidence of hearths. The buildings were apparently used for cooking and eating, but their large size and proximity to the main plaza suggests that they did not function as permanent family residences. We believe that they served as temporary housing for the great number of official visitors who flocked to Huánuco Pampa to participate in state-sponsored religious rites and ceremonies.

The most monumental part of Huánuco Pampa lies to the east of the main plaza, where the Inka emperor Thupa Inka Yupanki built a palace compound. This is linked to the main plaza by a series of dressed-stone gateways that led through two other spacious plazas surrounded by public

buildings. There excavators found the broken remains of hundreds of pottery vessels used for brewing, storing and serving *chicha* (maize beer). Guests of the Inka used these plazas and buildings to celebrate the various rites that marked the ceremonial calendar – the food and other supplies needed to support the center's elaborate feasts drawn from the storehouses on the hill.

Aqlla, the cloistered women who brewed *chicha* and wove fine cloth for the Inka, resided in a large compound north of the main plaza. Archaeologists have identified their residences and workshops by the spinning and weaving implements and the brewing jars they found in the compound (see Chapter 9). The *aqlla*'s output allowed the ruler to shower his guests with hospitality and gifts. Conspicuous and sumptuous royal hospitality was a key to Inka political and economic success, and the ruler rewarded loyal subjects with clothing and the prestige of participating in official ceremonies. Huánuco Pampa's emphasis was therefore not military or bureaucratic, as might have been expected of a center of state control in an expanding empire. The pomp and grandeur of this and similar official cities played a more important role than the Inka armies in creating and maintaining a wealthy empire.

Cieza tells us that 30,000 people "served" Huánuco Pampa, but he did not say that all of these people actually lived in the city. The kinds and quantities of archaeological materials uncovered in various areas of the site indicate which sectors were occupied permanently and which were occupied only occasionally. The brewers and weavers were permanent, as were a maintenance staff, administrators and, of course, the keepers of the storehouses. But many buildings seem to have been occupied only occasionally.

Several unfinished structures at Huánuco Pampa show that the turmoil of internal conflict and the Spanish invasion interrupted construction at the site. When the European invaders swept into Tawantinsuyu in 1532 and toppled the Inka empire, the speed with which people abandoned many cities, especially those in outlying regions, is remarkable. Huánuco Pampa provides a striking example; its remote location suited the Inka strategy of founding settlements to control scattered natural resources and human labor, but the site proved marginal to the needs of the Europeans. After a fleeting venture at settlement in the main plaza, the Spaniards founded the city they called León de Huánuco in the temperate, upper Huallaga valley, 150 kilometers (95 miles) to the north-east, almost 2,000 meters (6,500 feet) lower than its namesake.

The strengths of Inka cities lay in their role of fostering new levels of management of natural and human resources. In its heyday the Inka network of satellite cities administered and carefully orchestrated hundreds of parts, maintaining, co-ordinating and balancing an extremely complex

ecological and cultural diversity and directing economic resources to the capital and throughout the empire. Scattered over a landscape originally controlled (and still partly administered) by other polities, satellite cities behaved rather like miniature state enclaves. The Inka road system linked these enclaves, serving the needs of communication, the military and administration. The roads not only formed the infrastructural backbone of the empire, they also became the major means of linking the government with the peoples it ruled, acting as conceptual bonds between Cuzco and its vast hinterland.

The ceremonial quality of Andean cities persisted in Inka times, although the focus shifted to the rulers themselves. The rulers depended on a personal style of governing that mimicked, albeit on a much more opulent scale, the customs familiar to subjects in their own villages, and the satellite cities helped extend this personal style of governance throughout the empire. Effective control was based on impressing upon people the benefits of their participation in a wealthy kingdom. In return for their labor and allegiance, the rulers entertained them with feasts and ceremonies, lavishing them with ample food, drink and gifts. Such theatrical displays were especially important in a civilization that had not developed writing to codify its rules or fabricate and embellish its history.

The fall of Tawantinsuyu

In the end, Tawantinsuyu was even shorter-lived than the Andean empires that preceded it and served as its inspiration. Its rulers could not sustain their empire in the face of the onslaught of the European invasion, and it collapsed even more quickly than it rose. Nevertheless, despite this short-lived contribution to the history of New World empire-building, it is the enduring monuments of the Inka – scattered across Ecuador, Peru, Bolivia, Chile and Argentina – that to this day embody the Andean genius for combining diverse landscapes and peoples in intricate and ingenious ways.

It is interesting to speculate on how Tawantinsuyu's fragile design played into the hands of its conquerors and contributed to its demise. The growing demands of Cuzco's rulers for labor and sumptuary goods kindled resentment among the provincial lords, many of whose lands had only recently been conquered. Indeed, the Inka had not attempted real "unification," pursuing instead a kind of balanced diversity in which groups of peoples, led by their provincial lords, were frequently played off against each other. It was an empire based on the management, not the elimination, of conflict between groups whose loyalty to the empire was tenuous at best. In the early years of the Spanish invasion many groups allied themselves with the Europeans as they might have done with other Andean people, not realizing

that alliance with the Spaniards meant a commitment to a different culture and a new style of domination.

Moreover, the Inka had not established a simple mechanism, such as primogeniture, to direct the succession of Cuzco rulers. Instead the Cuzco nobles selected the most "competent and able" successor from among a deceased king's many sons, and the death of an emperor triggered protracted infighting and intrigue among the Inka nobles. When Wayna Qhapaq, Atawalpa's father, died, the squabbling over which of his sons should assume the throne turned into internal conflict. Francisco Pizarro therefore came upon an empire locked in a battle for succession between the forces of Atawalpa and his brother, Waskar. The struggle that ensued, and Pizarro's opportunist intervention in that struggle, shattered the foundations of Tawantinsuyu's carefully orchestrated social, political and economic institutions.

Unwittingly, the Europeans had contributed to the fall of the Inka empire almost a decade before Atawalpa's fateful encounter with Pizarro. Old World diseases were deadly to native peoples who had no natural immunity to them, and shortly after the first Europeans landed in the New World smallpox and measles began to spread through the Americas, killing thousands. In the late 1520s, a major epidemic, probably smallpox, spread into Tawantinsuyu from the north. Among its first victims was Wayna Qhapaq.

The new conquerors of the Andes came from another continent and an entirely different culture. The maces, slings and quilted cotton "armor" of Inka troops were no match for the technological and tactical superiority of Spanish soldiers mounted on horses, carrying firearms and brandishing lances and swords of Toledo steel. One chronicler described how Atawalpa's men were awed by the horses as their "hooves clattered loudly as they ascended the steps," creating "fiery sparks on the rocks."[48] Nor could armies used to the ritualized nature of Andean warfare handle the ambush tactics of the Spanish troops when they clashed with Atawalpa and his army for the first time in Cajamarca:

> *The marquis* [Pizarro] *... made a signal to the artillerymen. When they saw it they fired their cannon and the harquebuses. Then everyone came out at once and fell upon the Inca's men. The horsemen lanced them and the foot soldiers cut with their swords without the Inca's men putting up any resistance. Given the suddenness of the attack and never having seen a similar thing in all their days, the Indians were so shocked that, without defending themselves and seeing the great slaughter that they were undergoing, they tried to flee.*[49]

Several early chroniclers did, however, mourn the destruction their arrival had wrought. "To be sure, it is a sad thing to reflect that these idol-

worshipping Incas should have had such wisdom in knowing how to govern and preserve these far-flung lands, and that we, Christians, have destroyed so many kingdoms," lamented Cieza.[50] Many Spanish clergymen and others also recognized the moral implications of the Europeans' treatment of the natives. For the most part, though, Christianity became a pretext for the virtual enslavement of the indigenous population. The Andes were seen primarily as a source of gold and silver to enrich the Spanish Crown, and only secondarily as a source of new souls for the Church.

The conquerors also expected native laborers to deliver goods from their own communities as tribute, but without receiving in return the gifts and hospitality that Andean reciprocity and institutionalized generosity had traditionally bestowed. The Europeans did not understand, or did not recognize, their own obligations: peace and prosperity in Andean society required a generous ruler. The rules that had underpinned the social and cultural foundations of Andean cities crumbled, leading to the abandonment of many cities that the Inka had established throughout Tawantinsuyu. The Spaniards founded new cities with markets, Christian churches and other European features. But the new network of Spanish trade and bureaucratic control never effectively co-ordinated the fragmented wealth of this rich and spectacularly diverse land.

Reconstructing Life in the Ancient Cities

In a land without writing as we know it, archaeologists rely on the information from excavations, the often biased impressions of sixteenth-century conquerors and the observations of the descendants of ancient peoples to put flesh on the bones of past civilizations. How do these tools help researchers sketch a picture of Andean life in the past?

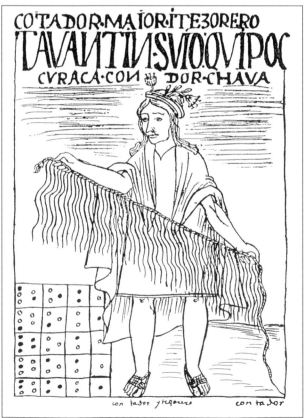

Inka record-keeping

135 (*above*) A *quipu* made of cotton includes many knotted cords in different colors. *Quipu* were used to tally goods kept in storehouses and to keep track of the empire's labor force; they may also have served as mnemonic aids for remembering oral tradition.

136 (*left*) A *quipucamayoc*, or reader and keeper of the *quipu*, is shown in this illustration by Poma de Ayala. The squares and dots in the lower left hand corner of the drawing represent a *yapana*, or counting device.

Despite their impressive accomplishments, neither the Inka nor their pre-decessors developed writing. What the Inka did have was *quipu*: devices consisting of a central cord from which hung a series of smaller cords with clusters of knots on them. From the Spaniards who observed sixteenth-century *quipucamayoc* (keepers and readers of the *quipu*) we know that they could interpret the information stored in the sequences of the knots, and that *quipu* were used to tally goods warehoused in the Inka storehouses and keep track of the empire's labor force; they may also have served as mnemonic aids for remembering oral tradition. In a sense, therefore, *quipu* qualify as a sort of writing. It is not, however, writing as we know it, and, although we know what kind of information they recorded, no one has actually been able to "read" *quipu*.

How, then, can we seek insight into these societies that left no written record? What tools and resources offer us the means to make plausible reconstructions and interpretations of Andean life in the past? There are three principal aids that help us understand what was clearly a complex series of civilizations: the impressions recorded by sixteenth-century Spaniards; ethnographic observations of the modern-day descendants of ancient Andean peoples; and the techniques of archaeology.

It is only at the end of the great sweep of Andean prehistory that Europeans' accounts can help us to elucidate the Andean past. Nonetheless, critical readings of their chronicles help us reconstruct the majesty of the final years of the Inka empire, and ethnohistorical documents can lend voices to peoples conquered by the Inka. The chronicles written by the priests and soldiers who accompanied the conquistadors are supplemented by the records of inspections, dictionaries, ecclesiastical manuals and legal and bureaucratic documents of the colonial administration. Through the words of soldiers of fortune and zealous priests we can feel some of the texture of the Andean world, and sense the awe and bewilderment that beset the Spaniards as they faced a society so alien to their own.

The Spaniards' principal sources and confidants were the Inka nobles of Cuzco and the provincial élite. These native informants buried the achieve-ments of the societies that had preceded or been subdued by their own, glorifying their own past and embroidering details of Inka exploits. This clouds the early first-hand accounts and influences the view that the written sources pass on to us. Moreover, this vision that the Spaniards have handed down to us has in turn been passed through the lens of sixteenth-century Spanish culture.

Furthermore, five hundred years of domination by European culture have obliterated all vestiges of the upper levels of Inka rule. What it has not obliterated, though, is the ability of native peoples to produce intricate and beautiful textiles, or to manage a diverse and fragile environment; nor has

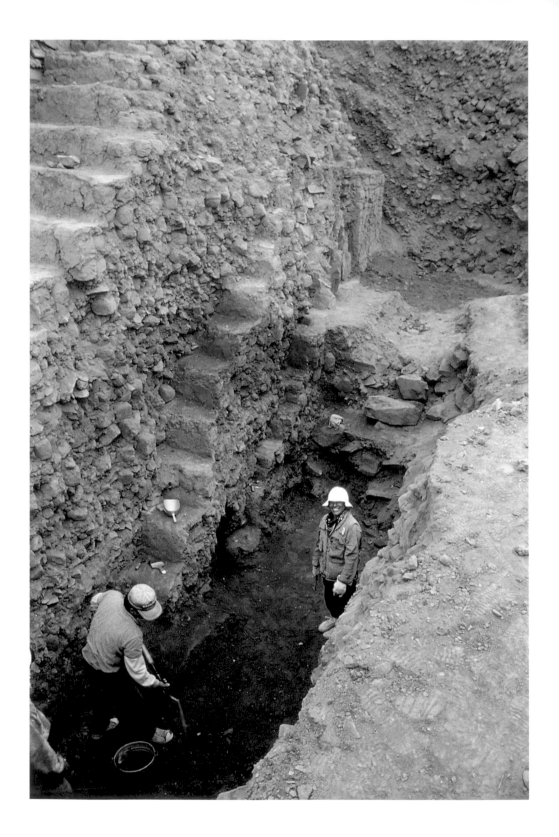

it erased their complex ideas about the cosmos. Ethnographic observation of the present inhabitants of the Central Andes can still help to explain many of the principles and customs that evolved over thousands of years before the European invasion.

It was only in the early twentieth century, with the advent of modern archaeology, that a picture of central Andean prehistory began to emerge that differed from the Spanish and Inka visions. Thousands of archaeological sites dot the Andes, and their excavation and the study of their contents – our most direct link with ancient Andean culture – has demonstrated that much of what the Inka wrought was based on technologies and institutions developed centuries earlier. In the first half of the twentieth century, research focused on discovering the pre-Inka cultures and determining their ages. As a chronology began to fall into place, archaeologists began studying the objects discarded by people and the contexts in which they occurred. By plotting associations and spatial relationships among artifacts and features of the sites they could begin to reconstruct the functions of buildings and the activities that took place within them.

To look at how these techniques can be combined, let us look at one city, Huánuco Pampa (described in more detail in Chapter 8), and see how archaeologists fit together information from excavations with that from sixteenth-century descriptions to sketch a picture of life there in Inka times. Huánuco Pampa was swiftly abandoned in the wake of the European invasion, and, although Spanish settlers established a small town within the Inka city's enormous central plaza, they abandoned it within a year. As a result, Huánuco Pampa's structures have survived relatively unmodified – unlike those of the Inka capital at Cuzco, where the conquistadors razed many buildings to make way for their own and took up residence in others.

Many Spaniards marveled at the empire's storage network and noted that the Inka often located storehouses on hillsides. To the south of Huánuco Pampa 497 stone structures are arranged in orderly rows on a hill. Were these storehouses? The buildings have small, window-like entrances with high thresholds and are clearly not suited for regular access. Excavations by Craig Morris of more than a hundred of these rectangular and circular buildings revealed that the city's residents had removed most of the contents and had burned others, perhaps to prevent their contents from falling into Spanish hands. Some of the rectangular buildings held the remains of potatoes and other tubers, carefully placed between layers of grass and tied into bales. One circular structure contained large, broken pottery vessels filled

137 Clearing of a looters' trench at Mina Perdida in the Lurín valley on the central coast revealed more than thirty construction phases dating to the second millennium BC. This view shows the remains of three superimposed stairways that led to the atrium of the central mound.

with charred, shelled maize. These contents, together with the Spanish descriptions, leave little doubt that the structures served as storehouses.

The interplay of architecture, excavation finds and evidence from written sources is also critical for interpreting the compound of fifty buildings excavated north of the plaza at Huánuco Pampa. Individually, the buildings in the compound are quite large and have many wide doors, but the compound itself has only one entrance, through a narrow corridor and a small entry court flanked by two small buildings. Clearly, not everyone was allowed to enter the compound. Excavations uncovered animal and plant remains and large quantities of artifacts. Cooking pots and plates suggested that people lived and dined in the buildings. Of the thousands of pottery sherds uncovered in the compound, though, more than four metric tons came from two kinds of large vessels that were used to brew and serve *chicha*; this pointed to large-scale production of *chicha*.

Perhaps the most surprising result of these excavations, though, was the discovery of evidence for textile production; excavators found more spinning and weaving tools in this compound than anywhere else in the city. Who were the brewers and weavers who lived in this enclosed and tightly controlled group of buildings? The clues come from the two sources: the Spanish chronicles, and a second group of archaeological finds.

Numerous large metal pins were excavated, of the type used by Inka women to fasten their cloaks. This does not necessarily imply a complete

absence of men in the compound, but it does suggest that women lived and worked there in significant numbers. So the archaeological evidence reveals a compound occupied by a group of weavers and brewers, many or all of whom were women. What do the Spanish sources offer us that best matches this archaeological template? Sixteenth-century writers describe groups of women sometimes called *aqlla*, to indicate their special "chosen" status. These "chosen women" performed religious duties and lived in compounds which the Spaniards likened to "nunneries." The chronicles also say that women spun and wove for the Inka, and a 1562 inspection of the Huánuco region reported that many women had gone to serve as *aqlla* in Huánuco Pampa. It is in this fashion that the careful study of historical material and archaeological evidence allows us to peer into the buildings of cities abandoned centuries ago and see what happened inside.

Are there other tools that archaeologists can use to reconstruct life in the past? Spanish eyewitness accounts can help us work out the functions of Inka buildings and aspects of Inka ritual and other activities, but what about the peoples who lived long before the Spanish conquest? The Moche, who dominated the valleys of Peru's north coast from around AD 100 to 700, left an especially vivid artistic legacy, particularly in their pottery and metal-work. This enables researchers to combine the study of Moche iconography – the imagery or symbolism depicted in their works of art – with archaeo-logical fieldwork to reconstruct details of a rich ceremonial life.

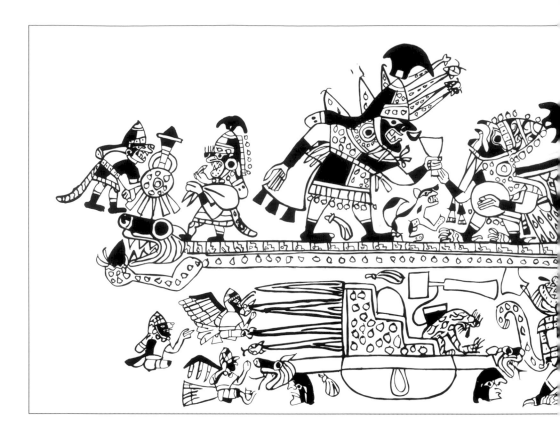

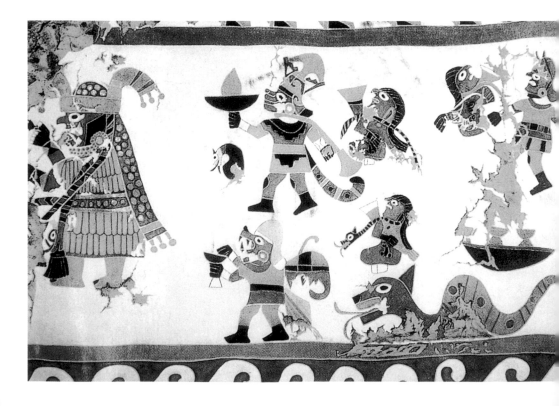

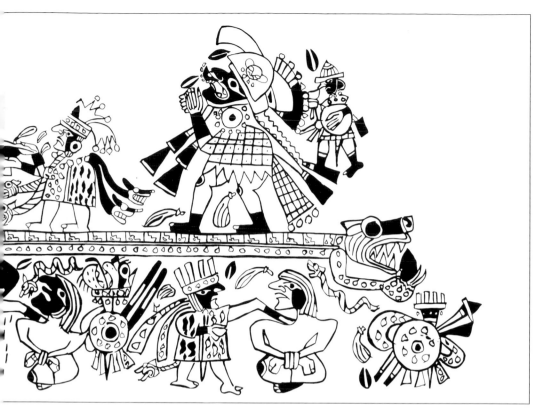

140–2 The Moche Sacrifice Ceremony A rollout from a Moche ceramic vessel (*above*) shows the major players in the Sacrifice Ceremony. A reconstruction of the Sacrifice Ceremony at Pañamarca in the Nepeña valley (*opposite*) includes the priestess on the left. Naked prisoners with ropes around their necks (*below*) are marched off to their arraignment in a relief decorating a terrace wall at the Moche site of Cao Viejo.

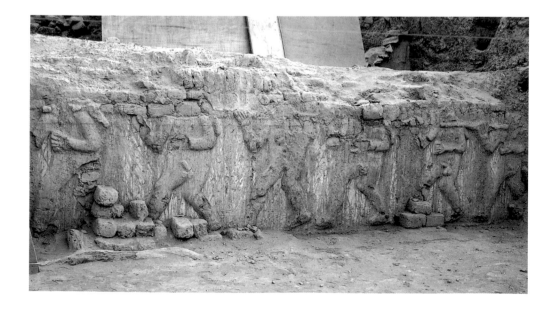

On their ceramics Moche potters painted fine-line scenes that are remarkable for their narrative quality, rivaled in the New World only by the work of their contemporaries, the Maya of Mesoamerica, and in the Old World by the Greeks. While Moche art may seem wide-ranging to the casual observer, in fact it restricts itself to representing a limited number of events or activities, which Christopher Donnan calls themes. One of these themes is the Sacrifice Ceremony: an elaborate blood-letting ritual illustrated on ceramics and in murals and friezes embellishing the walls of Moche temples.

Related to the Sacrifice Ceremony are portrayals of Moche warriors engaged in combat. The great majority of warriors wear Moche-style attire, and for this reason Donnan and other researchers believe that these scenes do not show Moche armies overpowering rival peoples. Rather, they represent episodes of ritual warfare that took place on the margins of irrigated valleys, amid cactus and scrub vegetation. Because the warriors are engaged in hand-to-hand combat, rather than in killing their opponents, Donnan believes that the main purpose of these battles was to capture prisoners for the Sacrifice Ceremony. The vanquished are shown stripped of their battle regalia and weapons and with ropes tied around their necks as they are marched off to their arraignment.

One of the most complete portrayals of the sacrifice narrative's final episode shows attendants slitting the throats of naked prisoners, after which the attendants present the captives' blood in goblets to four individuals presiding over the ceremony. The most important of these individuals, the so-called Warrior Priest, is identified by rays emanating from his shoulders and head, a conical helmet topped by a crescent-shaped headdress, a crescent-shaped nose-ornament, ear-ornaments and a back-flap (worn to protect the back). The figure to his right is called the Bird Priest, because of his beak-like nose and conical helmet or headdress with the image of an owl at its center. Next to him is a Priestess, distinguished by her long braids, dress-like garment and plumed headdress tipped with tassels. The fourth participant wears a headdress that ends in long streamers with serrated edges and decorated with an animal face, often that of a feline.

Until the discovery of the rich tombs at Sipán (described in Chapter 5) in 1987, Donnan and his colleagues believed that the Sacrifice Ceremony was an imaginary ritual or that it commemorated a mythical event. But finds at Sipán, and subsequently at other Moche sites, provided evidence that the Sacrifice Ceremony was a real event. Many of the funerary offerings found in the tombs at Sipán and elsewhere bear a remarkable resemblance to those worn by the mythical protagonists of the Sacrifice Ceremony. Like his mythical alter ego, Sipán's Warrior Priest went to the afterlife wearing a back-flap, crescent-shaped rattles, ear-spools, a gold, crescent-shaped

headdress-ornament and nose-ornament and two *tumi* knives. His tomb also contained a gold, box-like scepter.

Decorating the rattles and the back-flap is the Moche deity known as the Decapitator (also described in Chapter 5). Although he appears in a variety of guises, this deity invariably has a fanged mouth, often wears double ear-spools and holds a ceremonial *tumi* knife in one hand and a severed human head in the other. Sipán's Decapitator appears to be an anthropomorphized spider. Donnan suggests that spider imagery played a prominent role in north-coast ritual because of parallels that the Moche drew between spiders, which suck the life-juices out of their victims, and officiants in the Sacrifice Ceremony, who drained their victims of their blood.

Not far from the Warrior Priest's tomb, Sipán's excavator Walter Alva uncovered a second tomb. The grave goods were not as rich as those of the Warrior Priest, but they included a copper goblet and a distinctive headdress whose oxidized green color belies a once-magnificent ornament of shim-mering gilded copper. In the center of this headdress is an owl, whose outspread wings dangle with feathers and circular ornaments. The goblet identifies the man buried in this tomb as a member of the Sacrifice Ceremony, and his headdress distinguishes him as the Bird Priest.

Ten meters west of the Bird Priest's tomb Alva found small, sealed rec-tangular rooms filled with hundreds of ceramic vessels, as well as minia-ture copper war-clubs, shields, headdresses and goblets. Even more telling, though, were the skeletal remains of human hands and feet scattered among the offerings. Were these the dismembered remains of sacrificed prisoners? Were they buried there during an enactment of the Sacrifice Ceremony at Sipán?

Four years later more evidence emerged from San José de Moro in the Jequetepeque valley, where Donnan and Luis Jaime Castillo found the tombs of two women. The objects buried with them – especially their distinctive silvered copper headdresses with plume-like tassels and a black ceramic basin filled with cups and a goblet – identify them as the Priestesses who took part in the Sacrifice Ceremony. Donnan and his colleagues have now identified three of the four leading participants in the Ceremony.

The evidence shows that human sacrifice was a key ritual in Moche religion and that one of its rites, the Sacrifice Ceremony, had a long tradition spanning several centuries. The burials at Sipán date to around AD 300, while those at San José de Moro took place some two to three hundred years later. The ceremony, or rituals connected with it, was enacted at temples in many of the coastal valleys dominated by the Moche, such as the terraced adobe mound of Cao Viejo, part of the El Brujo complex in the Chicama valley. There, excavations revealed a terrace frieze showing a warrior leading a procession of ten life-size nude prisoners with ropes around their

necks. On the topmost terrace (sadly mostly destroyed) are the segmented legs of a spider or crab Decapitator, brandishing a *tumi* knife in its right hand. (Eyewitnesses who saw the frieze before it was destroyed by looters described a fearsome being with a fanged mouth and double ear-spools.)

Clearly, ceremonial complexes such as Cao Viejo and Sipán served as staging areas for human-sacrifice ceremonies, and the murals and friezes adorning the precinct walls may have served as templates for the rituals. When the priests who participated in the rite died, they were buried in the precinct, accompanied by the ceremonial paraphernalia that they used to perform the ritual.

Now that we have seen how researchers combine information from arch-aeological excavations with resources such as iconography and sixteenth-century accounts to sketch aspects of life in the ancient Andes, let us turn to the vignettes that illustrate Chapters 4–8. What kind of information did we draw on to create our interpretations?

A pilgrimage to Chavín de Huántar

Our story of a pilgrim's journey to Chavín de Huántar is set in 300 BC and is based on informed conjecture coupled with information drawn from excavations, observations of modern Andean peoples and analogies with accounts of later pilgrimage centers, such as Pachacamac on the central coast, which flourished centuries later.

In antiquity, several routes connected the valleys of the north-central coast with the Callejón de Huaylas, and three passes led over the Cordillera Blanca into the Callejón de Conchucos, where Chavín de Huántar lies. Our pilgrim's route follows the modern road to the Callejón de Huaylas up the Pativilca valley.

Caravans of llamas laden with striped saddle bags, the lead animal's ears festooned with colorful tassels, are familiar sights in some parts of the Peruvian Andes. Although they are increasingly rare, there are still modern llama drovers who trek from remote *puna* communities to the coast carrying highland produce or pottery which they exchange for coastal products such as dried fish and shellfish. Like our ancient pilgrim, modern people still deposit stones on piles of rocks, called *apachetas*, that mark mountain passes and make offerings of coca leaves before embarking on journeys.

And, like pilgrims going to Pachacamac, travelers to Chavín came bearing gifts to the oracle. As we saw in Chapter 4, Pachacamac served as the center of a vast ceremonial network. People feared its oracle because it was believed to punish offenders by sending earthquakes. To appease it, pilgrims brought tribute of cotton, maize, coca leaves, dried fish, llamas and guinea-

143 San Pedro cactus for sale in a market at Chiclayo on the north coast. Modern folk healers use San Pedro, whose active ingredient is mescaline, in their curing ceremonies.

pigs, as well as fine textiles, ceramic drinking vessels and raw materials such as gold, all stockpiled in the sanctuary's storehouses. Excavations at Chavín have yielded pottery vessels in a variety of styles and also such exotic materials as obsidian, the volcanic glass used to fashion spear-points, and *Spondylus* shell. This indicates that the residents of Chavín and the temple leadership enjoyed far-flung contacts.

Before pilgrims could enter the sanctuary at Pachacamac they had to abstain from salt, chili pepper, dried meat and sex for twenty days. A private consultation with the oracle involved abstaining for a year. Pachacamac's oracle did give public pronouncements and predictions, although oracular communication was more often private – with a priest consulting the oracle in private and conveying the reply to the public.

Oracular communication and the juxtaposition of private and public ritual appears to be an age-old Andean tradition. One of Chavín's cult objects, the *Lanzón*, lies in a chamber at the end of a narrow, dark interior gallery in which few people could have gathered. Priests may have conferred with the oracle and then emerged from the gallery onto the summit of the temple, conveying the oracle's words to worshippers gathered in the plazas below. Most worshippers were probably unaware of the labyrinth of passageways that honeycombed the temple's interior, explored in more detail

in Chapter 4. This allowed priests to appear mysteriously, adding to the cult's mystique.

People feared Pachacamac because it was believed to control earthquakes. What natural phenomena was Chavín's oracle thought to control? Like so much of ancient Andean religion, the oracle or oracles at Chavín may have been associated with weather gods and their control of rainfall, thunder, lightning, hail, frost and drought. Indeed, Chavín's temple may have literally roared, thunder-like, with the voice of its oracle. As we saw in Chapter 4, Chavín's builders not only designed a temple filled with secret passageways but also built an extensive network of vents and drains. In an experiment, Luis Lumbreras poured water into the drains and amplified the sound of the rushing water by closing and opening vents; he reports that the temple reverberated with a sound that he compared to undulating applause.

Strombus-shell trumpets, frequently depicted in Chavín art and found on some stone carvings at Chavín de Huántar, are still used today in the Andes to mark the onset of ceremonial occasions. Known as *pututus*, these were believed in antiquity to summon the weather gods who resided on cloud-shrouded mountain tops. *Strombus* and *Spondylus* shells come from the warm waters off Ecuador, far to the north of Chavín, and both shells are intimately related to rainfall and the fertility of crops and herds.

Depictions of San Pedro cactus (*Trichocereus pachanoi*) – whose active ingredient is mescaline, a powerful hallucinogenic – are common in Chavín art and in the coastal styles that served as its inspiration. San Pedro, which transports users into trance-like states, is still taken by modern folk healers and their "clients" in traditional curing ceremonies on Peru's north coast. Richard Burger suggests that the tenoned heads that once projected gargoyle-like from Chavín's temple façade (only one remains *in situ*), portrayed priests aided by hallucinogenic snuffs and brews such as San Pedro, and showed their successive altered states as they transformed themselves into jaguar or bird-of-prey alter egos.

Life at the Huaca del Sol and Huaca de la Luna

The story of the Huaca del Sol and the Huaca de la Luna, the paramount Moche settlement in the Trujillo valley from about AD 100 to 550, is based on excavations by the Chan Chan–Moche Valley project, led by Michael Moseley and Carol Mackey in the 1970s, and on continuing research at the site directed by Santiago Uceda and Ricardo Morales of Trujillo's Universidad Nacional de La Libertad.

Studies by Moseley and his colleagues at the Huaca del Sol clarified the construction history of this monumental, terraced mound. It is built of

millions of adobe bricks, impressed on the tops of which are an array of so-called makers' marks created while the mud was still moist. The brick-makers impressed the adobe with distinctive markings ranging from lines, dots and squiggles to hand- and footprints. Like-marked bricks are often arranged in tall, column-like segments, visible in the profiles of the now largely destroyed Huaca del Sol. Each construction phase saw the addition of new columns of bricks, which were then plastered and painted. Over time the Huaca grew into the impressive monument that even today still rises 40 meters (130 feet) above the valley floor.

Excavations of domestic architecture at the site show that the plain between the two Huacas housed a considerable resident population engaged in pottery-making, metalworking and probably other crafts such as weaving. As discussed in Chapter 5, the range of architecture indicates that residents differed in status and specialization. As was also noted earlier, excavations on the Huaca de la Luna revealed a series of stunning friezes as well as burials at the foot of the friezes; one tomb contained the warrior duck described in the vignette. Excavations on the plain below the Huaca de la Luna unearthed a pottery workshop, as well as the canal winding through the site that probably brought water to the potters and the city's residents.

The stones of Tiwanaku

Few ancient settlements in the Andes have aroused as much speculation as Tiwanaku, the city that flourished for centuries on the windswept *altiplano* south-east of Lake Titicaca. Our story of Tiwanaku's stones is based on the work of architect Jean-Pierre Protzen, who identified quarries on Mt Kappia on the Peruvian side of the lake between the towns of Yunguyo and Zepita, as the source of Tiwanaku's andesite blocks. (As noted in Chapter 6, sand-stone came from quarries in the Quimsachata range closer to Tiwanaku.) How did ancient quarry workers extract the stones? Protzen's studies of Inka quarrying techniques indicate that quarrymen followed natural fractures in the rock and used wooden, or possibly bronze, crowbars to extract the stone. Inka masons used hammer-stones to shape stones, and Tiwanaku stone-workers probably used them as well.

Workers then dragged the stones down to the lake's edge, where Protzen has found several abandoned blocks. The trail of stones emerges again on the Bolivian side of the lake near Iwawe, which apparently served as a land-ing area for boats that carried them across the lake. We have no evidence of what kind of boats the Tiwanaku people used to ship their stones. Since trees do not thrive in the harsh *altiplano* surrounding the lake, modern Titicaca fishermen make their boats out of bundles of *totora*, a reed that

Inka stone-working techniques
144 (*left*) A doorway in the residential sector of Ollantaytambo photographed during reconstruction for *The Incas*, part of the NOVA-BBC documentary series *Secrets of Lost Empires*. Double-jambed doorways like these led into the courtyards of the settlement's *kanchas*, but few remain intact.
145 (*below*) Architect Jean-Pierre Protzen using a hammer-stone made of river cobble to shape a block. Pockmarks on Inka stones show that masons used a series of different-sized hammer-stones to shape masonry.

grows along the lake shore, and it is not unreasonable to assume that such boats were used in antiquity as well.

How did the stones get to Tiwanaku? Neither the Inka nor other Andean peoples were familiar with the concept of the wheel, nor did they have strong draft animals, such as oxen. The technology used to move the stones was therefore quite simple and very labor-intensive: they dragged the stones, using ropes. A Spaniard who observed native laborers said their work involved "much human labor and great ropes of vine and hemp."[51] Protzen has detected drag marks on many Inka stones as well as on some stones at Tiwanaku, indicating that they were hauled over a stone surface. He estimates that the Gateway of the Sun, the portal that features in our story, weighs some 15 metric tons, and he reckons that it would have taken two hundred men five days to move it from the quarries on Mt Kappia to Tiwanaku.

How do we know that Tiwanaku's builders decorated their carved monuments with paint and gold inlay? Arthur Posnansky, who explored Tiwanaku in the early 1900s, found traces of gold in holes that had been drilled into the recessed areas of carvings and also detected traces of paint on many sculptures. William Conklin believes that workers applied molten gold to the recessed areas while the carving was still horizontal, and when the metal in the drilled holes hardened, it served as anchor pins to hold the gold sheet in place. In his analysis of a carved lintel from the Kantitayita sector at Tiwanaku, Conklin plotted the pattern of ancient holes drilled into the recessed areas of the carving and found that it coincided with damaged areas, indicating that vandals had hacked at the carving to pry out the anchor pins.

The descriptions of Tiwanaku's sacred core are based on recent excavations by Alan Kolata and his colleagues, as well as on earlier research by Carlos Ponce and Wendell Bennett in the 1930s. Although the Gateway of the Sun today stands by the Kalasasaya, architectural evidence ties it to the Pumapunku, the shrine under construction in our story.

The artisans of Chan Chan

Our story of Chan Chan's artisans is based on excavations by John R. Topic in craft-workers' homes and workshops scattered among the great adobe compounds that housed the kings of Chimú, and in caravanserais in the center of the city. The majority of Chan Chan's artisans and retainers lived on the city's southern, western and north-western sides, while others resided in the center or along the eastern edge of the city. Topic distinguished these enclaves as *barrios*, retainer areas and caravanserais.

As we saw in Chapter 7, the evidence for intensive craft production at

Chan Chan dates to around AD 1350–1470, late in the city's history, when Topic estimates that some 20,000 people resided at Chan Chan, serving the lords of Chimor. The evidence suggests that residents differed in status and specialization. About half were skilled weavers and metal-workers, while others served as laborers, traders and personal retainers.

Unlike the royal compounds, which were built of adobe bricks on foundations of stone and had their interior walls embellished with mud friezes, artisans' houses in the *barrios* were made of *quincha*, or wattle and daub. Dusty alleys wound their way through the *barrios*, which also had their own cemeteries and wells. Topic excavated single-family residential complexes with kitchens, storage areas, work-space and domestic animals. Refuse on the floors of kitchens included llama dung as well as feathers and bird dung, indicating that residents kept llamas and probably ducks in their homes. Topic also found the remains of a *cuyero*, or guinea-pig pen. Rooms devoted to craft production, sleeping and storage were cleaner than the kitchens. Residents used large pottery jars for storage, setting the vessels in bins or in special storerooms.

In these residences Topic uncovered rooms devoted to craft-working and administration. *Arcones*, three-sided structures with bins filled with cotton, tools or partly finished goods, recall the *audiencias* in the *ciudadelas*, described in Chapter 7. They point to administrative functions and are closely associated with craft production.

Shops tended to specialize in either metal-working, weaving or wood-working. Those devoted to metal-working yielded evidence of the melting of copper, as well as large amounts of ash and areas of scorched earth. One workshop contained a fragment of an ingot, scraps of copper, hammer-stones, chisels and a needle. There is no evidence for metal smelting in the city's workshops, which suggests that copper was brought to Chan Chan as ingots.

Evidence of weaving includes wool and cotton yarn wrapped on spindles, copper needles and wooden stakes, as well as scraps of fancy textiles and tassels. Unwoven and woven cotton and wool are common, but unspun wool is rare. Wool yarn, probably alpaca, was most likely brought to Chan Chan as pre-dyed skeins.

Retainer areas differ from the *barrios* because they are set on artificially constructed platforms with distinct kitchen arrangements. Topic believes these areas may have housed higher-status craft-workers who specialized in finishing goods. He reckons that some three thousand retainers lived at Chan Chan at the time of its abandonment.

Topic also excavated two caravanserais near the center of Chan Chan. The rooms here differ from those in the *barrios* and retainer areas and include communal kitchens, rooms with multiple sleeping benches, corral-

like enclosures, llama burials and even a macaw burial. He believes that these two caravanserais may have housed as many as six hundred people. They served as a nexus for the llama caravans that brought raw materials to Chan Chan from the hinterland. Skeins of pre-spun and pre-dyed alpaca wool may have been imported from the highland department of Ancash to the south-east, while ingots probably came from the Quiruvilca region, near the headwaters of the Moche river to the east. The majority of late Chimú metal artifacts are made of arsenical copper bronze; copper ores abound on the coast but arsenic-copper alloys probably came from highland mines, a three-day journey inland.

Pots left on hearths, ingots on floors, unfinished textiles, tools scattered about workshops, and storage bins filled with unspun cotton indicate that Chan Chan's residents abandoned their homes and workshops quite suddenly. This hasty departure probably dates to around 1470, when the Inka conquered the kingdom of Chimor. We know that the Inka looted the burial platforms of the kings of Chimor, and they probably plundered the workshops of the city's skilled artisans. Recognizing the high-quality output of Chan Chan workers, they took many artisans, especially metal-workers, to Cuzco and other Inka centers.

The Qhapaq Hucha sacrifice

No other vignette draws as much on ethnohistorical sources and chroniclers' accounts as our story of the Inka girl sacrificed near the summit of Mt Ampato. She was probably sacrificed during the all-empire sacrificial cycle known as the Qhapaq Hucha. The ritual began in Cuzco and culminated with the sacrifice of children at specially designated sites, many located at the very extremes of the empire: for instance, Cerro El Plomo in the Chilean Andes, Mt Aconcagua, straddling the Chilean–Argentine border, and the island of Puná off the coast of Ecuador. Votive offerings linked to the Qhapaq Hucha ritual – male or female figurines of gold, silver, bronze or shell dressed in elaborate garments, as well as figurines of llamas and miniature sets of ceramic vessels – have been discovered at Túcume on Peru's north coast, at Pachacamac near Lima and on the Island of the Sun in Lake Titicaca.

According to the Jesuit chronicler Bernabé Cobo, the Qhapaq Hucha was "a very special and solemn festival [which] was also celebrated after the death of the Inca when his successor took the fringe, which was the insignia of the king." These seem to have been the most important Qhapaq Hucha festivals, whose purpose "was to pray to the gods for the health, preservation, and prosperity of the Inca who was to be crowned." Although the Qhapaq Hucha appears to have been a yearly event, it was also

convoked "for things of great importance such as times of pestilence, famine, war, or other great disasters."[52]

Summoned to Cuzco, provincial lords brought the cult objects of their most important *huacas* to the capital, where they were consulted by the Inka ruler and asked to make predictions. (By this linking of the empire's most important shrines and cult objects to Cuzco, the Inka strengthened ties between the center of the empire and the periphery.) Cobo tells us that the provincial lords also took "the things that were to be offered in the sacrifice [to Cuzco's main square], namely, two hundred children from four to ten years of age, a large amount of gold and silver made into tumblers and figurines of sheep [i.e., llamas] and other animals, much very well made *cumbi* [fine cloth] ... a large amount of seashells ... colored feathers and up to a thousand sheep [llamas] of all colors." Cobo noted that the children were taken to Cuzco "by way of tribute throughout the kingdom ... the males were children of about ten years of age or younger, and some females ... were the same age as the boys, others were maidens fifteen or sixteen years of age ... They could not have any blemish or even a mole on their entire body."[53]

The account of the girl's journey to Cuzco and back to her village is based on descriptions by sixteenth-century chroniclers Cristóbal de Molina, Juan Polo de Ondegardo and Martín de Murúa, as well as seventeenth-century narratives by Cristóbal de Albornoz and Rodrigo Hernández Príncipe. Molina described the solemn and orchestrated processions of Qhapaq Hucha children traveling to and from Cuzco, following the roads to the capital and returning to their villages or designated places of sacrifice along imaginary, straight lines that began in Cuzco and led to the ends of the realm.

The colonial descriptions of the Qhapaq Hucha ritual are borne out by archaeology. Evidence for the rite comes mainly from mountain-top sanctuaries, especially those perched on the summits of volcanoes in southern Peru and Chile. Many such sites have been looted, and only a few scientifically excavated. They are often only rows of stones or low walls enclosing earthen platforms, although some include shelters that housed those who took part in the ceremonies, as well as llama corrals and trails leading to the summits.

The pioneering work of American anthropologist Johan Reinhard, who has scaled scores of Andean peaks above 6,000 meters (19,700 feet), has done much to clarify details of the Qhapaq Hucha sacrifices. In 1995, crowning more than a decade of exploration, he discovered the frozen body of a girl near the summit of Mt Ampato, which rises 6,300 meters (20,670 feet) in Arequipa's Cailloma province. Volcanic ash from nearby Mt Sabancaya, which had been belching plumes of vapor and ash for several years, had

melted Ampato's ice-cap. Earth tremors then caused the collapse of the summit ridge, where the so-called Ampato maiden had been buried in an earthen platform, causing her to tumble out of her icy tomb toward Ampato's crater.

Dressed in finely woven garments in the style of a Cuzco noblewoman, including a red-and-white shawl fastened with a silver *tupu*, or pin, the girl, in her teens, was accompanied by a small, similarly clad female figurine made of *Spondylus* shell. Near her body Reinhard recovered woven bags filled with maize kernels, a corncob and a small bag covered in feathers and containing coca leaves. Excavations below her summit tomb revealed the bodies of two other sacrificed children, suggesting that Mt Ampato served as the setting for multiple sacrifices. Whether these took place at the same time or over several years remains to be determined. A base camp at 4,890 meters (16,040 feet) included round and rectangular stone structures and a stone-lined llama corral. Archaeologists discovered the remains of a second camp-site at 5,760 meters (18,900 feet), and just below the ridge that led to the summit they found an area strewn with *ichu* grass, wooden tent-posts and a stone-walled platform.

Cobo tells us that the chosen children were given *chicha* before their sacrifice and that they lapsed into a drunken stupor. Others, he wrote, were "strangled with a cord or [had] their throats slit."[54] A computer-tomography scan of the Ampato maiden's mummy at Johns Hopkins University in Baltimore revealed a two-inch-long skull fracture above her right temple, which had resulted in hemorrhaging. Perhaps she fell unconscious and the priests who presided over her sacrifice delivered the blow as a *coup de grâce* before lowering her into her icy tomb near the summit of Ampato some five hundred years ago.

Gazetteer

Batán Grande

The major funerary and religious center in the Lambayeque region, Batán Grande was occupied from around 1500 BC until its abandonment at the end of the Middle Sicán (Lambayeque) period, about AD 1100. The largest concentration of Middle Sicán religious architecture lies within the Sicán Funerary-Religious Precinct: seventeen monumental adobe mounds surrounded by shaft tombs, multi-room enclosures, roofed terraces with colonnades and adobe-limestone flagstone floors.

Reference: Izumi Shimada, "Cultural Continuities and Discontinuities on the Northern North Coast of Peru, Middle-Late Horizon," in Michael E. Moseley and Alana Cordy-Collins (eds), *The Northern Dynasties: Kingship and Statecraft in Chimor* (Dumbarton Oaks, Washington DC, 1990), pp. 297–392.

Cahuachi

Cahuachi's ceremonial adobe mounds cap natural hills associated with plazas, covering some 150 hectares (370 acres). Recent excavations have shown that Cahuachi served as a pilgrimage center with few permanent residents and was abandoned around AD 500. The site faces north toward the geoglyph-etched *pampa* of San José, site of the famed Nazca markings.

Reference: Helaine Silverman, *Cahuachi in the Ancient Nasca World* (University of Iowa Press, Iowa City, 1993).

Cardál

One of four early Early Ceramic ceremonial complexes in Lurín, the southernmost valley where U-shaped centers have been found, Cardál was occupied from around 1300 BC to 900 BC. The site's 3-hectare (7½-acre) plaza is flanked by two wings; in the central mound a stairway 6 m (20 ft) wide led to summit rooms where archaeologists uncovered fragments of a frieze portraying a mouth band with interlocking teeth and fangs. Remains of domestic occupation were uncovered behind the public architecture, where houses were simple quadrangular structures, measuring 2.5 m (8 ft) on a side.

Reference: Richard L. Burger, *Chavin and the Origins of Andean Civilization* (Thames and Hudson, London and New York, 1992).

Cerro Arena

This Salinar settlement in the Moche valley dates from around 200–50 BC and sprawls over some 2 km (1¼ miles). Perched on a steep ridge, it is the largest known Salinar settlement, comprising some 2,000 separate structures built of quarried granite, ranging from crude one-room residences to elaborate 24-room structures. Contemporary sites located up-valley, near the intakes of canals that irrigated Cerro Arena's fields, hint at some kind of alliance.

Reference: Curtis Brennan, "Cerro Arena: Rise of an Andean Elite," *Archaeology*, Vol. 33, No. 3 (1980), pp. 6–13.

Cerro Baúl

A strategic Wari enclave in Moquegua, southern Peru, that sits on a sheer-sided mesa towering 600 m (1,970 ft) above the valley floor. It was occupied from around AD 650 to 700. The 10 hectares (25 acres) of summit architecture include remains of circular and D-shaped masonry structures, mainly contiguous rectilinear, single- and multi-storey rooms surrounding patios, in typical Wari fashion. Cerro Baúl lay within an area dominated by Tiwanaku, and its remains are the southernmost recorded Wari occupation.

Reference: Michael E. Moseley, Robert A. Feldman, Paul S. Goldstein and Luis Watanabe, "Colonies and Conquest: Tiahuanaco and Huari in Moquegua," in William H. Isbell and Gordon F. McEwan (eds), *Huari Administrative Structure: Prehistoric Monumental Architecture and State Government* (Dumbarton Oaks, Washington DC, 1991), pp. 121–40.

Chan Chan

The capital of the Chimú empire, founded around AD 1000 and abandoned when the Inka conquered the region in the 1470s. Located in the Moche valley near modern Trujillo, central Chan Chan covers 6 sq. km (1,480 acres) with a total area of 20 sq. km (4,940 acres). The site's most imposing architectural features are its rectangular compounds or *ciudadelas*, oriented north–south and surrounded by the residences of the Chimú kings, and adobe or *tapia*

(poured adobe) walls, some standing as high as 9 m (30 ft). The compounds probably housed the reigning Chimú monarchs, their retainers and bureaucrats. Most compounds have a single entrance on the north side, large entry courts decorated with mud-brick friezes, U-shaped structures (*audiencias*) connected to courts with rows of storerooms, and burial platforms. Adjoining wings held walk-in wells and probably housed retainers who provided services and maintenance. Archaeologists have found evidence for low-status domestic habitation and craft production scattered among some of the compounds.

References: Michael E. Moseley and Kent C, Day (eds), *Chan Chan: Andean Desert City* (University of New Mexico Press, Albuquerque, 1982); Michael E. Moseley and Alana Cordy-Collins (eds), *The Northern Dynasties: Kingship and Statecraft in Chimor* (Dumbarton Oaks, Washington DC, 1990).

Chavín de Huántar

Founded around 900 BC in the Callejón de Conchucos in the north-central highlands of Peru, Chavín de Huántar is strategically located about midway between the coast and the tropical lowlands. Although not the largest ceremonial center of its time, it was one of the most elaborate and played an important role in synthesizing pan-Andean religious beliefs, iconography and technology. In Janabarriu – the final Chavín phase, dating from 400 BC to 200 BC – the site covered approximately 42 hectares (104 acres), with some 2,000–3,000 people living around the ceremonial precinct. The Old Temple is a U-shaped platform enclosing a sunken circular courtyard. Its four-storey-high masonry wall was punctuated by projecting sculpted heads, and the temple's interior was honeycombed with narrow passageways and chambers, called galleries. In one of these stands a stone idol, carved in bas-relief, known as the *Lanzón*. During Chavín de Huántar's florescence, architects enlarged the ceremonial precinct, doubling in size the southern wing of the Old Temple.

Reference: Richard L. Burger, *Chavin and the Origins of Andean Civilization* (Thames and Hudson, London and New York, 1992).

Cuzco

The political, administrative and religious center of the Inka empire, Cuzco's central sector boasted a dual plaza surrounded by large halls or compounds with thatched roofs. Some compounds served as residences for Inka kings, while others were maintained by the descendants of deceased Inka rulers. The city's holiest and finest building was the Qorikancha (or golden enclosure), today the church of Santo Domingo, which included shrines to the creator god, sun, moon, rainbow and thunder. Agricultural terraces and storehouses surrounded the city; beyond lay planned agricultural settlements and scattered hamlets set among terraces and canals. Several roads emerged from the city, including the four main ones that linked Cuzco to the four quarters of the empire. Looming over the city from a hill to the north is the religious-military construction of Sacsawaman.

References: John Hyslop, *Inka Settlement Planning* (University of Texas Press, Austin, 1990); Graziano Gasparini and Luise Margolies, *Inca Architecture*, trans. Patricia J. Lyon (University of Indiana Press, Bloomington, 1980).

Farfán

Farfán's architecture recalls the rectangular adobe compounds of Chan Chan and may have served as a Chimú provincial capital. It was founded during the first wave of Chimú conquests, beginning around AD 1200. The six heavily looted compounds lie in a line along the Panamerican highway in Jequetepeque, the third largest valley on the north coast. Excavations have revealed early Chimú, Imperial Chimú, Chimú-Inka and Colonial occupations.

Reference: Richard W. Keatinge and Geoffrey W. Conrad, "Imperialist Expansion in Peruvian Prehistory: Chimu Administration of a Conquered Territory," *Journal of Field Archaeology*, Vol. 10, No. 3 (1983), pp. 255–83.

Galindo

This site sprawls over 6 sq. km (1,480 acres) near the neck of the Moche valley, inland from Trujillo. Almost all occupation dates to the final phases of the Moche sequence, AD 500–700. Galindo includes a residential area with storage facilities, benched rooms and kitchens. Its wealthier residents lived in large, well-constructed buildings while poorer ones lived on a crowded hillside overlooking the site, segregated by a large wall and ditch. The site's four *huacas*, or adobe platform mounds, are smaller than the traditional, older, Moche *huacas* and lie within walled enclosures that herald the compounds at Chan Chan.

Reference: Garth Bawden, "Galindo: A Study in Cultural

Transition During the Middle Horizon," in Michael E. Moseley and Kent C. Day (eds), *Chan Chan: Andean Desert City* (University of New Mexico Press, Albuquerque, 1982), pp. 285–320.

Huánuco Pampa

This Inka administrative center lay on the main Inka highland road, at an altitude of 3,800 m (12,500 ft) on the rolling *altiplano* of the north-central sierra. One of the largest Inka settlements, it covers 2 sq. km (495 acres) and the total number of buildings probably exceeded 4,000. Construction began sometime in the mid-fifteenth century and was still under way on the eve of the Spanish invasion. Huánuco Pampa's *ushnu* platform, a two-tiered structure 32 by 48 m (105 by 157 ft) at its base, is the largest ever built and dominates the site's plaza, which measures 550 by 350 m (1,800 by 1,150 ft). Archaeologists found the remains of an *aqllawasi*, *kallanka* and other Inka state installations; hundreds of storehouses lie on a hillside to the south of the site.

Reference: Craig Morris and Donald E. Thompson, *Huánuco Pampa: An Inca City and its Hinterland* (Thames and Hudson, London and New York, 1985).

Inkawasi

This well-preserved Inka state installation lies 10 km (6¼ miles) down-river from the modern town of Lunahuaná in the Cañete valley, where it sprawls across two dry ravines. According to the chroniclers, Inkawasi served as a garrison for Inka armies who spent several years fighting the people of Cañete, one of the last coastal valleys to fall to the Inka. Extensive storage facilities – a third to a half of the rooms appear to have had a storage function – may have warehoused foodstuffs and materiel. Two *ushnu*-like platforms lie in the site's two plazas; compounds with fine architecture probably served as élite residences.

Reference: John Hyslop, *Inkawasi – The New Cuzco* (British Archaeological Reports, International Series, Oxford, 1985).

Jauja

Modern Jauja, on the north bank of the Mantaro river in the central highlands of Peru, covers much of Hatun Xauxa, which was a major Inka provincial center. Remains of storehouses perch on hills to the west. An *ushnu* platform measuring 28 by 32 m (92 by 105 ft) – which is now badly damaged – lay within the Inka plaza. All the standing walls are of *pirca* (fieldstone), and archaeologists have found no remains of finely built walls. Inka Jauja lay along the main north–south highland road.

Reference: Terence D'Altroy, *Provincial Power in the Inka Empire* (Smithsonian Institution, Washington DC, 1992).

La Centinela–Tambo de Mora

The massive adobe compounds of La Centinela, the Chincha capital, featured multi-tiered mounds, many of whose walls were adorned with adobe friezes, and large fore-courts for public activities. Straight roads connected La Centinela to contemporary sites, suggesting that organization and planning linked this entire south-coast valley. Some 50–100 years later the Inka erected their buildings amid the earlier ones. The Inka compound, however, was of adobe bricks instead of *tapia*, with hallmark trapezoidal doorways and niches.

Reference: Craig Morris and Adriana von Hagen, *The Inka Empire and its Andean Origins* (Abbeville Press, New York, 1993).

Machu Picchu

Perched above the rushing Urubamba river north of Cuzco, in a dramatic setting of cloud forest framed by distant snow-covered peaks, Machu Picchu's architects skillfully integrated architecture and landscape. The site has been the subject of intense speculation since Hiram Bingham stumbled upon it in 1911 and called everything from frontier citadel, fortress and sanctuary, to the last refuge of the Inka. Early Colonial land-tenure documents, however, suggest that Machu Picchu served as an estate of the Inka emperor Pachakuti, who reigned in the mid-fifteenth century. Its inaccessible location, defensive walls and dry moat probably served to limit access to what was a highly religious site rather than to deter would-be invaders. The overall quality of the stonework is impressive, especially the Temple of the Three Windows and the *Torreón*, probably a sun temple. A chain of sixteen spring-fed water catchments supplied Machu Picchu with water, and the granite building material came from an on-site quarry.

Reference: John Hyslop, *Inka Settlement Planning* (University of Texas Press, Austin, 1990).

Manchán

This Chimú regional capital lies in the Casma valley on the southern fringes of the Chimú

empire. It was founded during the second Chimú expansion phase, after AD 1300. The site covers 63 hectares (155 acres) and includes nine adobe compounds composed of patios with benches and ramps and U-shaped, *audiencia*-like structures associated with storerooms. High-status individuals at Manchán were buried in separate compounds, in subterranean chambers accompanied by textiles, ceramics and carved wooden staffs. Archaeologists have also uncovered extensive remains of perishable domestic structures.

Reference: Carol J. Mackey and A. M. Ulana Klymyshyn, "The Southern Frontier of the Chimu Empire," in Michael E. Moseley and Alana Cordy-Collins (eds), *The Northern Dynasties: Kingship and Statecraft in Chimor* (Dumbarton Oaks, Washington DC, 1990), pp. 195–226.

Maranga
A major ceremonial and population center of the Lima culture in the Rímac valley, Maranga flourished from around AD 200 to 800 and covers 150 hectares (370 acres), including some twelve monumental platform mounds. One of the largest is Huaca San Marcos, which measures 300 by 120 m (985 by 395 ft) at its base and stands 30 m (98 ft) high, surrounded by rooms and walled enclosures. One walled enclosure covers 44 hectares (109 acres) and may have served as a residence for Maranga's élite.

Reference: José Canziani, "Análisis del complejo urbano Maranga–Chayavilca," *Gaceta Arqueológica Andina*, Vol. IV, No. 14 (1978), pp. 10–17.

Marca Huamachuco
This site, built by local people who dominated the region before the arrival of Wari peoples, covers approximately 2.4 sq. km (595 acres) and sits on a high plateau dominating the entire Huamachuco area, east of Trujillo. Architecture includes multi-storeyed, circular, curvilinear and rectangular buildings. It continued to be an influential site during the brief but intense Wari presence in the area around AD 650, centered at nearby Viracochapampa.

Reference: John R. Topic, "Huari and Huamachuco," in William H. Isbell and Gordon F. McEwan (eds), *Huari Administrative Structure: Prehistoric Monumental Architecture and State Government* (Dumbarton Oaks, Washington DC, 1991), pp. 141–64.

Moche – Huacas del Sol and de la Luna
By AD 450 the Pyramids at Moche, the Huacas of the Sun and Moon, had become the leading ceremonial and political center of the southern Moche realm. The Pyramid of the Sun is one of the largest structures ever built in the Americas and rises 40 m (130 ft) above the valley floor. Millions of adobe bricks were used to build this four-tiered structure, whose summit was reached by a ramp on its northern side. Little of its cross-shaped plan remains, however, because treasure-seeking Spaniards washed away two-thirds of the *huaca* by diverting the Moche River. On the other side of a 500-m (1,650-ft) open space, once filled with domestic architecture and workshops, lies the Huaca de la Luna, below Cerro Blanco. This is a smaller, three-tiered complex decorated with a rich and varied array of friezes and murals. The site may once have covered as much as 3 sq. km (740 acres).

References: Izumi Shimada, *Pampa Grande and the Mochica Culture* (University of Texas Press, Austin, 1994).

Moxeke–Pampa de las Llamas
Moxeke–Pampa de las Llamas covers over 220 hectares (545 acres) and was occupied by 1400 BC. Two large mounds, Moxeke and Huaca A, dominate the site. The multi-tiered Moxeke measures about 160 by 170 m (525 by 560 ft) and stands about 30 m (98 ft) high. A sculpted clay frieze portraying free-standing figures and heads painted red, blue, white, green and black adorned the façade. Facing Moxeke, and separated from it by a kilometer-long series of plazas, lies Huaca A, about 135 by 120 m (445 by 395 ft) and 12 m (39 ft) high. On its summit, accessible from either side, archaeologists uncovered numerous rooms with rounded corners. Low mounds and domestic constructions flank the plazas, the largest of which is 350 m (1,148 ft) long.

Reference: Shelia Pozorski and Thomas Pozorski, *Early Settlement and Subsistence in the Casma Valley, Peru* (University of Iowa Press, Iowa City, 1987).

Ollantaytambo
This Inka site lies north-west of Cuzco, at the confluence of the Urubamba and Patakancha rivers. It is divided into a residential sector on the east and a temple hill and its associated architecture lying below this to the west. Ollantaytambo had a permanent population of some 1,000 people and probably served as a residence for the Inka ruler and his entourage or as a ceremonial center and administrative seat. The sun temple on the temple hill was under construction on the eve of the Spanish

invasion, and the area is strewn with building stones. Elaborate waterworks and shrines of carved rocks and sculpted rock faces lie below and to the north of the temple hill. Stones that were being transported to the site from the rock-falls of Kachiqata still lie in fields around Ollantaytambo.

Reference: Jean-Pierre Protzen, *Inca Architecture and Construction at Ollantaytambo* (Oxford University Press, New York and Oxford, 1993).

Omo

This, the largest Tiwanaku settlement outside Bolivia, lies in the Moquegua valley on the far south coast of Peru. The site's plan, domestic structures and Tiwanaku domestic artifacts point to colonization in Tiwanaku IV (AD 400–750) and V (750–1000). At M10, the southernmost of the Omo bluff-top sites, archaeologists uncovered rectangular cane-walled residences and the remains of a Tiwanaku ceremonial structure composed of three adobe-walled courts. A staircase and a narrow, 1 m-wide doorway led from the middle court to the upper court, which contained a sunken court surrounded by rectangular rooms.

Reference: Paul Goldstein, "Tiwanaku Temples and State Expansion: A Tiwanaku Sunken-Court Temple in Moquegua, Peru," *Latin American Antiquity*, Vol. 4, No. 1 (1993), pp. 22–47.

Pachacamac

The leading pilgrimage center on the central coast, founded sometime in the first century after Christ, and occupied until the Spanish conquest in 1532. The site is close to the Panamerican highway just south of Lima and lies on a promontory overlooking the Pacific. At first Pachacamac played a part in local religion but later became one of the most feared and revered pan-Andean oracles. Both the Wari and the Inka used Pachacamac's religious prestige to enhance their empires. Most of the monumental constructions probably date to the period between the two empires, when the people of the Rímac and Lurín valleys were loosely organized under the kingdom of Ichma. The Inka built their temple over an earlier one and also constructed a large plaza, *ushnu* platform and *aqllawasi*.

Reference: Izumi Shimada, "Pachacamac Archaeology: Retrospect and Prospect," Introduction to reprint of Max Uhle, *Pachacamac* (1903) (University Museum of Archaeology and Anthropology, University of Pennsylvania, Philadelphia, 1991).

Pacatnamú

Pacatnamú perches on cliffs at the mouth of the Jequetepeque river in northern Peru, flanked by the ocean on one side and irrigated valley bottomlands on the other. A ceremonial city, its core covers around 1 sq. km (250 acres) and includes more than fifty truncated, mudbrick mounds, some of which once had elaborate structures on their summits. Courts, corridors and élite quarters flanked the mounds. Extensive (now looted) cemeteries lay within and without the city walls. Pacatnamú was an important regional pilgrimage center founded by the Moche and later occupied by the Chimú. Its religious influence has been compared to that of Pachacamac, and it retained its ceremonial importance long after its abandonment around AD 1370.

Reference: Christopher B. Donnan and Guillermo A. Cock (eds), *The Pacatnamú Papers*, Vol. I (Museum of Cultural History, University of California, Los Angeles, 1986).

Pampa Grande

Founded during the Moche IV–V transition, around AD 550, Pampa Grande covered an estimated 6 sq. km (1,485 acres) and was occupied for some 150 years until around AD 650 or 700. Located near the neck of the Lambayeque valley, much of the site's well-preserved architecture stands over 1 m high. Constructions include rooms, terraces, *huacas* and compounds. Huaca Fortaleza looms almost 40 m (130 ft) above the valley floor at its highest point. It measures 270 by 180 m (885 by 590 ft) at its base and was enclosed within a 600 by 400 m (1,970 by 1,300 ft) compound and reached by a ramp 290 m (950 ft) long. The summit of the *huaca* may have been the setting for rituals and elaborate feasts, or it may have served as a residence for Pampa Grande's ruling élite.

Reference: Izumi Shimada, *Pampa Grande and the Mochica Culture* (University of Texas Press, Austin, 1994).

Paracas

Paracas – a complex of cemeteries and habitation areas on and around Cerro Colorado on the arid, windswept Paracas peninsula of southern Peru – was occupied from around 300 BC to AD 200. In the Cerro Colorado habitation zone, contemporary with the Cavernas cemetery, archaeologists have recorded 4 hectares (10 acres) of habitation remains. On the north face of Cerro Colorado Julio C. Tello

uncovered hundreds of mummy bundles wrapped in elaborate textiles dating to the later Necropolis phase. Domestic structures and refuse also sprawl nearby for over 54 hectares (133 acres).

Reference: Helaine Silverman, "The Paracas Problem: Archaeological Perspectives," in Anne Paul (ed.), *Paracas: Art and Architecture* (University of Iowa Press, Iowa City, 1991), pp. 349–415.

Pikillacta

The largest provincial Wari center, Pikillacta may have been the residence of political and religious élites as well as a center in the Cuzco basin of Wari administration, which began around AD 650 and lasted for some 300 years. Rigid planning ignores topography, and the site is divided into four sectors, forming a rectangle measuring 745 m (2,444 ft) from northwest to south-east and 630 m (2,067 ft) from south-west to north-east: an area of nearly 2 sq. km (495 acres). Archaeologists recorded more than seven hundred structures within the main architectural blocks, some of whose walls still stand as high as 12 m (40 ft). They found very few corridors or doorways, which suggests tightly controlled access and movement.

Reference: Gordon McEwan, "Archaeological Investigations at Pikillacta, a Wari Site in Peru," *Journal of Field Archaeology*, Vol. 23, No. 2 (1996), pp. 169–86.

Pukara

An early ceremonial and urban center in the northern Titicaca basin, Pukara was occupied from around 200 BC to AD 200. Ceremonial architecture includes stone foundations of a rectangular sunken court. The residential area lay in the plain below the site, where the modern town is located, and sprawled over 4 sq. km (990 acres). Archaeologists have found stela carved with fish, lizards, felines and serpents, and Pukara's elaborate ceramics are polychrome, modelled and incised. Pukara influence extended 150 km (90 miles) north to Chumbivilcas in Cuzco and south to Chile.

Reference: Alfred Kidder II, *Some Early Sites in the Northern Lake Titicaca Basin*, Papers of the Peabody Museum, Harvard University, Vol. XXVII, No. 1, (Cambridge, MA, 1943).

Pumpu (Bombón)

This Inka administrative center lies in the central highlands on the north shore of Lake Junín, where the Mantaro river originates. Located along the main Inka highland road,

Pumpu was still under construction on the eve of the Spanish invasion. Its 17-hectare (42-acre) trapezoidal central plaza is surrounded on three sides by *kancha* compounds. In the center lies an *ushnu* platform, measuring 28 by 18 m (92 by 59 ft) at its base. Archaeologists also recorded over five hundred storehouses, circular house foundations, *kallanka* halls and the remains of a suspension bridge over the Mantaro river.

Reference: Ramiro Matos, *Pumpu: Centro Administrativo Inka de la Puna de Junín* (Editorial Horizonte, Lima, 1994).

Raqchi

This site lies south of Cuzco and is surrounded by lava flows, which provided its Inka masons with building material. It covers 80 hectares (200 acres), and 3.5 km (2.2 miles) of an enclosing wall are still preserved. The Temple of Wirakocha is an imposing *kallanka*-like hall, 92 m (300 ft) long and almost 25 m (82 ft) wide, and was one of the largest roofed Inka halls. Its interior is divided by a wall some 12 m (40 ft) high pierced by ten doorways. Southeast of the Temple are houses built in the *kancha* style. The remains of dozens of circular stone storehouses, approximately 8 m (26 ft) in diameter, lie in the site's southern sector.

Reference: Graziano Gasparini and Luise Margolies, *Inca Architecture*, trans. Patricia J. Lyon (University of Indiana Press, Bloomington, 1980).

San José de Moro

On the right bank of the Chaman river in the Jequetepeque valley, San José de Moro lies along the west side of the Panamerican highway. Its southern sector is dominated by heavily looted and eroded mounds, some almost 8 m (26 ft) high. Judging by the scatter of fancy sherds, archaeologists believe that these served as élite residences. Recent excavations have revealed that the northern sector of the site contained occupation mounds and served as a cemetery for Moche and Lambayeque peoples.

Reference: Christopher B. Donnan and Luis Jaime Castillo, "Finding the Tomb of a Moche Priestess," *Archaeology*, Vol. 45, No. 6 (1992), pp. 38–42.

Sechín Alto

Roughly contemporary with Moxeke–Pampa de las Llamas, Sechín Alto in the Casma valley boasts the largest stone construction of its time in the Americas – fifteen times bigger than

Chavín de Huántar's. The massive, solid, truncated mound measures 300 by 250 m (984 by 820 ft) and towers 44 m (144 ft) above the valley floor. Its builders used quarried stone set in a mortar of silty clay. In the center of the mound a looters' pit 20 m (66 ft) deep revealed an inner core of conical adobes, indicating an even earlier construction, dating to around 1500 BC or before. Three of the four plazas north-east of the central mound contain circular courtyards aligned with the axis of the central mound. Smaller constructions flank the plaza area, but remains of domestic occupation have been largely obliterated by modern cultivation.

Reference: Shelia Pozorski and Thomas Pozorski, *Early Settlement and Subsistence in the Casma Valley, Peru* (University of Iowa Press, Iowa City, 1987).

Sipán

This Moche site in the Lambayeque valley is famed for the rich tombs revealed by recent excavations. Moche nobles buried at Sipán's 10-m- (33-ft-) high burial platform were accompanied to the afterlife by a dazzling array of gold, gilded copper and silver jewelry and ornaments. Little is known of the skilled craftsmen who produced these rich grave goods. The remains of domestic buildings and cemeteries to the east of the site hint that they and others who served Sipán's lords may have lived there.

References: Walter Alva and Christopher B. Donnan, *Royal Tombs of Sipán* (Fowler Museum of Cultural History, University of California, Los Angeles 1993); Walter Alva, *Sipán* (Cervecería Backus & Johnston, Lima, 1994).

Tambo Colorado

An Inka administrative center in the Pisco valley, founded sometime after 1450 and straddling an important trunk road that connected the coast to Cuzco. This is one of the best-preserved Inca coastal sites and a good example of a planned Inca settlement built using local techniques. Traces of red, yellow and white paint can still be seen on the walls. At the western end of the trapezoidal plaza is a low-lying *ushnu* platform.

Reference: Graziano Gasparini and Luise Margolies, *Inca Architecture*, trans. Patricia J. Lyon (University of Indiana Press, Bloomington, 1980).

Tambo Viejo

This Inka administrative center in the south-coast Acarí valley covered an extensive, earlier Nazca occupation. Colonial buildings in turn destroyed some of the Inka constructions. The Inka remains include a large rectangular plaza bordered by a bluff adjacent to the Acarí river. An *ushnu* platform built of river cobbles perches on the side of the plaza overlooking the river. The main Inka coastal road led into the plaza.

Reference: Dorothy Menzel and Francis A. Riddell, *Archaeological Investigations at Tambo Viejo, Acari Valley, Peru, 1954* (California Institute for Peruvian Studies, Sacramento, 1986).

Tiwanaku

The ancient world's highest urban center is perched almost 4,000 m (13,100 ft) above sea-level and lies in Bolivia, south of Lake Titicaca. The site covered 4.5 sq. km (1,100 acres). Major construction was under way by AD 200, and by AD 500 Tiwanaku had become the capital of an expanding empire whose sphere of influence included the Bolivian lowlands and the Chilean and Peruvian coasts. Its religious and artistic influence extended north to Wari in Ayacucho (although the nature of the relationship between these two empires has yet to be elucidated). Excavations have focused on the site's monumental constructions, gateways and stone sculpture in the civic-ceremonial core; residential structures were built of adobe. A moat surrounded the city core, whose imposing constructions are aligned east–west. Its most sacred building was the Akapana temple, 17 m (56 ft) high and covering an area of 50 sq. m (540 sq. ft) with a sunken court, drained by canals, on its summit.

Reference: Alan L. Kolata, *The Tiwanaku: Portrait of an Andean Civilization* (Blackwell, Cambridge, MA, and Oxford, 1993).

Túcume

The largest concentration of monumental mounds in the Andes, Túcume covers 150 hectares (370 acres). Building began there when power in Lambayeque shifted to Túcume after Batán Grande, just to the east, was abandoned around AD 1100. Recent excavations have revealed that Lambayeque people built the majority of the 26 monumental adobe constructions that surround Cerro La Raya, a mountain and natural *huaca* rising 146 m (480 ft) above the valley floor. Túcume may have served as the center of Lambayeque dominion until the Chimú conquest of the region around AD 1350. Inka occupation began around 1470

and centered on the Huaca Larga, a monumental adobe construction 20 m (66 ft) high.

Reference: Thor Heyerdahl, Daniel H. Sandweiss and Alfredo Narváez, *Pyramids of Túcume: The Quest for Peru's Forgotten City* (Thames and Hudson, London and New York, 1995).

Vilcas Waman

Vilcas Waman lies 80 km (50 miles) south-east of Ayacucho in one of the first regions conquered by the Inka as they began expanding beyond Cuzco. Modern Vilcas Waman covers most of the Inka installation, which was probably an administrative center, and the modern plaza corresponds roughly to the Inka one. On one side of the plaza lay a terraced *ushnu* platform of finely fitted masonry, one of the most elaborate ever built. A stairway led to the summit through a double-jambed doorway. The sun temple also faced the plaza and was set on three terrace platforms with large trapezoidal doorways and niches. The approach to the temple was via a dual stairway.

Reference: Graziano Gasparini and Luise Margolies, *Inca Architecture*, trans. Patricia J. Lyon (Indiana University Press, Bloomington, 1980).

Viracochapampa

This planned Wari center 2.5 km (1.5 miles) north of the modern town of Huamachuco straddles a gently sloping plain and is roughly trapezoidal in shape. Many of the hallmarks of Wari architecture are present: great enclosing walls, rectangular buildings set around patios and limited patterns of access. The walls of its niched halls and galleries often stand 6 m (20 ft) high. Planning is less rigid here than at other Wari installations, suggesting that Viracochapampa was one of the earliest Wari provincial centers. It was apparently never finished or occupied.

Reference: John R. Topic, "Huari and Huamachuco," in William H. Isbell and Gordon F. McEwan (eds), *Huari Administrative Structure: Prehistoric Monumental Architecture and State Government* (Dumbarton Oaks, Washington DC, 1991), pp. 141–64.

Wari

Wari is located between the Huamanga and Huanta basins near Ayacucho in the south-central Andes. Its numerous walls, many standing as high as 6 to 12 m (20 to 40 ft), enclose rectangular compounds. Stones projecting from some walls supported multi-storeyed, residential structures. Limited excavation and poor preservation give only a partial picture of what the city looked like. In early Wari times the city grew rapidly, covering more than 100 hectares (247 acres), and served as both a residential and ceremonial center. Architecture from this time features megalithic, dressed-stone buildings, some of which recall the ceremonial architecture of Tiwanaku. The city flourished from AD 600 to 800, when most building was undertaken.

Reference: William H. Isbell, Christine Brewster-Wray and Lynda E. Spickard, "Architecture and Spatial Organization at Huari," in William H. Isbell and Gordon F. McEwan (eds), *Huari Administrative Structure: Prehistoric Monumental Architecture and State Government* (Dumbarton Oaks, Washington DC, 1991), pp. 19–53.

Further Reading

General overview

For an overview of Andean archaeology, see Karen Olsen Bruhns' *Ancient South America* (Cambridge University Press, Cambridge, 1996), which touches on the archaeology and technology (weaving, metallurgy, pottery) of areas beyond the Central Andes of Peru and Bolivia; Michael E. Moseley, *The Incas and their Ancestors* (Thames and Hudson, London and New York, 1992); James B. Richardson, *People of the Andes* (Smithsonian Institution Press, Washington DC, 1994); Craig Morris and Adriana von Hagen, *The Inka Empire and its Andean Origins* (Abbeville Press, New York, 1993), as well as Luis G. Lumbreras *The Peoples and Cultures of Ancient Peru*, trans. Betty J. Meggers, (Smithsonian Institution Press, Washington DC, 1974).

The forthcoming three-volume *Cambridge History of the Native Peoples of the Americas*, with a tome edited by Frank Salomon and Stuart Schwartz devoted to South America, will provide extensive coverage of the archaeology and early colonial period of South America, replacing Vol. 2 of the long out-of-print *Handbook of South American Indians* (Vol. 2, Bulletin 143, Bureau of American Ethnology, Smithsonian, Washington DC, 1946). Although somewhat dated, Paul Kosok's *Life, Land and Water in Ancient Peru* (Long Island University Press, New York, 1965), is a profusely illustrated book focusing on Peru's coastal civilizations and how they coped with the challenges of living in the desert.

Eyewitness accounts of the Spanish conquest and colonial administration by sixteenth and seventeenth-century observers, translated into English (the original dates of publication are in square brackets), are those by Pedro de Cieza de León, *The Incas of Pedro de Cieza de León*, trans. Harriet de Onis, ed. Victor W. von Hagen, (University of Oklahoma Press, Norman, 1959 [1553]); two works by Bernabé Cobo, *History of the Inca Empire*, trans. Roland Hamilton, (University of Texas Press, Austin, 1983 [1653]) and *Inca Religion and Customs*, trans. Roland Hamilton, (University of Texas Press, Austin, 1990 [1653]); Inca Garcilaso de la Vega's *Royal Commentaries of the Inca and General History of Peru*, trans. Harold V. Livermore, (University of Texas Press, Austin, 1966 [1604]); and Juan de Betanzos' *Narrative of the Incas*, trans. and ed. Roland Hamilton and Dana Buchanan, (University of Texas Press, Austin, 1996 [1551]). Nineteenth-century travelogues, such as Charles Wiener's *Pérou et Bolivie, Récit de voyage* (Hachette, Paris, 1880), quoted in Chapter 4, and E. George Squier's *Peru: Incidents of Travel and Exploration in the Land of* the Incas (AMS Press, Cambridge, MA, 1973 [1877]), cited in Chapter 6, offer lively narratives with many descriptions of pre-Hispanic monuments.

For discussions of domesticated plants in the Andes, see Margaret Towle, *The Ethnobotany of Pre-Columbian Peru*, Viking Fund Publications in Anthropology, 30 (Aldine, Chicago, 1961), and Barbara Pickersgill and Charles B. Heiser Jr, "Origins and Distribution of Plants Domesticated in the New World Tropics" in David L. Browman (ed.), *Advances in Andean Archaeology* (Mouton, The Hague, 1978: pp. 133–65), as well as the National Research Council's *Lost Crops of the Incas: Little Known Crops of the Andes with Promise for Worldwide Cultivation* (National Academy Press, Washington DC, 1989). On the earliest mummies in the Andes, see Bernando T. Arriaza, *Beyond Death: The Chinchorro Mummies of Ancient Chile* (Smithsonian, Washington DC, 1995) and, by the same author, "Chile's Chinchorro Mummies" (*National Geographic* 187/3, 1995: pp. 68–88).

Early monumental architecture

Michael E. Moseley analyzes the nature of early settlement on the coast of Peru and dependence on marine resources in *Maritime Foundations of Andean Civilization* (Cummings, Menlo Park, 1975).

A volume that explores the origins of monumental constructions in the central Andes is Christopher B. Donnan (ed.), *Early Ceremonial Architecture in the Andes* (Dumbarton Oaks, Washington DC, 1991); on Aspero, see the chapter by Robert A. Feldman "Preceramic Corporate Architecture: Evidence for the Development of Non-Egalitarian Social Systems in Peru" (pp. 71–92), and that by Terence Grieder and Alberto Bueno Mendoza on their excavations at La Galgada, "Ceremonial Architecture at La Galgada" (pp. 93–110); for a more detailed report on the archaeology of La Galgada, see Terence Grieder, Alberto Bueno Mendoza, C. Earle Smith, Jr, and Robert M. Malina, La Galgada, *Peru: A Preceramic Culture in Transition* (University of Texas Press, Austin, 1988). *Early Ceremonial Architecture in the Andes* also includes chapters by Peruvian architect Carlos Williams on U-shaped ceremonial complexes, "A Scheme for the Early Monumental Architecture of the Central Coast of Peru" (pp. 227–40), and by Thomas C. Patterson on La Florida, "The Huaca La Florida, Rimac Valley, Peru" (pp. 59–69).

Jonathan Haas, Shelia Pozorski and Thomas Pozorski (eds), *The Origins and Development of the Andean State* (Cambridge University Press, Cambridge, 1987) also includes chapters on early sites, for example, Robert Feldman's analysis of Aspero, "Architectural Evidence for the Development of Nonegalitarian Social Systems in Coastal Peru" (pp. 9–14). Richard L. Burger and L. Salazar-Burger discuss the archaeology of Cardál in "Recent Excavations at the Initial Period Site of Cardal, Lurin Valley" (*Journal of Field Archaeology* 18, 1991: pp. 275–96).

Shelia Pozorski and Thomas Pozorski explore the archaeology of the Casma valley in *Early Settlement and Subsistence in the Casma Valley, Peru* (University of Iowa Press, Iowa City, 1990), while Thomas Pozorski discusses

the early occupation of the Caballo Muerto complex in "The Early Horizon Site of Huaca de los Reyes: Societal Implications" (*American Antiquity* 45, 1980: pp. 100–10). The friezes of Huaca de los Reyes are described by Michael E. Moseley and Luis Watanabe in "The Adobe Sculptures of Huaca de los Reyes" (*Archaeology* 27/3, 1974: pp. 154–61).

Chavín de Huántar

A fine discussion on the origins and rise of Chavín de Huántar, reflecting current research, is Richard L. Burger's *Chavín and the Origins of Andean Civilization* (Thames and Hudson, London and New York, 1992). Burger analyzes his excavations at Chavín in *The Prehistoric Occupation of Chavín de Huántar, Peru* (University of California Press, Berkeley, 1984).

Useful summaries of the extent of Chavín influence are also provided in articles by Burger: "Unity and Heterogeneity within the Chavín Horizon," in Richard Keatinge (ed.), *Peruvian Prehistory* (Cambridge University Press, Cambridge, 1988), pp. 99–144; "Concluding Remarks: Early Peruvian Civilization and its Relation to the Chavin Horizon," in Christopher B. Donnan (ed.), *Early Ceremonial Architecture in the Andes* (Dumbarton Oaks, Washington DC, 1991), pp. 269–89; and "The Sacred Center of Chavín de Huántar," in Richard F. Townsend (ed.), *The Ancient Americas: Art from Sacred Landscapes* (The Art Institute, Chicago, 1992), pp. 265–78.

Anthropologist Johan Reinhard explores mountain-worship in the Andes and its relationship to ceremonial centers in "Chavin and Tiahuanaco: A New Look at Two Andean Ceremonial Centers" (*National Geographic Research*, 1, 1985, pp. 395–422). For an analysis of Chavín art, see John H. Rowe, "Form and Meaning in Chavin Art," in John H. Rowe and Dorothy Menzel (eds), *Peruvian Archaeology: Selected Readings* (Peek Publications, Palo Alto, 1967), pp. 72–103. For a discussion of Chavín textile arts, see William J. Conklin, "Chavin Textiles and the Origin of Peruvian Weaving" (*Textile Museum Journal* 3/2, 1971, pp. 13–19).

The first cities

For the most up-to-date synthesis of Moche civilization, see Izumi Shimada's *Pampa Grande and the Mochica Culture* (University of Texas Press, Austin, 1994). For an analysis of burial patterns, see Christopher B. Donnan and Carol J. Mackey, *Ancient Burial Patterns of the Moche Valley, Peru* (University of Texas Press, Austin, 1978) and Christopher B. Donnan, "Moche Funerary Practice," in Tom D. Dillehay (ed.), *Tombs for the Living: Andean Mortuary Practices* (Dumbarton Oaks, Washington DC, 1995), pp. 111–59.

Christopher B. Donnan looks at the art of the Moche in *Moche Art and Iconography* (UCLA Latin American Center, Los Angeles, 1976) and discusses themes covered by Moche artists in "The Thematic Approach to Moche Iconography" (*Journal of Latin American Lore*, 1/2, 1975, pp. 147–62).

On the building of the Huaca del Sol, see Michael E. Moseley, "Prehistoric Principles of Labor Organization in the Moche Valley, Peru" (*American Antiquity*, 40, 1975, pp. 191–6), and Charles M. Hastings and Michael E. Moseley, "The Adobes of Huaca del Sol and Huaca de la Luna" (*ibid.* pp. 196–203).

Fred L. Nials *et al.* explore the effects of *Niños* on the ancient peoples of northern Peru in "El Niño: The Catastrophic Flooding of Coastal Peru" (*Field Museum of Natural History Bulletin*, 1979, 50/7, pp. 4–14, and 50/8, pp. 4–10), as does Michael E. Moseley, "Punctuated Equilibrium: Searching the Ancient Record for El Niño" (*Quarterly Review of Archaeology*, 8/3, 1987, pp. 7–10). Recent research on droughts and *Niños* in the Andes is summarized by Izumi Shimada, C.B. Schaaf, Lonnie G. Thompson and E. Mosley-Thompson in "Cultural Impacts of Severe Droughts in the Prehistoric Andes: Application of a 1,500-Year Ice Core Precipitation Record" (*World Archaeology*, 22, 1991, pp. 247–70).

For a compelling account of the discoveries and excavations at Sipán, see Walter Alva's "Discovering the New World's Richest Unlooted Tomb" (*National Geographic*, 174/4, 1988, pp. 510–48) and "New Tomb of Royal Splendor" (*National Geographic*, 177/6, 1990, pp. 2–15), as well as articles by Christopher B. Donnan, "Unraveling the Mystery of the Warrior-Priest" (*National Geographic*, 174/4, 1988, pp. 551–5) and "Masterworks of Art Reveal a Remarkable Pre-Inca World" (*National Geographic*, 177/6, 1990, pp. 16–33). The splendid works in metal uncovered by the excavations at Sipán are reviewed by Walter Alva and Christopher B. Donnan in the exhibition catalogue, *Royal Tombs of Sipán* (Fowler Museum of Cultural History, University of California, Los Angeles, 1993).

Christopher B. Donnan and Luis Jaime Castillo describe their discovery of a Moche priestess's tomb at San José de Moro in "Finding the Tomb of a Moche Priestess" (*Archaeology*, 45/6, 1992, pp. 38–42), while Steve Bourget discusses his finds of sacrificial victims at the Huaca de la Luna in Moche in "Patio 3A" in Santiago Uceda and Ricardo Morales (eds), *Proyecto Arqueológico Huaca de la Luna: Informe Técnico 1995*, Vol I: *Textos* (Universidad Nacional de La Libertad-Trujillo, Facultad de Ciencias Sociales, 1996), pp. 52–61. Alana Cordy-Collins explores the origins of the Moche decapitator deity in "Archaism or Tradition? The Decapitation Theme in Cupisnique and Moche Iconography" (*Latin American Antiquity* 3/3, 1992, pp. 206–20).

On late Moche settlement in the Trujillo valley, see Garth Bawden, "Galindo: A Study in Cultural Transition during the Middle Horizon," in Michael E. Moseley and Kent C. Day (eds), *Chan Chan: Andean Desert City* (University of New Mexico Press, Albuquerque, 1982), pp. 285–320. Late Moche occupation in the Lambayeque valley is explored by Izumi Shimada in *Pampa Grande and the Mochica Culture* (University of Texas Press, Austin, 1994).

Useful summaries of Moche metallurgy are provided by Julie Jones, "Mochica Works of Art in Metal: A Review," in Elizabeth P. Benson (ed.), *Pre-Columbian Metallurgy of South America* (Dumbarton Oaks,

Washington DC, 1979), pp. 53–104, as well as by Heather N. Lechtman, Antonieta Erlij and Edward J. Barry, "New Perspectives on Moche Metallurgy: Techniques of Gilding Copper at Loma Negra, Northern Peru" (*American Antiquity*, 7/1, 1982, pp. 3–30). The principal source on Andean metallurgy, with extensive analyses of Moche metalwork, is Lechtman's "The Central Andes: Metallurgy without Iron," in T. A. Wertime and J. D. Muhly (eds), *The Coming of the Age of Iron* (Yale University Press, New Haven, 1980), pp. 267–334, and the same author's "Traditions and Styles in Central Andean Metalworking," in Robert Maddin (ed.), *The Beginnings of the Use of Metals and Alloys* (MIT Press, Cambridge, MA, 1988), pp. 344–78. Moche weaving is addressed by William J. Conklin in "Moche Textile Structures," in Ann P. Rowe, Elizabeth P. Benson and A.L. Schaffer (eds), *The Junius B. Bird Pre-Columbian Textile Conference, May 19th and 20th, 1973* (Textile Museum and Dumbarton Oaks, Washington DC, 1979), pp. 165–84.

For the archaeology of Paracas, on Peru's south coast, see Anne Paul (ed.), *Paracas Art and Architecture: Object and Context in South Coastal Peru* (University of Iowa Press, Iowa City, 1991), especially the articles by Richard E. Daggett, "Paracas: Discovery and Controversy" (pp. 35–60), on Tello's excavations at Paracas, and by Helaine Silverman, "The Paracas Problem: Archaeological Perspectives" (pp. 349–416). On Paracas textiles, see Anne Paul's *Paracas Ritual Attire: Symbols of Authority in Ancient Peru* (University of Oklahoma Press, Norman, 1990). Silverman discusses her excavations at Cahuachi in *Cahuachi in the Ancient Nasca World* (University of Iowa Press, Iowa City, 1993).

For summaries of current research on the Nazca lines, see Anthony F. Aveni (ed.), *The Lines of Nazca* (American Philosophical Society, Philadelphia, 1990). Johan Reinhard reviews the Nazca lines and their relationship to mountains, fertility and water in *The Nazca Lines: A New Perspective on Their Origin and Meaning*, 4th ed. (Editorial Los Pinos, Lima, 1988). For accounts of the Nazca lines and the work of Maria Reiche, see Evan Hadingham's *Lines to the Mountain Gods: Nazca and the Mysteries of Peru* (Random House, New York, 1987) and Tony Morrison's *The Mystery of the Nasca Lines* (Nonesuch Expeditions, Woodbridge, 1987) and *Pathways to the Gods* (Harper & Row, New York, 1979).

For studies on Nazca settlement patterns and their relationship to the *puquios*, or underground filtration galleries, see Katharina J. Schreiber and José Lancho Rojas, "The Puquios of Nazca" (*Latin American Antiquity*, 6/3, 1995, pp. 229–54). For an analysis of their dating, see Persis B. Clarkson and Ronald I. Dorn, "New Chronometric Dates for the Puquios of Nasca, Peru" (*Latin American Antiquity*, 6/1, 1995, pp. 56–69). Monica Barnes and David Fleming posit a post-conquest date for the *puquios* in "Filtration-Gallery Irrigation in the Spanish New World" (*Latin American Antiquity*, 2/1, 1991, pp. 48–68).

Imperial cities

On Chiripa, the culture that united the Titicaca basin before the rise of Tiwanaku, see Karen Mohr Chavez, "The Significance of Chiripa in Lake Titicaca Basin Developments" (*Expedition*, 30/3, 1988, pp. 13–19). For accounts of early exploration at Tiwanaku, see Arthur Posnansky, *Tihuanacu: La Cuna del Hombre Americano/Tihuanacu: The Cradle of Western Man*, 2 vols (J. J. Augustin, New York, 1945), and Wendell C. Bennett, "Excavations at Tiahuanaco" (*Anthropological Papers of the American Museum of Natural History*, Vol. 34, Pt. 4, 1934); the excavations at Pukara are addressed by Alfred Kidder, "Some Early Sites in the Northern Lake Titicaca Basin" (*Papers of the Peabody Museum*, Vol. XXVII/1, 1943).

On the rise of Tiwanaku, see David Browman, "New Light on Andean Tiwanaku" (*American Scientist*, 69, 1980, pp. 408–19), and his "Toward the Development of the Tiahuanaco (Tiwanaku) State," in David L. Browman (ed.), *Advances in Andean Archaeology* (Mouton, The Hague, 1978), pp. 326–49. Johan Reinhard explores Tiwanaku's relationship to mountain-worship in "Chavin and Tiahuanaco: A New Look at two Andean Ceremonial Centers" (*National Geographic Research*, 1, 1985, pp. 395–422). Alan L. Kolata summarizes current research at Tiwanaku, based on recent excavations, in *Tiwanaku: Portrait of an Andean Civilization* (Blackwell, Oxford and Cambridge, MA, 1993) and *Valley of the Spirits: A Journey into the Lost Realm of the Aymara* (John Wiley, New York, 1996).

For a popular account of *waru waru*, raised-field systems, in the Titicaca basin, see Baird Straughan, "The Secrets of Ancient Tiwanaku are Benefiting Today's Bolivia" (*Smithsonian*, February 1991, pp. 38–48). Clark L. Erickson looks at *waru waru* on the Peruvian side of the lake in "Application of Prehistoric Andean Technology: Experiments in Raised Field Agriculture, Huatta, Lake Titicaca: 1981–82," in Ian Farrington (ed.), *Prehistoric Intensive Agriculture in the Tropics* (British Archaeological Reports, International Series, No. 232, Oxford, 1985), pp. 209–32, and in "Raised Field Agriculture in the Lake Titicaca Basin: Putting Ancient Agriculture Back to Work" (*Expedition*, 30/3, 1988, pp. 8–16). For descriptions of raised fields on the Bolivian side of the lake, see Alan L. Kolata, "The Agricultural Foundations of the Tiwanaku State: A View from the Heartland" (*American Antiquity*, 51, 1986, pp. 748–62) and his "The Technology and Organization of Agricultural Productivity in the Tiwanaku State" (*Latin American Antiquity*, 2, 1991, pp. 99–125), as well as Kolata (ed.) *Tiwanaku and its Hinterland: Archaeology and Paleoecology of an Andean Civilization* (Smithsonian Institution Press, Washington and London, 1996). For a different perspective, see Charles Stanish, "The Hydraulic Hypothesis Revisited: Lake Titicaca Basin Raised Fields in Theoretical Perspective" (*Latin American Antiquity*, 5/4, 1994, pp. 312–32) and Gray Graffam, "Beyond State Collapse: Rural History, Raised Fields, and Pastoralism in the South Andes" (*American Anthropologist*, 94/4, 1992, pp. 882–904).

Amy Oakland Rodman explores Tiwanaku textiles in "Textiles and Ethnicity: Tiwanaku in San Pedro de Atacama, North Chile" (*Latin American Antiquity*, 3/4, 1992, pp. 316–40); a related article is William J. Conklin's "Pucara and Tiahuanaco Tapestry: Time and Style in a Sierra Weaving Tradition" (*Ñawpa Pacha*, 21, 1983, pp. 1–44). Paul Goldstein looks at the largest Tiwanaku settlement outside the Titicaca basin in "Tiwanaku Temples and State Expansion: A Tiwanaku Sunken-Court Temple in Moquegua, Peru" (*Latin American Antiquity*, 4/1, 1993, pp. 22–47).

For the most up-to-date coverage of current excavations and research on Wari and Tiwanaku, see William J. Isbell and Gordon F. McEwan (eds), *Huari Administrative Structure: Prehistoric Monumental Architecture and State Government* (Dumbarton Oaks, Washington DC, 1991), particularly the chapters by Isbell and McEwan, "A History of Huari Studies and Introduction to Current Interpretations" (pp. 1–18); William J. Conklin, "Tiahuanaco and Wari: Architectural Comparisons and Interpretations (pp. 281–91), and Michael E. Moseley, Robert A. Feldman, Paul S. Goldstein and Luis Watanabe, "Colonies and Conquest: Tiahuanaco and Huari in Moquegua" (pp. 93–119).

In the same volume, Isbell analyzes Wari architecture, in "Huari Administration and the Orthogonal Cellular Architecture Horizon" (pp. 293–315); see also, William J. Isbell, Christine Brewster-Wray and Lynda E. Spickard, "Architecture and Spatial Organization at Huari" (pp. 19–53). On the nature of Wari, the city, and its settlement patterns, see William J. Isbell, "City and State in Middle Horizon Huari," in Richard Keatinge (ed.), *Peruvian Prehistory* (Cambridge University Press, Cambridge, 1988), pp. 164–89, and William J. Isbell and Katharina J. Schreiber, "Was Huari a State?" (*American Antiquity*, 43/3, 1978, pp. 372–89).

In Isbell and McEwan's Dumbarton Oaks volume, Mario Benavides reports on his excavations at Wari, in "Cheqo Wasi, Huari" (pp. 55–69); Martha B. Anders discusses her work at Azángaro in "Structure and Function at the Planned Site of Azangaro: Cautionary Notes for the Model of Huari as a Centralized Secular State" (pp. 165–97); John R. Topic looks at Wari occupation in the north in "Huari and Huamachuco" (pp. 141–64); Gordon F. McEwan reviews his work at Pikillacta in "Investigations at the Pikillacta Site: A Provincial Huari Center in the Valley of Cuzco" (pp. 93–119) and in a later article, "Archaeological Investigations at Pikillacta, A Wari Site in Peru" (*Journal of Field Archaeology*, 23/2, 1996, pp. 169–86).

Katharina J. Schreiber addresses the nature of Wari rule beyond Ayacucho, focusing on her research in the Carhuarazo valley, in *Wari Imperialism in Middle Horizon Peru* (Museum of Anthropology, University of Michigan, Anthropological Papers, No. 87, Ann Arbor, 1992), and discusses Wari roads in "The Association between Roads and Polities: Evidence for Wari Roads in Peru," in Charles D. Trombold (ed.), *Ancient Road Networks and Settlement Hierarchies in the New World* (Cambridge University Press, Cambridge, 1991), pp. 243–52. On the famed pilgrimage site of Pachacamac and

Max Uhle's landmark excavations, see Izumi Shimada's introduction, "Pachacamac Archaeology: Retrospect and Prospect," in Max Uhle, *Pachacamac, A Reprint of the 1903 Edition* (University Museum of Archaeology and Anthropology, Philadelphia, 1991), pp. xv–lxvi.

The principal source on the iconography of Wari ceramics and dating is Dorothy Menzel, "Style and Time in the Middle Horizon" (*Ñawpa Pacha*, 2, 1964, pp. 1–105); see also, "New Data on the Huari Empire in Middle Horizon Epoch 2A" (*Ñawpa Pacha*, 6, 1968, pp. 47–114), and *The Archaeology of Ancient Peru and the Work of Max Uhle* (R. W. Lowie Museum of Anthropology, University of California, Berkeley, 1977). Anita Cook explores the similarities between Wari and Tiwanaku iconography in "Aspects of State Identity in Huari and Tiwanaku Iconography: The Central Deity and the Sacrificer," in Daniel H. Sandweiss (ed.), *Investigations of the Andean Past: Papers from the First Annual Northeast Conference on Andean Archaeology and Ethnohistory* (Cornell University Press, Ithaca, 1983), pp. 161–85.

Cities of the desert

The ethnohistory of Chimor is reviewed by John H. Rowe in "The Kingdom of Chimor" (*Acta Americana*, 6/1–2, 1948, pp. 26–59). On excavations and research at Chan Chan, see Michael E. Moseley and Carol J. Mackey, *Twenty-Four Architectural Plans of Chan Chan, Peru* (Peabody Museum, Cambridge, MA, 1974), which includes plans of the *ciudadelas*, and Michael E. Moseley and Kent C. Day (eds), *Chan Chan: Andean Desert City* (University of New Mexico Press, Albuquerque, 1982), especially chapters by Kent C. Day, "Ciudadelas: Their Form and Function" (pp. 55–66); Alan L. Kolata, "Chronology and Settlement Growth at Chan Chan" (pp. 67–86); Alexandra M. Ulana Klymyshyn, "Elite Compounds in Chan Chan" (pp. 119–44); Geoffrey W. Conrad, "The Burial Platforms of Chan Chan: Some Social and Political Implications" (pp. 87–118); and John R. Topic, "Lower Class Social and Economic Organization at Chan Chan" (pp. 145–77).

Maria Rostworowski de Diez Canseco and Michael E. Moseley (eds), *The Northern Dynasties: Kingship and Statecraft in Chimor* (Dumbarton Oaks, Washington DC, 1990) also covers aspects of Chan Chan; see, for example, Alan L. Kolata, "The Urban Concept of Chan Chan" (pp. 107–44); John R. Topic, "Craft Production in the Kingdom of Chimor" (pp. 145–76); Michael E. Moseley, "Structure and History in the Dynastic Lore of Chimor" (pp. 1–42); Patricia J. Netherly, "Out of Many, One: The Organization of Rule in the North Coast Polities" (pp. 461–88).

On the nature of Chimú expansion and administration beyond Chan Chan, see, in the same volume, Theresa Lange Topic's chapter, "Territorial Expansion and the Kingdom of Chimor" (pp. 177–95); Geoffrey W. Conrad, "Farfan, General Pacatnamu, and the Dynastic History of Chimor (pp. 227–42); and Carol J. Mackey and A. M. Ulana Klymyshyn, "The Southern Frontier of the Chimu Empire" (pp. 195–226). Mackey explores Chimú administration on the southern fringes of its territory in

"Chimu Administration in the Provinces," in Jonathan Haas, Shelia Pozorski and Thomas Pozorski (eds) *The Origins and Development of the Andean State* (Cambridge University Press, Cambridge, 1987), pp. 121–9.

On agriculture and irrigation in the Chimú heartland, see Michael E. Moseley and Eric E. Deeds, "The Land in Front of Chan Chan: Agrarian Expansion, Reform, and Collapse in the Moche Valley," in Michael E. Moseley and Kent C. Day (eds), *Chan Chan: Andean Desert City* (University of New Mexico Press, Albuquerque, 1982), pp. 25–54; Charles R. Ortloff, Michael E. Moseley and Robert A. Feldman, "Hydraulic Engineering Aspects of the Chimu Chicama–Moche Inervalley Canal" (*American Antiquity*, 47/3, 1982, pp. 572–95), as well as James S. Kus, "The Chicama–Moche Canal: Failure or Success? An Alternative Explanation for an Incomplete Canal" (*American Antiquity*, 49/2, 1984, pp. 408–15). See also Charles R. Ortloff, "Chimu Hydraulics, Technology and Statecraft on the North Coast of Peru, A.D. 1000–1470," in Vernon L. Scarborough and Barry L. Isaac (eds), *Research in Economic Anthropology* (JAI Press, Greenwich, CT, 1993), pp. 327–67, and, by the same author, "Canal Builders of Ancient Peru" (*Scientific American*, 256/12, 1988, pp. 67–74).

Izumi Shimada addresses the nature of the late Moche to Inka occupations in the Lambayeque valley in "Cultural Continuities and Discontinuities on the Northern North Coast of Peru, Middle–Late Horizons," in Maria Rostworowski de Diez Canseco and Michael E. Moseley (eds), *The Northern Dynasties: Kingship and Statecraft in Chimor* (Dumbarton Oaks, Washington DC, 1990), pp. 297–392. Shimada discusses his excavations at Batán Grande in "Temples of Time: The Ancient Burial and Religious Center of Batán Grande, Peru" (*Archaeology*, 34/5, 1981, pp. 37–44), and in Shimada *et al.*, "The Batan Grande–La Leche Archaeological Project: The First Two Seasons" (*Journal of Field Archaeology*, 8/4, 1981, pp. 405–46). On the flooding of Batán Grande, see Alan K. Craig and Izumi Shimada, "El Niño Flood Deposits at Batán Grande, Northern Peru" (*Geoarchaeology* I, 1986, pp. 29–38).

Metallurgy and mining at Batán Grande are explored by Izumi Shimada, Stephen M. Epstein and Alan F. Craig in "Batan Grande: A Prehistoric Metallurgical Center in Peru" (*Science*, 216, 1982, pp. 952–9), and in their "The Metallurgical Process in Ancient North Peru" (*Archaeology* 36/5, 1983, pp. 38–45); see also Izumi Shimada and John F. Merkel, "Copper Alloy Metallurgy in Ancient Peru" (*Scientific American*, 265/1, 1991, pp. 80–6), and Izumi Shimada and Jo Ann Griffin, "Precious Metal Objects of the Middle Sicán" (*Scientific American*, [April 1994], pp. 82–9). Paloma Carcedo Muro and Izumi Shimada look at the looting history of Batán Grande in "Behind the Golden Mask: The Sicán Gold Artifacts from Batan Grande, Peru," in Julie Jones (ed.), *Art of Precolumbian Gold: The Jan Mitchell Collection* (Weidenfeld and Nicolson, London, 1985), pp. 60–75. For a discussion of Chimú weaving, see Ann P. Rowe, *Costumes and Featherwork of the Lords of Chimor: Textiles from Peru's North Coast* (Textile Museum, Washington DC, 1984).

On the archaeology of Túcume and its Lambayeque, Chimú and Inka occupations, see Thor Heyerdahl, Daniel H. Sandweiss and Alfredo Narváez *Pyramids of Túcume: The Quest for Peru's Forgotten City* (Thames and Hudson, London and New York, 1995).

The archaeology of the south-coast Chincha valley is reviewed by Dorothy Menzel and John H. Rowe, "The Role of Chincha in Late Pre-Spanish Peru" (*Ñawpa Pacha*, 4, 1966, pp. 63–76) and by Dwight T. Wallace, "The Chincha Roads: Economics and Symbolism," in Charles D. Trombold (ed.), *Ancient Road Networks and Settlement Hierarchies in the New World* (Cambridge University Press, Cambridge, 1991), pp. 253–63.

Jeffrey R. Parsons and Charles M. Hastings explore the archaeology of the central and southern highlands of Peru in "The Late Intermediate Period" in Richard Keatinge (ed.), *Peruvian Prehistory* (Cambridge University Press, Cambridge, 1988), while John Hyslop reviews the culture history of Titicaca-basin societies on the eve of the Inka conquest, in "Chulpas of the Lupaca Zone of the Peruvian High Plateau" (*Journal of Field Archaeology*, 4, 1977, pp. 149–70) and in "Hilltop Cities in Peru" (*Archaeology*, 30/4, 1977, pp. 218–26). For the pre-Inka Wanka societies in the Mantaro valley of Peru's central highlands, see the relevant chapters in Terence D'Altroy's *Provincial Power in the Inka Empire* (Smithsonian, Washington DC, 1992). Brian S. Bauer explores the nature of the pre-Inka cultures in the Cuzco valley, in *The Development of the Inka State* (University of Texas Press, Austin, 1992).

The Inka empire

Although long out of print, a classic on the history and archaeology of Tawantinsuyu is John H. Rowe's "Inca Culture at the Time of the Spanish Conquest," in Julian H. Steward (ed.), *Handbook of South American Indians* (Vol. 2, Bulletin 143, Bureau of American Ethnology, Smithsonian, Washington DC, 1946, pp. 183–330). Rowe has stressed chronology and brought a strong historical tradition to the material. For a similar treatment, see, for example, Richard P. Schaedel, "Early State of the Incas," in H. Claessen and P. Skalnik (eds), *The Early State* (Mouton, The Hague, 1978), pp. 289–330.

On the layout of Inka Cuzco, John H. Rowe, "What Kind of a Settlement was Inca Cuzco?" (*Ñawpa Pacha* 5, 1967, pp. 59–76) is a portrait of the imperial capital, based on the author's surveys and early Colonial accounts. Both John Hyslop's *Inka Settlement Planning* (University of Texas Press, Austin, 1990) and Graziano Gasparini and Luise Margolies' *Inca Architecture*, trans. Patricia J. Lyon (University of Indiana Press, Bloomington, 1980) devote chapters to Inka Cuzco, drawing on early Spanish eyewitness reports and architectural and archaeological evidence.

Cobo's account of the ceque system is translated and analyzed by Rowe in "An Account of the Shrines of Ancient Cuzco" (*Ñawpa Pacha*, 17, 1979, pp. 2–80). See also, Tom Zuidema, "The Ceque System of Cuzco: The Social Organization of the Capital of the Inca" (*International Archives of Ethnography*, supplement to Vol. 5,

1964) and Brian S. Bauer, "Ritual Pathways of the Inca: An Analysis of the Collasuyu Ceques in Cuzco" (*Latin American Antiquity*, 3/3, 1993, pp. 183–205).

Much of what we know about the Inka is based on research beyond the imperial capital, for instance, Susan A. Niles, *Callachaca: Style and Status in an Inca Community* (University of Iowa Press, Iowa City, 1987). The "royal estates" near Cuzco are addressed by Susan A. Niles, in "Looking for 'Lost' Inca Palaces" (*Expedition*, 30, 1988, pp. 56–64), Ian S. Farrington, "The Mummy, Palace and Estate of Inka Huayna Capac at Quispeguanca" (*Tawantinsuyu*, 1, 1995, pp. 55–64), and Jean-Pierre Protzen, *Inca Architecture and Construction at Ollantaytambo* (Oxford University Press, New York and Oxford, 1993).

On Machu Picchu, the most famous Urubamba valley site, see Hiram Bingham's account of his 1911 discovery, *Machu Picchu: A Citadel of the Incas* (National Geographic Society and Yale University Press, New Haven, 1930; reprint Hacker Books, New York, 1970) and the biography by his son, Alfred M. Bingham, *Portrait of an Explorer: Hiram Bingham, Discoverer of Machu Picchu* (Iowa State University Press, Ames, 1989). Johan Reinhard, *Machu Picchu: The Sacred Center* (Nuevas Imagenes, Lima, 1991), links Machu Picchu to the sacred geography of the region.

Farther afield, Craig Morris and Donald E. Thompson, *Huánuco Pampa: An Inca City and its Hinterland* (Thames and Hudson, London and New York, 1985) and "Huánuco Viejo: An Inca Administrative Center," (*American Antiquity*, 35/3, 1970, pp. 344–62) detail excavations at this administrative center on the highland road connecting Cuzco and Ecuador.

There is a fine discussion of the economy of the Inka empire in John V. Murra, *The Economic Organization of the Inca State* (JAI Press, Greenwich, CT, 1980). On the *quipu* used by the Inka to keep track of their wealth and to manage their subjects, see Marcia Ascher and Robert Ascher, *Code of the Quipu: A Study in Media, Mathematics and Culture* (University of Michigan Press, Ann Arbor, 1981).

The discovery in 1995 of a young woman sacrificed on the summit of Mt Ampato as part of the Qhapaq Hucha sacrificial cycle is retold by Johan Reinhard in "Peru's Ice Maidens: Unwrapping the Secrets," (*National Geographic*, 190/6, 1996, pp. 62–81) and "Sharp Eyes of Science Probe the Mummies of Peru" (*National Geographic*, 191/1, 1997, pp. 36–43). On mountain-worship and human sacrifice, see Reinhard, "Sacred Peaks of the Andes" (*National Geographic*, 181/3, 1992, pp. 84–111), and "Sacred Mountains: An Ethno-Archaeological Study of High Andean Ruins" (*Mountain Research and Development*, 5/4, 1985, pp. 299–317), as well as Juan Schobinger, "Sacrifices of the High Andes" (*Natural History* 4, 1991, pp. 63–9). Colin McEwan and Maarten van de Guchte analyze aspects of the Qhapaq Hucha sacrificial cycle in "Ancestral Time and Sacred Space in Inca State Ritual," in Richard F. Townsend (ed.), *The Ancient Americas: Art from Sacred Landscapes* (The Art Institute, Chicago, 1992), pp. 359–71.

John V. Murra's "Cloth and its Functions in the Inca State" (*American Anthropologist*, 64, 1962, pp. 710–28) is still the best overview of the symbolism and uses of Inka weavings. See also, Heather N. Lechtman, "Technologies of Power: The Andean Case," in John S. Henderson and Patricia J. Netherly (eds), *Configurations of Power: Holistic Anthropology in Theory and Practice* (Cornell University Press, Ithaca, 1993), pp. 244–80. For analyses of Inka weaving structure and design, see John H. Rowe, "Standardization in Inca Tapestry Tunics," in Ann P. Rowe, Elizabeth P. Benson and A.L. Schaffer (eds), *The Junius B. Bird Pre-Columbian Textile Conference, May 19th and 20th, 1973* (Textile Museum and Dumbarton Oaks, Washington DC, 1979), pp. 239–64, and Anne P. Rowe, "Technical Features of Inca Tapestry Tunics" (*Textile Museum Journal*, 17, 1978, pp. 5–28).

For accounts of the Spanish conquest and the early years of colonial rule, see John Hemming, *The Conquest of the Incas* (Penguin Books, Harmondsworth, 1983) and James Lockhart, *Spanish Peru, 1532–1560* (University of Wisconsin Press, Madison, 1968) and, by the same author, *Men of Cajamarca: A Social and Biographical Study of the First Conquerors of Peru* (University of Texas Press, Austin, 1972). The impact of the Spanish invasion is explored by Nathan Wachtel in *The Vision of the Vanquished* (Barnes and Noble, New York, 1977). On the effects of western diseases in the New World, see John W. Verano and Douglas H. Ubelaker (eds), *Disease and Demography in the Americas* (Smithsonian, Washington, 1992), of particularl interest are the articles by John W. Verano, "Prehistoric Disease and Demography in the Andes" (pp. 15–24), and Noble David Cook, "Impact of Disease in the Sixteenth-Century Andean World" (pp. 207–14) as well as Cook's *Demographic Collapse, Indian Peru 1520–1620* (Cambridge University Press, Cambridge, 1981).

Notes to the text

1 Felipe Guaman Poma de Ayala [1614], *Nueva Corónica y Buen Gobierno*, transcribed and ed. Franklin Pease, 2 vols (Biblioteca Ayacucho, Caracas, 1980), p. 46.
2 Richard L. Burger, *Chavín and the Origins of Andean Civilization* (Thames and Hudson, London and New York, 1992), p. 87.
3 *Ibid*, p. 87.
4 Pedro de Cieza de León [1553], *The Incas of Pedro de Cieza de León*, trans. Harriet de Onis, ed. Victor W. von Hagen, (University of Oklahoma Press, Norman, 1959), p. 107.
5 Charles Wiener, *Pérou et Bolivie, Récit de Voyage* (Hachette, Paris, 1880), p. 203.
6 Burger, *op. cit.*, p. 165.
7 Cieza, *op. cit.*, p. 335.
8 Miguel de Estete [1533], "Report of Miguel de Astete [sic] on the Expedition to Pachacamac," trans. and ed. Clements R. Markham, *Reports on the Discovery of Peru* (Hakluyt Society, London, 1872), p. 82.
9 Helaine Silverman, *Cahuachi in the Ancient Nasca World* (University of Iowa Press, Iowa City, 1993), p. 326.
10 E. George Squier, *Peru: Incidents of Travel and Exploration in the Land of the Incas* (Harper & Brothers, New York, 1877), p. 273.
11 Alan L. Kolata, *Tiwanaku: Portrait of an Andean Civilization* (Blackwell, Oxford and Cambridge, MA, 1993), p. 173.
12 Cieza, *op. cit.*, p. 283.
13 *Ibid.*, p. 283.
14 Bernabé Cobo [1653], *Inca Religion and Customs*, trans. Ronald Hamilton, (University of Texas Press, Austin, 1990), p. 32.
15 Kolata, *op. cit.*, p. 230.
16 Cieza, *op. cit.*, p. 123.
17 Gordon F. McEwan, "Investigations at the Pikillacta Site: A Provincial Huari Center in the Valley of Cuzco," in William J. Isbell and Gordon F. McEwan (eds), *Huari Administrative Structure: Prehistoric Monumental Architecture and State Government* (Dumbarton Oaks, Washington DC, 1991), p. 98.
18 Quoted in Maria Rostworowski de Diez Canseco, "Mercaderes del Valle de Chincha en la época Prehispánica: Un documento y unos comentarios", *Revista Española de Antropología Americana*, 5, 1970, pp. 170–71.
19 Cieza, *op. cit.*, p. 71.
20 Graziano Gasparini and Luise Margolies, *Inca Architecture*, trans. Patricia J. Lyon (University of Indiana Press, Bloomington, 1980), p. 195.
21 Alexander von Humboldt, cited in Jean-Pierre Protzen, *Inca Architecture and Construction at Ollantaytambo* (Oxford University Press, New York and Oxford, 1993), p. 11.
22 Pedro Sancho de la Hoz [1534], cited in John H. Rowe, "What Kind of a Settlement was Inca Cuzco?," *Ñawpa Pacha*, 17, 1968, p. 63.
23 Cieza, *op. cit.*, p. 144.
24 *Ibid.*, p. 156.
25 Cristóbal de Molina [1575], cited in Gasparini and Margolies, *op. cit.*, p. 49.
26 Cobo, *op. cit.*, pp. 3–4.
27 Cieza, *op. cit.*, p. 62.
28 *Ibid.*, p. 148.
29 Juan de Betanzos [1551], *Narrative of the Incas*, trans. and ed. Roland Hamilton and Dana Buchanan, (University of Texas Press, Austin, 1996), p. 74.
30 *Ibid.*, p. 69.
31 Cobo, *op. cit.*, p. 15
32 Inca Garcilaso de la Vega [1604], *Royal Commentaries of the Inca and General History of Peru*, trans. Harold V. Livermore, (University of Texas Press, Austin, 1987), p. 428.
33 Cieza, *op. cit.*, p. 183.
34 *Ibid.*, p. 144.
35 Sancho, cited in John Hemming, *The Conquest of the Incas* (Penguin, Harmondsworth 1983), p. 119.
36 Inca Garcilaso, *op. cit.*, p. 426.
37 Cieza, *op. cit.*, pp. 146–7.
38 *Ibid.*, p. 145.
39 Sancho, cited in John Hyslop, *Inka Settlement Planning* (University of Texas Press, Austin, 1990), p. 54.
40 Cieza, *op. cit.*, p. 153.
41 Sancho, cited in Hyslop, *op. cit.*, p. 54.
42 Cieza, *op. cit.*, p. 153.
43 Garcilaso, cited in Jean-Pierre Protzen, *Inca Architecture and Construction at Ollantaytambo* (Oxford University Press, New York and Oxford, 1993), p. 17.
44 Cieza, *op. cit.*, p. 138.
45 *Ibid.*, p. 140.
46 *Ibid.*, p. 109.
47 Cristóbal de Molina (El Almagrista) [1553], cited in Craig Morris and Donald E. Thompson, *Huánuco Pampa: An Andean City and its Hinterland* (Thames and Hudson, London and New York, 1985), p. 59.
48 Betanzos, *op. cit.*, p. 254.
49 *Ibid.*, pp. 264–5.
50 Cieza, *op. cit.*, p. 62.
51 Pedro Gutiérrez de Santa Clara [c. 1555], cited in John Hyslop, *Inka Settlement Planning* (University of Texas Press, Austin, 1990), p. 55.
52 Cobo, *op. cit.*, p. 154.
53 *Ibid.*, p. 154.
54 *Ibid.*, p. 154.

List of illustrations

HALF-TITLE Tiwanaku gold plaque. Photo John Bigelow Taylor, courtesy Hoover Institution, Stanford University.

TITLE PAGE Pisac, Inka site in the Urubamba valley. Photo Christopher Rennie, Robert Harding Picture Library.

Chronological chart. Drawing Ben Cracknell.

1 Map of Andean countries. Drawing Petica Barry.
2 Sand dunes on Peru's north coast. Photo Heinz Plenge.
3 Oxbow lake, Amazon rainforest. Photo Adriana von Hagen.
4 Farmland near Cuzco. Photo Adriana von Hagen.
5 Reed boats on north coast of Peru. Photo Heinz Plenge.
6 Eruption of Huaynaputina. Drawing Felipe Guaman Poma de Ayala.
7 Flooding in northern Peru during 1982-83 El Niño. Photo Caretas.
8 Cordillera Blanca, Peru. Photo Adriana von Hagen.
9 Alpacas in their corral. Photo Tafos.
10 Llama caravan. Photo Tafos.
11 Quinoa. Photo Adriana von Hagen.
12 Coca. Photo Adriana von Hagen.
13 Maize. Photo Adriana von Hagen
14 Lupine. Photo Adriana von Hagen
15 Mashwa. Photo Adriana von Hagen
16 Farmers working fields with Andean foot-plow. Photo Tafos.
17 Sorting potatoes for processing into chuño. Photo Tafos.
18 Finely-built structures at Huánuco Pampa. Photo Craig Morris, courtesy American Museum of Natural History.

19 The circular plaza at Chavín de Huántar. Photo Wilfredo Loayza.
20 Aerial view of Lima's San Isidro district. Photo Servicio Aerofotográfico Nacional.
21 Aerial view of Ciudadela Laberinto, Chan Chan. Photo Shippee-Johnson, negative no. 334899, courtesy Department of Library Services, American Museum of Natural History.
22 Map of principal sites discussed in Chapter 3. Drawing Petica Barry.
23 Huaca de los Idolos, Aspero, isometric reconstruction. Drawing Diana Salles, after Robert Feldman, fig. 3, 1985: 75.
24 Temple of the Crossed Hands, Kotosh, Peru. Photo courtesy Yoshio Onuki, University of Tokyo.
25 Temple of the Crossed Hands, White Temple, Kotosh, Peru, reconstruction. Drawing Michael Glavin, after Seiichi Izumi, fig. 12, 1971: 65.
26 Temple of Crossed Hands, detail of one of the temple reliefs. Photo courtesy Yoshio Onuki, University of Tokyo.
27 La Galgada, Tablachaca canyon, Peru. Photo ©Edward Ranney.
28 U-shaped temple complex, idealized reconstruction. Drawing Diana Salles, after Carlos Williams, fig. 2, 1985: 229.
29 Detail of mudbrick frieze at Garagay, Rímac valley. Photo © Edward Ranney.
30 Cardál, aerial view of the central mound. Photo Richard L. Burger.
31 Cardál, detail of central stairway leading to atrium. Photo Richard L. Burger.
32 Cardál, isometric reconstruction of central stairway. Drawing Michael Glavin, after Richard L. Burger fig. 52, 1992: 67.
33 Sechín Alto, Casma valley, view from the summit. Photo Adriana von Hagen.
34 Cerro Sechín, Casma valley, victorious warrior on temple façade. Photo © Edward Ranney.
35 Cerro Sechín, Casma valley, defeated warrior on temple façade. Photo © Edward Ranney.
36 Huaca de los Reyes, Moche valley, detail of mud brick frieze decorating main façade. Photo Thomas Pozorski.

37 Huaca de los Reyes, Moche valley, detail of superimposed frieze set within a niche. Photo Thomas Pozorski.
38 Carved shell figurine of human-like figure. Photo John Bigelow Taylor, catalogue no. 41.2/8549, courtesy Department of Library Services, American Museum of Natural History.
39 Cupisnique-style ceramic vessel with feline and cacti. Photo John Bigelow Taylor, catalogue no. 41.2/7517, negative no. 5020, courtesy Department of Library Services, American Museum of Natural History.
40 Map of principal sites discussed in Chapter 4. Drawing Petica Barry.
41 Chavín de Huántar, bridge crossing the Wacheqsa river. Photo courtesy Billy Hare.
42 Chavín de Huántar, plan of sacred center. Drawing Michael Glavin, after Richard L. Burger, fig. 2, 1992: 26.
43 Chavín de Huántar, two tenoned heads. Photo Heinz Plenge
44 Chavín de Huántar, with Mt Huantsán in background. Photo Johan Reinhard.
45 Chavín de Huántar, detail of human figure, sunken circular courtyard. Photo Wilfredo Loayza.
46 Chavín de Huántar, detail of feline figure, sunken circular courtyard. Photo Wilfredo Loayza.
47 Chavín de Huántar, the Lanzón. Photo Alejandro Balaguer.
48 Chavín de Huántar, cross section, plan and drawing of sunken circular courtyard and Old Temple. Drawing courtesy Michael E. Moseley, fig. 66, 1992: 154.
49 Chavín de Huántar, eastern façade, Black and White Portal. Photo Heinz Plenge.
50 Lambayeque- (Sicán-) style gold funerary mask excavated at Batán Grande. Photo Yutaka Yoshii, Sicán Archaeological Project.
51 Gold crown found at Kuntur Wasi. Photo courtesy Yoshio Onuki, University of Tokyo.
52 Gold pectoral found at Kuntur Wasi. Photo courtesy Yoshio Onuki, University of Tokyo.
53 Kuntur Wasi, reconstruction of summit. Drawing Michael Glavin, after Yoshio Onuki, fig. 3, 1995: 49.
54 Gold and silver Chavín-style

snuff spoon. Photo Dumbarton Oaks Research Library and Collections, Washington DC.

55 Gilded copper feline excavated at Sipán. Photo Susan Einstein.

56 Map of principal sites discussed in Chapter 6. Drawing Petica Barry.

57 Plan of the Huaca del Sol and Huaca de la Luna, Moche valley. Drawing Michael Glavin, after Izumi Shimada, fig. 17, 1994: 17.

58 The Huaca del Sol and Huaca de la Luna, aerial view. Photo Shippee-Johnson, Negative No. 334917, courtesy Department of Library Services, American Museum of Natural History.

59 Residential remains at foot of Huaca de la Luna. Photo Adriana von Hagen.

60 Array of maker's marks found on adobe bricks at the Huaca del Sol. Courtesy Michael E. Moseley.

61 A necklace of gold spiders excavated at Sipán. Photo Christopher B. Donnan and Donald McClelland.

62 Cerro Blanco, background, and excavations, foreground. Photo Adriana von Hagen.

63 Huaca de la Luna, mud-brick frieze. Photo Adriana von Hagen.

64 Huaca de la Luna, detail of frieze. Photo Adriana von Hagen.

65 Huaca de la Luna, detail of frieze. Photo Adriana von Hagen.

66 Huaca de la Luna, detail of frieze. Photo Adriana von Hagen.

67 Painted Moche ceramic vessel. Photo John Bigelow Taylor, catalogue no. 41.2/7877, courtesy Department of Library Services, American Museum of Natural History.

68 Sipán, aerial view. Photo Adriana von Hagen.

69 The Huaca Fortaleza at Pampa Grande. Photo © Edward Ranney.

70 Double-faced, embroidered textile, Paracas. Photo John Bigelow Taylor, catalogue no. 41.2/714, courtesy Department of Library Services, American Museum of Natural History.

71 Detail of an embroidered Paracas mantle. Catalogue no. 41.0/1500, courtesy Department of Library Services, American Museum of Natural History.

72 Bay of Paracas, aerial view. Photo Shippee-Johnson, negative

no. 334697, courtesy Department of Library Services, American Museum of Natural History.

73 Remains of domestic structures, Paracas. Photo Adriana von Hagen.

74 Cahuachi, Nazca valley, aerial view. Photo © Marilyn Bridges.

75 Cantalloq, entrance to puquio, Nazca valley. Photo © Edward Ranney.

76 Ground markings at Sacramento, Palpa valley. Photo © Edward Ranney.

77 Map of principal sites discussed in Chapter 6. Drawing Petica Barry.

78 Tiwanaku, detail of Akapana temple. Photo Peter McFarren.

79 Tiwanaku, idealized reconstruction of Akapana. Drawing Michael Glavin, after Alan Kolata, fig. 5.5b, 1993: 106.

80 Tiwanaku, view from the Semi-Subterranean Temple toward the Kalasasaya. Photo Johan Reinhard.

81 Scattered stones of Tiwanaku's Puma Punku temple. Photo Wendell C. Bennett, negative no. 600906, courtesy Department of Library Services, American Museum of Natural History.

82 Ponce Monolith, Kalasasaya, Tiwanaku. Photo Peter McFarren.

83 Gateway of the Sun, Tiwanaku. Photo Wendell C. Bennett, negative no. 600909, courtesy Department of Library Services, American Museum of Natural History.

84 Farmers tend to their potatoes on raised fields near Lake Titicaca. Photo Wolfgang Schüler.

85 Sculpture of volcanic stone representing a human figure, from Wari. Photo Heinz Plenge.

86 Sculpture of volcanic stone portraying a feline, from Wari. Photo Heinz Plenge.

87 Capillapata sector, Wari. Photo Adriana von Hagen

88 Slab chambers at Wari's Cheqo Wasi sector. Photo Adriana von Hagen.

89 Viracochapampa, idealized reconstruction of a niched hall and patio complex. Drawing Michael Glavin, after John T. Topic, fig. 4, 1991: 146.

90 Pikillacta, a narrow room within a multi-storied gallery. Photo Gordon McEwan.

91 Aerial view of Pikillacta, Cuzco valley. Photo Shippee-Johnson,

negative no. 334819, courtesy Department of Library Services, American Museum of Natural History.

92 Cerro Baúl, a Wari outpost in Moquegua. Photo © Edward Ranney.

93 Tiwanaku-style gold plaque made of hammered and incised gold. Photo John Bigelow Taylor, courtesy Hoover Institution, Stanford University.

94 Map of principal sites discussed in Chapter 7. Drawing Petica Barry.

95 Aerial view of Chan Chan, Moche valley. Photo Shippee-Johnson, negative no. 334881, courtesy Department of Library Services, American Museum of Natural History.

96 Plan of Ciudadela Rivero, Chan Chan. Courtesy Michael E. Moseley.

97 Plan of Chan Chan. Courtesy Michael E. Moseley.

98 Mudbrick friezes, Ciudadela Tschudi, Chan Chan. Photo Adriana von Hagen.

99 Stylized birds at Ciudadela Tschudi, Chan Chan. Photo Adriana von Hagen.

100 Wooden figure guarding access to Ciudadela Rivero, Chan Chan. Courtesy Michael E. Moseley.

101 Wooden model of Chan Chan-like compound. Photo Adriana von Hagen.

102 Carved wooden doorway figure found at Farfán, a Chimú center. Drawing Michael Glavin, after Richard Keatinge and Geoffrey Conrad, fig. 9, 1983: 272.

103 Aerial view of Pachacamac, Lurín valley. Photo Shippee-Johnson, negative no. 334841, courtesy Department of Library Services, American Museum of Natural History.

104 A Pyramid with Ramp at Pachacamac. Photo © Edward Ranney.

105 Aerial view of La Centinela, Chincha valley. Photo Shippee-Johnson, negative no. 334734, courtesy Department of Library Services, American Museum of Natural History.

106 Frieze of stylized birds, La Centinela, Chincha valley. Photo © Edward Ranney.

107 Aerial view of Pisac, Urubamba valley, Cuzco. Photo Shippee-

Johnson, negative no. 334768, courtesy Department of Library Services, American Museum of Natural History.
108 Tambo Colorado, an Inka installation in the Pisco valley. Photo © Edward Ranney.
109 Silver figurine found on the summit of Cerro el Plomo, Chile. Courtesy Museo Nacional de Historia Natural, Santiago.
110 Qorikancha, Cuzco's sun temple. Photo Adriana von Hagen.
111 Aerial view of Sacsawaman, Cuzco. Photo Adriana von Hagen.
112 Llamas and alpacas at Sacsawaman. Photo Adriana von Hagen.
113 Panoramic view of Sacsawaman. Photo Adriana von Hagen.
114 Hypothetical, bird's eye view of Inka Cuzco. Drawing Vincent R. Lee.
115 Rock falls at Kachiqata, Ollantaytambo. Photo Adriana von Hagen.
116 Pan-like depressions on an Ollantaytambo stone. Photo Adriana von Hagen.
117 Detail of stonework at Ollantaytambo. Photo Adriana von Hagen.
118 Ollantaytambo, viewed from across the valley. Photo Adriana von Hagen.
119 Terraces below Ollantaytambo's Temple Hill. Photo Adriana von Hagen.
120 The Wall of the Six Monoliths, Ollantaytambo. Photo Adriana von Hagen.
121 Reconstruction of an Inka-style kancha. Drawing Vincent R. Lee.
122 Tipón, an Inka agricultural estate in the Cuzco valley. Photo Adriana von Hagen.
123 View of Machu Picchu through the Temple of the Three Windows. Photo Adriana von Hagen.
124 Aerial view of Machu Picchu. Photo Adriana von Hagen.
125 Machu Picchu, with Huayna Picchu behind. Photo Heinz Plenge.
126 Map of the Inka empire and its road system. Drawing Petica Barry, after John Hyslop. Fig. 10.4, 1990: 275, courtesy American Museum of Natural History, New York.
127 Inka road at Pisac, Urubamba valley. Photo Tony Morrison, South

American Pictures.
128 Ceramic vessel in the Chincha Inka style. Photo John Bigelow Taylor, catalogue no. 41.2/652, courtesy Department of Library Services, American Museum of Natural History.
129 View from the storehouse hill overlooking Huánuco Pampa. Photo William Burke, courtesy American Museum of Natural History.
130 Puma doorway at Huánuco Pampa. Photo Craig Morris, courtesy American Museum of Natural History.
131 Women spinning, Ocongate, Cuzco. Photo Tafos.
132 Women weaving, Yanaoca, Cuzco. Photo Tafos.
133 Woman weaving on a backstrap loom. Drawing Felipe Guaman Poma de Ayala.
134 A bag used to carry coca leaves, Inka-style. Photo John Bigelow Taylor, negative no. 41.2/622, courtesy Department of Library Services, American Museum of Natural History.
135 An Inka *quipu*, made of cotton. Photo John Bigelow Taylor, catalogue no. 41.2/6996, negative no. 4955, courtesy Department of Library Services, American Museum of Natural History.
136 A *quipucamayoc*, or reader of the quipu. Drawing Felipe Guaman Poma de Ayala.
137 Mina Perdida, Lurín valley, showing three superimposed stairways. Photo Adriana von Hagen.
138 Ceramic vessel excavated at Huánuco Pampa. Photo Craig Morris, courtesy American Museum of Natural History.
139 Bone weaving implements excavated at Huánuco Pampa. Photo William Burke, courtesy American Museum of Natural History.
140 Rollout drawing of the Moche Sacrifice Ceremony. Drawing Donna McClelland.
141 Reconstruction of a mural at Pañamarca. Drawing Felix Caycho, Photo Gonzalo de Reparaz, courtesy Christopher B. Donnan.
142 Frieze of nude prisoners, Cao Viejo, Chicama valley. Photo © Edward Ranney.
143 Hallucinogenic San Pedro cactus. Photo Adriana von Hagen.

144 Doorway under reconstruction, Ollantaytambo. Photo Adriana von Hagen.
145 Jean-Pierre Protzen using a hammer stone to shape a block. Photo Adriana von Hagen.

Acknowledgments

We would like to thank Peter Frost, Corinne Schmidt and Freda Wolf, who read early drafts of this book, as well as Carol Mackey, Gordon McEwan and Helaine Silverman, whose valuable comments were of much aid. We are also thankful to our friends and colleagues who supplied illustrative material for this book. We are especially grateful to Sumru Aricanli of the American Museum of Natural History who helped gather the illustrations and oversaw the production of maps and figures, and to Petica Barry and Michael Glavin for drawing the maps and figures. Finally, we would like to thank the staff at Thames and Hudson.

Index

(Page numbers in *italic* refer to illustrations, those in **bold** refer to entries for sites in gazetteer.)

adobe, 10, 84, 127, *167*; ceremonial architecture (*see* mounds); *ciudadelas*, 99, 140, 144, 145–7, *146, 150*, 152, 216; maker's marks on, 84, *91*, 92, 213; residential architecture, 103, 105, 119, 171, 177; sculpture, *54*, 56, 57

agriculture, 16, *17*, 22, *24–5*, 107; Chimú, 152, 153; Chincha, 157–8; Inka, 16, 165, 166, 175, 177, 179–81; Moche, 84, 85, 98–9; Preceramic and Early Ceramic, 40, 41, 43, 46, 47, 56; in Tiwanaku region, 114, 118, 125–7, *126*; Wari, 131; *waru waru*, 22, 118, 125–6, *126*. *See also* irrigation

Agua Tapada, 58

Akapana (Tiwanaku), 33, 120, *121*

alpacas, 16–18, *23*, 105, 125, 126, 137, 140, 160, *173*, 190, 217

Ampato, 163, 217, 218–19

Andean region: access to natural resources in, 22, 26, 34, 37; economies in, 10–11, 34, 35–6; landscape of, 10, 13–18, *15, 17*, 20–1; map of, *12*; natural disasters in, 18–22, *19*, 34; patterns of collaboration and conflict in, 26, 36–7; urban development in, 27–38

aqlla ("chosen women"), 177, 195, 205

architecture: diversity of, in cities, 28–32, 41, 86. *See also* adobe; ceremonial architecture; friezes; mounds; residential architecture; stonework

Arequipa, *19*

Aspero, 28, *42*, 43

Atawalpa, 165, 178, 197

Aucaypata (Cuzco), *174*, 177

audiencias, 148, 154, 216

Aymara, 166

Azángaro, 131

barrios, 140–1, 144, 149–52, 215, 216

Batán Grande, 34, *76*, 142–4, 154, 157, **220**

Bennett Stela (Tiwanaku), 120–4

Bird Priest, 208, 209

birds of prey, 26, *65*, 66, 67, 212

Bombón (Pumpu), **225**

bronze, 95, 141, 152, 217

Caballo Muerto, *54–5*, 56–7, 58

Cahuachi, 107–10, *108*, **220**

Cao Viejo, *207*, 209–10

caravanserais, 140–1, 152, 215, 216–17

Cardál, *50*, 51, 58, **220**

Casma, 48, 52–6

ceques (conceptual lines), 175–7

ceramics, 10, 119, 127, 131, 142, 149, 155; Chavín, 62, 63, 67, 70, 74–5, 78, 81, 82, 211; Cupisnique, *55*, 56, 57, 67, 81; Early Ceramic, 40, 47–8, 51, *55*, 56–8; Inka, *189*, 203–4; Killke, 160; Moche, 85, 86, 90, 92–4, *100*, 103, 205–9, *206–7*, 213; Nazca, 86, 109, 128; Paracas, 105; Wari, 111, 116, 128, 131, 133–7

ceremonial architecture: early, 39–58; Inka, 175, 177; orientation of, 33, 49–51, 62–3; Tiwanaku, 114, 115, 118, 120–5, *121–4*; Wari, 128–9. *See also* mounds

Cerro Arena, 86–7, **220**

Cerro Baúl, 133, *136–7*, **220**

Cerro Blanco, 81, 92, 93, *96*

Cerro Colorado, 105, *106*

Cerro Orejas, 88

Cerro Sechín, *53*, 56

Chakinini occupation (Chavín de Huántar), 70

Chancay, 142, 155

Chan Chan, 9, *31*, 35, 99, 139–41, 144–52, *146–51*, 154, 165, 168, **220–1**; *barrios* and artisans of, 140–1, 144, 149–52, 154, 215–17; palace compounds at, 140, 144, 145–7, *146, 150*, 152; tombs of Chimú kings at, 36–7, 145–7, *146*, 168

Chavín cult, 34, 56–9, 62, 70, 72; metalwork of, 59, 74–5, *76–7*, 78, *79, 80*; regional centers of, 78–81; spread of, 74–5, 78–9

Chavín de Huántar, 26, 34, 58, 59–82, *64–5*, **221**; eclectic iconography at, 67–72, 74; fall of, 81–2; founding of, 62–3; New Temple at, 60, 61, *64, 65*, 72–4, *73*, 80; Old Temple at, *29*, 62, 63, *64–5*, 66–70, *68–9, 71*, 72–3, 120, 212; oracle of, 60–2, 66, 67, 211–12; pilgrimage to, 60–1, 210–12; siting of, 33–4, 62–3

Cheqo Wasi enclosure (Wari), 128, *130*

chicha (maize beer), 67, 131, 163, 177, 181, 195, 204–5, 219

Chimor (Chimú), 9, *31*, 36, 99, 103, 139–41, 144–55, 168; economy of, 153, 155; expansion of, 152–5; origins of, 145; satellite settlements

of, 37, 139, *153*, 153–-5, 221, 222–3. *See also* Chan Chan

Chincha, 142, 157-8, *159*, 168, *189*, 190, 222

Chiripa, 116, 125

Chongos, 105

Chongoyape, 81

chulpas (burial towers), 160

cities of Andes: as ceremonial centers, 34–5, 37; characteristics of urban life and, 28–32; evolution of, 27–38; first, 83–112; orientation of buildings in, 10, 33, 49–51, 62–3, 118; precursors of, 39–82; reconstructing life in, 199–219; as redistribution centers, 10–11, 35–6; satellite settlements, 36–7 (*see also* satellite settlements and urban networks); secularization trend and, 36–7, 154; shifting populations in, 10, 35; siting of, 20, 33–4; social differentiation in, 28, 41, 47, 72, 213. *See also specific sites*

ciudadelas, 99, 140, 144, 145–7, *146, 150*, 152, 216

coastal desert, 14–16, *15, 17*, 70, 107–8; agriculture in, 16, 22, 43; early monumental architecture in, 40–3, *41*, 46–57, *48–50, 52–4*, 58; *Niños* and, 18–22, *19*; Wari's links to, 133–7. *See also specific sites*

Collique, 155

copper, *80*, 94, 95, 98, 141, 143, 209, 217

Cordillera Blanca, *20–1*

Cumbemayo, 58

Cupisnique, 48, *54–5*, 56–7, 66, 67, *77*, 86

Cusipata (Cuzco), *174*, 177

Cuzco, 9, 37, 119, 160, 162–8, 170–9, *174*, 186, 188, *189*, 196, 203, 217, 218, **221**; ceremonial core of, 175, 177; palace-compounds of, 177–8; plan of, *174*, 175–8; population of, 170–1

Decapitator, 93, 94, *96, 97*, 209, 210

Dos Palmas, 110

drainage systems, 66, 92, 115, 121, 129, 212

droughts, 18, 22, 34, 103, 131

Early Ceramic, 40–1, *42*, 46–58, 81; ceremonial centers of, 46–58, *48–50, 52–6*; pottery of, 40, 47–8, 51, *55*, 56–8; social organization in, 46–7, 56; textiles of, 40, 47, 53

earthquakes, 18, 22, 34, 75, 157, 210, 212

ecological complementarity, 26, 126, 168

El Brujo, *207*, 209–10

El Paraíso, *42–3*, 49

ethnographic observation, 201–3

Farfán, *153*, 153–4, **221**
felines, 42, *55*, 67, *80*, *129*, *153*, 208
figurines, 119, 158, *169*, 217, 219
fire-pits, 43–5, *44*, 46
fishing, 16, *17*, 43, 46, 47, 70, 84, 85,
 105, *106*, 152, 157–8
floods, 18–22, *19*, 34, 84, 98–9
friezes, 10, *29*, 39, 93, *96*, *97*, 148, 149,
 150, 158, *159*, *207*, 209–10

Galindo, 99, 103, 148, **221–2**
Gallinazo, 86, 87–8
Garagay, *49*
Gateway God, 118, *124*, 124–5
Gateway of the Sun (Tiwanaku), 120,
 124, 124–5, 215
geoglyphs, 14, 107, 109, 110, *111*
geography: of Andean region, 10,
 13–22, 35; sacred, 10, 33, 62–3, 118,
 183
gold, 142, 152, 177, 178, 179, 198, 217,
 218; Chavín, 59, 74–5, *76–7*, 78, *79*,
 81; Moche, 94, 95, *95*; Tiwanaku,
 115, 118, *138*, 215

hallucinogens, *55*, 66, 70, *211*, 212
Hatun Xauxa, 36, 222
highlands, 14, 16–18, *17*, 20–1, 37, 70,
 142, 148; agriculture in, 16, 22, 47;
 early monumental architecture in,
 40–1, 43–6, *44*, *45*, 57–8; residential
 architecture in, 45–6; siting of
 settlements in, 33–4; from 1200 to
 1400, 158–60; Wari in, 111–12. *See
 also specific sites*
Huaca de la Luna, 22, 84–5, *86*, 88,
 88–90, 90–3, *96–7*, 98–9, 102, 149,
 212, 213, **223**
Huaca de los Idolos (Aspero), *41*
Huaca de los Reyes (Caballo Muerto),
 54–5, 56-7, 58
Huaca del Sol, 22, 84–5, 86, *88–91*,
 90–2, 98–9, 102, 212–13, **223**
Huaca Fortaleza (Pampa Grande),
 102, *102*, 103
Huacaloma, 57, 58
Huaca Prieta, 42
huacas (sacred places, people, or
 objects), 75, 175–7, 218
Huancaco, 90
Huánuco Pampa, *29*, 35, 161, 166,
 190–1, 190–5, *204–5*, **222**;
 reconstructing life in, 203–5
Huarpa, 128
Huayna Picchu, *185*
human sacrifice, 149; Inka, 162–3,
 169, 217–19; Moche, 93–4, *95*, 97,
 206–7, 208–10
Humboldt current, 14-16, 18

Ichma (or Ychma or Ichimay), 157
Illapa, 125
Inka, 22, 47, 75, 119, 144, 155, 161–98,

213; agriculture of, 16, 165, 166, 175,
 177, 179–81; building style of, 167–8;
 collapse of, 195, 196–8; diversity in
 empire of, 165–6, 171, 196;
 expansion of, 149, 152, 160, 164–5,
 168, 189–90; human sacrifice, 162–3,
 169, 217–19; origin myths of, 137,
 168; reconstructing life in, 201-5,
 217–19; record-keeping of, 138, 166,
 200, 201; religion and ceremonies of,
 125, 154, 161–3, 166–7, 168, *169*, 177,
 181, 194, 217–19; residential
 architecture of, 171, 177, 182, *182*,
 183, 186, 195, *214*; road system of,
 27, 28, 37, 165, 166, *174*, 176, 177,
 183, 186–9, *187*, *188*, 196; satellite
 settlements of, 26–8, *29*, 35-6, 37,
 138, *164*, 165–8, *167*, 189–96, *190–1*,
 222–7; succession of rulers in, 197;
 Urubamba valley and, 179–86, *188*;
 Wari and Tiwanaku cultures' links
 to, 116, 137–8
Inkawasi, **222**
irrigation, 16, 22, 40, 41, 46, 47, 58, 84,
 86–8, 98, 99, 118, 131; Chimú, 152–4;
 Inka, 166, 175, 177; Nazca, 107, 108,
 109

jaguars, 26, *29*, 57, 61, *65*, 66, 67, *68*,
 80, 212
Janabarriu occupation (Chavín de
 Huántar), 70–2, 78
Jauja, 36, **222**
Jequetepeque, 57, 144, 145, 209
Jincamocco, 131

Kachiqata, *176*, 183
Kalasasaya (Tiwanaku), *122–4*,
 124–5, 215
kanchas (walled compounds), 182,
 182, *214*
Karwa, 72, 78
Killke, 160
Kotosh, 43–5, *44*, 58, 79
Kuntur Wasi, 57, 58, *76–8*, 79–81, 82

La Centinela–Tambo de Mora, 157–8,
 159, 167, **222**
La Florida, 51
La Galgada, *45*, 45–6, 58
La Leche, 144
Lambayeque (Sicán), 103, 142–4, 220,
 226. *See also* Batán Grande
Lanzón (Chavín de Huántar), 67, *69*,
 71, 74, 211
Layzón, 57, 58
llamas, 16, 18, *23*, 35, 70, 74, 125, 126,
 137, 140, 141, 160, *173*, 189, 210, 216,
 217, 218
Lukurmata, 126, 127
Lupaca, 158–60

Machu Picchu, 9, 183–6, *184–5*, **222**

maize, 16, *24*, 37, 127, 131, 181, 194,
 195, 204, 219
Manchán, 155, **222–3**
Maranga, 105, **223**
Marca Huamachuco, 132, **223**
markets: dearth of, 10–11, 35
Maymi, 111, 136
metalwork, 10, 36, 141, 149, 152, 165;
 at Batán Grande, 142–3; Chavín, 59,
 74–5, *76–7*, 78, *79*, *80*; Chimú, 154,
 168, 216, 217; Moche, 84, 86, 92–8,
 95, 205, 212–13
Mina Perdida, *202*
Minchançaman, 145
mit'a (communal labor), 46, 166
Moche, 22, 33, 36, 84–103, 142, 143,
 148, 221–2, 226; human sacrifice,
 93–4, *95*, 97, *206-7*, 208–10; late
 centers of, 99–103, *102*, 224;
 reconstructing life in, 205–13;
 spheres of influence 89–90; waning
 power of, 98–9, 111. *See also* Huaca
 de la Luna; Huaca del Sol
Mocollope, 90
monoliths, 67, *123*
Montegrande, 57
Moraduchayoq (Wari), 128, 129
Motupe, 144
mounds, *30*, 39, 99; adobe, 33, 39, 51,
 87, 88, 90–3, *101*, *102*, 103, 105, *108*,
 109, 212–13; Chavín, *29*, 60–3, *64–5*,
 66–7, *68–9*, 70, *71*, 72–4, *73*, 79–81,
 120, 212; Chimú, 144, 149;
 Cupisnique, 48, *54*, 56–7; Early
 Ceramic, 48–50, 48–58, *52–5*;
 Lambayeque (Sicán), 142–4;
 meaning of U-shaped layout, 49–51;
 Moche (*see* Huaca de la Luna; Huaca
 del Sol); Preceramic, *41*, 42–6, *44*, *45*,
 49; Pyramids with Ramps, *156*, 157;
 Tiwanaku, 120–5, *121–4*. *See also*
 ceremonial architecture
Moxeke–Pampa de las Llamas, 52,
 53–6, **223**
mummies, 105, 142, 149, 162
murals, 10, 93, 94, 115, *206*, 210

natural resources, 22, 26, 34, 37, 127,
 131, 137, 195–6
Nazca, 86, 105, 107–12, 128, 133
Nazca lines, 14, 107, 109, 110, *111*
Niños, 18–22, *19*, 93, 144; Moche and,
 98–9, 103

occupational specialization, 28, 47,
 70–2, 78–9, 86, 152, 157–8, 213
Ollantaytambo, *176*, 180–2, 181–3,
 214, **223–4**
Omo, 127, **224**
oracles, 35, 163; Chavín de Huántar,
 60–2, 66, 67, 211–12; Pachacamac,
 35, 75, 136, 142, 157, 168, 210–11,
 212, 224

Pacatnamú, 154, **224**
Pachacamac, 35, 75, 105, 136–7, 142, 155–7, *156*, 167, 168, 210–11, 212, 217, **224**
Pachakuti, 165, 175, 181, 186
Pacheco, 111
Pacopampa, 75, 79
Pampa de las Llamas. *See* Moxeke–Pampa de las Llamas
Pampa de los Incas, 90
Pampa Grande, 99–103, *102*, 107, **224**
Pañamarca, 90, *206*
Paracas, 78, *104*, 105–7, *106*, **224–5**
Pikillacta, 132, *134–5*, 165, **225**
pilgrimages, 34–5, 60–1, 119, 154, 210–12
Pisac, *164*, *188*
Ponce monolith (Tiwanaku), *123*
pottery. *See* ceramics
Preceramic, 28, 40–6, *41*, *44*, *45*, 49, 74
Puémape, 57
Pukara, 86, 116–17, 125, **225**
Pumapunku (Tiwanaku), 120, *122*, 124, 125, 215
pumas, 10, 115, 175, *191*, 194
Pumpu (Bombón), **225**
Pyramids with Ramps, *156*, 157

Qhapaq Hucha, 162–3, *169*, 217–19
Qhapaq Ñan, 186, 190
Qolla, 158–60
Qorikancha (Cuzco), 162, *170*, 178, 179
Quechua, 166, 171
quipu (record-keeping device), 138, 166, *200*, 201

Raimondi Stela (Chavín de Huántar), 74, 78, 81
Raqchi, **225**
religion and ceremony, 10–11, 34–5, 37; Chimú, 149, *151*, 154; Inka, 125, 154, 161–3, 166–7, 168, *169*, 177, 181, 194, 217–19; Moche, 93–4, *97*, 102–3, 205–10, *206–7*; Tiwanaku, 116, 118, 124–5. *See also* ceremonial architecture; human sacrifice; mounds
Reque, 144
residential architecture: Chimú, 144, 149–52, 155, 215, 216–17; Chincha, 158; Early Ceramic, 41, 51, 56, 57; Inka, 171, 177, 182, *182*, *183*, 186, 195, *214*; Moche, *90*, 91, *96*, 99, 213; at Paracas, 105, *106*; Preceramic, 41, 42, 45–6; at Pukara, 117; Wari, 129–31, 132, *133–5*
ritual battles, 10, *172–3*, 179, 208
road systems, 138; Chincha, 157–8; Inka, 27, 28, 37, 165, 166, *174*, 176, 177, 183, 186–9, *187*, *188*, 196; Wari and Tiwanaku, 37, 113, 116, 138

Sacrifice Ceremony, 93–4, *95*, *206–7*, 208–10
Sacsawaman (Cuzco), *172–4*, 175, 178–9
Salinar, 86–7, 220
San José de Moro, 209, **225**
San Pedro cactus, *55*, *68*, 70, *211*, 212
satellite settlements and urban networks, 36–7, 113, 116; Chimú, 37, 139, *153*, 153–5, 221, 222–3; Inka, 26–8, *29*, 35–6, 37, 138, *164*, 165–8, *167*, 189–96, *190–1*, 222–7; Wari, 37, 131–3, *133–7*, 138, 148, 165, 202, 224, 227
Sechín Alto, *52*, 52–3, **225–6**
Semi-Subterranean Temple (Tiwanaku), 120–4, *122–3*
Sicán. *See* Lambayeque
silver, 94, 98, 142, 152, *169*, 178, 177, 179, 198, 217, 218
Sipán, **226**; human sacrifice at, 93, 94, 208–9, 210; tombs at, *80*, 95, *95*, *101*, 108, 143, 208–9
social differentiation, 28, 41, 47, 72, 213
Spanish chroniclers, 14, 37, 62, 75, 124, 128, 145, 160, 175, 177–9, 181, 186–8, 197–8, 201, 204, 205, 217–18
Spanish invasion, 92, 149, 164, 175, 178, 182–3, 186, 195, 196–8, 203
spiders, *49*, 94, *95*, 110, *111*, 209, 210
Spondylus shells, 35, 36, 47, 57, 67, 70, 74, *80*, 102, 132, 149, 211, 212, 219
stone sculptures, *53*, 56; Chavín, 61, *65*, 66–72, *68*, *71*, 74, 79; Tiwanaku, 114–16, 120–5, *122–4*; Wari, *129*
stonework: Inka, 167-8, *176*, 177, 213, *214*; Tiwanaku, 114–25, *122–4*, 213–15; Wari, 128, *130*
storehouses, *31*, 36, 119, 148, 152, 211; Inka, 22, 175, 194, 201, 203–4
Strombus shells, 57, 67, 70, 74, 79, 81, 212

Tacaynamu, 145
Tambo Colorado, *167*, **226**
Tambo de Mora. *See* La Centinela–Tambo de Mora
Tambo Viejo, 110, **226**
Temple of the Crossed Hands (Kotosh), 43–5, *44*
terracing: agricultural, 16, 22, 128, 175, *183*
textiles, 10, 36, 155, *192–3*; Chavín, 59, 70–2, 74–5, 78; Chimú, 140, 149, 152, 216, 217; Early Ceramic, 40, 47, 53; Inka, 165–6, *169*, 178, 195, 201, 204–5, *205*; Moche, 84, 86, 92; Nazca, 86, 105; Paracas, *104*, 105; Preceramic, 42, 46; Tiwanaku, 118, 119, 126; Wari, 111, 116, 131
Thunupa, *124*, 124–5

Tipón, *183*
Titicaca, Lake, 18, 22, 33, 114, 116–18, 120, 125, 127, 137, 168, 190, 213–15, 217
Tiwanaku, 22, 33, 35, 72, 74, 75, 86, 112, 113–27, *138*, 142, 165, 158, 224, **226**; ceremonial core of, 114, 115, 118, 120–5, *121–4*; economy of, 125–7; expansion and decline of, 127; forerunners of, 116–17; legacy of, 116, 137–8, 168; reconstructing life in, 213–15; religion of, 116, 118, 124–5; remnants of, 117–18; residential areas of, 119; siting of, 118; stone monuments of, 114–25, *122–4*, 213–15; Wari's links to, 116, 133
tombs, 46, 47, 58, 81, 105, 111, 128; at Batán Grande, 142, 143; of Chimú kings, 36–7, 145–7, *146*, 168; *chulpas*, 160; Moche, 94, 95, *101*; Nazca, 107, 108; at Sipán, *80*, 95, *95*, *101*, 108, 143, 208–9
trade, 35, 113, 126–7, 140–1, 152, 157–8, 168
tropical forest, 14, 18, 58; Chavín iconography and, 67–70
tsunamis (tidal waves), 18
Túcume, 144, 154–5, 217, **226–7**
Tunanmarca, 158

Urabarriu occupation (Chavín de Huántar), 63–70
Urubamba valley, *164*, 167, 171, 179–86, *188*
ushnu, 167

Ventilla, 110
Vilcabamba, 186
Vilcas Waman, 36, **227**
Viracochapampa, 103, 132, *133*, **227**
volcanoes, 18, *19*, 163

Wall of the Six Monoliths (Ollantaytambo), *181*, 182-3
Wanka, 158
Wari, 26, 36, 75, 103, 111–12, 128–37, 142, 155; city of, 35, 37, 112, 113, 116, 128–31, *130*, 165, **227**; coast and, 133–7; legacy of, 116, 137–8, 168; residential architecture of, 129–31, 132, *133–5*; satellite settlements of, 37, 131–3, *133–7*, 138, 148, 165, 202, 224, 227; Tiwanaku's links to, 116, 133
Warrior Priest, 94, *208–9*
waru waru (raised fields), 22, 118, 125–6, *126*
Wayna Qhapaq, 162–3, 165, 177, 197
weaving. *See* textiles

Zaña, 144